	DATE	

Native North American Art

Oxford History of Art

Janet Catherine Berlo is the Susan B. Anthony Chair of Gender and Women's Studies and Professor of Art History at the University of Rochester, in New York. She is the author of numerous studies of the indigenous arts of the Americas, including *Plains Indian Drawings 1865–1935: Pages from a Visual History* (Abrams, 1996) and *The Early Years of Native American Art History* (University of Washington Press, 1992).

Ruth B. Phillips is Director of the Museum of Anthropology at the University of British Columbia and Professor of Fine Art and Anthropology. Her publications on Native American art include *Patterns of Power: The Jasper Grant Collection and Great Lakes Indian Art of the Early Nineteenth Century* (1984) and *Trading Identities: The Souvenir in Native North American Art from the Northeast, 1700–1900* (University of Washington Press, 1998).

Oxford History of Art

Native North American Art

Janet Catherine Berlo
and Ruth B. Phillips

Oxford New York

OXFORD UNIVERSITY PRESS

1998

Oxford University Press, Great Clarendon Street, Oxford OX2 6DP

Oxford New York
Athens Auckland Bangkok Bogota Bombay
Buenos Aires Calcutta Cape Town Dar es Salaam
Delhi Florence Hong Kong Istanbul Karachi
Kuala Lumpur Madras Madrid Melbourne
Mexico City Nairobi Paris Singapore
Taipei Tokyo Toronto Warsaw
and associated companies in Berlin Ibadan

Oxford is a trade mark of Oxford University Press

© Janet Catherine Berlo and Ruth B. Phillips 1998

First published 1998 by Oxford University Press

British Library Cataloguing in Publication Data
Data available

Library of Congress Cataloging in Publication Data
Data available

0–19–284218–8 Pbk
0–19–284266–8 Hb

10 9 8 7 6 5 4 3 2 1

Picture Research by Virginia Stroud-Lewis
Designed by Esterson Lackersteen
Printed in Hong Kong
on acid-free paper by
C&C Offset Printing Co., Ltd

Contents

Acknowledgements

We are grateful to the many friends and colleagues who shared their expertise and current research with us. Some of them also read portions of the manuscript and gave us helpful insights and suggestions: Arthur Amiotte, Jonathan Batkin, Michael Blake, Christopher Carr, Marjorie Halpin, Marion Jackson, Aldona Jonaitis, J. C. H. King, Andrea Laforet, Nancy Parezo, Jolene Rickard, W. Jackson Rushing, Leona Sparrow, Judy Thompson, Richard Wright, and Robin Wright.

As always, our friend and colleague Aldona Jonaitis gave encouragement and support, as did our husbands, Bradley D. Gale and Mark Phillips. Emma Phillips provided the drawings used in several margin illustrations. Kim Patten, our research assistant on this project, deserves a special note of thanks for her wide-ranging capabilities in all things bibliographic, artistic, editorial, and technical.

Janet Berlo's Research Board Grant from the University of Missouri, St Louis (1995–97) provided financial assistance for travel, research, and manuscript preparation. Ruth Phillips is grateful to the National Gallery of Canada for the award of a fellowship at the Canadian Centre for the Visual Arts during the final period of writing. Our special thanks go to our editors, Simon Mason and Katie Jones, whose good judgement and enthusiasm helped make this a better book.

Janet Catherine Berlo
Ruth B. Phillips

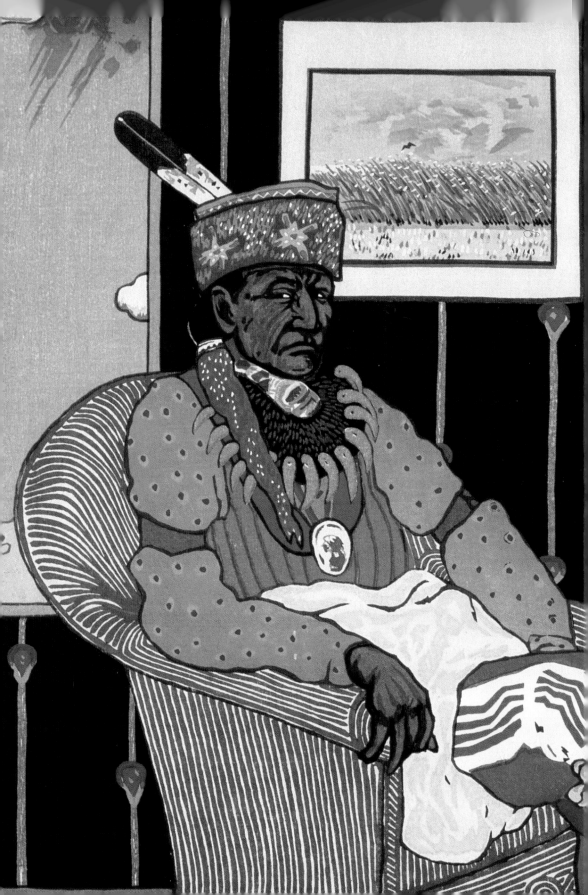

An Introduction to the Indigenous Arts of North America

1

Native North American art, after five centuries of contact and colonialism, is extraordinarily rich and diverse. Today, Native artists, male and female, trained in their communities and in professional art schools, and living in cities and on reserves, work in a broad range of media, conceptual modes and expressive styles. As the half millennium of contact drew to a close, Angelique Merasty (1924–96), a Cree artist from Western Canada, was practising the ancient art of birchbark biting, creating intricate designs in thin, folded sheets of birchbark that might later serve as patterns for a piece of beadwork or embroidery. At the same time Tony Hunt Jr, a Kwakwaka'wakw artist from British Columbia, might be carving a mask destined either for a non-Native collector or for use in a potlatch, its forms defined by an equally ancient and exigent set of techniques and stylistic rules [1]. And as they worked, James Luna, a Diegueño-Luiseño performance artist from southern California, might have been preparing his 'Artifact Piece', in which he transformed himself into a living artefact in order to critique the way that these and other Native arts and cultures have been represented in Western museums [2].

These three moments of art-making, chosen from many possible examples, encompass the sacred and the secular, the political and the domestic, the ceremonial and the commercial. The visual pleasure afforded by a Cree woman's bitten birchbark pattern captures the reality of her inner vision, and enhances daily life whether it lives on in the design of a pair of moccasins or remains the ephemeral experience of an afternoon. When used in a potlatch, a Northwest Coast mask, by displaying the image of a non-human being from whom its owners inherited valuable powers and prerogatives, makes an important statement about the location of political power. And, in the hands of Native American artists, contemporary Western art forms such as performance and installation have become powerful tools of cultural critique by which the representation of Native people and their arts in Western institutions is being challenged and changed. The contemporary vitality of Native American art is also evidence of an extraordinary story of survival. A century ago, most non-Natives (and many Native people as well) had become convinced that Aboriginal arts and cultures would

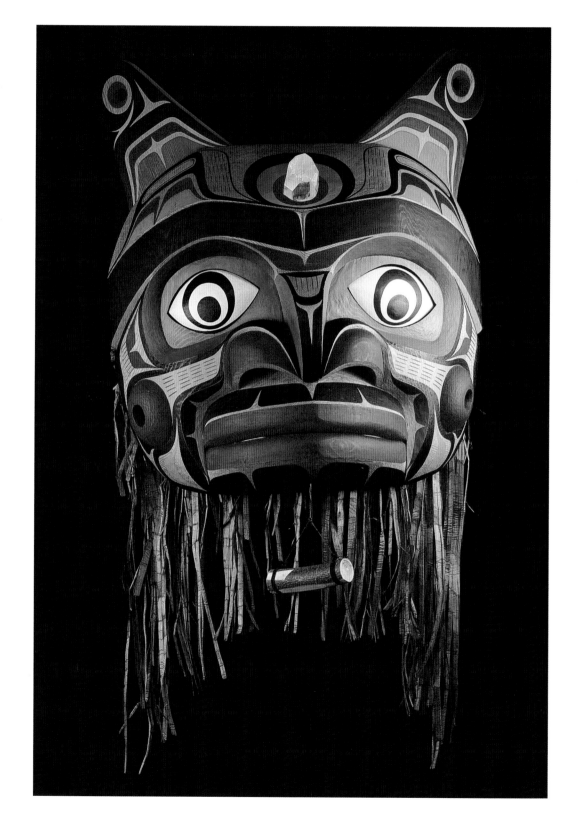

1 Tony Hunt, Jr (b. 1942), Kwakwaka'wakw

Sea monster mask (red cedar, bark, copper, quartz crystal, cord), 1987

The mask represents a specific sea monster named *Namxxelagiyu*, one of the ancestors of the '*Namgis*, who came out of the sea to build a house, assisted by a thunderbird. Too large to be worn in the normal way, the mask is manipulated at potlatches by a dancer who emerges from behind a screen. The crystal incorporated into the mask signifies power, and the copper, wealth.

soon disappear. Yet, today, these arts are thriving and receiving renewed attention, both within Aboriginal communities and from non-Native students, art-lovers and museums. The visual arts have long played a critical role as carriers of culture within Native American societies. They are also among the most eloquent and forceful articulations of the contemporary politics of identity.

Art history and Native art

This book is intended to introduce readers to the richness of Native American art forms in all their temporal depth and regional diversity. It is also intended to make readers aware of the problems we now recognize in the way these arts have been represented in museums and scholarly writing. As art historians we approach this enormously challenging task in the belief that the comprehensive historical overview is a useful exercise, even though it must always be highly selective and can never be definitive. A continent-wide geographical scope encourages us to look for both unity and diversity, to recognize the many common beliefs and practices revealed in these arts at the same time as we savour the distinctiveness of local and regional artistic traditions. The temporal dimension of the historical survey complements this spatial breadth in its revelation of both change and continuity.

Yet the survey, like all forms of narrative, shapes the story it tells. Aboriginal conceptions of time are often organized around principles of cyclical rather than linear order. Western traditions of historical narrative which, in contrast, tend to privilege moments of change, are appropriate to a history of Native American art in the sense that much of the story of this art over the past five centuries tells of successive visual responses to crises such as epidemics, forced removals from homelands, repressive colonial regimes, religious conversion, and

2 James Luna (b. 1950), Diegueño/Luiseño

'The Artifact Piece', 1987–90

In a work that combined elements of installation and performance, Luna placed himself in an exhibition case in a San Diego Museum of Man hall containing a conventional ethnographic display about American Indians. Labels pointed to marks on his own body received in drinking and fighting incidents. The piece thus subverted the museum objectification and romantic stereotyping of Native people while drawing attention to their actual social problems.

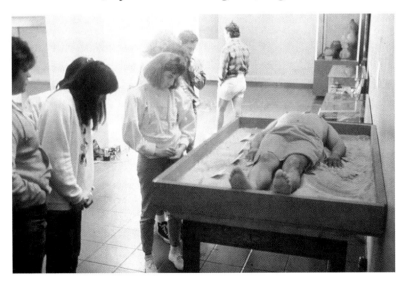

contact with foreign cultures and their arts. Yet it is also a story of the enduring strength of traditions. The many moments of transformation, rupture, and renewal in art contained in this story reveal the importance of visual arts in maintaining the integrity of spiritual, social, political, and economic systems.

Aboriginal oral traditions and Western scholarship account differently for the origin of the world and the human presence in it. Stories of creation are as various as the peoples of North America, although those of neighbouring peoples often share common features. They are 'histories' in the sense that they are chronological, eventful narratives that explain the origins of present realities, but they are posited on a different notion of authority, that of inherited, transmitted truth that has the force of moral explanation, rather than that of scientifically verifiable fact that has no moral force. In discussing the art of each region we provide an example of indigenous knowledge about Creation and a summary of Western archaeological knowledge.

Western scholars characteristically divide their historical narratives into two large epochs predating and following European contact. This fundamentally Eurocentric periodization is largely determined by the new kinds of record-keeping made available; post-contact history can make use of written texts, depictions, photographs and films, while pre-contact history usually relies on archaeological evidence and the Aboriginal oral traditions themselves. It is clear from these latter sources, however, that during the thousands of years that preceded the arrival of Europeans the cultures of indigenous peoples changed and adapted to new features of the environment. Communities traded with and were influenced by other indigenous peoples. The advent of the Europeans was the most violent and traumatic of the cross-cultural encounters and the most challenging to existing Aboriginal concepts and styles of art. However, the notion of the 'prehistoric' is misleading, because it implies a clear dividing line between eras of 'history' and 'before history' and appears to deny the momentous changes and developments that occurred prior to 1492. Although also Eurocentric, the term 'pre-contact' is preferable.

In the next five chapters, devoted to the historical arts of the five major regions of the continent, the Southwest, the East, the West, the Northwest Coast, and the North, we regularly interrupt our chronological accounts with examples of contemporary art. These interruptions are intended as interventions in the standard narrative of decline and revival in Native American art. They introduce the assertions made by many contemporary Aboriginal people of the continuities and the unity of traditions their cultures manifest against all the historical odds. This view is part of an emerging post-colonial re-presentation of Aboriginal history and culture that has important parallels with contemporary postmodernism, for both seek to disrupt linear perceptions

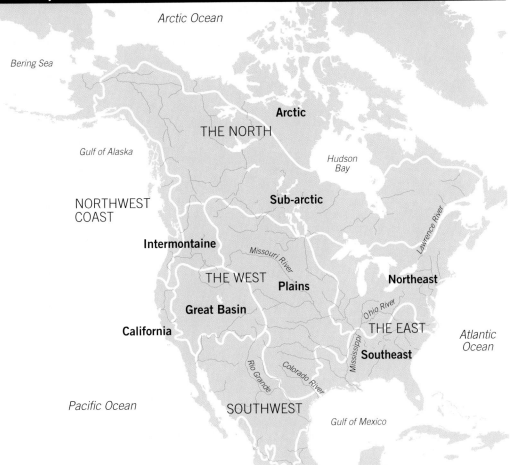

of historical time. The last chapter addresses contemporary art as a subject unto itself, looking at the engagement of Native artists with Western artistic movements including modernism and postmodernism. Together, these studies of Native art, whether historic or contemporary, offer insights into philosophies and historical experiences that can't be recovered from written sources. As Mohawk historian Deborah Doxtator has written: 'Visual metaphors impart meanings that sometimes do not have words to describe them.'[1]

All surveys are, of course, arbitrary in their selection of examples. In a book such as this, where strict limitations on length and illustration are imposed, we have been able to write only briefly about some individual artistic traditions and have had to omit many others of great interest and beauty. The specific examples and traditions we use to illustrate our thematic and regional discussions have, inevitably, been influenced by the state of the literature in the field, as well as by the areas of our own scholarship and research. Although, recently, this

3 Anasazi artist

Bi-lobed basket, *c.*1200 CE, Mogui Canyon, Utah

Basketry is perhaps the oldest indigenous American art; in many regions artists have produced works of enduring use and beauty out of coiled, twined, and wrapped plant fibres.

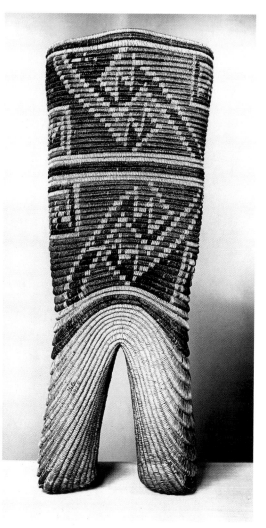

literature has grown rapidly, as the bibliographic essay at the end of the book indicates, much more study is needed, particularly by Native authors able to offer indigenous perspectives on the role of visual art within broader expressive systems.

More importantly, our choices have been guided by our belief in the importance of addressing Native American arts in terms of a specific set of issues. Some of these—such as the role art plays in the expression of political power, group identity and cosmological belief, or in the presentation of the individual self—are long-standing concerns of art-historical work. Others, such as the impact of gender, colonialism or touristic commoditization on the production of art, represent more recent concerns within art history that have a particular resonance for the arts of indigenous peoples colonized by the West. Our current understanding of these arts, then, responds to another important thrust of recent post-structuralist and post-colonial theories: the 'de-

centring' of the representation of art, and the replacement of a unitary, Eurocentric history of the Western tradition with multiple histories of art, including those of women and marginalized peoples. Such a 'new' art history must, of course, attend carefully to recent interpretative work by Native American writers and scholars.

What is 'art'? Western discourses and Native American objects

It is important to have a working definition of the way we use the term 'art' in this book. In relation to historical (generally pre-twentieth-century) objects, where all acts of classification are retroactive, this volume uses the term 'art' to refer to an object whose form is elaborated (in its etymological sense of 'worked') to provide visual and tactile pleasure and to enhance its rhetorical power as a visual representation. The impulse and the capacity to elaborate form, as Franz Boas eloquently argued at the beginning of the twentieth century, appears to be universal in human beings. His stress on the importance of practised skill in achieving the control over materials and the regularity of form and pattern that are the necessary preconditions for the evocation of aesthetic responses is an essential corollary to his definition. The capacity for making art is also *useful*; an artfully made object will draw and hold the eye [**3**]. Skill, virtuosity and elaboration, therefore, confer what anthropologist Warren d'Azevedo has termed 'affective' power on an object, a capacity that can be exploited to focus attention on persons or things of importance, or to enhance the memorability or ritual efficacy of an occasion [**4**].[2]

However carefully we distinguish certain objects as 'art' (and, by implication, relegate others to the realm of 'non-art'), we enter inevitably into a cross-cultural morass. As a judgement made in relation to historical objects, the distinction imposes a Western dichotomy on

4 Chippewa artist

Feast bowl (ash wood), nineteenth century

In the Great Lakes, individuals brought beautifully carved bowls to communal feasts, often carved from the tight-grained and durable wood burl. Rims often display highly stylized animal motifs that transform the bowl into the body of an animal that was probably of special spiritual significance to its owner. The representation of anthropomorphic figures on bowls is less common; here they extend out from the slanting sides of the bowl, creating a dramatic visual tension.

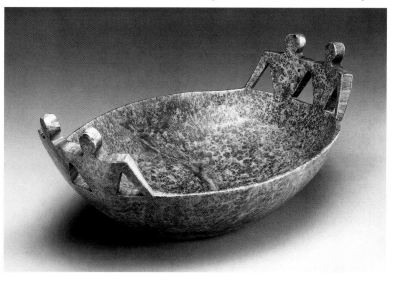

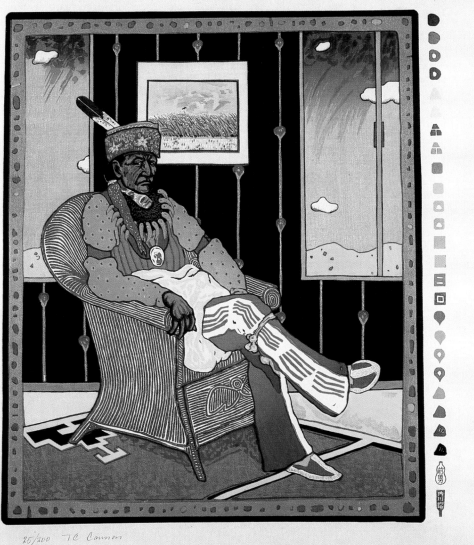

25/200 TC Cannon

things made by people who do not make the same categorical distinc-
tion and whose own criteria for evaluating objects have often differed
considerably. In relation to contemporary Native art the use of
Western categories is less problematic, for many contemporary artists
were trained in Western art schools and work in full cognizance of the
discourses and debates current in New York or Santa Fe, Vancouver or
Toronto—although they often contest aspects of the integrated system
of scholarship, collecting, museum display and market value that James
Clifford has called the Western 'art and culture system'.

When speaking of historical Native objects, the statement is often made that Native languages have no exact equivalent for the post-Renaissance Western term 'art'. The implication of this statement—that Native artists in the past were unreflexive about their own art-making and lacked clear criteria of value or aesthetic quality—is manifestly untrue, as scholars have repeatedly demonstrated.[3] Though specific criteria vary, Native Americans, like people everywhere, value the visual pleasure afforded by things made well and imaginatively. They also value many of the same attributes that make up the Western notion of 'art', such as skill in the handling of materials, the practised manipulation of established stylistic conventions, and individual powers of invention and conceptualization. There is also ample evidence, however, that in Native traditions the purely material and visual features of an object are not necessarily the most important in establishing its relative value, as they have come to be in the West. Other qualities or associations, not knowable from a strictly visual inspection, may be more important. These may include soundness of construction to ensure functional utility, or ritual correctness in the gathering of raw materials, or powers that inhere because of the object's original conception in a dream experience, or the number of times it was used in a ceremony.

Modes of appreciation: curiosity, specimen, artefact, and art

An art history is always contingent on a corpus of known works, however accidental their survival and however arbitrary (from the producers' vantage point) the reasons they became prized by collectors. Native criteria of value were rarely taken into account in collecting and preservation and are still not well enough understood. Rather, the majority of the objects that survive today were selected because they appealed to Western collectors' criteria of value and beauty. It is, therefore, important to look reflexively at the ways that Western ideas of the object have affected the circulation, preservation, study and display of things made by Native Americans, and how these criteria have changed over time. Such an enquiry also helps us to understand the ethical issues that arise today in relation to the ownership and display of many Native objects, because these problems are often linked to the circumstances in which they were collected [**5**].

The oldest objects we know of that fit the criteria for 'art' outlined above date back more than 5,000 years and were recovered archaeologically [**6**]. Several kinds of issues arise in relation to this material [**6**]. The first has to do with its incompleteness as a representative sample of visual aesthetic expression; since organic materials survive only in unusual circumstances, most of what exists today from the pre-contact period is made of stone, metal or pottery. Whole categories of visual art—almost everything that was made of wood, fibre or hide—can

6 Archaic Period Woodland artist

Notched ovate banner-stone (banded slate), 2000–1000 BCE, Michigan

Bannerstones deposited in graves as gifts to the dead for use in the next world often display extraordinary workmanship and aesthetic sensibility. With consummate skill and judgement the maker of this spear weight created a highly refined form and revealed the symmetrical pattern lying at the heart of the stone.

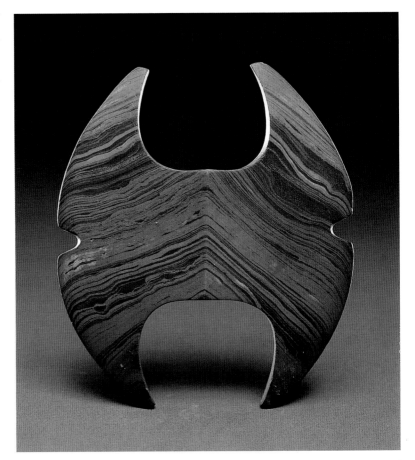

only be guessed at or reconstructed on the basis of depictions preserved within surviving art works. A second issue has to do with modes of display and conservation. Some of the finest pieces were made as burial offerings, intended to accompany the dead into the next world. Some Native people believe these should now be returned to the earth, regardless of whether they were scientifically excavated or plundered by grave-robbers.

A second group of extant objects consists of things carefully conserved by Native people over many generations because of their inherent medicine power, their importance in ritual or as historical record. Although some of these objects have never left Native hands, a great many were given or sold to ethnologists during the early decades of the twentieth century as a last hope for their preservation at a time when many Native peoples despaired of the survival of their cultures. Native communities are today emerging from the dark days of official assimilationism, and many are requesting the return of such objects. In recognition of their moral right, laws and official polices (adopted in the United States and Canada in the early 1990s) require the repatriation of sacred objects and what the American law calls 'objects of

'In earlier days, people were sometimes taken captive by raiding parties. When they were returned to their homes, either through payment of ransom or by a retaliatory raid, they were said to have "u'mista". Our old people said that the return of the collection was like an u'mista—our treasures were coming home from captivity in a strange place.'[4] In these words Gloria Cranmer Webster explains the name given to the modern cultural centre in Alert Bay, British Columbia that has housed, since 1980, a valuable collection of Kwakwaka'wakw coppers, masks, rattles, boxes, blankets, and whistles that had been illegally confiscated by an Indian agent at a great potlatch held in 1921 by her father, Daniel Cranmer.

How major museums in Ottawa, Toronto, and New York came to give back to the Kwakwaka'wakw their much-missed treasures is the story of a determined Native campaign for justice and of an emerging willingness of governments and some non-Native museums to reverse a long history of colonial appropriation. In 1884 the Canadian government banned the holding of potlatches, celebrations of central importance in the ritual, social and political lives of many Northwest Coast peoples. Many people defied this

ban, but in 1921 a local Indian agent decided to make an object lesson of Daniel Cranmer's potlatch. He arrested forty-five people, most of high rank, and released them from jail sentences only on condition that they surrender all their potlatch paraphernalia (some 450 objects) which were then sold or placed in distant museums.

The Kwakwaka'wakw never forgot this loss and in the late 1960s began to lobby actively for their return, using a number of strategies including the making of two widely circulated documentary films. The National Museum of Canada responded first, agreeing to return its holdings on condition that an appropriate building be constructed to house them. The U'mista Cultural Centre is not, however, a museum. The objects are displayed in the open rather than behind glass, and in the order in which they would appear at a potlatch rather than in conventional typological groupings. They are accompanied, as James Clifford has observed, by texts that do not give their uses and symbolism but record the memories of specific community members, speaking directly of their recent history of captivity and return.[5]

cultural patrimony' to the legitimate descendants of their original owners.[6] These often go on display in community centres or museums from which they can be removed for use in ceremonies or for study by artists (see above). Native representatives have requested that certain kinds of objects be permanently removed from display and that their photographs not be reproduced because their inherent powers may cause harm to casual viewers and because they are intended to be seen only by knowledgeable people able to control these powers. For this reason, for example, no images of Iroquois *Ga'goh'sah* (False Face masks) are reproduced in this book, although these masks, which represent forest spirits assigned by the Creator to lend their healing powers to human beings, have throughout this century been featured as a major form of Iroquois 'art' in exhibitions and publications.

The last and largest category of Native American historical art available for study and appreciation consists of non-sacred and non-

7 Cree artist

Set of quilled ornaments,
1662–76

Collected on the voyage of
one of the first Hudson's Bay
Company ships to reach
James Bay, these ornaments
were in an English cabinet of
curiosities by 1676. They are
probably the earliest extant
post-contact objects from
the Eastern Sub-arctic. The
neck ornament, belt, and
arm-bands testify to sophisti-
cated techniques of quill-
working and a cultural value
for fine ornaments that were
well established at the time
of contact.

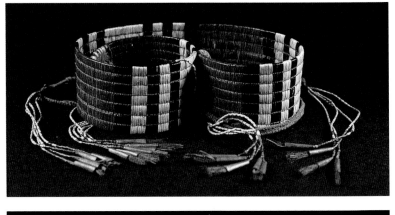

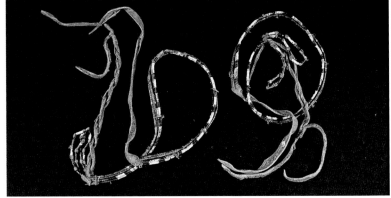

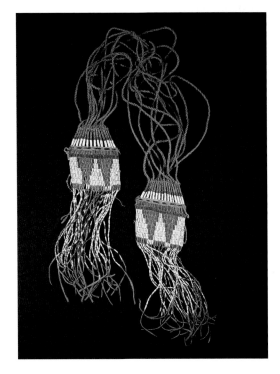

ceremonial objects. (The distinction is often hard to make because the sacred/secular dichotomy is another Western overlay on Native modes of thinking.) These were acquired by Western collectors, mostly through trade, purchase, or as gifts, but also by violence and theft. The kinds of objects acquired depended on the tastes and interests of the collectors, which in turn reflected the intellectual culture of their times. The corpus of objects available from a particular area is dependent also upon when contact with Euro-Americans began, a time period that is different for each region. For the Eastern Woodlands, the Southwest and some coastal areas of the Arctic the early contact period lasted from the sixteenth century to about 1800. Although a great many Native American objects were sent back to Europe during this period, especially from the Eastern Woodlands, not many survive; further information about material culture and art, however, can be retrieved from written texts and (often inaccurate) depictions. Collecting during this early period was governed by a generalized concept of the exotic object as a 'curiosity'—something that excited wonder and interest because of its craftsmanship, its use of unfamiliar materials or because its forms appeared to Europeans as strange or grotesque. Quilled ornaments [7] collected from the Cree of Hudson's Bay in the early 1670s, for example—the earliest known such pieces—were eagerly received into a cabinet of curiosities that also included such objects as (fake) ancient cameos and 'the finger bone of a Frenchman'.[7] Unlike this example, however, few of the objects that survive from the early contact period can be attributed with certainty to a particular people, either because collectors were not interested in recording specific provenances, or because they did not understand Native cultural and political divisions well enough to do so accurately.

The curiosity value of Native American objects has remained a factor in their attraction down to the present. During the nineteenth century, however, when active collecting extended to the West, the Northwest Coast and the North, another equally powerful paradigm of collecting and study was gaining dominance. With the establishment of anthropology as an academic discipline in the last quarter of the nineteenth century, Westerners began to regard indigenous objects within a new framework borrowed from one of the era's most prestigious fields of study: natural history. Native-made objects came to be regarded as scientific specimens, 'artefacts' that contained information about the stages of technological development, the beliefs and the practices of their makers. Ethnological collectors assembled huge quantities of Native American material in museums newly built to receive them, as part of a large scholarly project designed to reconstruct the historical evolution of humankind [8]. Official government policies of the Victorian period were based on the premise that indigenous cultures could not survive in the modern world and had to be helped to

8

Installation of Nuxalk [Bella Coola] masks, American Museum of Natural History, New York, 1905

A taxonomic, natural history display paradigm featuring grid-like arrangements of objects has until recently dominated ethnographic museums. It is represented by this image from the permanent exhibitions installed at the American Museum of Natural History under Franz Boas. Such displays fostered processes of comparison and typological identification intended to yield information about historical development, diffusion, and cultural differentiation.

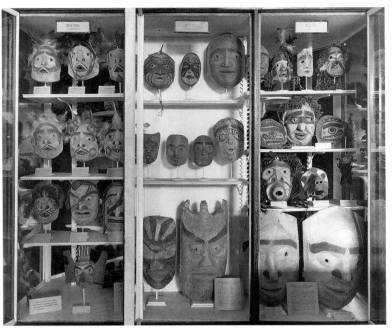

9

Installation of Northwest Coast art at the exhibition 'Indian Art of the United States', Museum of Modern Art, New York, 1941

The innovative modernist installations at the 1941 MOMA show set the pattern of art museum display up to the present. Individual 'masterpieces' were isolated against luxurious expanses of wall space with a minimum of label text. The intent of such displays is the promotion of intense visual experiences of the objects' formal and expressive qualities rather than of their specific cultural meanings.

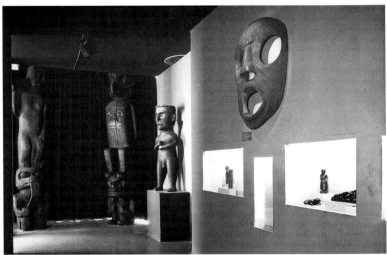

assimilate, and museums were regarded as the proper places in which to preserve a valuable scientific record of 'vanishing' Aboriginal cultures. The comprehensiveness of this collecting activity is suggested by one dramatic but representative example: between 1879 and 1885 the Smithsonian Institution collected over 6,500 pottery vessels made by Pueblo women from Acoma and Zuni, villages of just a few hundred inhabitants.[8] Ethnological collecting, which was often carried out by anthropologists who were among the most liberal and humane people of their era, has left a precious legacy. But although it preserved much that might otherwise have been lost, it also reflected assimilationist assumptions and was often highly destructive of artistic and ritual

continuity within Native communities because it stripped them of the objects that could serve as models for young artists and that supported a community's spiritual life.

As we would expect, the early ethnologists shared the theories of art in general circulation at the end of the nineteenth century. Among these was the notion, formulated in the aesthetic theory of Immanuel Kant, that functionality limited the 'highest' capacity of a work of art to achieve formal beauty and to express ideas. For this reason they assigned most Native American arts, which often adorned 'useful' forms such as pots, clothing or weapons, to the inferior category of 'applied art' or craft. Modernist European artists began to challenge this view during the first decade of the twentieth century. They re-evaluated African and Oceanic objects and proclaimed them equal or superior to the art of the West. These early connoisseurs of 'Primitive Art' were interested in the formal properties and general concepts expressed in

10 Horace Poolaw (1906–84), Kiowa

Horace Poolaw, Aerial Photographer, and Gus Palmer, Gunner, Mac Dill Air Base, Tampa, Florida (gelatine silver print), *c.*1944

During his two years in the US Army Air Corps during World War II, Poolaw taught aerial photography. In this slyly humorous image, the photographer plays on stereotypes about the noble Indian warrior of the Plains photographically recording an image of twentieth-century warfare.

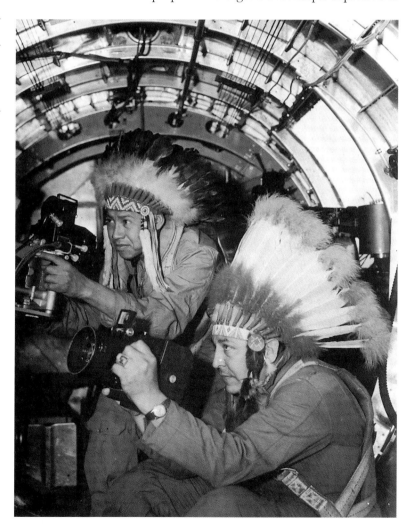

non-Western objects, and deemed necessary only a minimal under-standing of their original uses and meanings. It took two more decades for Native American objects to receive similar attention. Landmark exhibitions in Canada and the United States in 1927, 1931, 1939, and 1941 displayed Northwest Coast masks, Pueblo pottery and other objects [9] in large urban art museums for the first time (see Chapter 7). As scholars have recently shown, the appropriation of Native American objects as art was part of a broader desire for cultural de-colonization among members of the settler-colonial intelligentsia of the United States and Canada.[9] Artists like the New York Abstract Expressionists Jackson Pollock (1912–56) and Barnett Newman (1905–70) or members of the Canadian Group of Seven, made refer-ence to Native images in their work, in part to sever their own colonial ties to Europe by grounding their art in traditions indigenous to North America.[10]

Despite their differences, the art and artefact paradigms of collect-ing shared a common assumption about the nature of authenticity in Native American art. Both defined those objects that dated back to the early period of contact and displayed a minimum of European influ-ence as the most interesting and valuable. This definition of authentic-ity is part of a widespread tendency to romanticize the past of Native peoples at the expense of their present [10]. Although the image of the Native man as 'noble savage' or of a Native woman as 'Indian princess' may appear to express unqualified admiration for Native culture, such images can also crowd out, in a damaging way, the possibility of engagement with the modern lives, problems and accomplishments of contemporary Native people—in art as in everything else. Such stereo-types, furthermore, are based on early but enduring fantasies about indigenous culture and society that have little basis in fact [11]. Judgements of authenticity in art, then, carry important implications. Currently, the subject of authenticity is being scrutinized by scholars in relation to Native arts produced in response to the growth of tourism in North America in the late nineteenth and twentieth centuries, the commoditization of Native art and issues of stylistic hybridity. These factors, which have long been deplored by scholars and art connois-seurs, are now being recognized as among the most important stimuli for artistic production during the past 150 years.

It is also important to note, finally, that the singling out of *visual* arts in this discussion reflects a privileging of the visual sense that has characterized Western cultures for much of their history.[11] One of the effects of Western domination over Native American cultures has been to devalue the importance of other expressive forms, such as oratory or dance, that have traditionally been equally, if not more highly, valued in Native societies. Many contemporary Native writers and artists are working to restore a balance and an integration among art forms more

11 Gerald McMaster (b. 1953), Plains Cree

'Cultural Amnesty', 1992

In his 1992 exhibition 'Savage Graces', McMaster used installations, paintings and collages to mount a comprehensive critique of the pervasiveness of stereotypes of indigenous people in museums and in popular culture. The Cultural Amnesty box was a directly interventionist element of the exhibition; a label invited visitors to bring in and discard objects similar to those displayed in the exhibition.

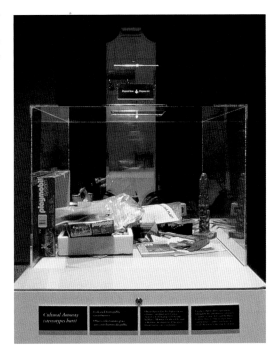

typical of their historical cultures, and they often work in more than one expressive medium, or collaborate with writers, dancers and dramatists.[12] Native artists are thus part of a contemporary process of debate and critique in which the boundaries that separate art from non-art, art from other forms of visual culture, and the graphic and plastic arts from print culture and new electronic technologies are being called into question. As these explorations proceed, they will also, undoubtedly, bring new insights to the understanding of historical visual arts.

What is an Indian? Clan, community, political structure, and art

Particular forms of social organization and particular strategies for subsistence are closely tied to the kinds of objects that are made and choices of medium and scale. In groups where populations are small, for example, the distribution of power among members tends to be relatively egalitarian and the systems of leadership more informal. The autonomous power of each individual is recognized and expressed in a range of different artistic contexts, often centring on personal adornment and the artistic elaboration of weapons, tools, pipes and other objects that acknowledge an individual's sources of personal empowerment. Certain individuals—shamans, healers, chiefs, elders—whose special wisdom and powers of healing or vision are called upon by the group as a whole, may arrange for the creation of particularly elaborate ritual equipment or dress. If a group's way of life is nomadic, works of art will tend to be small and portable. Among nomadic peoples such

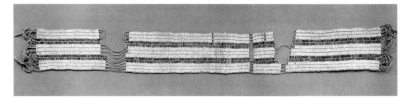

'Gaswenta', Two-Row wampum, seventeenth century

The Two-Row wampum was first exchanged between the Dutch and Mohawk in the seventeenth century and later versions with the British, French, and Americans. According to the belt's traditional reading, the two purple lines represent canoes travelling in parallel paths in the same river. It symbolizes an ideal of peaceful but separate and equal co-existence between Native and non-Native communities that is frequently cited by contemporary Native leaders.

skills as weaving, embroidery, hide painting, and body decoration are often brought to a level of consummate artistry [**7**]. Architectural structures are typically lightweight and made of articulated components—a feature that does not preclude the monumental marking of land and rock or the building of large-scale structures that can shelter an entire community on ceremonial occasions, such as the Anishnabe *mide* lodge, the Plains sun-dance lodge, or the Eskimo winter dance house.

Other indigenous nations—such as the Pueblo peoples of the Southwest, the Mississippian cultures of the pre-contact Southeast, the Iroquois of the Northeast, or the Northwest Coast peoples—developed political systems in which authority was more formally assigned within families or to particular hereditary classes. Their subsistence systems permitted the creation of permanent villages and favoured the building of large structures of wood, earth or masonry. Such settled communities were more likely to make use of larger, heavier, and permanently installed art forms such as carved masks, monumental sculptures, and mural paintings.

In Native North America, as elsewhere, many visual artistic forms are created primarily to help people conceptualize the social and political bonds (both ideal and actual) that unite them. Art forms can present models of collaboration and co-operation with which members of a community are asked to concur. In the Northeast, for example, leaders displayed objects made of wampum (shell beads) strung in designs that reminded viewers of specific contractual agreements [**12**]. And there are innumerable examples of art forms that make visible the authority or special powers of an individual through clothing, body art, and ritual objects.

The names applied to the indigenous peoples of North America are integral elements in the construction of individual and group identity. Because early Europeans frequently misunderstood the nature of Aboriginal political organization or wished to interfere with political structures that hindered their colonial aspirations, they often assigned inaccurate names. These continue to cause confusion today. In some instances, these repeat derogatory names picked up from neighbouring peoples. As indicated in this book, the names of many peoples are currently being changed at their request in order to correct historical mistakes. The word 'Indian' reflects, of course, an initial error: the early explorers' mistaken idea that they had arrived in the East Indies.

Today, although the term 'Indian' remains acceptable to many people, terms such as 'Native', 'Aboriginal', and 'First Nations' are often preferred because they convey more clearly the primacy of the indigenous peoples as occupiers of the North American continent.

Even with these adjustments, however, in an important sense the term 'Native American' in the phrase 'Native American Art' represents the imposition of Western notions of political and ethnic identity just as foreign to indigenous people as was, historically, the aesthetic construct signalled by the term 'art'. For most of the indigenous peoples of North America the most fundamental unit of membership is the clan or lineage, a group of kin descended from a common ancestor. An individual's clan membership is inherited through the mother in a matrilineal system (or through the father if the system is patrilineal) and clans may, in turn, be grouped into two larger divisions or 'moieties'. The original ancestor or associated being of a clan or lineage is known as a 'totem' (from the Anishnabe word *dodem*), and is usually an animal such as a turtle, eagle, wolf, or crane. Images of clan animals are important in many art traditions, appearing in graphic or carved form on masks, personal belongings, grave markers, or other objects where they act as identifying marks and sometimes as a kind of 'signature'. Today the images of clan animals are often worn in the form of fine contemporary jewellery and clothing.

The Canadian government has defined the basic unit of organization as the 'band', while the United States government uses the term 'tribe'. Although these terms have different meanings in classical anthropological theory, both are used today to describe individual Native communities and are often coterminous with the reservations (reserves, in Canada) to which Aboriginal people have been assigned since the second half of the nineteenth century. Both terms are, however, inaccurate as descriptions of other historical group identities that are equally important. In many areas complex and sophisticated forms of political and military alliance were in existence long before the arrival of Europeans. (The Iroquois Confederacy, which, some scholars have argued, provided a model for the federal structure of the United States, is a good example.) All over North America, too, small hunting groups came together seasonally for purposes of ceremonial observance, trade and sociability. Today, contemporary Aboriginal people, especially in Canada, have appropriated the Western term 'nation', to assert their sovereignty and to name the larger group identities they share.

To be legally identified as an Indian (to have 'status' in Canada, or to be 'enrolled' in the US) one must be listed as a member of a recognized band or tribe. The control of indigenous populations by such forms of enumeration is a classic tool of colonial domination. It is also a strategy of exclusion that denies Native identity to many people whose ancestry

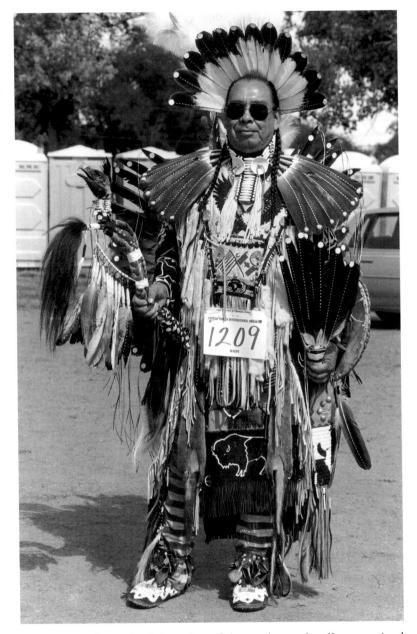

is no more or less mixed than that of those who are legally recognized by laws and policies that derive from outmoded racial theories, patrilineal bias or geographical segregation.[13] Contemporary critical thought about identity, in contrast, stresses the importance of an individual's subjectivity—of the identity developed as a result of personal and family history. Yet legal definitions continue to place many Native people in invidious positions.[14] The subject remains a painful and difficult issue for many Native people, and is regularly addressed in the work of contemporary artists [**13, 150**].

Cosmology

Identity is not, of course, only—or even primarily—a matter of legal definition. On a more profound level, it is constructed from the way an individual understands his or her relationship to place, to community and to the cosmos. Contemporary Aboriginal people are heirs to unique knowledge systems that have developed out of thousands of years of living, dreaming and thinking about the lands, waters, plants, animals, seasons, and skies of the North American continent. These epistemological systems explain the fundamental structures of the cosmos, the interrelationship of humans and other beings, the nature of spirit and power, and of life and death. They have provided the basis for the development of specific ritual practices that make human beings effective in the most critical of activities—hunting, growing crops, working in offices or factories, curing disease, making war, accomplishing the journey through this world to the next. The unique world views of Native Americans have been amplified over the centuries by encounters with other spiritual systems, and particularly with Christianity, which many Native people have accepted either in place of, or alongside, traditional spiritual systems.

Since the second half of the nineteenth century the American and Canadian governments have collaborated directly with Christian missionaries as part of a formal policy of directed assimilation. For more than a century both governments used their power to remove thousands of Native children from their families to residential schools, mostly missionary-run, where it was expected that they would, within a single generation, become Christian and 'civilized', and where their ties to Aboriginal languages and cultures would finally be severed.[15] From today's perspective the educational benefits of this policy are far outweighed by the anguish of separation experienced by parents and children, the abuse that was common in the schools, and the legacy of family breakdown that has resulted.[16] Equally serious was the radical disruption in the orderly transmission from one generation to the next of Native languages, traditional beliefs, practices and arts. These effects are captured in the remarks made by one Native graduate of the Hampton Institute (one of the most famous US residential schools) in the 1930s: 'What does the Indian of today care about his art? Or about some ancient tool that a scientist might uncover? That time is past, and should be kept there. Personally, I wouldn't give up the experiences I have had for all the old-time ceremonies and "Indian culture".'[17]

Many decades later, indigenous peoples are struggling to repair the losses inflicted by this history. The very brief account of world-view that follows, then, is an abstraction that describes neither the many individual combinations of belief and practice that have resulted from the history of contact and directed assimilation, nor any one traditional world view. Rather, it attempts to point out some broad historical

patterns of world-view that underlie and link the rich diversity of contemporary Aboriginal life—and that also link the spiritual systems of Native Americans with those of indigenous peoples in Meso- and South America, Siberia and the Pacific Rim, with whom they have many ties of history and of blood. These shared beliefs concern the nature and location of 'spirit', the fundamental structures of space and time, the concept of power (including that of 'medicine'), the value of visionary experience, the role of shamans, and the importance of feasting and gift giving in the validation of blessings received from spirit protectors.

The map of the cosmos

A fundamental feature of a world-view is the way it 'maps' space. Native American cosmologies characteristically divide the universe into distinct spatial zones associated with different orders of power. A supplicant's proper orientation in relation to these spatial structures is vital to the efficacy of ritual. Because space is experienced in relation to specific configurations of land, sky, and water, the specifics of cosmology in each region reflect and reflect *upon* particular environments and ecologies. In the Plains and Woodlands, for example, cosmic space is subdivided into three zones of sky, the earth's surface, and the realms beneath earth and water. Earthly space is also conceived of as circular; it is divided into quadrants identified with the four cardinal directions of north, south, east and west, and with winds that blow from these directions bringing the changes of season. On the Northwest Coast, in contrast, the significant spatial zones define a water realm of sea or river, a coastal zone where human settlements are located and a realm of forests and mountains. Everywhere in North America the zones of earth, water and sky are also linked by a central, vertical axis that provides a path of orientation along which human prayers can travel between realms of power. This axis is visualized in various ways: as a great tree, an offering pole, or a path along which smoke travels from a central hearth to the smoke hole above it [14].

The beings that inhabit the separate zones of the cosmos are sources of danger, power and wealth for humans. Mythic systems explain how the powers and knowledges essential to human survival may be transferred to human beings, how this occurred in the time of creation and how it occurs in the present. They also explain how power can be transferred among humans by inheritance or exchange, and how humans can seek it through prescribed rituals. The rights and privileges conferred by lineage ancestors of Northwest Coast families are, for example, clearly identified with particular power zones in the sky, the sea, or the forest. The Kachinas who are called by Pueblo peoples in annual rituals to bring the rain and fertility from sky and earth to human villages are also located in particular zones of earth and sky.

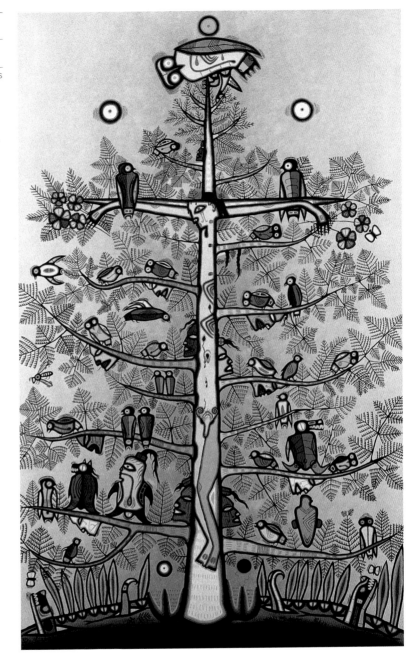

The spirit beings that embody the different cosmic zones are, finally,
interconnected by relations of complementarity and oppositionality;
these relationships are expressed in myth and illustrated in art by
images of the great spirits of the upper world and underworld—
Thunderbird and Underwater Panther, Eagle and Killer Whale—
locked in great battles that energize cosmic space.

15 Innu (Naskapi) artist

Shaman's painted hide
(unsmoked caribou skin,
porcupine quills, paint, fish
glue, hair), *c*.1740

At the centre of this sacred
chart is the image of the sun,
the most important spiritual
power, and the source of
growth and life. Around it are
arrayed rows of double curves
that may represent the plants
and the caribou that feed on
them, each in its season. Innu
shamans ritually exposed hide
robes painted with sacred
designs to the rising sun and
wrapped them around their
bodies with the painted
designs inside as aids to
spiritual meditation.

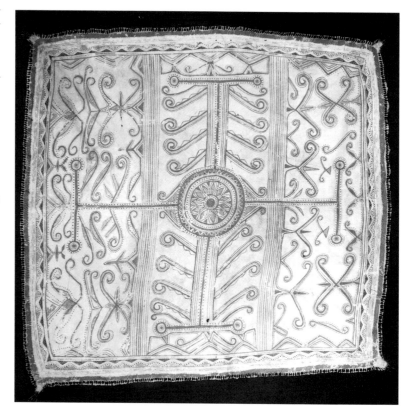

The nature of spirit

Such beliefs and rituals are posited on a concept of 'power as spirit' that is widespread throughout North America. In Aboriginal belief, soul or spirit, understood as an animating and personifying principle, is not confined to human beings as it is in Judeo-Christian or Moslem belief, but is also present in many other entities contained in the universe, such as animals, features of land and water, plants, and the heavenly bodies. (The notion of 'medicine' as a substance imbued with active and affective power is a part of this larger definition of the animate.) The presence of what the anthropologist Irving Hallowell called the 'other-than-human beings' often manifests itself through the ability to transform or change shape. Native creation stories account for many familiar features of our world as the products of magical transformative acts performed by tricksterish culture heroes—figures such as Raven (on the Northwest Coast), Coyote (on the Plains), or *Nanabozo* (in the Great Lakes) who travelled the earth after the Creator had finished the basic acts of creation.

The interrelationships of the material world, animate force, and powers of transformation are complex, as an anecdote related by Hallowell suggests. After being told by a Saulteaux Ojibwa consultant

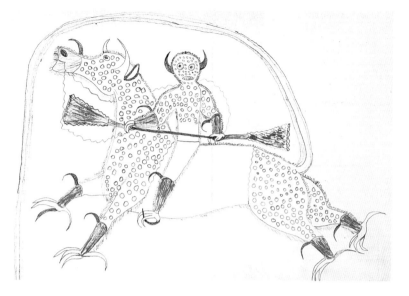

16 Black Hawk (c.1832–c.1889), Sans Arc Lakota

'Dream or Vision of Himself Changed to a Destroyer or Riding a Buffalo Eagle' (pencil on paper), 1880–1

For the Lakota and other peoples of the Great Plains, Thunder Beings are powerful supernatural creatures who appear to supplicants in vision quests. Their appearance often combines attributes of eagle, horse, and buffalo, all sacred animals. Here a horned and taloned figure rides a similarly endowed beast. Both steed and rider are covered with small dots, representing hail, and are connected to each other by lines of energy. The beast's tail forms a rainbow through which the figures travel. Black Hawk's vivid image of his vision graphically displays the potency of these awesome sky dwellers.

that certain stones were imbued with thunderbird powers, Hallowell asked if all stones shaped in this way were animated with power. 'No,' he was told, 'but *some* are.'[18] The ability to recognize and access the powers located in plants, animals or the features of the earth required learned techniques, attentiveness and an attitude of profound respect for the created world [**15**].

Dreams and the vision quest

Human beings need to acquire power from the non-human beings if they are to be effective in the world. Liminal states of being—such as the dream and the trance—and bordering places—such as shorelines that offer access to waterlands, heights of land that reach towards the sky and crevices in rock that are channels to realms below the earth's surface—all favour contacts between terrestrial and extraterrestrial beings. Native Americans have developed a repertoire of techniques that facilitate the crossing of boundaries between conscious and un-conscious experience and between spatial zones of power. The vision quest, widely practised throughout the continent, requires fasting, sleeplessness and isolation, all sacrifices designed to provoke the pity of other-than-human beings and to induce them to confer blessings of power. Historically, such powers were maintained with the help of aesthetically elaborated forms—the image received in a vision could be painted on a tipi, a shield, or the body, or even in the pages of a book [**16**]. It could be embroidered on a medicine bag, or carved as a mask. Equally, of course, it was expressed through the songs and dances per-formed on ceremonial occasions. Today some of these representational practices continue in the regalia worn at powwows, traditional dances and potlatches and in more private ritual contexts.

Shamanism

All Native American societies also recognized the exceptional receptivity to visionary experience of certain individuals, and the ability such people have to gain access to especially powerful spirit protectors. These individuals, or shamans, could be of either sex, though they have most often been men. They could put their powers at the service of other people to heal, to guide a hunter, or for other constructive purposes. Oral history and myth account for the existence of evil in the world by explaining how such powers can be also used destructively. According to Mircea Eliade's influential formulation, shamanism has diffused over a large portion of the globe over thousands of years from a place of origin in central Asia. It is associated with a highly specific complex of beliefs, including the distinctive patterns of cosmological mapping we have already discussed, particularly the notion of a world axis that opens a channel of communication between zones of power. In the past shamans commonly use drumming to induce trance states, and emphasized public performances involving visual and dramatic arts to relate their experiences of out-of-body travel. They wore distinctive dress and used amulets and masks to display the images of their power beings, among which the bear is especially prominent across northern North America. A specific visual iconography is associated with shamanism that derives from these beliefs and practices. It features such motifs as skeletal markings to represent the liminal state the shaman occupies between life and death, the marking of the joints, which are points of entry and exit for the soul, and hollowed-out or projecting eyes that signify the shaman's extra-human powers of sight [17].

One of the distinctive features of Native American art is that shamanism and its typical iconography provide the fundamental metaphors that can be exploited to convey notions of power in a wide variety of contexts. Esther Pasztory has made a useful distinction between 'shamanistic' societies, where the shaman is a central authority figure, and others in which individuals wielding power display 'shamanic traits' but are not actually shamans. Shamanic traits, for example, mark the art and practice of Pueblo priests and men's societies, as well as that of Iroquois healing societies.[19] Among Northwest Coast peoples, high-ranking individuals, whose authority is primarily political, display shamanic motifs on their ceremonial dress and masking prerogatives. (The shamanic trance is also, to give a further example, incorporated into the initiation rituals of the Hamatsa society whose members are drawn from the highest-ranking families.)

Art and the public celebration of power

A corollary to the importance of spiritual empowerment is the need to acknowledge and validate the acquisition of power through public

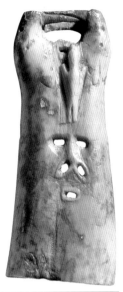

17 Dorset artist

Shaman's tube (ivory), *c.*500 CE, Dorset Culture (Prehistoric Inuit), Canada

Shamanic practice and shamanic art are both concerned with transformation. In this small item used in medicine rituals, the tube has a human face, but out of its head spring two walruses who interlock their tusks, perhaps in struggle, or in assistance.

forms of celebration. Throughout North America people do this through events that combine feasting, dance performances and the lavish distribution of gifts. In the Great Lakes 'eat-all' feasts were held to celebrate occasions such as a boy's first successful hunt. Participants would attend these wearing fine dress and bearing beautifully carved feast bowls and spoons. In her novel *Waterlily* the Dakota linguist Ella Deloria recounts the year-long production of quillwork and other fine gifts to distribute at a feast held following the death of a woman of great stature in the community.[20] The most famous example of feasting and gift-giving, however, is the Northwest Coast potlatch, held by a high-ranking family to mark the acquisition of an inherited title by one of its members. All these forms of feasts were and are occasions not only for lavish hospitality and eating, but also, and importantly, for the production of visual art of all kinds—from masks to rich clothing, to the decoration of the interior, and the making of gifts to present to guests.

The power of personal adornment

Lakota artist and scholar Arthur Amiotte observes that, in his culture, people have a phrase for fine ceremonial dress—*saiciye*—meaning 'being adorned in proper relationship to the gods'. Similar aesthetic principles were widely shared across Native North America. Because of the way in which European art has developed over the past few centuries we tend to forget the importance that the body can have as a canvas for art. In Native American traditions, however, dress, including body decoration and clothing, has been one of the most important vehicles of artistic expression—a tradition that is carried through into contemporary powwow dress [13]. The use of body painting was also widespread, and was as important as clothing in the construction of the self-image an individual chose to present. Many early travellers recount watching Native people stop to apply face paint and other body ornamentation before entering a settlement or another Native encampment. Although for historical traditions all we usually have left are fragments of clothing, written descriptions and occasional paintings, drawings, or photographs, these arts should be thought of as creative assemblages. A number of the most important body arts practised at the time of contact have disappeared, suppressed by missionaries and government authorities who disapproved of what they regarded as the natives' state of 'nakedness'. Tattooing, for example, was widely practised by Woodlands, Inuit and Dene peoples in the early contact period as a medium for the representation of guardian spirits, for the marking of gender, and for personal beautification.

The treatment of the body could also signal important passages in an individual's life; in the Great Lakes and elsewhere, people purposely ceased to groom themselves during times of mourning; in many

Photo of Tlingit Indians
in ceremonial finery at a
potlatch, Sitka, Alaska,
9 December 1904

Wearing Chilkat blankets
woven by the Tlingit, trade-
cloth cloaks, and ermine-skin
coats modelled on Russian
and American military officers'
garments, the people pictured
here show how the creative
transformation of diverse
goods produced a striking
visual display of wealth and
cosmopolitanism. Much of
the beadwork is worked in
floral patterns learned from
Northern Athapaskan women
upriver. Most of the faces are
stamped and painted with
ephemeral tattoos.

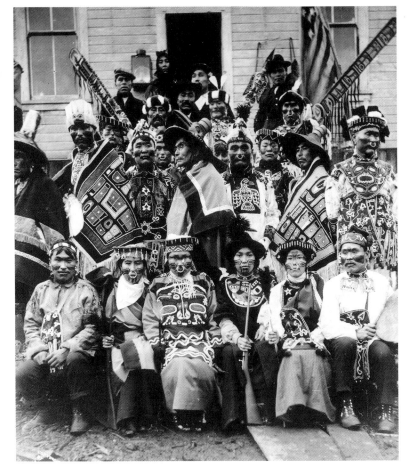

regions, marriages were occasions for ritualized displays of an excess of
finery. Pueblo and Navajo people often wear their wealth—turquoise
and silver necklaces, bracelets, concha belts, and rings may represent a
family's entire fortune. The Plains aesthetic of personal adornment
and self-display was a highly idiosyncratic one. Men, in particular,
incorporated into their clothing items they made after visionary
experiences, items they obtained in battle from the bodies of their
enemies, and all sorts of trade goods.

'Creativity is our tradition':[21] innovation and tradition in Native American art

The introduction of new trade goods was welcomed by Aboriginal
people and they responded with tremendous creativity to the new tex-
tures, colours and techniques that began to circulate. Manufactured
materials added new possibilities for richness and diversity of self-
display and, like artists everywhere, Native artists were eager to experi-
ment with new materials, iconographies, and techniques, and to
incorporate them in their own repertoire. They were also proud to wear

and use items made by outsiders. A photo taken at a Tlingit potlatch in Sitka, Alaska in 1904 is a visual encyclopaedia of the diverse materials that Northwest Coast women were using in their art by the turn of the twentieth century [18]. Tlingit access to all of these foreign goods through commerce in furs and fish sparked a creative explosion in women's textile arts. Through the cosmopolitan artistry of Tlingit women, the ranking participants of this Northwest Coast society make an emphatic statement about their status, wealth, power, and ability to assimilate goods and ideas from both distant and neighbouring worlds.

For many years Westerners have looked at such images as examples of a degeneration and corruption of Native arts because of the incorp-oration of imagery and materials from elsewhere. Native American art of at least the last millennium should, however, be thought of as objects that are in a perpetual dialogue with other objects and their makers. There is much evidence in the ethnological record (and some for archaeological material as well) that the exotic and the unusual were always highly valued by Native peoples—something that will be discussed in subsequent chapters.

When the explorer Prince Maximilian of Wied (1782–1867) and the artist Karl Bodmer travelled up the Missouri River in 1833 and 1834, they explored lands on the Northern Plains that very few non-Indians had seen. Yet long-distance trade goods were already an accepted part of Mandan and Blackfeet societies. In 1738, a French trader saw evi-dence of a lively exchange between the sedentary Mandan in their vil-lages on the river and other indigenous groups. This trade included many goods of European manufacture, acquired from French and British traders in New France, as Canada was then called. At Fort McKenzie in August 1833, Prince Maximilian was surely surprised when high-ranking Blackfeet chiefs distributed gifts to his party which included a British officer's scarlet coat given to the Blackfeet in a previous inter-cultural encounter. In his diaries, the Prince recorded his distress at seeing the chiefs wearing such overcoats and European hats as finery.[22] Of course the artist on his expedition, Karl Bodmer, deliberately omitted any such 'tainted' influence in his portraits of the Mandan and Blackfeet. Yet he unwittingly painted one man wearing a Navajo trade blanket and a Pueblo silver neck pendant [19], both of which were prized by Indians across the Plains, hundreds of miles from their place of manufacture in the desert Southwest. In their fascination with new types of cloth and styles of clothing, Native Americans demonstrated the same very human interest in new ideas about dress as did the British enthusiasts for chinoiserie during the eighteenth cen-tury or the Victorians for imports from India and other exotic places.

When glass beads were first introduced they were a precious com-modity. In a number of Native languages they were named with words that identified them with other reflective, translucent materials that

19 Karl Bodmer (1809–93)

'Kiasax (Bear on the Left),
Piegan Blackfeet Man',
(watercolour on paper),
1832–4?

Swiss watercolourist Karl
Bodmer was one of several
nineteenth-century artists,
including George Catlin, Paul
Kane, and Rudolf Kurz, whose
pictures of traditional Indian
life on the Great Plains were
widely exhibited and repro-
duced, providing a potent
visual image of 'Indianness'
that remains paradigmatic
to this day.

were regarded as gifts from the spirit world. (According to Frank
Speck, in the language of the Innu of Northern Quebec a word for
glass bead translates literally as 'eyes of the *manito*', or spirit, and a word
for trade cloth translates as 'skin of the *manito*'.) On the Great Plains,
in the early years of their use, a horse might be traded for just a handful
of beads. By the middle of the nineteenth century, beads were fully
integrated into Woodlands, Sub-arctic and Plains cultures, themselves
becoming a 'traditional' medium.

All across North America, Native people have long enhanced their
status not only through personal displays of trade goods but also by in-
corporating new and exotic motifs and images. Chumash basket-
makers on the West Coast incorporated into their coiled baskets
motifs from Spanish heraldry. Northern Plains beadworkers, in the
decades after 1880, created marvellous hybrid objects, as they appropri-
ated the American flag and alphabetic inscriptions into their bead-
work, sometimes beading new forms like valises [**20**], purses, bible
covers, and lace-up shoes. The floral designs that are ubiquitous in
Western decorative art were even more powerfully influential in the
development of new Native iconographies. Floral designs, which were
highly regarded during the nineteenth century when assimilationist
policies discouraged the continuing use of motifs connected to what
the dominant culture considered 'pagan' spirituality, came in many
places to replace older traditions of imagery [**21**].

Changes in the styles and images of personal adornment continued
throughout the twentieth century, as artists at powwows and regional

20 Nellie Two Bear Gates (1854–1935), Yanktonai Sioux

Valise (hide and beads on commercial travelling case), 1907

While some hybrid objects were made as commodities for the tourist market, this leather bag was meticulously beaded by the artist as a wedding present for her son-in-law. Traditional Plains warrior imagery combines with an alphabetic inscription to produce a very modern-looking work at the beginning of the twentieth century.

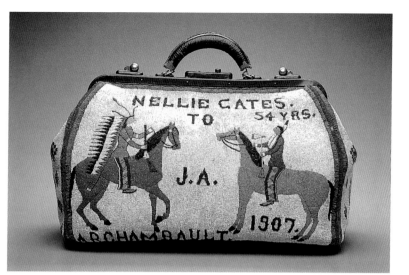

21 Potawatomi artist

Men's leggings (wool, cotton, silk, sequins, glass beads), c.1885

The floral motifs that replaced earlier geometric and spirit designs in Woodlands art during the nineteenth century continued to express beliefs in the spiritual powers that inform the natural world. The prominence of berries (an important ceremonial food), the symmetrical four-part structures of some flowers, and the clarity with which the inner structures of leaves are depicted are clues to the visionary inspiration behind much women's art.

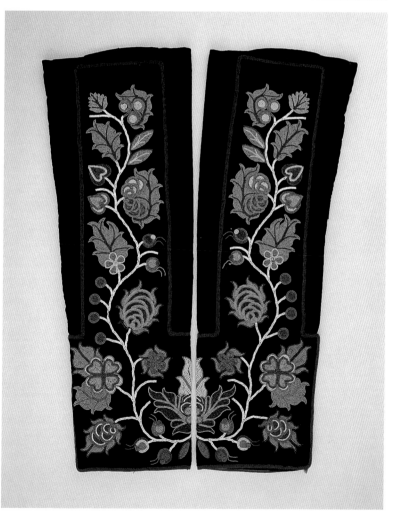

art fairs adopted pan-Indian styles of dress and adornment, and a truly multicultural artistic vocabulary. One of the most celebrated Native artists of the 1990s is Marcus Amerman (b. 1959), a Choctaw whose contemporary beadwork is produced in a painstakingly realistic style. Many of his beaded pendants and bracelets draw upon nineteenth-century photographs of Indians as their inspiration, but his subject matter also includes global youth culture, as a beaded replica of a *Rolling Stone* magazine cover of the '80s pop singer Janet Jackson attests.[23]

As mentioned earlier in this chapter, the literature on the Native arts of North America is rife with preconceptions concerning what is 'authentic', 'traditional', and 'native'. Many collectors strive to obtain the oldest or the most pristine examples of an artefact type. Pieces that show no evidence of contact with non-Native materials or methods of manufacture are often celebrated as being more authentically Native American, as if they represented some pure moment in which the essence of Native art could be captured. As Jonathan King has pointed out, the major collections of American Indian artefacts in Canada and the US were created during the years between 1860 and 1930, and 'the standards by which traditionalism in Indian art is judged depend upon these collections for purposes of definition and comparison'.[24] Paradoxically, of course, these were years of tremendous change and upheaval in Native American societies, and much of the art collected in the West and North during these years (like that collected during the previous century in the eastern half of the continent) reflects that upheaval. These problems in defining authenticity will be discussed further in subsequent chapters.

Gender and the making of art

In almost every traditional society in the world, distinctions are drawn between arts that are under the purview of men, and those in the realm of women. Native North America is no exception. In some regions, men's arts tend to be representational, while women's are abstract. Usually, carving is a male prerogative, while women control arts associated with clay, fibre, and basketry. Among some Pueblo peoples in New Mexico, for example, only women excavate sacred clay from the body of mother earth and shape this living material into pottery. On the Great Plains, men traditionally carved ritual pipes out of catlinite —said to be the blood of sacred buffaloes which had seeped into the earth and hardened to stone as a gift to humans—while women embroidered with porcupine quills in a method taught to them by female supernaturals.

It is important to remember that, in the Native world-view, male and female endeavours are complementary parts of a whole, each necessary to the existence of the other. A Plains woman's quillwork

might serve as fulfilment of a sacred vow; when joined with a man's figurative painting, both give efficacy to a warrior's shirt [**74**]. Innu (Naskapi) women of Arctic Quebec and Newfoundland painted geometric designs on the caribou-skin coats worn by male hunters, for 'animals prefer to be killed by hunters whose clothing is decorated with designs' [**93**].²⁵

Value judgements based on a Eurocentric, patriarchal approach to art history colour much of the writing on Native art, especially that written before 1970. Male arts were often valorized as sacred and individualistic, growing out of a personal visionary experience, while women's arts—such as weaving, basketry, and beadwork—were characterized as quotidian, secular 'craft'. Too often, items made by women and used in daily life—coiled baskets, beaded moccasins, woven blankets—were not seen to be connected to spiritual or political power, while men's carvings or paintings were. This reflects the bias of the Western observer on two levels. European observers tended to privilege the public contexts for art associated with political, military, and ceremonial life most similar to their own, and which seemed to them attributable to Native men. European concepts of art, furthermore, have been grounded in the assumption that artists take inert raw materials and make them into meaningful human creations. Finally, the European classification divides art forms into separate realms of the sacred and the secular. These concepts are alien to Native world views which are founded on the notion that all artistic creation involves the utilization of materials in which power may reside, including wood, stones, grasses, and pigments. When human beings undertake to transform these power-full materials for another purpose they engage in relationships of reciprocity with non-human powers. This is no less true of a woman gathering sweet grass for a basket than for a man taking wood for a mask from a living tree. Because of this engagement, furthermore, in studying Native American art it is impossible to draw a line between what is 'sacred' and what is 'secular'. In more recent efforts to correct misunderstandings about the way that gender operates in Native American art, art historians today draw upon three decades of work by feminist scholars who have produced critiques of Western art-historical practice demonstrating, among other things, that the European hierarchical classification of applied and fine arts developed relatively recently and has operated to reinforce unequal relations of power between men and women.

Ethnographic evidence, when closely scrutinized, makes it clear that both male and female artists gain inspiration for their work in dreams and visions. Ruth Landes reported that one early twentieth-century Ojibwa artist, Maggie Wilson, 'is proud of her beadwork because it is acknowledged that she is more skilled than others. She devotes herself incessantly to this form of embroidery, and receives

In Native cultures, the role of the shaman or medicine man has long been a pivotal one. Shamans sometimes have physical characteristics that distinguish them from others. Hosteen Klah was left-handed, and may also have been a hermaphrodite. In Navajo thought, a *nadle*, one who combines the physical attributes and/or talents of both genders, is a person honoured by the gods.

Unlike some Navajo children of his generation, Klah (1867–1937) did not attend the white man's school; instead he apprenticed with a succession of ritual experts—those who performed the complex songs, made the painstaking images in sand of Navajo supernatural figures, and mastered the herbal doctoring that form the Navajo medicine man's practice—studying for more than a quarter of a century. Even as a child, Klah had a great aptitude for memorizing the arduous visual and aural details for the necessary completion of ceremonies which could last many nights. It was said that, by age ten, he was able to choreograph all the complex components of the Hail Chant learned from his uncle.

Like many women of their generation, Klah's mother and sister were expert weavers. As a young man who showed interest in both male and female realms, Klah, too, became expert in spinning, carding, and weaving the wool from his family's large flock of sheep. He even built his own looms on a much larger scale than was customary for weaving an ordinary Navajo blanket or rug.

Klah demonstrated weaving at the World Columbian Exposition in Chicago in 1892–3, and was known as an expert craftsman who could copy complex techniques from archaeological textiles and experiment with weaving designs of Navajo deities in rugs—an act that was considered to be extremely dangerous. In Navajo origin stories, it is said that the supernaturals used the evanescent materials of the universe—such as clouds, rainbows, hail, lightning, and pollen—to create healing pictures. Therefore, human ritual practitioners should make ephemeral designs as well. That is why a traditional sandpainting made for healing purposes is made of sand and crushed minerals, and is always destroyed during the ceremony.

But Hosteen Klah flourished, both as a healer and a weaver, and he taught both his nieces to weave sandpainting designs, with no ill effects befalling any of them. Klah made his first sandpainting textile in 1919, and went on to make many more before his death at age 70 in 1937. His work is a good example of the way in which a superior artist who has spiritual powers can transgress the gender roles of his culture, transforming the arts of that culture in the process (see **22**).

visions in connection with it, just as a man would receive visions in connection with hunting, divining, or war [**21**].'[26] In women's textile arts of the Great Lakes region there is, thus, an intimate connection between perfection in a skill and the possession of extra-human powers. Outstanding talents and achievements are understood to be evidence of extraordinary power. As discussed in Chapter 2, a finely woven Navajo blanket, made by a woman, projects *hozho* (beauty and harmony) into the world no less than does a finely constructed sandpainting made by a male healer.

While gender roles may seem strict in pre-twentieth-century Native life and artistic production, they could also be transgressed

Photo of Hosteen Klah with one of his Yeibichai tapestries, c.1930, Navajo

under certain conditions. In general men painted the narrative or visionary scenes on Plains tipis and kept the historical records or winter counts. Yet individual circumstances exist where women transgressed these boundaries—one Blackfoot woman painted her husband's war experiences on his tipi because she was such a good artist, and several Southern Plains women were entrusted with the keeping of a pictorial calendar count by a male relative. In Native North American societies, artistic and technical knowledge is a form of property or privilege, which can be transferred from one individual to another as a gift or financial transaction. If an uncle sees fit to bestow such property on his niece, her rights of ownership abrogate the 'rules' of gender which usually define artistic practice. Powers associated with shamanism can transcend gender rules too. A famous Navajo medicine man, Hosteen Klah, practised both the male art of sandpainting and the female art of weaving, having great powers in both realms [22]. Transsexuals commonly practised the art of the 'other' gender. A famous example of this was the Zuni potter We'wha (1849–96), who was born a man but by inclination was a woman, both in terms of dress and artistry.

In most regions, gender roles in art production have relaxed considerably within the last fifty years. There are male potters in the Southwest, and female wood carvers on the Northwest Coast. Today, beadworkers in many regions may be male or female. Many contemporary artists draw from both male and female realms in style, materials, and iconography. In Colleen Cutschall's paintings from her series, 'Voice in the Blood', the tiny hatchings and densely dotted patterns of her brushwork are a homage to the quillwork and beadwork patterns of her female ancestors, while the pictorial narration of cosmological concepts in her work has traditionally been part of Lakota men's art.[27]

The Southwest

2

Four black and white striped clowns, made of clay but looking uncannily alive, push themselves upwards [**37**]. The artist, potter Roxanne Swentzell of Santa Clara Pueblo, has captured them in the moment of emergence from the earth. 'The four *koshares* [clowns] symbolize the four directions', she says. 'They're the ones who came out of the earth first and brought the rest of the people to the surface. My message is, "Remember where you came from".'[1]

This modern image encapsulates several fundamental features of indigenous ritual that still flourish in the Southwest. Humankind's emergence from the earth is often re-enacted in public performance in which sacred figures emerge from a hole in the roof of the *kiva*, the subterranean enclosure characteristic of Pueblo religious architecture. Moreover, public religious performance is constantly reaffirmed as being central to the cycle of life. In the Pueblo world-view, human beings have a spiritual obligation to replay the ancient act of emergence, and to don masks and special garments to impersonate and personify the spiritual forces of the world (including the *koshares*—buffoons who remind people of their flaws and shortcomings).

The Southwest as a region

The Southwest encompasses diverse ecological zones—from the arid Sonoran desert of Southern Arizona and New Mexico to the expansive plateaux and pine-clad mountain peaks of the northern regions of these two states and the southern part of Colorado and Utah. The Southwest is home to several cultures whose artistic legacies have been exceptionally well preserved, precisely because of the aridity of the climate. This region is noteworthy for its 3,000-year record of continuous cultural history that affirms great time-depth and longevity for religion and ritual, architecture, and the arts, especially in the Pueblo cultures of northern New Mexico and Arizona.

The principal ancient cultures are the Hohokam of Southern Arizona, the Mimbres/Mogollon of Southwestern New Mexico, and the Anasazi of the 'Four Corners' region—where the states of Arizona, New Mexico, Colorado, and Utah converge. All of these people were agriculturalists who coaxed corn, beans, and squash from the dry earth,

Detail of 37

37

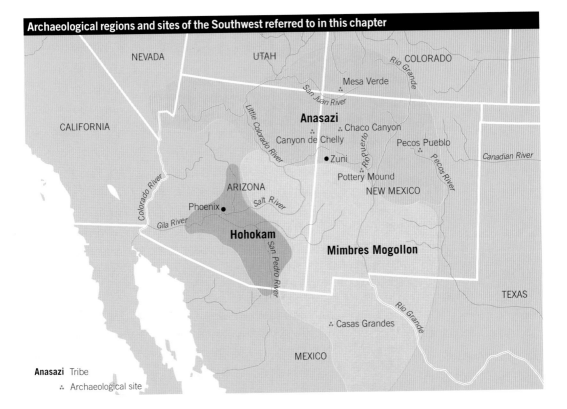

Archaeological regions and sites of the Southwest referred to in this chapter

NEVADA

UTAH

COLORADO

Rio Grande

Mesa Verde

San Juan River

CALIFORNIA

Anasazi

Chaco Canyon

Canyon de Chelly

Pecos Pueblo

Little Colorado River

Rio Grande

Zuni

Canadian River

Pottery Mound

ARIZONA

NEW MEXICO

Phoenix

Salt River

Colorado River

Gila River

Hohokam

Mimbres Mogollon

San Pedro River

TEXAS

Rio Grande

Casas Grandes

Pecos River

MEXICO

Anasazi Tribe

∴ Archaeological site

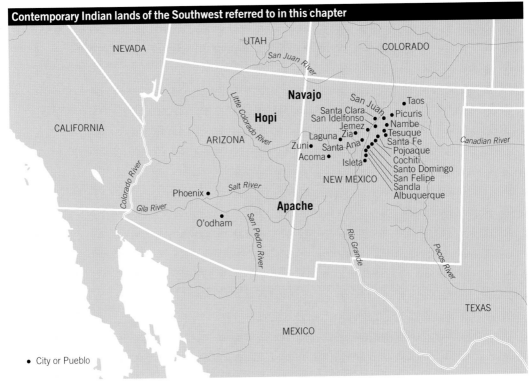

Contemporary Indian lands of the Southwest referred to in this chapter

NEVADA

UTAH

COLORADO

San Juan River

Navajo

Taos

Hopi

San Juan

Santa Clara

Picuris

San Idelfonso

Nambe

Little Colorado River

Jemez

Tesuque

CALIFORNIA

Laguna

Zia

Santa Fe

ARIZONA

Zuni

Santa Ana

Pojoaque

Acoma

Cochiti

Isleta

Santo Domingo

NEW MEXICO

San Felipe

Sandla

Colorado River

Salt River

Albuquerque

Phoenix

Canadian River

Gila River

Apache

O'odham

San Pedro River

Rio Grande

Pecos River

TEXAS

MEXICO

• City or Pueblo

petitioning the spirits and the clouds for rain. Although they were farmers, many were urban as well, living in communities of several hundred to several thousand, while travelling on a regular basis to farm fields beyond the limits of the community. All were part of a vast trade network that extended to the Gulf of California in the west, to Central Mexico in the south, and to the Great Plains to the north and east. Religious ideologies and iconographies were widely shared (and almost certainly modified to local needs) across this region and further south into central Mexico as well. Today, for simplicity's sake, we tend to refer to these as discrete 'cultures', but in fact they should be seen as no more than patterns in cultural practice—patterns discerned from building types and artefact styles. Within each of these regional patterns of material culture, there were many variations.

These cultural traditions evolved over many centuries; much of their ancient heritage is alive today in the indigenous cultures which remain so strong in this region. The O'odham (or Pima and Papago) of Southern Arizona are heirs to the traditions of the ancient Hohokam. The Pueblo peoples at Hopi, Zuni, Acoma, and the Rio Grande Pueblos (so named because the sixteenth-century Spanish explorers, impressed at the urban nature of their settlements, characterized them by the word 'pueblo', the Spanish term for town or city) are descended from the ancient Anasazi. These ancient inhabitants have been joined over the past 500 years by the relative 'newcomers' to the Southwest— the Navajo and Apache, whose long migrations from Northwest Canada and interior Alaska brought them to the Southwest in the thirteenth to fifteenth centuries. They, in turn, absorbed and reinterpreted aspects of indigenous Southwestern artistic and religious practice, creating new hybrid arts and cultural traditions. Finally, the Spanish, who in the seventeenth and eighteenth centuries wrought profound changes in the cultural landscape, and the other 'Anglos' who subsequently settled in the Southwest, brought further changes.

Pueblo peoples' own historical narratives stress migration as an important feature of their early existence. The Zuni, for example, talk about a 'Search for the Middle Place' that took them on a quest in various directions in search of the ideal homeland. The archaeological record corroborates this, for over the past two millennia there has been much movement of peoples throughout the Southwest. And of course, in the post-contact period, some of the migrations were enforced by the will of outsiders, as we shall see.

Often in the history of art and culture we make the mistake of narrating a story of continuous 'development' of a tradition, towards an ever better and 'improved' way of doing things. Yet here, as in many parts of the world, the archaeological and ethnohistoric record tells a different story. Notably, the people who lived in this region a thousand years ago lived in communities whose scale was more vast, and whose

architecture more ambitious than anything their descendants have produced in the past nine centuries. Some of the finest ancient achievements in architecture and the arts occurred during relatively brief periods of social stability, punctuated by times of ideological change and conflict, cultural reorganization and migration in search of more reliable water sources, better land, and safer living conditions. The huge, multi-storey apartment complexes at Chaco Canyon, and the complex system of irrigation practised by the Hohokam, have no parallels in recent centuries.

The small villages well-known in the nineteenth and twentieth centuries [29] have preserved many ancient traditions, and have modified them as a result of 500 years of acculturation to European ways. And while aspects of modern Pueblo culture usefully illuminate the past, in fact the social organization of ancient societies, especially at places like Chaco Canyon, was far more complex than that of their nineteenth- and twentieth-century descendants (a phenomenon that was true of the chiefdoms and confederacies of the East, as well (see Chapter 3)).

Yet, despite a thousand years of tumultuous history involving drought, warfare, invasion, slavery, pestilence, and multiple colonizing forces, the persistence of tradition in the Southwest is remarkable. The Hopi village of Oraibi, for example, has been occupied for over a millennium. While this may be a common occurrence in European or Asian cities, no other community in North America can lay claim to this distinction. It is a duration of time that is impressive in a country whose modern political history has endured a scant 200 years.

The ancient world

'Anasazi' is a Navajo word that translates as 'enemy ancestors'. Many Anasazi ruins are on Navajo land, and it is understandable that the modern inhabitants would have coined a term for the makers of such remarkable architectural ruins, which they recognized were not made by their own ancestors. We don't know what these ancient peoples called themselves; presumably there were scores of different, specific names used within the multitude of communities whose ruins dot the Southwestern landscape. The people we call Anasazi were the ancestors of modern Hopi, Zuni, and other Pueblo peoples. Their achievements in the arts ranged from monumental architecture to ceramic technology, to painting on walls of vessels and walls of houses, to work in shell, bone and fibre. Most of their perishable arts have disappeared, but historical and modern arts of performance and visual display, combined with a handful of well-preserved textiles, suggest that ancient Anasazi people had remarkable traditions in these realms. But it is by their formidable achievements in architecture and painted pottery that they are best known to the world.

23

Interior view of Cliff Palace,
Mesa Verde, *c.*1250 CE,
Colorado, Anasazi culture

Enclosed within natural,
spacious concavities in the
rock mesas, the cliff dwellings
at Mesa Verde offer protection
from both hot and cold
weather. Cliff Palace, the
largest, had over 200 rooms,
and two dozen *kivas*.

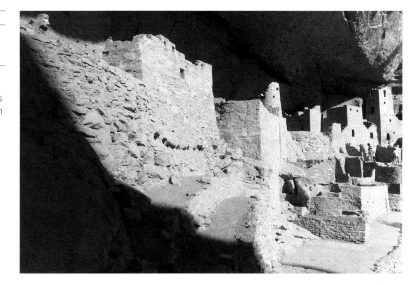

Anasazi architecture, ritual and world-view

The original permanent architectural form used by Anasazi people and
their neighbours was a modest-looking semi-subterranean structure
known as a pit house. The key features of a pit house included support-
ing wooden posts, an entrance hole in the roof, and walls and ceilings
of sticks and dried adobe mud plaster. The *sipapu*, a hole in the floor,
served as a symbol of the hole of emergence from the underworld.

In the centuries after 900 CE, social and demographic factors led to
a specifically Anasazi development. The rather humble circular form,
combined with small rectangular rooms, became the building block for
the most ambitious architectural constructions ever conceived in
Aboriginal North America: the great apartment complexes and 'cliff
palaces' that, by 1100 CE, dotted the landscape of the Four Corners
region.

Many of these ancient structures were orientated in relation to the
heavens and the underworld but were constructed with a sophisticated
knowledge of passive solar heating, as well as an appreciation for the
cooling properties of stone walls. At sites like Mesa Verde's Cliff Palace
[**23**], the low winter sun enters the pueblo and warms the stone and
adobe structures, which then give off reflected heat. In contrast, the
summer sun is too high to shine in on the buildings constructed within
the cliff's overhang, and the shady stone structure provides welcome
relief from the dazzling heat of the valley floor and the mesa top.

In the complex multi-room, multi-storey apartment complexes of
the eleventh and twelfth centuries, the cultural memory of the ances-
tral architectural form—the semi-subterranean circular pit house with
an entrance hole in the roof—lives on as a ceremonial enclosure known
as a *kiva*. Some *kivas* are small and were used primarily for family
ritual. Others, like the Great Kivas at Chaco Canyon, are enormous

Cross-section of Anasazi
architecture, Chaco Canyon,
New Mexico, c.1150 CE

The wide walls at the lowest
level provide the strength
to support multiple storeys.
The floors are formed by
layers of pine beams plastered
with mud.

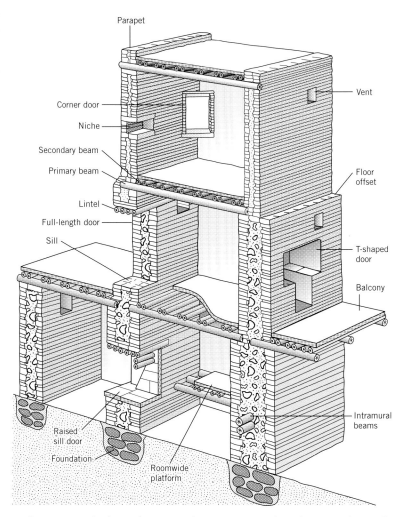

and must surely have been used as ceremonial gathering places for
hundreds of people, many of whom came from miles away, along a
system of roads that traversed the whole Chaco region.

At Chaco Canyon, New Mexico, are some of the most magni-
ficent examples of indigenous North American architecture. Within a
fifteen-kilometre range nearly 300 separate apartment compounds
have been mapped. Some are on the valley floor, with mesa cliffs as
their backdrop; others are on top of the mesa. Pueblo Bonito, the
grandest of these compounds, was built in semi-circular form. At the
apex of Chacoan cultural achievement, around 1100 CE, Pueblo Bonito
achieved its final size. It may have had as many as 800 rooms which
were built five deep and four to five storeys high, using fine sandstone
masonry [24]. Some three dozen circular rooms may have functioned
as *kivas*. One particularly noteworthy architectural feature found at
Pueblo Bonito and elsewhere at Chaco is the Great Kiva, which art
historian J. J. Brody has so evocatively described:

They were ritual theaters designed and built with the same structural elegance and superb masonry as the Great Houses. They are almost perfect circles, generally from forty-five to sixty feet across, and entered by staircases at either end of a north-south axis. Spectators could be seated on a stone bench circling the kiva floor, and some had windowed rooms on an upper level, which may have been reserved for more privileged viewers. At least one had a hidden passageway that opened under the kiva floor, presumably to allow performers to make theatrically spectacular entrances and exits. All had stone altars, foot drums, fire boxes and fire screens. Their roofs were ordinarily supported by four enormous wooden columns that might be cased in masonry and rested upon yard-wide circular stone footings sunk into the kiva floor.

Most Great Kivas were subdivided with geometric precision into two sets of quadrants, one oriented to the cardinal directions, the other, halfway between, to the intercardinals. Many had niches precisely spaced around the circumference. These may have had calendrical significance, and there are other relationships between architectural details, cardinal directions, and calendrical and astronomical regularities. These details often parallel modern Pueblo ritual patterns and lend support to the view that the Great Kivas, like modern ones, were conceived and designed as cosmic maps, metaphors of an ideal universe and cosmology.[2]

Nearly 300 separate apartment compounds at Chaco Canyon were part of a regional hub that probably served as both a ceremonial centre and the linchpin for a great inter-regional economy. Marine shells from the Gulf of California, copper bells and live tropical birds from Mexico passed through this canyon metropolis for more widespread distribution, while a large turquoise industry was carried out here and its products widely distributed. A number of roads radiate out from Chaco. Up to several metres wide, some extend in straight lines for more than eighty kilometres.

Anasazi architecture at places like Chaco Canyon and Mesa Verde gives visual expression to a communal social organization that has long been important to Pueblo peoples. In these close-knit living quarters, communities of small rooms are punctuated by larger spaces, both private and public. Interior, circular kivas hint at private rituals, while exterior dance plazas show that, in ancient times as in the modern Pueblo world, to gather publicly and dance for the gods was a fundamental way of being human.

Anasazi fibre arts and pottery

Among the earliest known artistic artefacts from the Southwest are objects made of twined, coiled, and woven plant fibres. Indeed, the term 'the Basketmaker Culture' has long been used by archaeologists to describe the ancient Pueblo peoples who lived in the Four Corners region from 100 BCE to 700 CE. (Although evidence for weaving in the Southwest and Great Basin has recently been shown to be far older than previously believed—as much as 9,400 years old.) Yucca fibres,

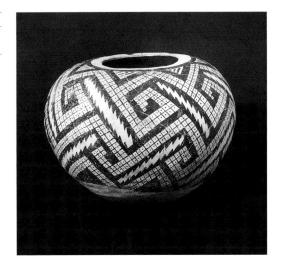

other plant materials, and even strands of hair were coiled and twined into baskets, clothing, sandals, and other useful forms. Sometimes these were painted with geometric designs, while in other instances geometric patterns were formed by alternating different-coloured plant materials in the weaving process [**3**]. Some baskets were coated with pitch or resin to make watertight containers, though among Pueblo peoples these were generally replaced by fine pottery after 700 CE.

The superbly crafted baskets and pottery made in the Anasazi area were the beginning of an unbroken tradition that persists today. In recent centuries, both pottery and basketry consistently have been the work of women in Pueblo culture (with a few exceptions in the painting and manufacture of some pots in the twentieth century). It seems likely that in ancient times these arts were under the purview of female artists as well.

Much scientific experimentation went into the development of these two arts over scores of generations. Women determined which roots and grasses would endure processing without excessive fading and cracking. Ecological, practical, and aesthetic considerations merged in ancient fibre arts, as artists ingeniously combined materials of different properties to serve particular functions: strength for a carrying basket or sandals, aesthetics for a gift basket or a basket placed in a burial, watertightness for a food basket.

The making of fired clay pottery is a hard-won technical skill developed over hundreds of years of constant experimentation. Two periods stand out as the high points of pottery making, one ancient and one modern: the era from 1000–1250 CE when Anasazi women and their Mimbres neighbours were making finely crafted vessels [**25–27**]; and the modern era of Pueblo pottery during the late nineteenth and early twentieth centuries, best seen in works from Zuni [**34**], Acoma,

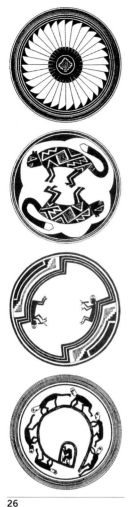

26

Drawing of Mimbres pottery
designs, *c*.1100 CE

and San Ildefonso [**36**]. In Anasazi pottery (especially in late pre-contact times, after the fall of Chaco), there were many regional polychrome traditions, some of which developed directly into historic polychrome pottery, like that made at Hopi. But the black-on-white tradition was both the most widespread and the most enduring style, from its roots in the ninth century to its decline in the thirteenth. As in modern Pueblo pottery, ancient Anasazi pottery was characterized by regional as well as individual diversity. The Anasazi potter was not only a master of the elegant vessel form, she also devised brilliant abstract designs out of a simple decorative vocabulary. Often this was done with negative painting, as in the seed jar in **25**, where black paint defines the negative space, giving the illusion of white painting on a black background. This method of creating surface design by painting the negative spaces to delineate a form was reused almost a thousand years later in San Ildefonso black-on-black ware [**36**]. Anasazi potters made a number of different vessel forms, including mugs with handles, bowls, wide-shouldered water jars called *ollas*, seed jars, and animal-effigy forms.

An animated universe: the world of Mimbres painted bowls

During the same decades that Anasazi potters were perfecting their fine-line geometric painting, their Mimbres neighbours devised another sort of container as the vehicle for their expressive painting tradition—the hemispheric bowl. Named after the Mimbres mountains in Southwestern New Mexico that were their home, Mimbres was one branch of the larger Mogollon culture that extended as far south as Northern Mexico.

While pottery was made in the Mimbres region for over 500 years—from 600 CE to 1150 CE, the high point of the tradition occurred in the eleventh and early twelfth centuries, leading this to be called the 'Classic Mimbres' period. Most Mimbres pots are hand-coiled bowls which were smoothed and shaped, and then painted with black and white slips before firing. Only the interior hemisphere of the bowl was painted. Over 10,000 of these bowls are known, and they display a vast iconographic lexicon [**26**]. Some feature geometric designs and fine-line painting reminiscent of Anasazi pottery painting; others push the boundaries of abstraction, reducing animal forms to their sparest recognizable forms. Others provide a window into a world that indicates that Mimbres people held beliefs similar to those of their Mesoamerican neighbours far to the south. They may have been exposed to these ideas through the intervening presence of Paquimé, the largest of all Southwestern centres and trading sites (located in Northern Chihuahua, Mexico), as the latter was emerging by the twelfth century. Mimbres also shared beliefs with their closer Hohokam and Anasazi neighbours. But, of the three major

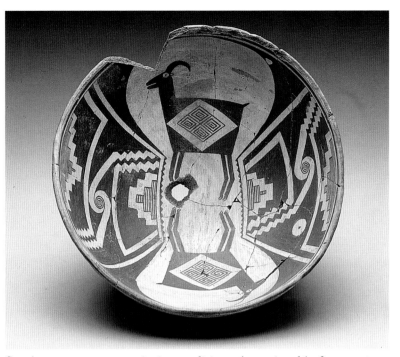

Southwestern pottery painting traditions that existed before 1200 CE, only the Mimbres created a complex representational iconographic vocabulary that expressed their relationship to the world of nature and the supernatural.

Recognizable animals, such as mountain sheep [**27**], bats, fish, and rabbits, appear on Mimbres pots, as do composite mythological beings such as horned water serpents, and humans in transformational guise. The characteristic black and white striped clowns known from historic Pueblo ritual [**37**] make their first appearance on Mimbres vessels, and are among evidence that suggests that, after the great migrations of the twelfth and thirteenth centuries, some aspects of Mimbres culture were absorbed into Pueblo culture. The Mimbreños themselves were part of an even larger inter-cultural conversation. Painted on their pots are images that suggest linkages with Northern and Central Mexican iconographic traditions, as well as with their Pueblo neighbours.

Most of these bowls have been found in burials interred beneath the floors of simple one-storey apartment complexes. Usually inverted over the head of the buried individual, the bowls are sometimes stacked in groups of three or four. Most were ritually punctured or 'killed' before burial, at the very bottom of the bowl where the first tiny coil was shaped to form the vessel (see **27**). Barbara Moulard has demonstrated that 'ethnographic analogy' (illuminating some features of the archaeological past by analogy with related historical cultures) can be used to shed light upon the meaning of these unusual painted bowls and their placement in graves.[3]

Modern Pueblo people describe the sky as a dome which rests upon the earth like an inverted bowl, a dome that can be pierced to allow passage between different worlds. The essential Pueblo idea, discussed in the beginning of this chapter, about human emergence from a hole in the ground on to the surface of the earth, restates this idea of permeating the boundaries between worlds. By placing their elegantly painted and pierced 'domes' over the heads of the dead, the Mimbres people may well have been expressing their ideas about the emergence of the honoured dead into the spirit world, just as modern Pueblo people often speak of the transformation of the dead into Kachinas (spirit beings) and clouds in the dome of the sky.

Hohokam art and culture
Around the same time as the Pueblo and Mimbres fluorescence, further south and west near present-day Phoenix, Arizona, there developed a civilization known as the Hohokam. Their architecture was on a more modest scale than the multi-storeyed Anasazi architecture; they built earthen platform mounds, and pit houses. The more subterranean focus to their architecture may have reflected their more extreme environment. Living in the exceptionally dry Sonoran desert, they devised a complex series of irrigation canals. The existence of ballcourts at most Hohokam sites, including a 200-foot-long ballcourt at Snaketown, is evidence of participation in a ceremonial realm derived from Central Mexico. We know that Hohokam people had extensive trade networks both north and south. They exported fine shellwork and textiles. In the arts, particularly noteworthy are their stone paint palettes in human and animal effigy form.

Drought, migration, and culture change
In the twelfth century, a severe drought occurred in the Anasazi region which may have triggered the collapse of the complex economy centred at Chaco Canyon and elsewhere. The twelfth century was a time of socio-political and cultural reconfiguration. Many sites were abandoned, and there was a rise of new, smaller, regional centres. An even more widespread drought in the late thirteenth century led to large-scale migrations into the better-watered Rio Grande River Valley and the Mogollon Rim country. In the west, the communities of Hopi, Acoma, and Zuni began to grow. Most oral histories of Pueblo peoples make mention of ancient migrations in search of the proper homeland. These may be cultural memories of the migrations that occurred during the late pre-contact period.[4]

From the colonial era to the modern Pueblos
It is a tribute to the strength and tenacity of Pueblo people that they have survived in order to flourish in the late twentieth century, for the

history of the European entry into the Pueblo world was a history of death, pestilence, and destruction. The handful of small villages along the Rio Grande River, the Western New Mexican villages of Zuni and Acoma, and the Hopi villages in Northern Arizona are all that remains today of the vast Pueblo world of the sixteenth century. Some 150 towns flourished when the Spaniard Francisco Vasquez de Coronado (c.1510–c.1554) and his men set forth from Mexico in 1540 in search of the rumoured golden cities of the north. Over just a few months, they gave the Pueblos a taste of the pillaging, slavery, and murder that would take hold in earnest some decades later. From 1581–1680, Franciscan friars organized the cultural conquest of what came to be called 'The Kingdom of New Mexico'.[5] People were forced to repudiate their traditional religion and all its icons. Ceremonial masks, Kachina dolls, and other regalia were seized and burned. Crosses and churches were erected, *kivas* destroyed. Using a technique that had been successful in gaining control over the Aztec world, the new political authorities consolidated dispersed populations into fewer, larger villages. Due to warfare and smallpox epidemics (as well as the periodic droughts which were a constant problem of this arid region) the Pueblo population was reduced from approximately 60,000 at the beginning of the seventeenth century to fewer than 10,000 at the beginning of the nineteenth. Friars tried to supplant indigenous ritual dramas with theatrical liturgies concerning Jesus, Mary, the saints, and public performances commemorating the battles of the Moors and the Christians. (Even today, at some Pueblos, the *Matachines* dance, which derives from the Dance of the Moors and the Christians, may be enacted one day, and an ancient animal masquerade performed the next.)

This stranglehold on Pueblo society was released for a few years when in 1680 the Pueblos banded together to overthrow the Spanish, successfully driving them out of New Mexico for twelve years. Churches and crosses were burned and *kivas* reconsecrated. In the eighteenth century, traditional Pueblo religion was driven underground. The secrecy that exists in most Pueblos today is the result of a turbulent history in which secrecy was the only successful strategy for survival. For that reason, most Pueblos do not permit photography of sacred Kachina dances; nor do they believe that ceremonial regalia should be considered as 'art' for consumption by outsiders. For this reason, this publication includes no photographs of Kachina masks or performances (though such photographs were routinely taken in the nineteenth century), but rather a painting produced by a Hopi artist [**30**].

Pueblo architectural space and ritual performance

Despite a diversity in languages and in some aspects of culture, there is enough uniformity of culture to speak of a Pueblo world-view that is

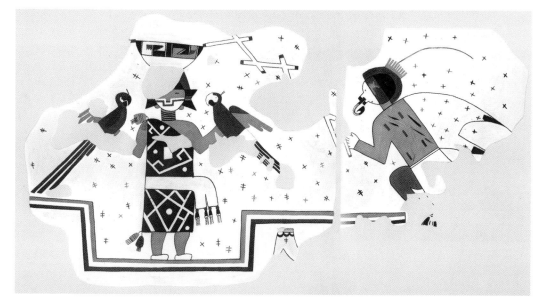

28

Reproduction of Kiva mural,
Pottery Mound, New Mexico,
c.1400 CE, Pueblo

Spirit figures responsible for
rain-making may be depicted
in this mural. A female holding
a parrot and a macaw wears
atop her head a bowl from
which lightning emerges.
A Mosquito Kachina
approaches her. The back-
ground is studded with
dragonflies, symbols of rain.

reflected in art, ceremony, and ideology. In this world-view, the village is the heart of the world, and the *kiva* is at the heart of the village.[6] The *kiva*, with its *sipapu*, serves as a connecting point between the visible world and the spirit world. The rest of the built environment grows outward and upward from there. Private rituals take place within the *kivas*, and the walls are sometimes painted with scenes of sacred iconography. Excavations at numerous archaeological sites reveal that this has long been the case [**28**].

Anasazi construction techniques at Chaco Canyon and Mesa Verde favoured the use of stone blocks. In the last few centuries, however, most Pueblo architecture has used adobe bricks as building blocks. Made in wooden moulds, by hand, by many members of the community, adobe block construction was an innovation introduced by the Spanish. Women have traditionally specialized in the plastering of the walls with wet mud to provide a durable coat over the mud bricks.

Some Pueblos, like Acoma and the Hopi villages, retain a fortified position on high mesa tops, where, from a distance, the earth-coloured buildings merge into the rocks that support them, revealing nature and culture to be a harmonious whole. In contrast to this, most of the Rio Grande Pueblos, including Taos [**29**], were built on the valley floor rather than rising up out of a rock outcrop. At Taos, two apartment complexes, a north and a south house block, rise on either side of the vast dance plaza, which is also bisected by a stream. Behind them rises Taos Mountain, the pyramidal shapes of the apartment complexes echoing its form. As architectural historian Vincent Scully has pointed out, many cultures sought in their architecture to replicate the natural forms of the landscape. Taos' north house block in some areas rises to five storeys, each higher one set back from the one beneath it, forming

Multi-storey apartment block,
Taos Pueblo, New Mexico

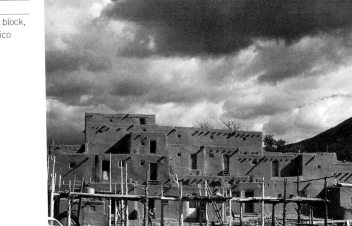

terraces which serve as viewing stands for ceremonial activity in the
plaza below, as seen in a Hopi artist's view of a ceremony at Hopi [30].
The continuity of this basic architectural form over a millennium
demonstrates how fundamental it is to a Pueblo world-view.

In the nineteenth century, Zuni, too, had five levels of terraces and
set-backs, most of which are now gone. The densely packed urban core
has been dispersed into one-storey buildings (some made of concrete
blocks covered with adobe-coloured stucco) and modern homes. Yet
the oldest part of the settlement, with its flat dance plaza, remains the
ceremonial heart of the community. Even those who live far from their
ancestral communities return to the dance plaza for festival occasions,
to reaffirm their connections to the Pueblo world.

In September 1879, ethnologist Frank Hamilton Cushing (1857–
1900) first laid eyes on the village of Zuni. His lengthy description
remains one of the most evocative ever published.

Below and beyond me was suddenly revealed a great red and yellow sand plain.
It merged into long stretches of gray, indistinct hill-lands in the western dis-
tance, distorted by mirages and sand-clouds. [. . .] To the rock mountain, a
thousand feet high and at least two miles in length along its flat top, which
showed, even in the distance, fanciful chiselings by wind, sand, and weather. . . .
But I did not realize that this hill, so strange and picturesque, was a city of the
habitations of men, until I saw, on the topmost terrace, little specks of black
and red moving about against the sky. It seemed still a little island of mesas,
one upon the other, smaller and smaller, reared from a sea of sand, in mock
rivalry of the surrounding mesas of Nature's rearing. [. . .]

Imagine numberless long, box-shaped adobe ranches, connected with one
another in extended rows and squares, with others, less and less numerous,
piled up upon them lengthwise and crosswise, in two, three, even six stories,

each receding from the one below it like the steps of a broken stairflight—as it were, a gigantic, pyramidal mud honey-comb with far outstretching base—and you can gain a fair conception of the architecture of Zuni.

Everywhere this structure bristled with ladder-poles, chimneys, and rafters. The ladders were heavy and long, with carved slab cross-pieces at the tops, and leaned at all angles against the roofs. The chimneys looked more like huge bamboo-joints than anything else I can compare them with, for they were made of bottomless earthen pots, set one upon the other and cemented together with mud, so that they stood up, like many-lobed oriental spires, from every roof top. Wonderfully like the holes in an ant-hill seemed the little windows and door-ways which everywhere pierced the walls of this gigantic habitation; and like ant-hills themselves seemed the curious little round-topped ovens which stood here and there along these walls or on the terrace edges. [. . .]

Not an Indian was anywhere to be seen, save on the topmost terraces of this strange city. There hundreds of them were congregated, gazing so intently down into one of the plazas beyond that none of them observed my approach, until I had hastily dismounted, tied my mule to a corral post, climbed the refuse-strewn hill and two or three ladders leading up to the house-tops. The regular *thud, thud*, of rattles and drum, the cadence of rude music . . . sounded more like the soughing of a storm wind amid the forests of a mountain than the accompaniment of a dance.[7]

While the colonial mission churches are, in some Pueblos, the tallest structures today, it is the dance plaza that is the focus of the architectural and ritual environment, for it is in the public space of the dance plaza that human beings demonstrate the reciprocity between their world and the spirit world [**30**, **31**]. Pueblo people say that the elemental forces of nature, including plants, animals, and aspects of the weather, are embodied in supernatural beings known as 'Kachinas' or 'Katcinas'. Human beings, too, upon their deaths, join the world of the

**30 Fred Kabotie
(1900–86), Hopi**

'Hopi Ceremonial Dance'
(watercolour on paper), 1921

A long line of Kachinas perform in the dance plaza accompanied by four ritual clowns whose buffoonery displays what is 'ka-Hopi' or improper behaviour. Kabotie was one of the very first Pueblo artists to depict ceremonial activities and village scenes in his work.

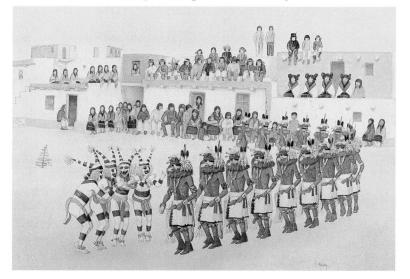

Photo of Tewa Deer Dancers,
Tesuque Pueblo, New
Mexico, December 1991

In a mid-winter performance,
males of all ages wear white
leggings, kilts, and deer
antlers adorned with feathers
and fresh pine boughs. With
blackened faces, they dance
in a long line, crouched with
canes in their hands, mimick-
ing the effect of these four-
legged animals.

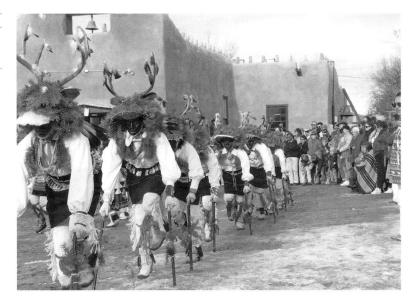

Kachinas. These ancestors and other spirit beings retain a proprietary influence upon the affairs of the living, and they are made manifest through the public performance of masks and specialized clothing by male members of various Kachina societies. Indeed, the Zuni phrase for such an activity (which in English we would call 'impersonating the gods') is 'they allow the god to become a living person'.[8] In other words, through religious and artistic activity, spiritual force is transformed into an incarnation that human beings can recognize.

Within the Pueblo world, ritual knowledge is owned by particular families, clans, and specialized ceremonial organizations, whose interlocking responsibilities map out the ceremonial years and keep the world in balance. While only men don the masks that allow the gods to become manifest, Pueblo women do dance (although unmasked) as the manifestation of certain spiritual principles as well. They wear finely woven textiles, wooden headgear, and dance with painted dance wands [32].

Barton Wright has, succinctly, described Pueblo ritual performance:

The Kachina dance is an integrating force for the villages in that it offers some form of participation for everyone either as audience, contributor, or performer. It combines the dramatic presentation of theatre with the entertainment of comedy and burlesque, the solemnity of prayer and sacred ritual interspersed with popular song and contemporary humour. It is both theatre and church with the emphasis on the process of the ritual rather than the result. The dancers are the prayer and the audience the contrapuntal support.[9]

Each Pueblo has its own view of the origins and meaning of the Kachinas (and in some, like the northeasterly communities of Taos and

Picuris, Kachinas are not prominent). The well-studied Zuni system provides some insights into Pueblo views about their spiritual world and artistic representations of it. The Zuni say that many Kachinas come from a location called 'Kachina Village' (beneath a lake to the west of Zuni), which is also the source for game animals such as deer, mountain sheep, and antelope. Kachinas are fundamental to all aspects of fertility—human procreation, rain, agricultural abundance, and success in hunting. According to Zuni belief, men who have been initiated into the Kachina society and their wives will, after death, join the spirits at Kachina Village, and take part in dancing and festival activity for all eternity.[10]

Among the Hopi, the complex annual ceremonial cycle is divided into Kachina Season, from February to July, and Non-Kachina Season, from August through to January. At *Powamuya*, in February, people petition for the return of Kachinas to the human community. Gifts are bestowed upon the children: Kachina dolls, baskets, and dance wands for girls, prayer sticks and rattles for boys (who don't need the education provided by the Kachina dolls, for during their initiation into male ceremonial practice they will learn all about the spirit beings). The positive results of Kachinas' presence in Hopi life are evident from the first bean sprouts germinated in the *kiva* in February to the corn and other crops that grow to maturity by mid-summer. After the summer solstice, the *Niman* ceremony bids farewell to Kachinas who return to their home in the distant San Francisco mountains.

32 Hopi artist

Line drawing of dance wands (wood, pigment, feathers), late nineteenth century

Pueblo women dance with basketry plaques or with prayer boards like these. In the Hopi women's Mamzrau Society, women dance sometimes with real ears and stalks of corn and sometimes with these painted dance wands, which symbolize the profound connection between human and agricultural fertility.

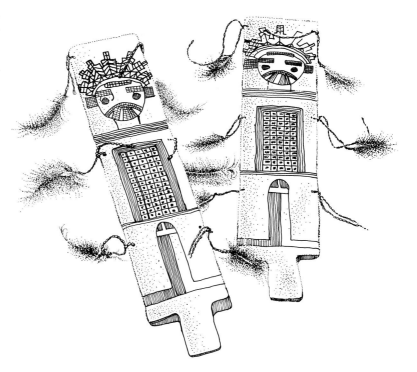

Shalako Kachina doll (wood, feathers, pigments), early twentieth century

The most impressive Kachinas at Zuni are the Shalako. Six of them, each towering eight feet in height, appear in early December. Swooping like giant birds, they visit from dusk until dawn, clacking their giant beaks. No arms are carved on this wooden doll, for the Shalako do not reveal their arms, using them inside the wicker framework to control the long pole that makes them tower over the spectators.

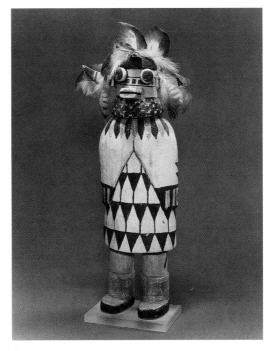

Hundreds of different Kachinas appear within the Pueblos in sacred performances. Pueblo people increasingly insist that Kachina masks worn in these ceremonial dances are *not* art objects and should not be displayed in museums. (Indeed, when collector Stuart Culin of the Brooklyn Museum was collecting artefacts at Zuni in 1902, a town crier walked around proclaiming that he should not be sold any masks—upon pain of death to the transgressor.) Within most Pueblos, masks are dismantled after ceremonial use, or at least scraped of paint, and they are kept either within the *kivas* or within the homes of their owners. A Kachina mask enshrined within a museum, lifeless and devoid of its ceremonial context, is considered a profanation of sacred, restricted knowledge, for only initiated men are supposed to understand the profound relationship among the gods, the masks, and their wearers.

Over the past hundred years or so, many depictions of Kachina dances have been painted by Pueblo artists [**30**], and wooden replicas of Kachina figures, known as Kachina dolls, are created not only for Pueblo children, but as a major category of art made for outsiders [**33**]. The Hopi have produced the largest number of these for sale, but Zuni and other Pueblo people have made them as well. Traditionally this type of carving was a male art; only a few women have worked as carvers. While cottonwood root is the preferred medium, pine and other woods are also used.

A few simple, carved wooden icons and painted stone effigies from the prehistoric era suggest that the making of Kachinas has a long

history. Frederick Dockstader has suggested that the increasing realism and three-dimensionality of Kachina dolls in the historic period (especially in Zuni dolls, which featured articulated arms at an earlier date than Hopi ones) were a result of the influence of eighteenth- and nineteenth-century Spanish friars who taught Native artists to carve statues of saints for the mission churches.[11] Although most late nineteenth-century Kachina dolls were simple painted effigies, today, many are richly adorned with additional materials, including feathers, turquoise, cloth, and rawhide. The twentieth century has also brought an increased realism of pose, with 'action figures' mounted on a wooden base and caught mid-step in a dance pose.

Pueblo pottery

Pueblo pottery has been as carefully studied as almost any other traditional art form in the world. Hundreds of thousands of Pueblo pots can be found in museums and private collections. Thousands more are for sale in Indian Pueblos and galleries worldwide. Historic pots by legendary potters, such as Maria Martinez of San Ildefonso or Nampeyo of Hopi, fetch auction prices of five figures, as do ancient pots by their Anasazi ancestors. The study of Pueblo pottery offers an insight into scientific processes, traditional world-view, and twentieth-century socio-economic processes as well.

The details of pottery production differ from village to village, depending on clay, tempering additives, and surface decoration of the vessels. This section offers only a few hints of the enormous technical complexity of this art. For most Pueblo potters, prayer precedes all work. Despite her later role as chemist and firing expert, at the start of the process a Pueblo potter is a daughter of Mother Earth, asking 'Clay Woman' for the use of her bodily material. Traditionally, at some Pueblos only women could harvest the clay from Mother Earth. At Zuni, for example, men were customarily prohibited from going to the clay source at Corn Mountain. (Yet gender classifications are flexible; in the late nineteenth century at Zuni, We'wha, who was biologically male yet dressed as a woman and excelled at women's arts, gathered clay with women.)[12]

Choosing the clay is a crucial part of the process, for all subsequent decisions rest on its initial selection. Clays vary widely in their chemical structure, requiring different tempering materials, variable methods of working the clay in its wet state, and alterations in the mode of polishing and firing. Some potters experiment widely with clays from different sources, noting variability in shrinkage, colour, and durability. Contemporary San Ildefonso potter Barbara Gonzales says, 'I have looked over almost every inch of our reservation and gathered many different colours of clays. Some I haven't tried yet, but I like having lots of clays, and I know where there are lots more.'[13]

Refining the raw chunks of newly mined clay is arduous work. At Acoma, women may grind up large chunks of clay in a hand-crank grinder, and then further refine it by grinding it to powder on a *metate* (grinding stone). The powdered clay is then soaked in water so that any impurities can rise to the surface and be poured off. The clay dries on baking trays in the sun, and then is ground again, and screened through a fine wire mesh.[14]

Most clays require the addition of some non-plastic material so that the clay can withstand firing at high temperatures without cracking, and so the vessel will have a smooth surface. This material is called temper. (Only at Hopi Pueblo can some clays be worked without the addition of tempering material, for Hopi potters have discovered a pure, fine kaolin clay that is strong and resists shrinkage.)

Potters have understood the principles of tempering for well over a thousand years. Anasazi women used a variety of sands and sandstones, and by 900 CE they had discovered that old potsherds—bits of previously fired, discarded pots—were also an excellent tempering material.[15] Potters would grind the broken bits of old pottery on their *metates*, just as they would grind corn for food. This use of potsherd temper is a tradition that continues today in some Pueblos. Not only is it scientifically sound practice, but it also provides an emotional link with the potters of the past.

After the temper has been added, the clay is mixed vigorously. Then the mixture must mature. Potters often make the analogy between processing clay for pots and processing flour into bread dough. Both require a practised hand in the mixing of diverse elements, both require kneading, and both must be put aside to rest. The dough rises, and the clay cures. Whereas bread is baked in the round 'beehive' ovens that stand outside many Pueblo homes, pottery is fired, in most instances, on the ground in an open-air firing. The *ad hoc* appearance of this technique is deceptive; in fact, an expert Pueblo potter is controlling many diverse factors when she fires her pots: the ambient temperature, the force of the wind, and the exact composition of the dried animal dung used in the firing process. All of these affect the outcome.

Pueblo pottery is painted with a liquid clay called 'slip' before firing. It is in the painting of pots (as well as in the technical excellence of their manufacture) that one sees the continuity of this thousand-year-old tradition. Certain motifs and geometric designs repeat, and reappear in different generations. Particular design elements and colours are characteristic of particular Pueblos: the black-on-black ware of San Ildefonso [36], the finely controlled use of delicate parallel lines to form dazzling geometric patterns at Acoma, and the graceful figural and geometric imagery of Zuni Pueblo [34]. Many potters today find inspiration in Anasazi and Mimbres iconography. At the beginning of the twentieth century this inspiration was likely to be derived from

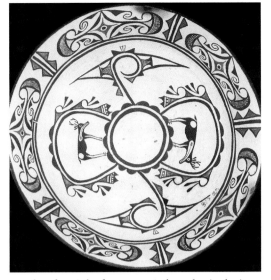

Painted bowl (fired clay,
pigments), c.1910

A characteristic design in Zuni
pottery painting is the deer
with a red arrow of life or
breath (*binanne*) extending
from its mouth to its chest.
Zuni pottery painting motifs
have been adapted by Hopi,
Laguna, and Acoma potters
for more than 100 years.

potsherds picked up at archaeological sites, and today artists own
lavishly illustrated art books from which they might adapt a Mimbres
rabbit design to an Acoma pot, for example, just as contemporary easel
painters like Joe Herrera do [**35**].

When anthropologist Ruth Bunzel worked with Pueblo potters in
the 1920s, she discovered that girls were given instruction in technical
aspects of pottery-making, yet were expected to exercise their own cre-
ativity when it came to the painting of the pots. None the less, the
weight of tradition ensured that a young artist would choose from a
familiar vocabulary of forms to generate a design that would be indi-
vidual, yet recognizably part of the village style. Many potters spoke of
dreaming of their designs; all insisted that copying from another's
work was inappropriate. When issues of quality and artistry were
raised with these artists, Bunzel found that, for the most part, women
did not see the painted surface of the vessel as the 'artistic' part of the
work. These critics were more concerned with the technical excellence
of the pottery ware itself: careful shaping and correct firing produced
an object of beauty.

At most Pueblos, all aspects of pottery production—from gathering
the clay at secret, sacred sources, to forming the vessel, to painting it—
were clearly the domain of female artists. But in the early twentieth
century, a situation arose in which touristic demands far exceeded the
supply of painted pots. The development of pottery as a business gave
rise to a number of strategic alliances between Pueblo potters and their
painter husbands. Maria and Julian Martinez are the best known of
a number of such collaborations in which males painted designs on
the pots of their wives or female relatives. This co-existed—at
San Ildefonso, for example—with many instances in which women
both shaped and painted their own pots. Today, gender rules are more

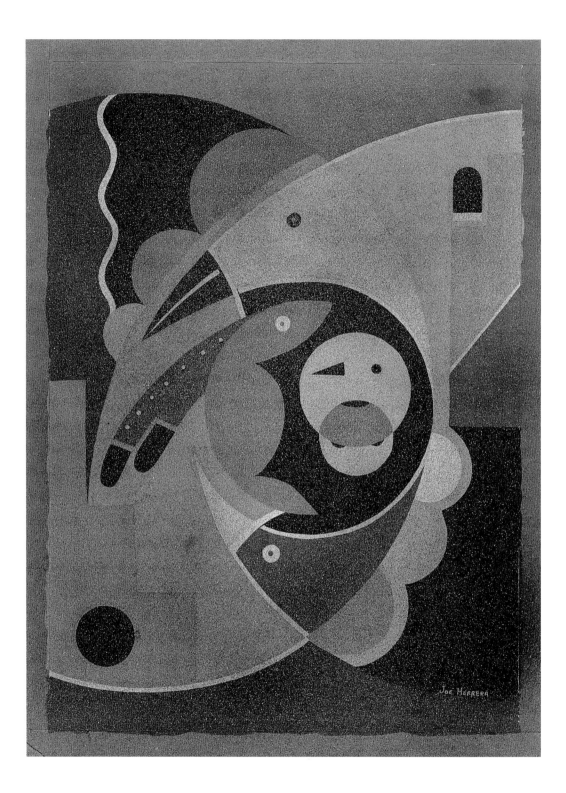

Maria Martinez

Perhaps the most famous of all Native American artists, Maria Martinez (*c.*1881–1980) was born at San Ildefonso Pueblo. She learned the art of pottery-making from her aunt, Nicolasa Peña. Maria married Julian Martinez in 1904, and they immediately left by train for St Louis to spend the summer at the World's Fair, so Maria could demonstrate pottery-making. At the time, she was making polychrome pottery.

Only in 1918 did Maria and Julian Martinez inaugurate their unique experiments with black-on-black ware for which Maria achieved worldwide acclaim. Julian over-painted Maria's already slipped and highly burnished vessel with an additional layer of slip. He painted feathers, water serpents, and other Pueblo designs. Upon firing, the burnished areas of the vessel burned to a high gloss, while the slip-painted areas retained a matte finish. This added a new aesthetic dimension to blackware pottery, and brought the artists immediate acclaim. Soon thereafter, they shared their technical knowledge with other San Ildefonso potters.

After 1920, Anglo patrons suggested that Maria sign her pots. Sales were booming, and to the Anglo buyer, a signature would increase the worth of the object. To the Pueblo potter, a signature was of no consequence, for within the community the work of an individual hand was immediately recognizable through stylistic and technical idiosyncrasies. In the 1920s and '30s, Maria signed pots made and painted by others, and she slipped, burnished, and signed pots that others had shaped. To the Western art world, this may seem to be misrepresentation; however, within the Pueblo world-view, where community balance and harmony are valued over individual achievement, this was a mechanism by which other artists could share the high prices brought by Maria's overriding fame [**36**].

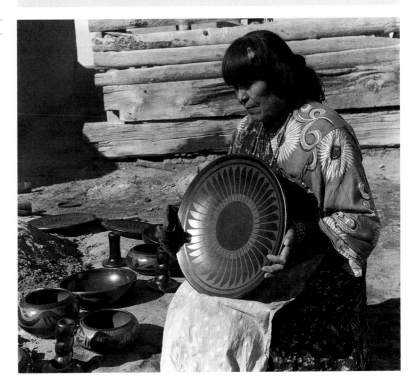

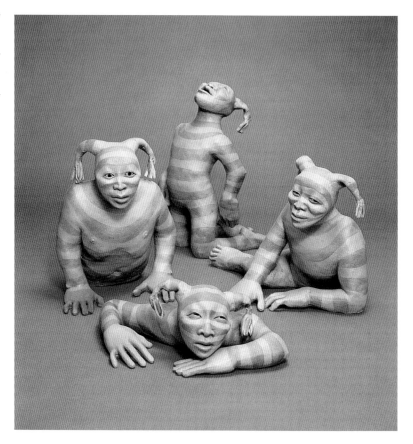

flexible, as in many areas of artistic production throughout indigenous North America.

Potters continue to produce a dizzying array of ceramic forms, from traditional pots and water jars to figural sculptures. Roxanne Swentzell [**37**] and her niece Nora Naranjo-Morse are two of the best-known potters making sculptural ceramic forms; though their work is highly contemporary and often marked by humour or heightened realism, both see themselves as part of a long tradition of Pueblo potters.

Navajo and Apache arts

While migration stories are central to Pueblo peoples' histories, the most ambitious migration to the Southwest was the long journey made by bands of Athabaskans from their original homelands in the interior of Alaska and in Canada's far Northwest. The groups that, today, we call the Navajo and the Apache were nomadic hunters who arrived in the desert Southwest between 1200 and 1500 CE. Over the course of many generations, the cultures of these Southern Athabaskan peoples became quite different from those of their Northern Athabaskan fore-bears who were nomadic hunters in the Sub-arctic, although their languages remain quite similar (see Chapter 5). (And, even today, in

recognition of their special relationship with northern peoples, groups of Navajo travel to Alaska each summer for the World Eskimo and Indian Olympics held in Fairbanks.)

These newcomers to the Southwest were adaptable and innovative, transforming aspects of Pueblo religion and art into a distinctly Navajo or Apache configuration. Navajo and Apache religion both feature Kachina-like spirit beings who are the source of supernatural power. Among the Navajo these are called *Yei*, or Holy People; among the Apache, *Gaan*, or Mountain Spirit People. Masked men dance as *Yei* or *Gaan* in numerous ceremonials [38]. Navajo women adapted the Pueblo art of weaving, transforming it into one of the most distinctive Native American artistic traditions. Both Navajo and Apache women learned the art of basketmaking, with Western Apache women, in particular, excelling at this art form.

Arts of medicine and performance

While the exact nature of contact between Pueblo and Southern Athabaskan peoples in the colonial period is unclear, periods of sustained, profound interchange must have occurred, for complex aspects of Pueblo ceremonialism were transferred from one group to the other. In Pueblo *kiva* rituals, elaborate diagrams are sometimes 'painted' in dry materials on the floor as part of an altar. The Navajo took this relatively minor aspect of Pueblo artistry and developed it into an extraordinary art form which became the centrepiece of ritual. The appearance of masked spirit figures at some Navajo and Apache ceremonials suggests another adaptation of Pueblo forms.

Yet Apache and Navajo people were dispersed populations, and remained somewhat nomadic until the reservation period. The close community fostered within multi-storey Pueblo apartment

38

Photo of *Gaan* or Mountain Spirit maskers, 1899, Mescalero Apache

Among the Apaches, spiritual power and curative knowledge reside in the Mountain Spirit People who live beneath the mountains. Masked impersonators of these spirits wear high moccasins, dance kilts, cloth hoods, and distinctive slatted wooden head pieces.

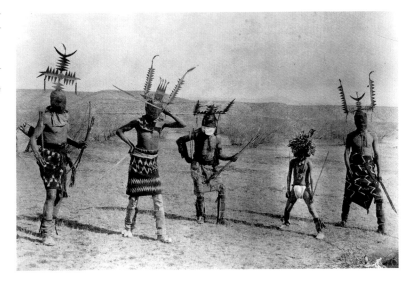

Conical forked-pole *hogan*
(male)

Four-sided leaning log *hogan*

Corbeled log roof *hogan*
(female)

39

Diagram of *hogan* types,
Navajo

compounds never appealed to them; they retained far less elaborate styles of architecture. The conical Navajo house or *hogan* [**39**] and [**41**] may, at first glance, seem to resemble a *kiva*, but the hole in the roof is for ventilation; the structure is entered through an eastward-facing door. It is sometimes made of logs, sometimes of stones. Some Apaches retained the brush shelters that were a legacy from the far north; those who lived nearer the Southern Plains adopted the tipis of their Kiowa and Comanche neighbours.

While Pueblo ceremonial arts were fostered within the communities' interlocking clan-based religious hierarchy, Navajo and Apache adaptations of masquerade and ceremony were very much a matter of personal vocation. Individual shamans or healers learned the dozens of songs necessary for the proper enactment of curing ceremonies. The Navajo sandpainter took on an apprentice who, of his own volition, decided to follow the path of ritual and healing. It is in the realm of ceremonies for healing and psychological harmony that the Navajo art of sandpainting is performed [**40**]. It is superficially like the Tibetan Buddhist art of sandpainting that has been publicly performed by monks in the West in recent years: complex yet evanescent pictorial designs are painstakingly made by casting thin lines of coloured sands, crushed stones, and pollens on to a prepared bed of sand.

The practitioner of this art (called a 'chanter' or 'singer' for the other important function he performs) is usually male. He is the repository for most of the religious, psychological and medical knowledge of the group, and there are specialists for different problems. The chanter must memorize complex songs that recount the epic myths or adventures of the Holy People. The process of making a sandpainting is the culmination of a multi-night ritual performance of numerous songs and other activities. The making of a sandpainting in a ritually correct manner is thought to draw upon the healing powers of the Holy People. When the arduous design has been completed, the patient is led into the painting to sit and absorb the powerful forces which will help restore harmony or *hozho* to the sick individual. After its use, the sandpainting is obliterated and the material returned to the desert. According to Navajo stories, the deity who taught them the art of sandpainting illustrated the epic stories in impermanent materials—he drew in the clouds. For this reason, the healer's complex designs are equally ephemeral.

The Abstract Expressionist Jackson Pollock was influenced by the gestural quality of the sandpainter's art, and his 'action paintings' reflect his interest in both the healing process and the technique of scattering materials freehand on to a prepared surface on the ground.[16] In recent years, the sale of small-scale replicas of sandpaintings has become an important source of income on some parts of the reservation. Images in sand, glued down on to masonite boards, are sold in

Photo of Navajo sandpainters at work, 1930s

Since the end of the nineteenth century, some chanters have worked with anthropologists to record the songs and copy the sand-paintings of several dozen ceremonial cycles for posterity. The demonstration of sandpainting techniques at numerous fairs and museum exhibits throughout the twentieth century caused this to become a well-known practice despite its ephemeral form, and its use in private healing ceremonies.

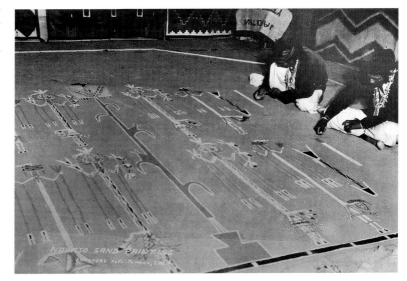

tourist shops throughout the Southwest. These are not generally made by healers, but by entrepreneurs who are trying to earn a living by marketing the most recognizable feature of their culture.

As in Pueblo ceremony, Navajo healing rituals were often multi-night affairs, sometimes culminating in the appearance of masked figures representing the Holy People. In the Nightway ceremony, for example, spirit figures appear wearing deerskin masks adorned with shells, hair, and other accoutrements. These bear superficial resemblance to Kachina masks, and may, in the distant past, have been influenced by Kachina performances. Apache *Gaan* dancers appear on several festive occasions, the most important being the girls' puberty ceremony [**38**]. These Navajo and Apache rituals are also an important subject for modern artists. The noted Chiricahua Apache modernist, Alan Houser, completed many paintings and large-scale sculptures depicting these dramatic figures, while numerous paintings of the Night Chant and other ceremonials have been painted by twentieth-century Navajo artists.

Navajo weaving, Apache baskets, and the powers of transformation
Southern Athabaskan fibre arts also reveal a legacy of change, mutability, and adaptation. For example, a Navajo woman weaves many cultural strands into her textile: a technology learned from neighbouring Pueblo people during the centuries between 1500 and 1800, materials such as sheep's wool and chemical dyes introduced by colonial Hispanic and modern Anglo people, a Navajo aesthetic ideology that informs the creative decisions each weaver makes, and finally, a practical knowledge of the changing international market for her art.

The weaver uses a fixed, upright loom. Historic photographs show tree limbs, or even two trees growing close together, serving as fixed

Photo of Navajo weaver, flock, and *hogan*, c.1926

Sheep are considered a Navajo woman's wealth, for she owns the family's flocks and their products, including the rugs she makes on her loom.

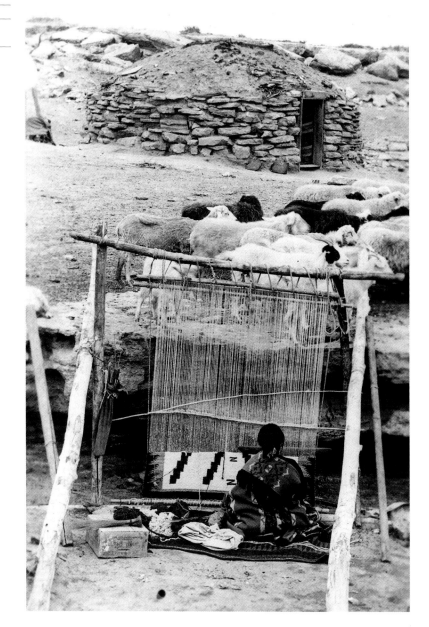

vertical poles to which horizontal beams were lashed [**41**]. Today most weavers have strong, free-standing metal and wooden looms that can be used inside or outdoors. Weaving traditionally depended upon having many sheep—for a prosperous weaver can, theoretically, produce her art without access to any outside products: raising and shearing the sheep, carding and spinning the wool, and dyeing it with natural dyes from the surrounding environment. Today, few women perform all these steps. Some specialize in spinning, and sell or barter their yarn. Other women specialize in dye technology. Others might

weave only with purchased yarn. A study of all the steps involved in weaving an average-size Navajo rug revealed that over 400 hours might be spent on shearing, spinning, and dyeing, in comparison to about 160 spent on the weaving itself,[17] so it is understandable that many women would be eager to shorten the process.

Traditionally, small girls learned at their mothers', aunts', or older sisters' looms, and some of them were already weaving at the age of just four or five. The Navajo matrilocal residence pattern lent continuity to the passing on of this artistic legacy, for generations of daughters and sisters tended to stay in the same area.

Navajo weaving has evolved through many stages and styles in the past 200 years; little is known of the art form before then. Early nineteenth-century textiles were relatively plain, striped wearing blankets. Throughout the nineteenth century, successive phases of the so-called 'chief's blanket' reveal a graphic boldness and simplicity: conjoining stripes, cross patterns, and diamond forms. These blankets were widely traded throughout the Southwest and the Great Plains. Numerous nineteenth-century drawings by Cheyenne and Kiowa artists, for example, depict men wearing such fine robes.

For Navajo weavers, the period between 1880 and 1920 was a time of tremendous cross-cultural fertilization and artistic innovation. With the coming of the railroad in 1882, weavers had greater access to new materials. Chemical dyes and machine-spun Germantown yarn began to be widely employed. Use of this fine yarn (and the tremendous time saved in not having to spin and dye) gave rise to inventive experimentation in colour and pattern. Today, these rugs are called 'eye dazzlers' because of their optic properties. Weavers often balanced complementary colours, such as red and green, or outlined colours with narrow bands, causing the vivid hues to oscillate in the viewer's eye [42].

By the late 1890s, Anglo trading-post owners encouraged weavers to draw upon intricately patterned Persian carpet designs in order to make their rugs more marketable in late-Victorian households in the Mid-West and New England. Out of this grew the proliferation of regional styles recognizable today, including Teec Nos Pos, Two Grey Hills, and Ganado.[18] During this era, most weavers also adapted their textiles for use as floor rugs rather than wearing blankets.

It would be a mistake to assume that the Navajo weaver passively submitted to these successive strata of outside influences. On the contrary, central to Navajo philosophy is the idea of change, transformation and renewal.[19] This allows the Navajo artist to creatively incorporate many diverse realms into her work. Weaving is a sacred activity, as well as a paradigm for womanhood. It is a means for creating beauty and projecting it into the world. The universe itself was woven on an enormous loom by the mythic female ancestor, Spider Woman, out of the sacred materials of the cosmos. Spider Woman

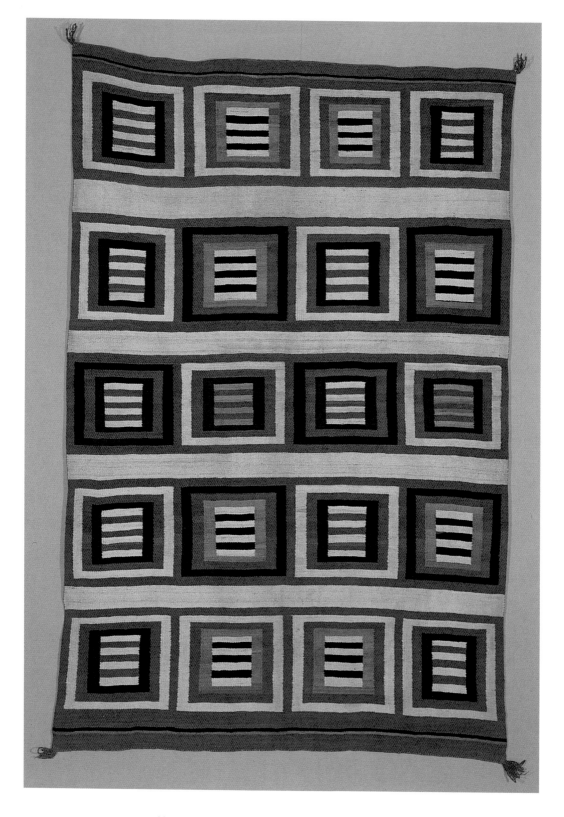

42 Navajo artist

Woven blanket (handspun wool), c.1885

Woven at a time when wearing-blankets as well as rugs were being made, this fine work combines aspects of both. Its wool fibres are handspun but the weaver is experimenting with some of the optic properties of colour associated with 'eye dazzlers' made from imported machine-spun yarn. The beige, green, and black rectangles give the appearance of projecting into space at different rates, creating animated surface patterning.

taught Changing Woman, one of the most important Navajo supernaturals, how to weave.

Changing Woman provides the model for the Navajo aesthetic of transformation. She is, in essence, Mother Earth, clothing herself anew in vegetation each spring. Displaying their evocative love of rich aesthetic patterns both in textile and in story, Navajo people say that when she was discovered on a sacred mountain top by First Man and First Woman, Changing Woman wore the same cosmic materials from which Spider Woman wove the universe. Her cradleboard was made of rainbows and sunrays, with a curved rainbow arching over her face. She was swaddled in black, blue, yellow, and white clouds, laced together by zigzag lightning and sunbeams. Changing Woman's puberty ceremony, attended by all the gods, was the model for *Kinaalda*, the girl's puberty ceremony still performed today. (A related ceremonial takes place among the Apache.)

Navajo women imitate Changing Woman's transformational processes as they combine the world of plants (the wood for loom parts; vegetal dyes), the world of animals (sheep wool), and the world of humans (her own dexterity and aesthetic sensibility) in order to make a rug.[20] People have looked in vain for some sacred meaning to Navajo textiles—there is no sacred meaning to the finished product or its geometric designs. An artist is more interested in the transformative process of weaving, rather than the finished product.

Like the making of Pueblo pottery, Navajo weaving has long been a woman's art, yet in both systems there always was room for gender cross-over. As discussed in Chapter 1 (see p. 34), the Navajo singer Hosteen Klah was an expert weaver. His experimentation in weaving

43 Western Apache artist

Basketry *olla* (willow, and devil's claw), late nineteenth century

The large *olla* or jar-shaped basket is characteristic of Western Apache fibre arts. Human and animal forms are often woven amidst the geometric designs.

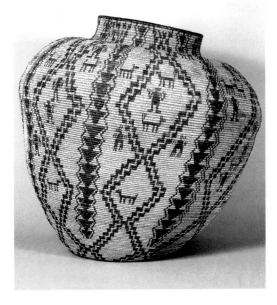

sandpainting iconography into textiles in the early years of the twentieth century opened the way for female weavers (who did not have his specialized ritual knowledge of such imagery) to make sandpainting textiles as well.

Among the Apaches, basketry has long been the pre-eminent art form. Different Apache groups make many sorts of baskets, both twined and coiled. Jicarilla Apaches produce watertight basketry bottles coated with pine pitch and/or clay, while Western Apache bands make some of the most well-known types, including elaborately coiled shallow trays and *olla*-like storage jars [**43**]. Woman exploit the diverse plant materials of the Southwestern environment, including willow and cottonroot for the body of the container, and black devil's claw and red yucca root for decorative effects. The dynamic designs on Apache baskets include stars, interlocking geometric forms, mazes, and human and animal figures. Their neighbours to the south, the O'odham, use many similar designs. For over a hundred years the main outlet for basketry has been the commodity market, yet some baskets are still an important part of ritual. Apaches' burden baskets, for example, are sometimes still used to carry the gifts distributed in the Sunrise ceremony that marks a girl's coming of age.

Navajo and Pueblo jewellery

The making of silver jewellery—cast, beaten, stamped, or worked by hand in other ways—is another example of the innovative genius of the Navajo. Their ability to forge a new art form out of a variety of external models and materials formed the basis for the explosion of jewellery-making as a major medium in the twentieth century.

For over a thousand years, Pueblo people fashioned fine ornaments out of semi-precious stones and shell. Native silverworking was added to this in the mid-nineteenth century. In the 1850s, Atsidi Sani (*c*.1828–*c*.1918) was the first Navajo to learn smithing from a Mexican blacksmith, making bridles and other sorts of ironwork. Some years later he began experimenting in a new material, silver, and eventually taught his sons and other Navajo men. Fine horse equipment and bells made out of hammered silver coins were among the objects that nineteenth-century silversmiths made. They also cast silver in clay or rock moulds to make bracelets, buckles, bridles, and other goods. By the late nineteenth century, Navajo silversmiths were setting turquoise stones in silver. The fine necklaces and concha belts which are so characteristic of twentieth-century Southwestern jewellery had their genesis at that time. The famous 'squash blossom necklace' is a standard jewellery form made by Navajo silversmiths, sometimes incorporating prodigious amounts of turquoise as well as silver into its design. At Zuni Pueblo, too, silversmithing grew out of blacksmithing technology. Navajo silversmiths taught Zuni blacksmiths how to work this

new metal. In the early years of the twentieth century, commercialization of Native silverwork, because of the increase in tourism, opened vast new markets for Pueblo and Navajo silversmiths. Today the making and marketing of jewellery is one of the economic mainstays of indigenous life in the Southwest.

The East

3

'*Neh nih Che yonh en ja seh*'—'When the world was new'—begins the Iroquois teller of the story of the creation. He tells of Sky Woman, who, pushed from the land of the sky people through a hole opened up by the uprooting of the great tree of light, was borne on the wings of birds to a safe landing on the back of a great turtle [**44**]. He tells how muskrat brought up a clod of earth from beneath the waters, and how the clod expanded as she walked around until it became the earth we know. He tells of the birth of a daughter to Sky Woman, and how she, in turn, became the mother of twins. One, Good Mind, created human beings and the things that would be useful to them, but at every pass he had to counter the actions of his twin, Bad Mind, who went about unleashing destructive and negative things. In the story, the existence of evil—although it remains ultimately inexplicable—can be traced to an initial act against nature. Seneca elder Jesse Cornplanter recounts that Sky Woman's daughter, just before the twins' birth

was so surprised to hear them talking while still within her. One was saying for them to come out by the nearest way while the other kept saying to come to the world in the proper way; so after a while they were born—the first came out as in the usual manner while the other came out through her arm-pit, which caused her death.[1]

In Vincent Bomberry's (b. 1958) 1982 sculpture, 'The Birth of Good and Evil', the challenge of moral choice is powerfully expressed as a physical tension that twists and pulls at the mother's body [**45**]. Both sculpture and story alert the listener to central themes of Iroquois traditional teaching, the dangers of antisocial conduct and the need for vigilance in maintaining order and peace.

The East as a region

The Iroquois Confederacy that united much of New York State and adjacent parts of the Northeast from the fifteenth to the end of the eighteenth century was the most recent of a series of powerful political chiefdoms and confederacies that have arisen in the eastern half of the North American continent over the past 2,000 years [**46**]. This dynamic history of complex political organization has been

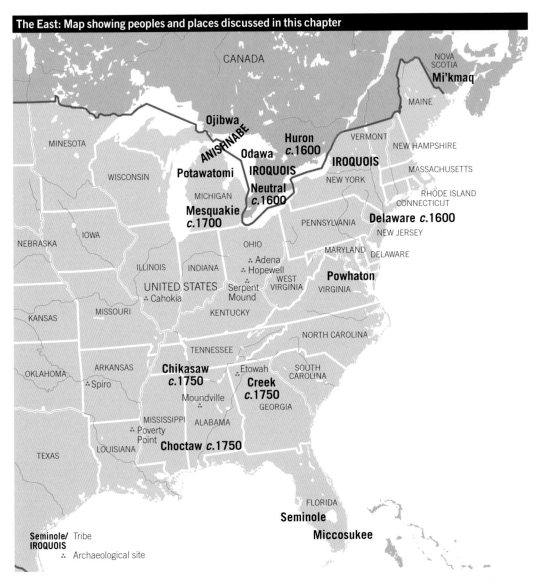

CANADA

NOVA SCOTIA

Mi'kmaq

MAINE

MINESOTA

Ojibwa

ANISHNABE

Odawa

Huron
c.1600

VERMONT

NEW HAMPSHIRE

IROQUOIS

IROQUOIS

NEW YORK

MASSACHUSETTS

WISCONSIN

Potawatomi

MICHIGAN

Neutral
c.1600

RHODE ISLAND
CONNECTICUT

Mesquakie
c.1700

PENNSYLVANIA

Delaware c.1600

NEW JERSEY

IOWA

NEBRASKA

OHIO

MARYLAND

DELAWARE

ILLINOIS

INDIANA

∴ Adena
∴ Hopewell

WEST
VIRGINIA

Powhaton

UNITED STATES

Serpent
Mound

VIRGINIA

∴ Cahokia

KANSAS

MISSOURI

KENTUCKY

NORTH CAROLINA

TENNESSEE

OKLAHOMA

ARKANSAS

Chikasaw
c.1750

Etowah
∴

SOUTH
CAROLINA

∴ Spiro

Creek
c.1750

Moundville
∴

GEORGIA

MISSISSIPPI

ALABAMA

∴ Poverty
Point

Choctaw c.1750

TEXAS

LOUISIANA

FLORIDA

Seminole

Seminole/
IROQUOIS Tribe

Miccosukee

∴ Archaeological site

overshadowed by the more popular and romantic image of the Eastern Indian as James Fenimore Cooper's Uncas—a lone hunter in the forest on the edge of extermination. However, in order to appreciate the region's artistic traditions, it is important to adjust this picture. During the past two millennia, at least as many Eastern Native Americans have lived in settled communities with sophisticated political and religious institutions as have lived in small nomadic hunting bands, and many important forms of visual art and architecture have developed within this complex socio-political context. This chapter will also stress the role that visual art has played in negotiating cultural values as indigenous ways of life were repeatedly disrupted—a process that began much earlier in the East than in most other parts of the

44 Ernest Smith
(1907–75), Seneca
(Iroquois)

'Sky Woman', 1936

This painting, showing the
fall of Sky Woman to earth, or
'Turtle Island', is part of a large
corpus of paintings begun by
the artist in the 1930s as part
of a Works Progress Admin-
istration project. Using a
Westernized pictorial idiom,
Smith freshly visualized
the traditional world of the
Iroquois, fusing oral and
ceremonial traditions with
archaeological and historical
research. The village of long-
houses in which the people of
the skyworld live, for example,
brings to life the schematic
drawings made by early
contact-period European
observers.

continent. Today, more Woodlands people live west of the Mississippi
than in their ancient Eastern homelands. The continuities of artistic
style and imagery that continue to link peoples separated by thousands
of years and thousands of miles are all the more remarkable given the
profound impacts of missionization, epidemics, and displacements
that began more than four centuries ago.

As a culture area, the East is bounded on its western side by the
Mississippi valley and, to the east by the Atlantic Ocean. It extends
north from the Gulf of Mexico to the boreal forests that edge the Great
Lakes, the Ottawa and the St Lawrence Rivers. Anthropologists have
termed the East 'the Woodlands' because of the trees that originally
covered much of the land, providing the inhabitants with nuts and
deer, beaver, and other game animals. Equally important to Native
history, however, have been the sea coasts that are rich in fish and

marine life and the fertile river flood plains that could be most easily cultivated before the introduction of metal tools. Within this huge geographic area, of course, variations of climate, ecology and history have created distinct sub-areas. The major division is into northeastern and southeastern sub-areas which are differentiated primarily by the greater reliance on agriculture in the south and the attendant differences in ceremonial and political life.

Eastern North America is relatively homogeneous linguistically in comparison with other parts of the continent. Most Woodlands peoples speak languages belonging to three large language families, Algonkian and Iroquoian in the Northeast, and Muskogean in the Southeast; in the Great Lakes, there are also smaller groups of Siouan speakers. Historically, a second vitally important unifying factor has been the trade routes that have linked the Great Lakes with the Gulf Coast, the Mississippi Valley with Florida, and Mesoamerica with all of these regions. Over these routes came new food crops, exotic materials for the making of art, and—of equal importance—spiritual, political and artistic concepts.

Hunting cultures, burial practices, and Early Woodlands art forms

Archaeologists date the first occupancy of Eastern North America to big-game hunters who lived in the region from about 14,000 to 10,000 years ago. This Palaeo-Indian phase was followed by an era known as the Archaic, a long period that lasted until about 1000 BCE, during

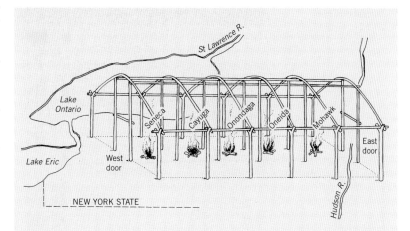

Conceptual drawing of map of the Iroquois Confederacy as a longhouse

The traditional dwelling of Iroquoian peoples is the longhouse, a large house up to 400 feet long. Made of poles sheathed in sheets of elm bark, they sheltered a number of families of the same lineage. The Iroquois Confederacy is metaphorically expressed as a longhouse as shown in this conceptual drawing. It shelters five related peoples (six after the Tuscarora joined in 1722–3) and is guarded by the Seneca and the Mohawk, the Keepers of the Western and Eastern Doors.

which Woodlands peoples lived by hunting and gathering and developed many of their characteristic spiritual and ceremonial practices, such as the ritual preparation of the dead and the placement of red ochre, rattles and smoking pipes in graves.

The first appearances of the kinds of visually elaborated objects that we call 'art' also occur during the Archaic Period. More than a thousand graves were found, for example, at Indian Knoll, Kentucky (used between 5,000 and 4,000 years ago), many of which contained exquisitely wrought bannerstones [6]. These were used to weight *atlatls*, launching sticks for spears. Few of the bannerstones show signs of use, however. They are carved of exotic imported stones with an exceptional artistry that exploits the natural colours, patterns, and striations of the stones to afford maximum visual satisfaction. Other Archaic Period burials contain oversized spear points made of cold-beaten Great Lakes copper, a metal which, though lustrous and beautiful, is too soft to make an effective weapon. Such objects were clearly not intended for use; David Penney has termed them 'sumptuary implements' that 'may have been thought of as effigies of tools rather than as utilitarian objects'.[2] Their primary value lay in their symbolic and aesthetic worth rather than in their tool-like efficiency.

The Archaic Period also saw the beginning of a 5,000-year-long tradition of building large-scale earthworks for use as burial sites and ceremonial centres. Between about 1800 and 500 BCE (the time of Stonehenge in England and the Olmec civilization in Mexico), Native Americans at Poverty Point, Louisiana, in the lower Mississippi Valley, built an immense ceremonial centre formed of six concentric embankments measuring three quarters of a mile across and totalling seven miles in length. This is an achievement comparable to other, better-known, great building projects of the ancient world, demanding a sustained investment of human labour and organizational skill and the cultural will to sustain the effort over many centuries.[3] The Great

47 Adena artist

'The Berlin Tablet'
Early Woodland Period,
500 BCE–1 CE

48 Adena artist

Human effigy pipe,
Early Woodland Period,
500 BCE–1 CE

Lakes copper, Missouri lead ore, and the special kinds of stones imported from all over the Southeast that have been found at Poverty Point also testify to the beginnings of a taste for exotic goods that would become a constant feature of Woodlands cultures for 2,500 years. Its builders left tiny, finely carved stone beads and pendants depicting owls, falcons and humans that evince new traditions of effigy carving.

The Archaic was followed by the long Woodland Period (300 BCE–1000 CE, and usually subdivided into Early, Middle and Late Periods), which produced some of the most dynamic political and artistic developments of Native American history. Pottery became established during this era and Early Woodland cultures also produced large-scale embankments, burial mounds, and fine works of art. The Adena culture (1100 BCE to 200 CE) is known from its principal site in Southern Ohio as well as from about 500 other related sites in the Central Woodlands. Adena people are known for a variety of types of art, for example a series of stone tablets (about thirty-five are extant) that may have been used as stamps for textiles or wall decoration [47]. From the Adena site also comes a large stone pipe carved as the effigy of a man wearing ear spools and other refined elements of dress similar to a Mesoamerican type [48]. In these two examples of Adena art can be seen aesthetic approaches that remained fundamental to Woodlands art for nearly 2,000 years. The figure–ground relationships on many of the tablets produce an optical oscillation similar to that experienced when viewing historic-period ribbonwork appliqué [63]. The rounded, organic forms and relatively naturalistic approach to representation of the Adena pipe are equally suggestive of historic-period pipe effigies and other carvings.

During the Early Woodland Period there was also a new focus on mound building dedicated specifically to highly elaborate burials. These developments, though widespread throughout the East, reached a particular intensity in the central Ohio River Valley between about 1–350 CE at the Middle Woodland Period sites of the Hopewell culture. Hopewell mound complexes are marked by a geometric precision of design and construction. In them, Hopewell people placed an unprecedented quantity of offerings of luxury goods and works of art whose artistic quality still impresses and moves the modern viewer. Hopewell artists cut sheets of mica and copper imported from the Appalachian Mountains and Lake Superior into plaques shaped as birds, animals, and the human figure, head and hand [49]. They engraved ceramic pots and bones with intricate curvilinear drawings of humans and animals which are directly related to those on the Adena tablets, and they carved wonderfully lifelike stone platform pipes in the shapes of birds, frogs, beavers, and other animals [50]. They placed in graves elaborate breastplates and animal effigy head-dresses of beaten

49 Hopewell artist

Mica ornament in the shape of a hand, Middle Woodland Period, 200 BCE–400 CE, Mound 25 Hopewell site, Ron County, Ohio (sheet mica), Ohio Hopewell Culture

This famous example of the economy and elegance of form achieved by Hopewell artists was placed in an élite grave together with many other gifts, including other mica effigies, shell and river pearl ornaments, and objects of copper, stone and bone. The holes that perforate the palm suggest it was worn as a pendant. The hand motif may have represented both an ancestral relic and a symbol of the potency and creativity of the empowered human being.

copper, and they piled up treasures of shell and copper jewellery. All this and more was offered only to the deceased of the élite, implying a hierarchical social structure that contrasts with the Archaic Period. Silverberg has written eloquently of the 'stunning vigor' of Ohio Hopewell: 'To envelop a corpse from head to feet in pearls, to weigh it down in many pounds of copper, to surround it with masterpieces of sculpture and pottery, and then to bury everything under tons of earth—this betokens a kind of cultural energy that numbs and awes those who follow after.'[4]

Ohio Hopewell were not an isolated people; rather they participated in a network of exchange—called the 'Hopewell interaction sphere'—which stretched from Ontario to Florida. The desire for exotic luxury goods, such as Great Lakes copper, Gulf Coast shell, Rocky Mountain grizzly bear teeth, obsidian from what is now Yellowstone Park, Florida alligator and shark teeth, and Appalachian mica found in the burial sites of the participants in this exchange network, can be compared to the late medieval spice trade that drove European merchants to push beyond the Mediterranean, around Africa and across the Atlantic. Although each Middle Woodland Period culture was distinctive, the desire for trade goods across the East during the first four centuries CE ensured the transmission of similar artistic concepts and cultural inventions throughout the region.

Activity at the great Hopewellian mound complexes tailed off rather suddenly after about 350 CE, and by 500 CE they had been deserted completely. The phenomenon of sudden abandonment after

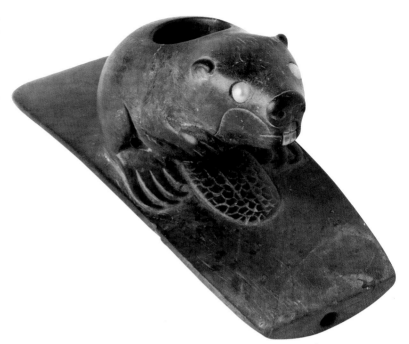

centuries of cultural activity is a familiar pattern in the pre-contact
Americas, one that scholars usually attribute to the exhaustion of crit-
ical resources through human overuse, often exacerbated by climate
changes. Narratives of 'abandonment' and 'disappearance' are decept-
ive, however, when they imply that the peoples and their belief systems
simply vanished without a trace. Although earthwork building ceased,
the makers and their intellectual cultures survived in new locations.
The cosmological principles and spiritual beliefs of the Woodlands
Period continue to inform later cultures; the traces of Hopewell are
everywhere to be seen in the historical arts and cultures of the East.

Woodland Period world-view is revealed not only in burial prac-
tices, but also in its visual iconography. Both pre- and post-contact
Eastern cultures attribute primary cosmic power to sky beings imag-
ined as predatory, raptorial (falcon or eagle-like) birds, and to horned,
long-tailed earth and water beings that combine panther-like and am-
phibian traits. Such a being, with two pairs of curved horns, a reptilian
skin, a panther's body and a long tail, was represented by a Hopewell
sculptor almost 1,500 years ago;[5] and an almost identical supernatural
was represented in a rock painting made around the time of contact,
and by female weavers and embroiderers only 200 years ago [**51** and
66]. Many other artistic conventions found in historic Woodlands and
Plains art are also found in Hopewell-related works, such as the repre-
sentation of a bear by its clawed paw print or a raptorial bird by its
taloned claw. The cosmological symbols of the circle and the cross of
the four directions are found both in the large-scale geometries of the
mounds and the designs of individual ornaments.

Some archaeologists now speculate that, on occasion, mound build-ing might also have been a response to observations of the heavens. For many years the most famous single earthwork of the Hopewell phase was thought to be the Serpent Mound at Locust Grove, Ohio, but a new carbon date of 1070 CE has raised the possibility that this great earthwork actually belonged to the next great era of Woodlands his-tory, the Mississippian Period which began about 900 CE. The Serpent Mound is anomalous both in form and in function. It contains no burials, and is designed as an oval enclosure (the 'head') and a long twisting, sinuous embankment which are together nearly a quarter of a mile long. One archaeologist, noticing that the new dates coincided with two dramatic mid-eleventh-century astronomical events—the light effects from the supernova produced by the Crab nebula in 1054 CE and the sighting of Halley's comet in 1066—has speculated that the 'Serpent Mound' may actually reflect an image of the comet.[6]

Eastern Woodlands people probably first began to cultivate indi-genous plants during the Late Archaic Period (3000–1000 BCE), but they remained relatively unimportant to subsistence until the Middle and Late Woodland Periods. The economic basis of social life became the intensive cultivation of corn, originally domesticated in Mexico, which permitted population growth and density capable of supporting some of the most ambitious building projects ever undertaken in the Americas. In the centuries before the arrival of Europeans the rich agricultural lands of the Mississippi Valley may have supported as many as four million people and the eastern seaboard and adjacent areas, two million.[7]

Mississippian art and culture

Building on the conceptual legacy of the Archaic and Woodland era peoples, and stimulated by renewed contacts with Mesoamerica, the Mississippians carried mound building, ceremonialism and creativity

in the visual arts to new levels. During the Mississippian Period the centres of power and influence in Eastern North America shifted southwards. Major Mississippian towns include Cahokia, Illinois (near modern-day St Louis), Spiro, Oklahoma (on the Arkansas River in northeastern Oklahoma), Etowah, Georgia (near modern Atlanta), and Moundville (in northern Alabama). Each was a ceremonial centre for a large area of surrounding countryside whose inhabitants paid tribute to a ruling class. The concentrated wealth of the élite was directly expressed in its art and architecture. The major Mississippian sites are typically located at strategic points at the confluence of rivers or on the boundaries between two eco-zones. Here people could exploit the rich soil of the flood plains at the same time as they controlled trade between regions possessing different kinds of resources. Such sites had to be defensible and most were surrounded by high stockades. The importance of warfare and warrior cults, clearly evident in the arts of the era, is a distinguishing feature of the Mississippian Period.

Many features of Mississippian art and architecture are clearly derived from Woodland Period cultures, such as the shapes of many of the mounds, the use of conch shell and copper as important artistic media and the wearing of ear spools and other forms of body decoration. Like their predecessors, too, the world-view of the Mississippians was structured according to a three-tiered universe inhabited by powers specific to the realms of below-earth, earth, and sky. This structure expressed itself visually in the continuing prominence of images of raptorial birds and great serpentine monsters in Mississippian art.

But new conceptual and artistic ideas—many recognizably of Mesoamerican origin—amplify and reconfigure these elements. Politically, socially and spiritually, these include more centralized structures of authority in which classes of rulers and priests acted as intermediaries to the spirit world for the common people. There is much evidence that the Mississippians regarded the sun as a representative of the ultimate spiritual power from which both political authority and sustenance flowed. The chiefdom of the Natchez, a Mississippian people that survived into the contact period (though reduced in size and power and altered by the adoption of refugees from other depopulated Mississippian chiefdoms), was described in some detail by late seventeenth-century European missionaries and explorers. The Natchez were divided into distinct social classes, the highest of which were the 'Suns'. The ruler was called the Great Sun and was regarded as a god. On ceremonial occasions his subjects carried him to avoid the contamination of contact with the earth, a ritual avoidance that explains the meaning of the litters found at many Mississippian sites and that also suggests comparison with systems of divine kingship in Mesoamerica, Europe, Africa, and Asia.

It is probable that the Mississippians expressed their beliefs in the

Cahokia

Some Mississippian mound sites, like Spiro, were primarily ceremonial centres serving a number of satellite towns. The mounds at such sites typically contained great numbers of burials of prominent people. Others, like Cahokia (near East St Louis, Illinois) [52], were residential metropolises; its mounds and plazas served for the staging of public ceremonials and contain few burials. With an estimated population of 20,000 and an area of six square miles, Cahokia was, at its height, the largest city in Native North America. It originally contained over 120 mounds, the biggest of which, Monk's Mound, measures 1080 by 710 feet at its base and rises to a height of 100 feet. Over a period of three centuries, twenty-two million cubic feet of earth were deposited to build the largest earthen mound ever constructed in the Americas and perhaps in the world.

At Cahokia (as at earlier Woodlands sites) the great mounds and other specially built structures may have been used to make astronomical observations that helped to determine the agricultural calendar. (Monk's Mound is aligned with the position of the sun at the equinoxes.) The mounds and large plazas were also used to stage great public ceremonials similar to the post-contact Green Corn Ceremony. The plazas would also have been the settings for ritual ball games played by elaborately costumed teams of high-ranking men, and for the gathering of great crowds at important times of festival. Cahokia thrived for four centuries before it was abandoned just before 1500. Its decline may have been brought about by a similar combination of resource exhaustion and climatic change that may have led to the abandonment of the earlier Middle Woodland Period mounds.

52

Cahokia, 900–1200 CE, Mississippian culture

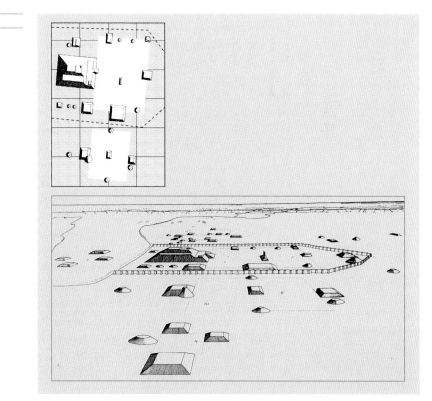

sun and its powers through annual ritual celebrations, as have their direct descendants in historic times. For historic-period Southeastern peoples the Green Corn Ceremony (*boskita* or the 'busk' in modern Muscogulge[8] languages and English), has been the culminating rite of the yearly calendar. Occurring at the full moon in July or August, it is both a thanksgiving for the harvest and a rite of renewal. Its central event is the extinguishing of the central fire of the chiefdom, conceived as kindled directly from the sun, and of all the other individual town and household fires. These fires burn at the centre point of a cross formed of four logs laid at right angles to each other—a living embodiment of the cross and sun-circle motif that is so common in Mississippian art. The extinguishing of the fires is followed by days of ritual preparation, including the drinking of the purifying 'black drink', which sixteenth-century French artists depicted as having been drunk from conch shell cups. At the end of this period, new fires are lit from embers carried from the chiefdom's central fire, and the green corn is roasted as a symbol of renewal and new life—a ritual guarantee, too, of the continuing power of the sun.

In structure and concept the Green Corn Ceremony had close parallels and perhaps precedents in Mesoamerica. The sun imagery central to Mississippian iconography is also a feature of coeval Mexican peoples, notably the Aztecs. Other images, such as the feathered serpent (resembling the Aztec Quetzalcoatl), and the long-nosed 'gods' carved on Mississippian ear spools and other objects, also suggest the commonalities of Southeastern and Mesoamerican cultures. Most strikingly, however, the principal mounds built by the Mississippians are flat-topped and slope-sided—Mexican in all but their lack of stone cladding. In both regions, temples, mortuaries, and houses for important people were built on top of the mounds. They were constructed of wattle and daub and roofed with thatch like the houses of historic Southeastern peoples such as the Creeks and Seminoles. Despite all these evidences of contact, no Mexican objects have been found at Mississippian sites (or vice versa). Exchanges between the two regions probably occurred through trade, possibly conducted by aristocratic merchants like the Aztec *pochteca*—men well-enough versed in matters of political power, warfare and ritual to have been effective transmitters not only of goods, but also of ideology.

Like Hopewell and other Middle Woodlands communities, Mississippian chiefdoms were linked by a network of trade and cultural exchange that promoted the diffusion of similar art forms and images over a wide area. Although Mississippian sites display considerable diversity, the arts found across the Southeast have so many common iconographic features that they have all been associated with a shared religious and political ideology referred to in the literature as the 'Southeastern Ceremonial Complex' or, more misleadingly, the

Copper breastplate from Lake Jackson site, Safety Harbor Culture, Florida

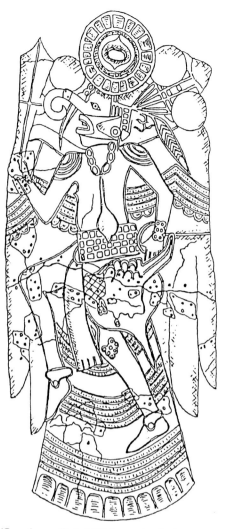

'Southern Cult'. This art includes an elaborate iconographic tradition engraved on shell gorgets (large disc-shaped neck pendants), ceremonial conch shell drinking cups,[9] embossed copper plaques, and other objects that together reveal much about Mississippian beliefs and ritual practices. Some figures hold distinctively shaped maces or sceptres as emblems of power, faithful representations of stone and copper maces found at Mississippian sites [**53**]. Others show cosmological maps—such as suns surrounding four-directional crosses—references to divine ancestors—such as hands with eyes inscribed in the centre—or men lavishly costumed with elaborate head-dresses, aprons and ornaments.

A ritual–artistic balancing of forces attributed to the upper world—represented by images of the sun, sacred fire, thunderers, and the falcon—and the underworld—represented by water, the cougar and the rattlesnake—informs this iconographic language. Human beings

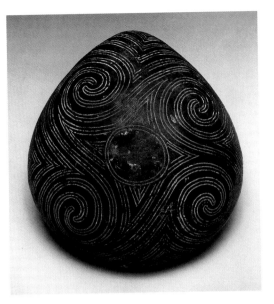

54 Mississippian artist

Marine-shell effigy bowl
(terracotta), 1350–1500 CE,
Fort Walton culture, Florida

Key elements of the graphic
notation with which Missis-
sippian and other Woodlands
cultures have for millennia
expressed fundamental
cosmological beliefs are
combined on this bowl: the
central circular form of the
world and the sun, the four
points of the cardinal
directions, and the four,
activating, spiralling lines that
may indicate winds, seasons,
or the spinning motion of the
cosmos as a whole.

55 Mississippian artist

'Big Boy' effigy pipe (bauxite),
1200–1350 CE, Spiro site,
Leffore County, Oklahoma

This figure, which probably
represents a Caddoan chief,
comes from a workshop
located in Southeastern
Illinois and was made over a
century before being buried
at Spiro (Oklahoma) with the
body of a deceased member
of the élite. The figure is
shown in a trance state and
wears a copper head-dress,
ermine-skin cape, massive
shell-bead necklace, and ear
ornaments, illustrating how
objects found at Mississippian
sites would have been used
by living people.

intervene to entreat and manipulate the protective powers conferred by the beings of both upper and lower realms.[10] Within this imagistic complex is evidence of particular cults that seem to offer direct links to the later warrior societies of the Great Plains. James Brown has identified a widespread set of images showing men with distinctive forked eye-markings and feathered costumes with fragments of feather-patterned cloth found at Spiro. He has argued convincingly that these images represent a warrior dance of an important cult of falcon impersonators.[11] Related to these images are shell masks with lightning-like thunderbolt lines extending from the eyes that were the principal objects contained in sacred war bundles [72].

Another key element of Mississippian ritual practice (and of divine kingship systems in general) was the veneration of relics of high-ranking ancestors. Archaeological remains of mortuaries reveal that the bodies of the dead were prepared for burial in highly specific ways that may have involved the removal of body parts. A type of effigy pot particularly common at sites in Alabama takes the shape of a human head with closed eyes, and often displays tattoo markings or other sacred symbols. These head effigy pots are now thought to represent relics of honoured leaders or ancestors. The most common form of decoration on the fine pottery produced by the Mississippians was the spiral, a motif whose symbolic meanings may be related to the circular and cyclical concepts of time and sacred and ritual movement held by historic Woodlands peoples [54].

Among the greatest of all Mississippian works are sculptural renderings of human beings in pottery and stone. Pottery made for ritual purposes took a multitude of shapes including shallow bowls, high-necked vases, and effigy pots made in the forms of animals and

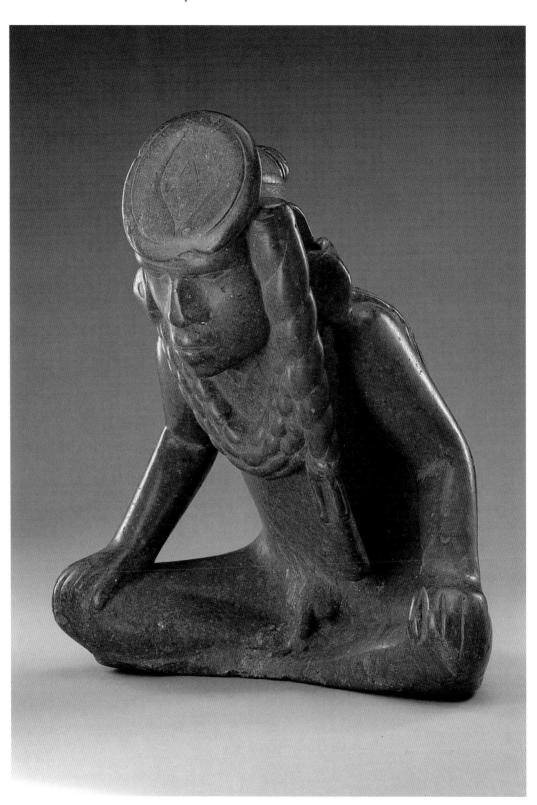

humans. A sixteenth-century painting made in the Virginia colony by John White (active 1585–93) shows a mortuary house with the dead prepared for burial. Presiding over this scene is a statue, probably of an ancestor, which resembles those found at some Mississippian sites. A number of large effigy pipes also take figural form, and represent seated men—elaborately dressed as befitted persons of high rank—in trance postures or engaged in playing chunkey, a game still played in historic times that may have been used by the Mississippians for divination [55]. The Mississippian artists who made these sculptures captured with immediacy and naturalness the expressive quality of the human figure at the moment of intense inner concentration that precedes action, an artistic problem that has challenged sculptors worldwide (and that lies at the heart of Michelangelo's (1475–1564) almost con-temporaneous 'David').

The cataclysm of contact: the Southeast

The Mississippian chiefdoms maintained their power and dynamism for about five centuries, into the period of the European invasion of North America. Like Cahokia, however, the major sites were probably abandoned shortly before Europeans arrived, perhaps because they could no longer support previous population densities. We stress again that in the Southeast, as in the Southwest around the same time, the people who abandoned the great centres did not vanish but moved elsewhere. At the turn of the twentieth century there were still, for ex-ample, a few speakers of the Natchez language living among the Cherokee, who had absorbed their eighteenth-century forebears.[12]

The diseases, religions and economic systems introduced by Europeans were far more serious threats to the survival of pre-contact Native cultures and languages than the re-adjustments and relocations caused by environmental changes had been. The cataclysm of contact began almost a century earlier in the Southeast than the Northeast. The DeSoto expedition, one of the first and most extensive, travelled through the Southeast from Northern Florida to the Mississippi River in search of gold between 1539 and 1543. Its members observed a num-ber of thriving later-Mississippian chiefdoms, engaged in violent battle with some of them, and everywhere introduced the germs that were the cause of the ultimate destruction of the Native polities. Over the next century and a half, the Aboriginal population of the Southeast was reduced, according to some estimates, by nearly 80 per cent. Historians, searching for a word that can even begin to capture the magnitude of this disaster, have rightly termed it a holocaust, though one that was, at its inception, unintended. It is impossible to trace the history of art in the East without stopping to try to conceive of the effects of such a loss. The survivors, pressed from every side, their numbers reduced beyond their ability to maintain their former social

56 Choctaw artist

Beaded sash (stroud cloth, beads), before 1812, Mississippi

The spiral or scroll designs common on Mississippian pottery continued into the historic period. This sash also evidences the love of red stroud among eastern peoples and the use of white-glass beads as an analogue for white shell. The five-pointed stars, derived from the United States flag, probably translate older iconographic references to cosmic bodies into a new visual system.

57 Clara Darten (dates unknown), Chitimacha

Nested covered baskets (woodsplints, dye), 1904

The active collecting culture that existed for Native American basketry around the turn of the century provided the context within which Chitimacha in Mississippi promoted basketry traditions whose motifs and forms undoubtedly have roots in the pre-contact Southeast. This nested set, made for the 1904 St Louis Exposition, called forth a virtuoso display of technical weaving skills and artistic design.

and ceremonial institutions, formed new alliances and recombined into new peoples, blending formerly localized cultural and artistic traditions. The historic-period Creeks, Muscogulges, Chickasaws, and Choctaws are confederations of remnant Mississippian peoples. Many memories of Mississippian heritage are preserved in the oral traditions and visual designs of these peoples, and the great mounds often remained the sites of ritual observance [**56, 57**]. In the Choctaw creation story, for example, the Nanih Waiya mound (in the present state of Mississippi) is identified with the Great Mother and source of life, and remains the site of the modern Green Corn Ceremony. During the historic period, furthermore, intermarriages with whites and African-Americans further contributed to cultural and artistic traditions. Eighteenth-century Creeks and Muscogulges kept Indian and black slaves whom they sometimes adopted into their families. During the early nineteenth century, when some of these peoples fled to Spanish Florida to escape the forced removals imposed by the American Government, they again mixed with African-American slaves seeking freedom. Not only Euro-American patchwork but also African-American cloth appliqué traditions may have contributed to the

58 Florence I. Randall

Photo of Seminole Women at
Musa Isle Indian Village,
Florida, 1930

After World War II the visual
display offered by the colour-
ful patchwork clothing worn by
the Seminole and Miccosukee
drew tourists to their 'exhib-
ition villages' and provided
welcome opportunities for
economic development.
Visitors watched women, their
sewing machines whirring in
their open-walled sewing
chickees, create intricate
geometric designs formed of
tiny squares, rectangles, and
triangles of cotton cloth,
steadily introducing over the
years new patterns and new
clothing fashions.

Seminole Belles Musa Isle Indian Village

distinctive patchwork invented by the Seminole and Miccosukee after
they moved to Florida [**58**]. The emergence of this brightly hued tex-
tile tradition and of the equally distinctive styles of men's 'big shirts'
and women's skirts and capes around the time of World War I displays
particularly clearly the creative hybridity that has been a part of many
Native American clothing traditions. As Dorothy Downs has shown,
two centuries of exchanges between the antecedents of the Miccosukee
and Seminole and Scottish and English settlers in Georgia and
Alabama lie behind the more recent textile tradition.[13] Patchwork, pre-
viously stitched by hand, was made technically more viable by the in-
troduction of sewing machines and was economically stimulated by
the growth of tourism to the Everglades during the twentieth century.
Out of these circumstances came a new art form that has assumed a life
of its own and that continues to develop today.

The early contact period in the Northeast

Although the first contacts between Europeans and Northeastern
Native peoples occurred at the beginning of the sixteenth century, such
contacts did not become sustained until the early seventeenth century,
when the French, English, Dutch, and Swedish established colonies
on the Atlantic coast and the lower St Lawrence River. The focus of
the Europeans was soon fixed on the fur trade, especially the beaver
skins used to make felt for men's hats. The effects of European pres-
ence and of the new trade networks were soon felt far into the interior
by people who had not yet experienced contact directly. As in the
Southeast, these effects included devastating epidemics that affected
the entire region and the rapid destruction of coastal communities ex-
posed to the greed for land and the violence of the colonists. Although
Jesuit missionaries penetrated the Great Lakes and Mississippi,

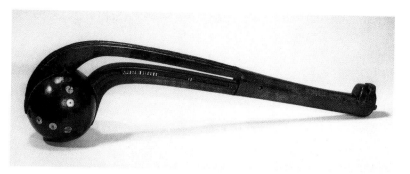

Ball-headed club (wood, shell beads and bone (?) inlay), seventeenth or early eighteenth century, Eastern Great Lakes

The shell disk beads inlaid in this club are of a type found in contact-period North-eastern graves. Their spiritual symbolism combined with the effigy of a spirit bear carved on the end of the handle suggests that the club may have been used in ceremonial display. It has been tentatively identified by Jonathan King with one listed in Sir Hans Sloane's early eighteenth-century catalogue, as 'A Tamarhack or Indian *mace* or *clubb* used by them to knock one another on the head in their wars'.

initially they had relatively little effect on the patterns of belief and ways of life of which they left such valuable descriptions. In the interior, on the periphery of the contact zone, the first half century of contact was, generally, a period during which the influx of exotic goods was assimilated to existing belief systems, enriching rather than altering artistic and ceremonial life.

A Neutral Indian cemetery dated to 1640–50 at Grimsby, Ontario, in the Niagara Peninsula, affords a glimpse of the initial integration of European trade goods into Eastern Great Lakes visual culture. In keeping with widespread Northeastern practice the Neutral periodically celebrated a 'Feast of the Dead', a ritualized sequence of ceremonies in which the recent dead were disinterred, reburied in common graves and lavished with gifts to take into the next world. The inventory of gifts found in the Grimsby cemetery is highly suggestive. It includes clay and stone pipes whose bowls bear effigies of birds and animals (the accurate representation of a macaw on one pipe testifies to the continuing impact of Mexico); antler combs with handles carved in low-relief with 'cut-out' images of bears and other animals; whole conch shells and shell gorgets imported from the Gulf of Mexico; cylindrical red catlinite beads from Minnesota; a wealth of Great Lakes copper formed into sheets, beads, coils of wire, and a rattle; pottery, some containing remnants of food; beaver skins and woven cedar bark mats (only fragments of which survive); turtle-shell rattles; numerous trade brass kettles; a great array of imported multi-coloured glass beads; and a wampum belt made of tubular white-glass trade beads. The list testifies equally to the continuation of the ancient trade with the South and West and to the new vectors of trade directed at Montreal and the Atlantic Coast.

The persistence, after a thousand years, of the same symbolic language of materials—red stone, white shell, shiny metal—that characterizes Adena and Hopewell burials is particularly striking [**59**].[14] George Hamell has termed the early contact-period commerce between Indians and Europeans a 'trade in metaphors', motivated on the Native side not—as the Europeans believed—by an economic rationale similar to their own, but by an indigenous system of value based

on the symbolic and spiritual qualities attached to certain classes of materials. He uses numerous travellers' reports to show that, during the first phase of contact, Native peoples classified the European invaders together with their traditional under(water)world beings from whom humans acquire gifts of crystals, copper, and shell—all medicine substances with life-giving, healing properties. Many of the gifts offered by Europeans—mirrors, glass beads, trade silver, and metals—have similar physical properties of whiteness, brightness, reflectiveness, and transparency. In the pre- and early contact-period Woodlands, the aesthetic qualities of these materials thus carried strong moral associations of self-knowledge, introspection, and understanding. Hamell's argument that glass beads first 'entered Native thought' as analogues of crystal not only explains why the most common burial offerings found in seventeenth-century graves are glass beads and white-shell wampum beads, but also helps to explain why glass beads have remained a privileged artistic medium among the interrelated peoples of the Woodlands, Plains, and Sub-arctic. Native artists, of course, quickly understood that glass beads were European manufactures and not supernatural gifts, but their initial manner of integration into Native visual cultures undoubtedly carried over ancient and enduring concepts and aesthetic values to the new medium.

Arts of the middle ground

The historian Richard White, building on Hamell's thesis, argues that the need to acquire suitable ceremonial gifts was the most important motivation for the Native trade with Europeans during the seventeenth century.[15] One of the major gift-giving obligations was, as we have seen, to the dead, and the Feast of the Dead emerges as one of the most important stimuli for the production of art during the early contact period. Although only the durable components of these gifts survive in archaeological contexts—shell, stone, pottery, and glass—we know from the descriptions in early European texts that the prepared gifts would also have engaged the skills of the hide tanner and painter, the embroiderer in porcupine quills and moosehair, the weaver, and the wood carver. The enormous quantities of gifts needed required the investment of a great deal of cultural energy, not only in the prosecution of trade but also in artistic production.

The dead could make no exchange for these gifts, but among the living exchanges of gifts were, as ethnohistorians have stressed, a vital means of resolving conflicts and furthering social cohesion. During the seventeenth century, warfare increased dramatically among Great Lakes peoples as a result of the pressures the colonists exerted on Native peoples to move west and because of competition among Native nations for control of European trade. The Neutral, again, exemplify a widespread pattern. They, like their neighbours the

Huron, were attacked, defeated, and dispersed by the Iroquois confederacy in the middle of the seventeenth century. As already noted, in numerous cases such historical episodes, though violent and bloody, can be understood as leading not so much to total 'extinction' as to the radical recombination of cultural groups. Individual captives were adopted into existing communities to replace family members who had been lost to disease or warfare. In some cases whole groups were taken in: 500 Hurons, for example, joined the Seneca after the Iroquois attacks of 1648–9. In many other cases groups of refugees fled west and formed new villages with refugees from other nations in the central Great Lakes. Huron and other Iroquoians from the eastern Great Lakes mingled, for example, with Odawa (Ottawa), Ojibwa, and Potawatomi. All three are speakers of closely related Algonkian languages and today refer to themselves collectively as Anishnabe.

What must have happened to local stylistic traditions during this century or more of chaos and cultural mixing? Indigenous practices that provided a mechanism for the integration of captives through adoption must have had a considerable impact on artistic traditions during this era when disease and warfare had so depleted populations that adoptions were particularly important in the restoration of communities. In the East, captives assumed the names of deceased family members, intermarried and became full members of the adopting community. This point is worth developing further because it illuminates the very different concepts of race and nationality held by Native peoples from those inscribed under colonialism. Nineteenth-century Western notions are, in contrast, essentialist, holding race and national identity to be an irreducible and unchangeable core of which cultural traits, like art styles, are expressions. Such notions of the link between ethnicity or nationality and art continue to inform the practice of Native art history.

For the East, as for other regions of North America, a primary goal of both material culture and art-historical studies has been the identification of a set of discrete tribal styles. The small but precious corpus of objects that has survived from the seventeenth and eighteenth centuries, mainly in European curiosity cabinets, has, however, resisted precise attribution. It has proved almost impossible to identify with certainty a pair of porcupine-quill embroidered moccasins or a moosehair-embroidered belt as Seneca rather than Mohawk, or even as Iroquois rather than Odawa or Potawatomi. Even in the rare cases where we know the provenance of an object we can almost never be sure whether it was made by a member of the group living there, whether it was acquired in a gift exchange from another community, or whether it was made by an adopted person trained in the art traditions of a quite different locale.[16] It is time, perhaps, to recognize that the clarity we seek eludes us for good reasons. On the one hand it is

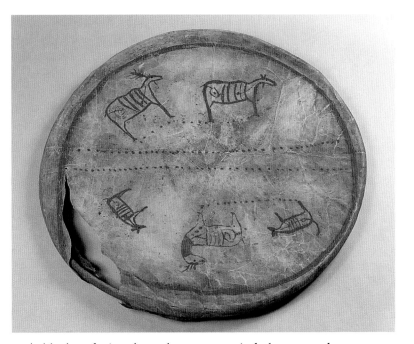

probable that, during the early contact period, the tremendous amount of long-distance travel, mixing and recombination of cultural groups in which Eastern peoples were engaged led to an unprecedented era of hybridity. It is also probable that narrow stylistic distinctions had little meaning for the makers themselves. The importance of this point is all the greater because early contact-period objects have been regarded as benchmarks of authenticity in Eastern Native American art. In contrast, the objects produced during the nineteenth and twentieth centuries, when confinement to reserves does seem to result in the development of more clearly definable local styles, have been regarded as less authentically 'Indian' because of the greater European and North American influence they display. As White has noted of the larger scholarly project of which this typological effort has been a part, 'the accounts of early ethnologists who studied these tribes and codified them are full of internal contradictions because they sought to freeze and codify what was, in fact, a world in flux'.[17]

In this 'world in flux', furthermore, ancient practices of gift exchange became even more important, as did visual forms associated with peace making and diplomacy. White's concept of the seventeenth- and eighteenth-century Great Lakes as a 'middle ground' of intra-Indian and Indian–European negotiation is very important to the understanding of the visual forms associated with three ritual complexes: the *Midewiwin*, or Grand Medicine Society, of the Great Lakes peoples, the calumet ceremony and wampum exchange.

The *Midewiwin* is a society of shamans dedicated to the prolongation of life and the accomplishment of a safe journey to the after world.

During the early contact period, when epidemic diseases so threatened the survival of Native communities, the powers of its members, like those of the Iroquois Society of Faces (or False Face Society), were probably employed even more than in previous times for healing and the prevention of disease. Although the basic practices and beliefs of the *Midewiwin* are ancient, the elaboration of its organizational structure, its spread and a number of innovative visual forms appear to be phenomena of the seventeenth century. Prominent among the latter are long, rolled birchbark scrolls incised with figures of animals and anthropomorphic beings, often drawn with an elegant economy of line. *Midewiwin* members use these scrolls as mnemonic aids that codify the Society's oral traditions and ritual procedures. A similar graphic language is seen in rock painting and on drums, wooden song boards and other Anishnabe ritual objects [**51**, **60**]. In the twentieth century, Anishnabe artists have returned to the visual tradition of the scrolls and rock paintings as a means of recording and reinterpreting oral traditions and principles of indigenous spirituality.

While *Midewiwin* rituals are directed primarily at the spiritual realm, those of the calumet and of wampum are intended to promote harmony among human communities. The calumet ceremony, which originated among the Plains Pawnee and spread as far east as the Iroquois during the seventeenth century, was a highly effective means for making peace among warring groups. It gives physical form to the fundamental cosmological principles of complementarity and unity. The finely carved stone bowl, usually made of red catlinite, symbolizes the earth with its feminine regenerative powers, while the long stem, decorated with porcupine quills, paint, eagle feathers and other materials, symbolizes the male energizing powers of the sky world.

Like the calumet ceremony, the use of wampum was also developed and disseminated throughout the Woodlands during the seventeenth and eighteenth centuries as a strategy for imposing political order. Because of the ancient significations of enlightenment, healing, and peace carried by white shell, the exchange of strings and woven belts made of this material invoked spiritual empowerment and blessing for agreements made among humans. Exchanges of wampum were therefore regarded as legal transactions confirming that agreements had been made and accepted by all parties. In the traditional narration of the formation of the Iroquois Confederacy, an event that probably occurred (according to Western time-keeping) during the second half of the fifteenth century, the introduction of wampum is a critical event. Wampum was introduced when the Creator dried up a lake, revealing white-shell beads on its bed, in order to condole Ayonhwatha (Hiawatha) after the deaths of his children. Only after Ayonhwatha made the shells into strings of beads to symbolize and externalize his grief was he able to join the Peacemaker, Deganawidah, in reconciling

Deerskin robe (hide, margin-
ella shell), before 1638

This famous robe entered
the curiosity collection
assembled by the royal
gardener and botanist John
Tradescant through the
agency of British colonists
at Jamestown, Virginia. It
may come from the temple
treasure of the great chief
Powhattan, father of
Pocahontas. Its central
image of a human figure
flanked by two animals is
widespread in the East, as is
the use of shining white shell
as a spiritually empowered
ritual-artistic medium.

the warring Iroquois nations. Deganawidah later used Ayonhwatha's
wampum in an important ritual of renewal.

The patterns of white and purple beads on wampum strings and the
abstract and pictographic designs woven into belts are mnemonic de-
vices whose meanings are precisely remembered by designated wam-
pum keepers [12]. The display of a wampum and the recitation of its
history are intended to remind the parties of the agreement that they or
their ancestors made. Native people have continued to use wampums in
this way; in the twentieth century they have been presented in courts of
law and their meanings recalled in speeches in support of land claims
and cultural agreements. Although many of the verbal texts that give
wampums their legal force were lost during the assimilationist era of
the late nineteenth and early twentieth centuries, a work of recovery is
currently under way that has resulted in the repatriation of important
groups of belts from museums. The Circle Wampum, for example,
repatriated to the Six Nations Iroquois by the Canadian Museum of
Civilization, models the structure of the Iroquois Confederacy itself as
a circle of unity. The 50 strings that extend inwards represent the
Confederacy chiefs in the order in which they sit and speak in council.

Arts of self-adornment

It is remarkable how little the style of dress described by eighteenth-
century travellers varied from the Carolinas to the Ohio River to the
forts of the Great Lakes. The rich dress and body decoration of
Woodlands people impressed all the early European observers, who
left numerous descriptions and a number of somewhat less reliable
graphic depictions. It is clear from this evidence that, during the seven-
teenth and eighteenth centuries, the body was one of the most import-
ant spaces for visual artistic expression, as it continues to be today in
community celebrations and at the modern powwow across North
America [13]. The texts also make clear that elaborate dress was re-
served for ritual celebrations and for formal occasions such as visits to
foreign villages and forts. Assemblages of clothing and body decora-
tion were primary vehicles for the display of the powers an individual
acquired from guardian spirits through the vision quest, a rite that
began at puberty and was widely practised by men and women
throughout the Woodlands. The visual expression of these powers
took many artistic forms, ranging from elaborate tattoos and body
paintings to carved, embroidered, and painted depictions of guardian
spirits on clubs, pouches, and medicine bundle covers. Missionaries,
who deplored both 'nakedness' and 'pagan' images, attacked the prac-
tice of tattooing. By the end of the eighteenth century it had largely
disappeared because of these negative pressures and also due to the
inherent attractions of clothing made of luxurious trade cloth that
covered much more of the body. The use of face and body paint, how-

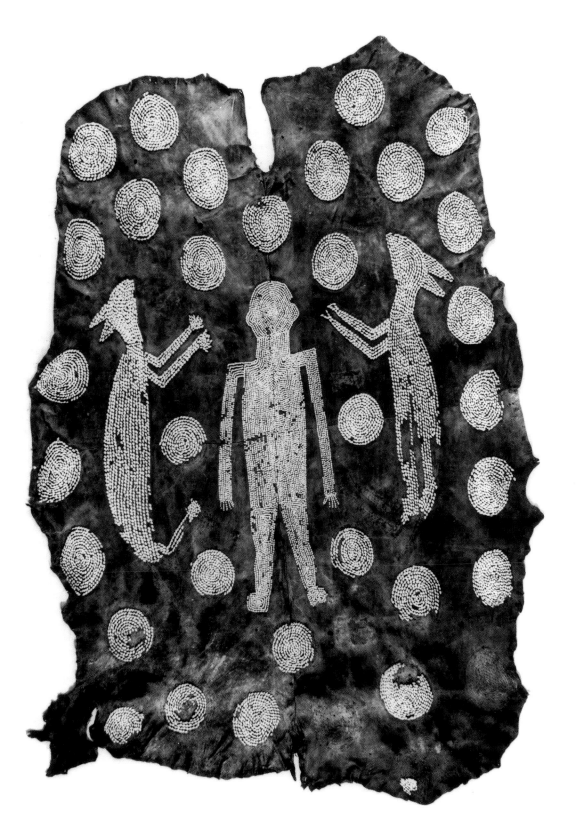

ever, remained important into the nineteenth century as an aspect of formal dress and continues as a key element of powwow dress. The hair, too, was the subject of careful grooming. In the East, most men shaved the head except for a long lock at the crown, while women allowed their hair to grow as long as possible and dressed it with beaded and quilled ornaments.

A man's garments consisted of tightly fitted woollen or hide leggings, a breech cloth, a blanket, and often a shirt made of printed calico. Women wore leggings and moccasins with, in the eastern Great Lakes, a knee-length, kilt-like skirt and cloth shirt. In the central and western Great Lakes women wore a dress cut like a chemise, held up by shoulder straps to which were added two sleeves with overlapping chest panels. The ornamentation of these and more recent garments has remained a fertile field for women's creative artistry since pre-contact times. Woodlands women tanned the deerskins of which most pre-contact clothing was made with consummate skill, achieving a velvet softness and colours ranging from light brown to near black. Modern evidence from the Plains and Sub-arctic shows that the choices of woods and lengths of time used in smoking hides are carefully calculated to produce particular colours and odours, and that these choices are dictated by aesthetic criteria.[18] At the time of contact, Eastern peoples ornamented their hide clothing with mineral pigments of black, white, and red, painting patterns of stripes and curvilinear designs that reminded some Europeans of lace. They embroidered the edges with dyed porcupine quills and, sometimes, with attachments of shell beads [61]. The vegetable dyes they developed for dyeing quills produced a brilliant scarlet that was the envy of Europeans, who regarded it as superior to their own [67].

Native people's long-established traditions of connoisseurship in textile textures and colours clearly lay behind their strong attraction to and highly selective appreciation of imported trade cloths. At the beginning of the eighteenth century, when red wool stroud from English mills became available, the Native demand for this cloth was so great that it threatened to redirect trade from French Montreal to British Albany, in New York. Red stroud, it is clear, was another 'analogue', appreciated both for its quality and because its colour resembled the ochre indigenous people had valued for millennia, and which had long been used as medicine and as paint.

The adoption of cloth gave rise to new techniques of ornamentation. Silk ribbon came to replace paint, and beads came to replace porcupine quills. In the earliest ribbonwork appliqué, broad ribbons are sewn to trade blankets rather crudely, to form stripes that imitated the painted patterns of hide robes. By the end of the eighteenth century Northeastern and Great Lakes women had invented a far more complex appliqué technique in which they cut and layered different-

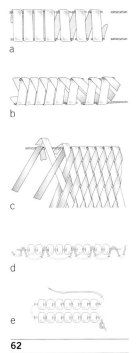

a

b

c

d

e

62

Techniques of porcupine
quillwork and beadwork

Porcupine quills seem an unlikely artistic medium, but Native American women devised an ingenious technology for working with them. Using a vast knowledge of dyeing, and numerous variants of wrapping, weaving, plaiting, and sewing, women formed quills into complexly patterned geometric and representational designs, and used them as ornamentation for all sorts of clothing and implements.[19]

The porcupine quill is a stiff, hollow tube, 2½–5″ in length. One good-sized porcupine can yield 30,000–40,000 quills. After plucking the quills and washing them, the artist sorts them according to size and dyes them in batches. To soften and make them flexible for use, she pulls the quills repeatedly through her teeth.

Dyes for quills are numerous, ranging from barks, roots, mosses, and minerals, to berries, nuts, and flower petals. In many regions, artists understood the need for mordants—a substance to set the colour and make it insoluble. When trade cloth became available, women sometimes boiled bits of cloth with quills in order to colour them. Once chemical dyes were available in the later nineteenth century, these were eagerly embraced. Late nineteenth-century women sometimes boiled quills with bits of trade blankets to produce dark blue or red.

Numerous methods were devised to attach quills to hides. The artist might spot-stitch the hide with long parallel rows of sinew thread and wrap the quills between the two threads (fig. a). Two quills might be used simultaneously to give a plaited appearance (fig. b), and if these were different colours, a striped effect would result. The quills could actually be plaited to produce a diamond-shaped woven effect (fig. c). Clever variations of folding and plaiting using colour variations would produce even more complex effects. Quills could be wrapped around a horsehair or plant-fibre rope and then coiled, giving an effect much like basketry. Today, quillwork is enjoying a renaissance among Great Plains and Great Lakes artists.

In the Great Lakes and Sub-arctic women also wove quills on a narrow bow loom and appliquéd these geometrically patterned strips on to bags and clothing.

When glass beads became available, they were quickly adapted to pre-existing quillwork techniques, and new techniques were also invented. Beads were woven on looms into even larger panels. Two equally common methods for covering large surfaces with beaded designs are the lazy stitch and the overlaid stitch (fig. d and e). Both techniques save the artist from having to stitch down each bead individually to the cloth or skin backing.

In the overlaid stitch, the beads are strung on a thread or sinew, and set down on the cloth or skin in the desired pattern. A stitch is taken between every two or three beads, affixing the string of beads to the backing. This works particularly well for floral or curvilinear patterns, for the outlines can be set down first, and smaller strings of beads set progressively within.

In the lazy stitch, used principally by Plains artists, the thread on which the beads are strung is sewn directly to the background. The thread is knotted to the fabric, about seven beads are strung on the thread, and then the thread pierces the fabric again. Another seven beads are strung on the thread, and it is laid parallel to the previous row. These rows are built up in bands. The subtle effect of banding introduces another element into the design, in addition to the bolder pattern made by the contrasting colours of the beads. The banding made by lazy stitch is reminiscent of the banding produced by some techniques of Plains quillwork [**62**].

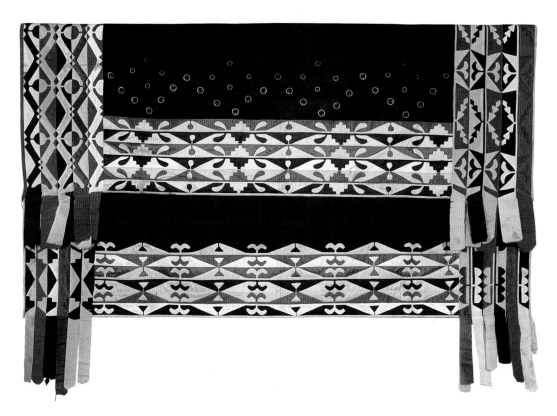

63 Mesquakie artist

Blanket with ribbon appliqué
(wool cloth, silk ribbon,
German silver brooches),
c.1880, Iowa

The Mesquakie brought
ribbonwork with them
when they moved from the
Great Lakes to Iowa in the
mid-nineteenth century.
Contemporary artists say that
the colours and organic forms
are spiritual and cosmological
references to night and the
plant world. Adeline Wanatee
has explained the design ideal
that is reached in this master-
piece: 'When two different
patterns join together to form
a third, we call that "art".'

coloured ribbons to produce dense, optically active patterns that form wide borders on leggings, skirts, and blankets [63]. Similarly, the early uses of glass beads evolved from a simple white-bead border that gives the effect of a simple porcupine-quilled edging stitch, to the more complicated appliquéd and woven beadwork that began to appear at the beginning of the nineteenth century. Despite the transformations of the materials used in Native clothing, however, the basic cut and disposition of garments changed very little until the first half of the nineteenth century.

A notable exception to this pattern of adaptation of trade goods is the hide moccasin. Although glass beads and ribbon soon formed part of its decoration, the superior comfort of Native hide and the beauty of indigenous cuts and designs for footwear have held their own against European shoes down to the present. Moccasins were one of the first forms of Native art to be commoditized for sale to non-Natives and re-main one of the largest categories of Native art in museum collections. The Sieur de Diereville reported in 1708, for example, that the Mi'kmaq were making a type of quill-decorated moccasin much ad-mired by the French who 'wish to procure them for display in their own Land'.[20] At the end of the same century the Irish traveller Isaac Weld described in detail the particular styles worn by men and women, 'tastefully ornamented with porcupine quills and beads'.[21]

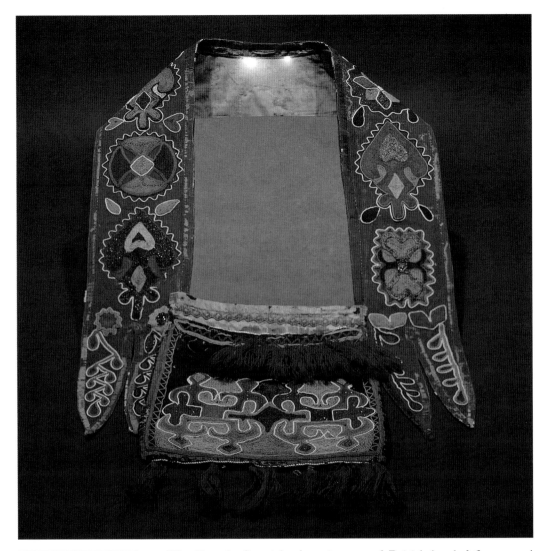

64 Delaware artist

Bandolier bag, c.1850–70

The bag was given to the
Philbrook Museum by the
grand-daughter of its owner,
Charles Journeycake
(1817–94), the last principal
hereditary chief of the Dela-
ware. The bold, free-form
blocks of colour are typical
of a beadwork style that dev-
eloped in the early nineteenth
century among the South-
eastern peoples with whom
the Delaware lived after their
forced removal from their
New Jersey homelands.

The French, Spanish, Americans, and British battled for control
over Eastern North America throughout the eighteenth and early
nineteenth centuries. Once the main struggles were resolved after the
War of 1812 the strategic need of the Europeans and Americans to
maintain alliances and diplomatic relations that recognized the sover-
eignty of Native nations ended, initiating a renewed period of radical
disruption to indigenous life in the East. The opening up of western
New York State and the central and eastern Great Lakes to white
settlement resulted in rapid and massive appropriations of Native land.
The Removals Policy adopted by the United States in 1830 forced most
Eastern Indians to leave their ancient homelands and to move thou-
sands of miles west to Indian Territories established in Kansas and
Oklahoma. In the Southeast, the Five Civilized Tribes (Cherokee,
Choctaw, Chickasaw, Creek, and Seminole), many of them peaceful

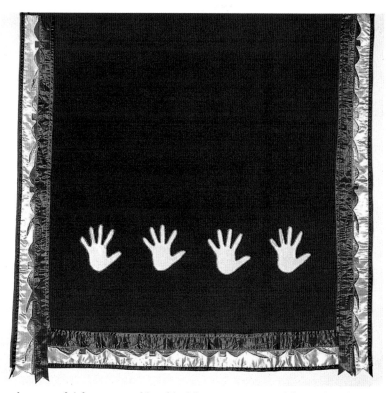

and successful farmers and land holders, were evicted from their homes and forced to make the long overland journey known as the Trail of Tears. The treaties negotiated by the British in Canada resulted in equivalent losses of lands and freedom and in confinement to reservations that rapidly became inadequate to support their Native populations. The removals, the losses of traditional subsistence bases, the greatly intensified contacts with non-Native people, and the renewed era of intense Christian missionization led within decades to far more radical changes than had occurred during the preceding two centuries. Even in Kansas and Oklahoma, however, visual arts still preserve much that was brought from the Eastern homelands [**64, 65**].

A history of bags

These changes can be traced in the design and iconography of bags, a large and important category of Woodlands artistry that has not yet been discussed. The oldest examples of eastern bags preserved in early European curiosity collections are made of whole animal skins or of hide cut into long rectangular pouches, both types worn folded over a belt. Painted on the body of the rectangular bags and woven into the netted quillwork panels attached along the bottom were intricate geometric motifs and images of important *manitos* (spirit beings) such as the Sun or the Thunderbird. Another type of bag that is certainly of pre-contact origin is the twined or finger-woven bag used to store

personal possessions and foods. Examples that display images of *mani-tos* or designs symbolizing their powers probably served as containers for medicine bundles [**66**].

During the eighteenth century Native artists invented a new type of square or rectangular bag attached to a bandolier strap copied from European military uniforms. Despite this innovative cut, however, eighteenth-century bandolier bags continued to display large central images of thunderbirds and underwater beings or abstract designs that probably also expressed the protective powers acquired from *manitos* during the vision quest [**67**]. In the contact zone of the Great Lakes, other styles of bags also circulated, cut in different ways and decorated with other techniques such as appliquéd bands of quillwork woven on narrow bow looms. During the second and third quarters of the nineteenth century, with lightning rapidity, Anishnabe women experimented with all these bag designs, weaving decorative bands of glass beads instead of quills, replacing hide with fabric, and dyed deer hair with wool yarn [**68**].

Their major innovation, however, was the introduction of an entirely new type of floral imagery borrowed from the art of the European and North American immigrants [**21**]. Evidence of the attraction floral designs had for Great Lakes Anishnabe is found in the memoir of an early Southern Ontario pioneer, Catherine Parr Traill, who wrote of the visits paid to her in the 1830s by Ojibwa women from the neighbouring Rice Lake community. One woman, Traill wrote, 'fell in love with a gay chintz dressing-gown belonging to my husband, and though I resolutely refused to part with it, all the [women] in the wigwam by turns came to look at the "gown".'[22]

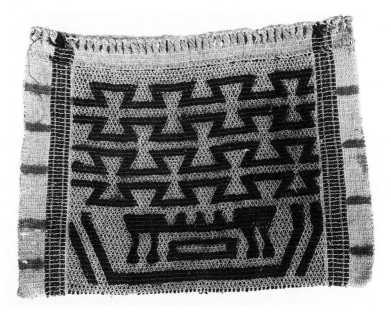

66 Anishnabe (probably Odawa) artist

Twined medicine bundle cover (nettlestalk fibre, animal hair, wool yarn, pigment), *c.*1800–9

This sacred image of a *Misshipeshu* or Underwater Panther indicates that the bag held a medicine bundle. The great *manito* of the under-earth realm, a source of danger as well as wealth and healing powers, is represented both by a rendering of its lower body and by rows of power lines expressing the great waves whipped up in the Great Lakes by its long tail.

67 Anishnabe artist

Shoulder bag (deer skin, moosehair, porcupine quills, metal cones, deer hair), c.1760–84

The great *manito* of the upper-world, the Thunderbird, whose cosmic battles with the under-earth beings energize the earth-world of human beings, appears on this fine bag collected by General Frederick Haldimand. It displays a virtuoso array of indigenous needlework, tanning, and dyeing techniques, including embroidery in porcupine quills on the body of the bag and moose-hair false embroidery on the strap.

68

Photo of Sophia Smith (Minnesota Ojibwa) with a bandolier bag, 1890s

The large, flamboyant bandolier bags made by Ojibwa women were important commodities of the western Great Lakes trade. Traded for horses to the neighbouring Sioux, they carried the Great Lakes floral design into the Central and Southern Plains. Worn across the shoulder singly or in pairs, with Western suits or garments of Native cut, they came to represent Native identity at annual treaty days and Anishnabe spirituality at *Midewiwin* ceremonies. Sophia Smith made this one for the first Bishop of Minnesota.

During the early eighteenth century Ursuline nuns in Quebec had already introduced a commoditized production of small objects made of birchbark and embroidered in dyed moosehair with floral and other designs. The nuns sold these wares as souvenirs to the transient European population until around 1800 when the local Huron-Wendat Indians took over the production [**69**]. Although it has often been stated that the floral designs that were widely adopted during the nineteenth century across North America all came from this single source, there were, in fact, many possible separate introductions of

69 Huron-Wendat artist

Moccasins (deer hide,
moosehair), 1832

Collected at Niagara Falls by
an aristocratic Swiss traveller,
these moccasins are an
example of the large
production of birchbark and
hide wares embroidered in
dyed moosehair by the Huron-
Wendat living near Quebec
City throughout the nineteenth
century. Through the long-
distance trade initiated by
the Huron-Wendat, their
object types and floral designs
helped to stimulate other
similar productions in Native
communities all over the East.

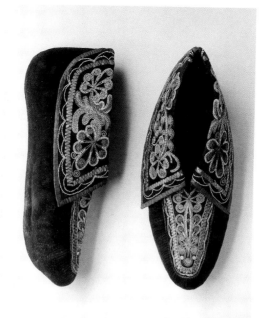

European floral designs. Flowers are one of the most important forms
of European imagery, ubiquitous in textiles, ceramics, interior decor-
ation and a frequent subject for painters. During the nineteenth
century, the 'cult of flowers', as one anthropologist has termed it,
gained further importance. One of the most striking aspects of the
artistic traditions that developed during the nineteenth century is the
originality of Native beadworkers' interpretations of these designs.
None of their realizations of floral designs in media as diverse as porcu-
pine quillwork, beadwork or silk embroidery is stylistically identical to
a European prototype. Indeed, during the nineteenth century, features
appeared in women's magazines that instructed European and North
American readers in the Native art of floral beadwork. For the
Victorians, floral motifs were not empty of meaning as they came to
be in the twentieth century. They regarded flowers as the epitome of
the beauty of God's natural creation and as the essence of refinement
and femininity. Missionaries, teaching needlework to Native women,
would have urged the adoption of this imagery as an outer sign of
Indians' acceptance of 'civilization'. The teaching of missionaries and
their opposition to traditional Native spirituality was certainly an
important stimulus for the adoption of floral motifs, yet these pressures
do not seem sufficient to explain the enormous and enduring popular-
ity of floral designs among Native artists. Although representations of
flowers had not previously figured in Native textiles, they possessed
meanings within Native oral traditions. Vegetation is revered within
Native spiritual systems as an essential part of the cycle of the creation.
Many plants are used as healing medicines and others—particularly

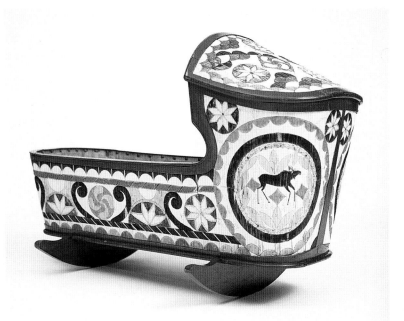

berries—play an important role as ritual foods, symbolizing seasonal renewal and the food of the dead on their journey to the after world. The prominence of berries in Native beadwork and quillwork should be viewed in this context.

Many of the objects that were embellished in quill- and beadwork with the new floral designs during the nineteenth century were made not for Native consumption but for sale in a rapidly developing art commodity market. Catherine Parr Traill, like other settlers and travellers throughout the nineteenth century, bought baskets and flower-decorated objects from entrepreneurial Native artists to decorate her home. These wares took a wide variety of innovative forms designed to please the non-Native consumer. 'Our parlour', Traill wrote, 'is ornamented with several very pretty specimens of their ingenuity … which answer the purpose of note and letter-cases, flower-stands and work-baskets.'[23]

The importance of art commodity production in the history of Eastern Native art has been underestimated because of the tendency to regard Native artists' negotiations of the economic and artistic situations in which they found themselves as a 'sell-out' of authentic indigenous traditions. The new art styles and types of commodities were the result of a ferment of creativity and invention on the part of Native makers, but they were also motivated by the extreme economic deprivation brought about by the taking of their land [**70**]. Unable to rely on hunting, gathering, and cultivation for their subsistence and often resistant to official government policies designed to transform Native people into a class of farmers, many Eastern peoples chose instead to

rely on a more mixed economic base, one in which travel and trade were central, as they had been for untold past centuries. Between the 1830s and the 1930s newly developed tourist and vacation sites became the destinations of Native travel. At spas, summer fairs, and coastal resorts along the Atlantic—and above all at Niagara Falls—they sold a wide variety of products including birchbark objects embroidered in porcupine quills, beaded purses, pincushions, wall pockets and moccasins, dolls and model canoes, and ash-splint fancy baskets.

Until the early twentieth century these art commodities were enthusiastically bought and widely admired. Although the advent of a new modernist aesthetic in the twentieth century caused the popularity of Indian fancy wares to wane, the production of art commodities and souvenirs remained an important outlet for Native artistry during the first half of the twentieth century, and a vital link to the emergence of a new contemporary art of easel painting, printmaking and sculpture among Woodlands artists such as Ernest Smith during the mid-twentieth century [44]. Important aspects of this development will be discussed, together with contemporary art from other parts of North America, in Chapter 7. Here, however, it is important to note the ways that both commodity sales and touristic performances have often provided the means, not only for economic, but also for cultural and political survival. Margaret Boyd (c.1814–after 1884), a renowned Odawa maker of quill-embroidered birchbark model canoes and other wares who was educated at the Catholic mission school in Harbor Springs, Michigan, is a good example. She sold her highly priced art in order to finance a trip to Washington DC in the 1870s, enabling her to bring the problems of her community (which had negotiated to remain in its Michigan homeland despite the official removals policy) before the President of the United States.[24]

Although the medium had changed, the stimulus for art making was not so different a century later when another Odawa artist, Daphne Odjig (b. 1919), began using easel painting and print making to represent oral traditions and to explore history from the Native point of view. Odjig, furthermore, has forcefully argued the link between the 'traditional' and the 'contemporary' or between 'craft' and 'fine art'. 'Artists were feeling their way in the middle and late '60s,' she has said. 'Native peoples were starting to come out for themselves and expressing themselves. But long before that I had always painted. Art was all around me as a child, my grandfather, my father and the native women were making quill boxes. You couldn't help but be creative in those days.'[25]

The West

4

Lakota cosmology merges with modern physics in one sentence that describes the mystery of life: '*Taku skan skan*', rendered imperfectly into English as 'Something that moves moves'. This one phrase encapsulates the idea that the entire universe is in motion, as well as infused with power and mystery.[1] Life was created out of the primal rock that squeezed from within itself its own blue blood to make water and the dome of the heavens, and developed out of the differentiation of earth and sky, sun and moon. Notably, the spatial and temporal ordering of the world was only completed when the Four Winds (represented in Lakota stories as four young brothers) established the cardinal directions and the division of time into day and night and the annual round of lunar months and seasons.

Contemporary artist Colleen Cutschall demonstrates the ritually active potential of a postmodern art installation and the profundity of Lakota epistemology in 'Sons of the Wind' [**71**]. She depicts the directions as four pillars, tinted with symbolic colours, that link the airy realm of sky and birds to the human domain of solid land. These columns also recall the centring axis of the Sun Dance pole, which is so important to Plains world-view. For some viewers, the columns will also evoke the fundamental orders of the classical tradition in Graeco-Roman art. Cutschall's work is a sophisticated, almost minimalist, construction as well as an unambiguous visualization of Lakota spiritual beliefs. On the Great Plains, as in other Native American traditions, one can only understand one's place as a human being by understanding how the cosmos has been generated.

Introduction

Most outsiders, in considering the Native arts of the American West, do not think about such sophisticated cosmological concepts. Instead, the image of the Plains Indian in fringed hide clothing and feather bonnet comes to mind, perhaps the most common stereotype in the minds of people worldwide when thinking of indigenous America. Yet, in the long history of Native life in the West, this image belongs to a relatively brief period, lasting only from about 1700–1870 CE. At the beginning of this era, wild herds of horses, introduced by the Spanish

Detail of 86

**71 Colleen Cutschall
(b. 1951), Lakota**

'Sons of the Wind' (tubing, acrylic, papier mâché), 1992

All of Cutschall's work is inspired by the great oral traditions of the Lakota which describe the origin of the world and the supernaturals. The physical experience of this ambitious installation is one of spatial harmony achieved through the understanding of the structure of the cosmos.

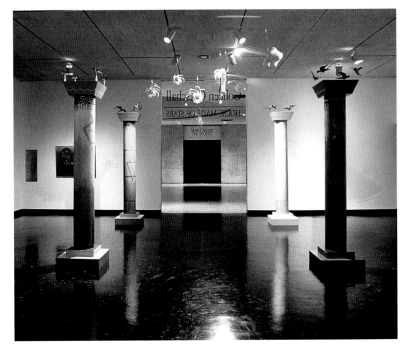

to the Americas less than two centuries before, had migrated north. They became available to peoples living at the western and southern margins of the tall grasslands long inhabited by the great, migrating herds of buffalo which were so central to the economy and spirituality of Plains peoples. With horses, and guns (acquired first from tribes further east engaged in the fur trade, and later through direct trade with whites), Plains peoples were able to hunt buffalo in new, efficient ways.

The buffalo-hunting life was a rich and generous one, encouraging the development of a multitude of visual arts in skin, hide, quillwork, featherwork, painting, carving, and beadwork. These represent some of the foremost achievements of Native art. The almost exclusive focus of outsiders on the male warrior societies and their associated arts reflects a particular fixation of romantic nineteenth-century travellers and twentieth-century collectors and has distorted our understanding of Native arts as they were made and used over a far longer period and a greater geographical range in the West.

This chapter considers the arts of diverse cultures in the western half of North America, including the peoples of the Great Plains, the Intermontaine region, and the Great Basin and California (see map). The peoples of these regions and their arts suffered unusually rapid alterations during colonization and settlement by Euro-Americans. From the Spanish settlements in coastal California in the eighteenth century to the incursions on to the Great Plains by Euro-Americans and Euro-Canadians in the nineteenth, many indigenous peoples were

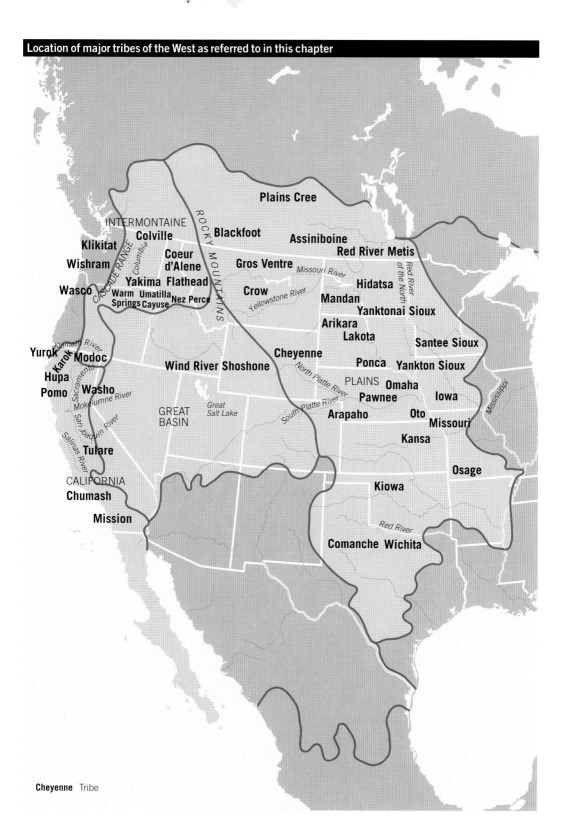

Plains Cree

INTERMONTAINE

Colville

Klikitat

Wishram

Coeur
d'Alene

Yakima Flathead

Wasco

Warm Umatilla
Springs Cayuse Nez Perce

ROCKY MOUNTAINS

CASCADE RANGE

Columbia

Blackfoot

Gros Ventre

Crow

Assiniboine

Red River Metis

Missouri River

Red River
of the North

Hidatsa

Mandan

Yanktonai Sioux

Arikara

Lakota

Yellowstone River

Yurok

Klamath River

Karok Modoc

Hupa

Pomo

Washo

Sacramento

Mokelumne River

San Joaquin River

GREAT
BASIN

Great
Salt Lake

Cheyenne

Wind River Shoshone

North Platte River

South Platte River

Ponca

Santee Sioux

Yankton Sioux

PLAINS Omaha

Pawnee

Arapaho

Iowa

Oto

Missouri

Kansa

Tulare

Salinas River

CALIFORNIA

Chumash

Mission

Osage

Kiowa

Red River

Comanche Wichita

Mississippi

Cheyenne Tribe

removed from their homelands and either resettled on distant reserva-
tions or forced to accept greatly reduced access to their ancestral lands.
Intensive Christian missionizing led to the diminution of arts used for
traditional ceremonial purposes, and by the mid-nineteenth century,
many of the arts being made were part of a larger intercultural
exchange between whites and Natives.

 This chapter is devoted principally to art on the Great Plains be-
cause it has been so central to this Euro-American image of the Indian.
Focusing on such neglected questions as the importance of art as an ex-
pression of complementary gender roles in society, we will examine
how these roles and artistic expressions have shifted in response to the
new social realities of the last 125 years or so. We will also look at the
various ways in which quillwork, beadwork, and fibre arts have been
central to the expression of cultural values. The uni-dimensional image
of the warrior, looming so large in the Euro-American imagination,
has not only crowded out discussion of some of these other arts but has
also distorted our understanding of men's arts, which are not simply
about military prowess. Moreover, it has left no room for an under-
standing of the complex intellectual underpinnings of indigenous art
and life. For example, cosmological concerns and a profound interest
in history and time-keeping underlie many of the pictorial arts made
by men on the Great Plains.

 The Plains extends from the boundary of the Eastern Woodlands
(just west of the Mississippi River) to the Rocky Mountains in the
west. Stretching from Southern Canada and sweeping down to the
Mexican border of Texas, this land was inhabited by more than two
dozen different ethnic groups during the post-contact period, among
them the Assiniboine, Plains Cree, Lakota, Crow, Mandan, Pawnee,
Kiowa, Arapaho, and Cheyenne. Linguistic and archaeological evid-
ence suggests that the historic cultures of the Great Plains grew out of
other, prior, ethnic configurations. Some, like the Shoshone and
Comanche, arrived from the Great Basin to the west. Others, such as
the Lakota and related Siouan peoples, pushed westwards out of the
Great Lakes region due to population pressures from other Native
groups and whites. Others were migrants moving northwest from the
great Mississippian cultures of the Southeast, bringing with them an
influential legacy of concepts of leadership and symbolic expression.

 Some groups, like the Mandan and Hidatsa, have lived on the Plains
for more than a millennium, in semi-permanent villages of spacious
earth lodges [82]. They had a mixed economy combining horticulture,
hunting, and fishing. The Lakota, Crow, and others were true nomads,
whose temporary camps followed the migrating herds of buffalo and
other game animals across the grassy landscape. Even their archi-
tecture was eminently portable, consisting of painted hide lodges or
tipis draped over sturdy poles [79].

72

Prehistoric shell gorget, Calf Mound, Manitoba, *c*.1500 CE

Archaeology reveals that most of the peoples of the Plains had been involved in extensive trade networks for centuries before the arrival of Europeans: shells from California and the Gulf of Mexico, obsidian and flint from distant quarries, are found together with evidence of intellectual and artistic transmissions. The worked shell pendant excavated from a Plains site in Manitoba, for example, features the forked eye motif that is ubiquitous in ancient Mississippian iconography [**72**]; see also Chapter 3. In Ted Brasser's words, on the Great Plains 'Mississippian cosmology was grafted on to the world-view and rituals of northern buffalo hunters'.[2]

The Spanish explorers who disrupted the Pueblo world in the Southwest (see Chapter 2) also made brief forays on to the Southern and Central Plains. They reported modes of life in the sixteenth century very much like those documented by nineteenth-century explorers and painters. Some communities, like the Wichita, were living in grass-lodge villages while others lived in temporary encampments of dozens of tipis. Everywhere, great herds of buffalo traversed the landscape.

The Plateau or Intermontaine region is a 400-mile-wide area extending from the Cascade Mountains in Western Washington northwards into Southern British Columbia, eastwards into Idaho and Montana, and south to the California border. For centuries it has been the crossroads for many traditions and, predictably, the art styles of this region show correspondences with those of its neighbours in all four directions. Some cultures along the Columbia River had much in common with coastal peoples, while others, further east, were more like their Plains neighbours, including reliance on the horse.

In the area of California and the Great Basin, there are many different ethnic groups living in radically diverse ecological regions, ranging from the rich coastal areas of California to the harsher, more arid interior zone of Nevada. Hunting, fishing, and gathering were the main subsistence strategies here as well, and in the arts there was a great proliferation of basketry, shell, and featherwork used in ceremonial life.

Before the twentieth century, basketry was a central feature of existence, used in all aspects of daily life in the Intermontaine region, California, and the Great Basin. Men caught fish in basketry traps. Women harvested wild seeds using a woven seed beater and a burden basket. Roots were stored in large twined bags. Watertight baskets held liquids, and food was cooked in baskets. Babies were placed in basketry carriers, and various types of baskets were prominent in ceremonies ranging from birth, to marriage, to death. Along with the Southwest, these are among the most renowned basket-producing regions of North America. In addition to their indigenous uses, by the end of the nineteenth century baskets from these regions were a

fundamental part of the lively trade in touristic commodities; indeed, California baskets were among the most prized.

The Great Plains

Until the second half of the nineteenth century, reliance on the buffalo was the defining feature of life across the prairies of Central North America. This animal was the primary source of food, clothing, and shelter for most tribes. Buffalo skin was the medium for almost all arts. Men painted historical and autobiographical accounts on hides and made shields which afforded spiritual as well as physical protection [80, 81]. Women made sturdy, portable tipis, storage containers, clothing, and moccasins. Foremost in importance was buffalo hide, although deer, antelope, mountain lion, and other skins were valued as well. Except for the large-scale earth lodges and grass lodges of a few tribes, almost all arts on the plains were eminently portable. The expression of individual identity and achievement through adornment of oneself and one's possessions was one of the most important functions for art. Men, women, children, and horses were all beautifully dressed and adorned with amulets, feathers, claws and other items derived from or modelled upon the natural world [73]. A universe of meaning

73 Cheyenne artist

Dragonfly hair ornaments (rawhide, pigment, feathers, and buttons), c.1880

Dragonflies, admired for their speed and agility, are often seen on the shields, clothing, and bodily adornment of Plains Indian men, who desired to emulate such traits when they engaged in warfare and in horse raids. These hair ornaments might have been worn in battle as well as in ceremony.

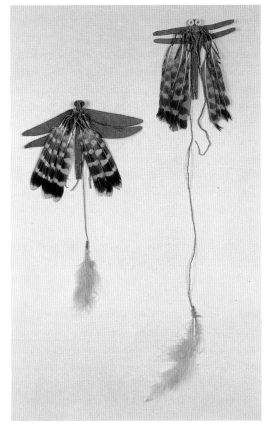

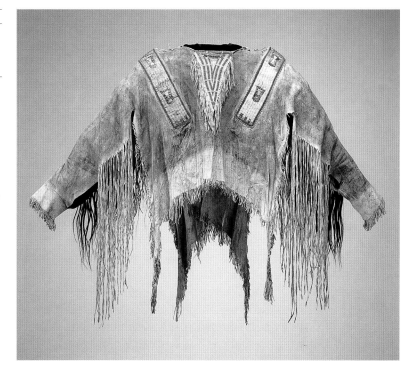

74 Lakota artists

Man's war shirt (tanned hide, porcupine quills, human hair, pigment, trade beads, and sinew), *c.*1870

All across the Plains in the nineteenth century, men's shirts were decorated with quillwork and painted designs. Here, bearclaw designs are worked into the quilled shoulder strips. Fringes made of human hair locks sometimes represent scalps taken in battle. In other instances, especially among the Lakota, they are often the locks of friends and loved ones, offered in honour of the brave warrior.

could be discerned in the painted, quilled, and beaded designs on clothing, and in the way that people presented themselves. As mentioned in Chapter 1, phrases in Plains languages reveal that people adorned themselves 'in proper relationship to the gods'; in some cases, powerful items of ceremonial gear were described in words whose approximate translation is 'something sacred wears me', a reversal of ordinary assumptions about who is the wearer and what is worn. Clothing arts also revealed much about cosmological concerns and secular hierarchies. Ideas about the spirit world and humans' relationship to it are expressed in beaded and painted garments. A man's accoutrements composed an easily readable constellation of signs marking his rank in one of the warrior societies, as well as his individual military honours.

Men and women brought complementary skills to the making of ceremonial clothing. In some instances, both men and women might work on one object; a man's war shirt, for example, combined quilled and beaded panels made by women along with painted and fringed ornaments made by men [**74**]. In other cases, as in a pictorial robe depicting a man's war exploits, or a woman's beaded dress, an individual artist would work alone. Men might work communally on a pictorial history, while women would work collectively on a large tipi. We will consider the traditional realms of women's arts and men's arts in turn before examining the changes that have occurred in these two intersecting realms since the Reservation Era.

Women's arts

Individual women tanned hides, and decorated them in geometric and semi-abstract designs which contrast with the narrative, figural designs painted by men (compare **75** and **81**). Women incised and painted abstract designs on their robes, dresses, tipi liners, and storage boxes. Porous buffalo bones, thin reeds, and even buffalo tails were used as brushes. Hematites, clays, carbonized materials, and plants provided natural pigments, and these media were later supplemented by the vivid commercial pigments obtainable from traders. Chokecherry tree resin and boiled buffalo hoof jelly were used as fixatives.

One of the unique features of Plains women's artistry was its organized communal structure. A Crow myth gives insight into Native beliefs about female artistic power and co-operation. It describes a woman who was warned by her fiancé that he would only marry her if she were powerful. He made the unreasonable demand that she tan a buffalo hide and embellish it with quillwork all in one day. As she cried in the woods, numerous animal helpers appeared. Female beavers and badgers staked the hide, while moles, mice, ants, and flies removed the flesh, dried it, and scraped it smooth. A porcupine offered its quills to the ants who completed the quillwork.[3] This tale articulates through analogy with the animal world the ideal response of co-operation when faced with an ambitious artistic task. While individual hide paintings and quilled items reflected an individual woman's artistic inspiration, quillwork was undertaken as a sacred endeavour, within the structure of women's artistic guilds. Large-scale tasks, such as making and raising a tipi, were often undertaken as group endeavours, with specialists performing particular tasks.

75 Cheyenne artist

Parfleche (rawhide, pigment), before 1875

The French term *parer flèche* (to turn away arrows) describes the impenetrable properties of sturdy, Indian-made rawhide. The term came to refer to the large storage containers made by Plains Indian women and painted with a variety of elegant abstract designs. This is a fine example of the delicacy of line characteristic of Cheyenne parfleche painting.

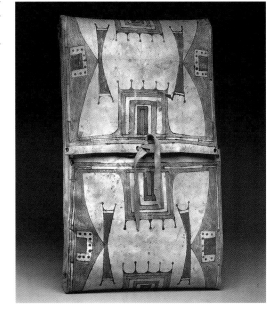

Some aspects of skin and hide working were highly specialized, and by doing them women earned both stature and wealth. Among the Cheyenne, to belong to the guild in which women gained expertise in designing, constructing, and ornamenting a tipi was one of the highest female aspirations, even into the twentieth century. Membership in the tipi-makers' guild was a mark of special prestige, and Cheyenne mothers encouraged their daughters to strive for this honour.[4] Membership in the tipi-makers' guild implied stamina, fortitude, and patience as well as artistic expertise. Because of the lavish feasts that were held, and the fees paid to expert designers, it also implied that a woman had achieved a respectable level of wealth.

The making of a tipi or lodge was recognized as so demanding a task that if a woman made one by herself—carrying out every step from tanning and sewing the skins, cutting the lodge poles, and producing all of the interior and exterior quill or beadwork—she was considered to be an exemplary individual. More often, tipi-making was a communal artistic undertaking. The intention to make a tipi was publicly announced and a feast would be held. A high-ranking member of the guild who was an experienced lodge maker would be responsible for the design and fit of the skins, arranging them and tacking them together before the other women completed the sewing. Other Plains groups had similar customs, even if they were not organized into a formal guild as were the Cheyenne. Crow women would commission an expert designer to lay out the tipi. This specialist in both architecture and tailoring, who would be paid for her services with four different types of property, supervised as many as twenty women who collaborated on sewing the skins. In payment for their services, the owner threw a lavish feast.

Blackfoot Indian women made the largest tipis of the Great Plains (up to twenty-eight skins and forty lodge poles). They, too, had regular work teams that would make new tipis in late spring.[5] Before calling together her collaborators, a woman would select and stockpile several dozen buffalo skins, numerous buffalo sinews from which to make threads, and a collection of awls. She would prepare a feast, and announce her intentions to her colleagues. After the meal, the sinews would be distributed, and the day spent splitting them to make thread. The following morning, expert needle women and a designer would commence laying out and sewing together the tipi. Other women would use knives to peel the bark and trim branch stubs from the assembled tree poles, cutting them to the desired diameter. When all work was completed, the poles were raised, and the new tipi stretched upon them. The edges would be pinned to the ground and a fire laid inside the tipi to smoke the skins. This would keep them flexible throughout the repeated soakings and dryings afforded by the harsh weather on the Great Plains.

Tipi painting was, in general, a male art, as discussed below, although individual instances are known in which a particularly talented artist who was female might paint the narrative scenes on tipis. While a family might need a new tipi only once every second or third year, female artistry did not stop with the raising of new houses in the late spring. The process of making and adorning tipi liners, back-rests, storage bags, and robes for the interior, as well as clothing for all daily and ceremonial occasions, continued throughout the year. Quillwork and beadwork were the main forms of artistic elaboration (see Chapter 3, p. 97).

The exchange of women's quillwork and beadwork was central to maintaining relations among neighbouring groups across Western North America. Through the exchange of these arts at inter-tribal gatherings and trading sites, artistic styles were disseminated across a wide area. We know a great deal more about the meaning and social beliefs concerning quillwork on the Great Plains than in the other areas where this work was done. On the Great Plains, quillwork was a sacred art form, the mastery of which gave grace and prestige to the artist. Lakota women teach that the supernatural known as Double-Woman gave them the sacred art of quillwork, by appearing to a young woman in a dream. This young woman taught the art of quillwork to other women. Still practised by Lakota women, quillwork continues to be a sacred art.

The anthropologist George Bird Grinnell, who lived among the Cheyenne in the 1890s, observed of quill- and beadwork: 'This work women considered of high importance, and, when properly performed, quite as creditable as were bravery and success in war among men.' He goes on to relate that, in meetings of the quillwork society, the assembled women recalled and described their previous fine works, 'telling of the robes and other things that they had ornamented. This recital was formal in character, and among women closely paralleled the counting of coups by men.'[6]

Counting coup, the quintessential act of male bravery in warfare, in which an enemy is touched by his opponent with a lance or coup stick, demands courage, finesse, and a great deal of personal style. Apparently women's fine artistic designs demand these traits as well. This idea still persists today among some Plains people. Expert Crow beadworker Winona Plenty Hoops, of Lodge Grass, Montana says, 'A good design is like counting coup.'[7] Beautifying the world by vowing to undertake an artistic project was an act of honour and devotion. As in many Amerindian traditions, the finished object was in some ways less important than the process of undertaking it in a ritually prescribed manner. On the Great Plains, a woman's path to dignity, honour, and long life lay in the correct and skilled pursuit of the arts.

There were set procedures for a young Cheyenne woman to follow

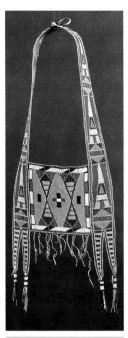

76 Crow artist

Beaded horse collar, *c.*1890–1900

Classic Crow beadwork of the Reservation Era is defined by bold geometric designs of triangles and hourglasses in which pink, blue, and white are the predominant colours. Crow people recount that Old Man Coyote, who created their world, was the first to dress and ornament horses as beautifully as human beings would dress. For this reason, even today Crow horses are more beautifully ornamented than any other horses on the Plains. Every summer at Crow Agency, Montana, horses and people display the finest beadwork of Crow women, some of which is modelled after classic nineteenth-century pieces like this.

when she embarked upon her first major quillwork project. She made a public vow in front of the assembled guild, describing her intention to undertake an ambitious project. She held a feast, and requested aid from one of the more senior guild members, asking the older woman to draw in white clay a preliminary pattern of the intended design on the robe. All these steps show the seriousness with which women approached these arts.

For no other tribe do we have as complete a picture of traditional quillwork societies as we do for the Cheyenne, but some features are similar in other groups. Both the Blackfeet and the Lakota believe that quillwork in ancient times came from divine inspiration. Among the Hidatsa, a young woman's increasing artistic skill was publicly recognized and rewarded by other women. Girls were given 'honor marks': ornaments such as belts, bracelets, and rings for successful completion of artistic works.[8] Rattling Blanket Woman, a Lakota, recalled the year when, during the summer Sun Dance camp, she challenged other women to come and sit in a circle and recount their achievements.[9] Each woman was given a stick for every piece of work she had quilled. The women with the four highest tallies were seated in places of honour and served food before all the others. The tallies, or 'quilling coups', were recorded on the tipi liner of the Red Council Lodge, along with the achievements in warfare of the males.

Early in the nineteenth century, trade beads were such a valued and unique commodity on the Great Plains that one horse would be exchanged for only 100 beads. Indian women quickly recognized beads' artistic potential in terms of individual design units. Often beads were used alongside quillwork for extra richness of ornamentation. But in many regions of the Great Plains, they came to replace quillwork by the mid-nineteenth century. Strong and durable, with a vivid range of non-fading colours, beads were easy to work with, compared to quills. Yet, like quills, beads could be used to form small, discrete colour areas, as well as large monochromatic ones. Easily sewn to both hide and cloth, they could be used to outline a form, or to ornament a fringe. In some areas of the Plains, as in the Great Lakes region, small hand looms were used to weave beads into panels which would then be sewn to cloth.

Distinctive regional and tribal differences exist in style, aesthetics, and technique. Lakota beadwork of the late nineteenth century, for example, usually has a fully beaded background of one colour (often blue or white) crafted in bands of lazy stitch with figural or geometric design. Much nineteenth-century Crow work is boldly graphic in pattern, favouring light blue. Large blocks of colour are outlined by thin stripes of white beads [**76**]. But it is not always so easy to label with confidence an artist's work as coming from a particular tribe. In previous centuries, as today, Plains peoples of different groups gather in

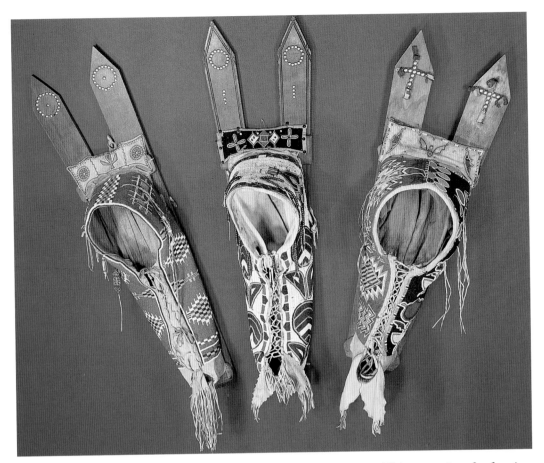

large summer camps for festival occasions. This was a time for feasting and dancing, a time when artists would scrutinize the newest works of their peers from other bands or tribes. Innovative designs might be re-membered, adapted, and transformed into a personal aesthetic state-ment. Long-distance trade among different tribes was common, too. Raw materials, like hides, as well as finished goods, such as moccasins and bags, were exchanged. By the early twentieth century, inter-marriage became more common, providing another avenue for artistic change.

While all beadwork speaks eloquently of the Plains artist's sense of colour, graphic design, and craftswomanship, two items deserve special notice: elaborately beaded cradles, and moccasins with beaded soles. Museum catalogues often state that beaded-sole moccasins are made for the dead; in fact, they were made for the living as well. Cheyenne artist Mary Little Bear Inkanish (1877–1963) remembered that her aunt had made such a pair for her when she was small, and that it was a customary gift for a bride. Wealthy horse-riders wore beaded-sole moccasins to indicate that they need not walk on the earth, but would always be astride a mount.[10] The metaphoric intention in all of

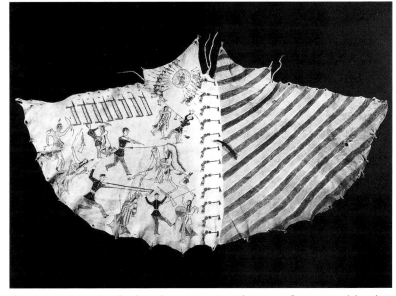

Photo of Black Leggings tipi of the Kiowa warrior society, 1980s

The yellow and black stripes refer to important nineteenth-century war expeditions. The other side of the tipi is painted with twentieth-century military insignia, commemorating the history of modern Kiowa warriors who bravely served their country in every military engagement since World War I.

these cases is to imply that the wearer is so honoured or so wealthy that her feet need not touch the ground.

Fully beaded baby carriers are notable for the lavish artistry expended upon them. Different tribes not only had distinctive beadwork designs, but distinctive methods of cradle construction. The Kiowa and Cheyenne, for example, favoured a V-shaped frame made of two long pieces of wood that extended well beyond the top of the beaded bag [**77**]. These ensured protection for the baby's head if the cradle were to fall. The cradle could be worn like a backpack, or hung from a horse's saddle, a tipi pole, or a tree. A multi-purpose piece of equipment, the cradleboard combined crib, playpen, carriage, and high chair, protecting babies until they were old enough to walk with the other children. Often given as valued gifts from a female relative, and embellished with designs that were personally as well as tribally distinctive, they are among the most beautiful examples of the beadworker's art.

Men's arts

There are very few areas of indigenous North America where art was concerned with the chronicling of recent historical events, or with the keeping of time in a linear sense. Yet on the Great Plains, a profound sense of history has long compelled men to illustrate important events in their lives pictorially. Images chipped or painted on rock faces served for centuries as a large-scale, public way of marking historical events and visionary experiences. Narrative scenes on buffalo-hide robes and tipis validated and memorialized a man's exploits in war or success in hunting [**78**]. Or, as in the Great Lakes, they depicted images from dreams and visions [**79, 81**].

79 Kiowa artists

Drawing of Underwater
Monster tipi

The horned, fishlike monsters
on this tipi are reminiscent of
the horned water serpent of
Pueblo cosmology and the
Misshipeshu of Great Lakes
cosmology.

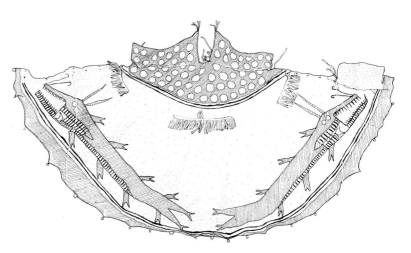

**80 Arapoosh (Sore Belly)
(?–1834), Crow**

War shield (buckskin,
rawhide, pigments, stork,
feathers, deer tail, flannel),
c.1820

Because shield designs were
often given to men in vision
quests or dreams, the rights
of ownership of particular
designs were strictly observed.
Arapoosh, chief of the River
Crow in the early nineteenth
century, painted this visionary
image of a skeletal moon spirit
on his war shield. Eagle and
other feathers, a deer tail,
and the head and body of a
stork complete the powerful
medicine of this important
item of war equipment.

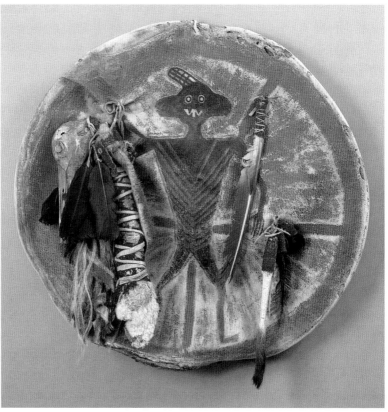

In some nations, such as the Kiowa on the Southern Plains and
the Lakota on the Northern Plains, the recorded accounts extended
beyond a particular individual's experiences. Family or band history
was inscribed pictorially in 'winter counts'—records of the most im-
portant events of a year, each distilled into one economical picto-
graphic image which oral historians could use as a linchpin upon which
to anchor their memories of all the other important events of

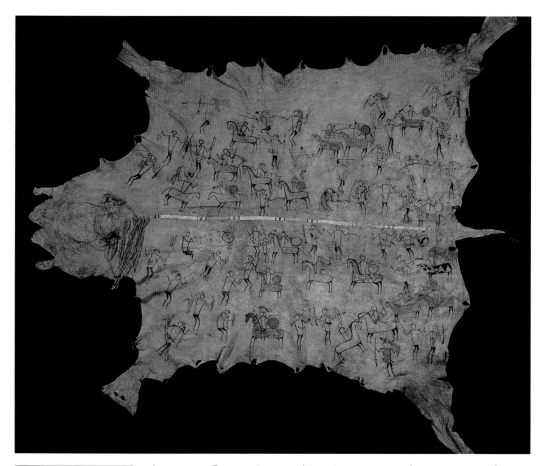

81 Mandan artist

Buffalo robe painted with narrative scenes (hide, porcupine quills, and pigment), c.1800

The explorers Lewis and Clark collected this painted hide in 1804, in what is today Central North Dakota, and presented it to President Thomas Jefferson, under whose auspices they conducted their Western expedition. The indigenous men's painting style of the Great Plains is well represented in this ambitious battle scene of some five dozen figures. Semi-abstract pictographic men and horses range across the hide. With the help of painted robes like this, powerful warriors would recount the histories of their battles.

the group. Some pictographic winter counts depict events of many decades, or even centuries.

War exploits and autobiographical episodes were sometimes painted on the exterior of tipis [78]; alternatively, images from personal dreams or visions might embellish the tipi [79]. Such imagery was very much the personal property of one individual and, in effect, he held the rights to such designs, although he might sell or bestow upon another individual the right to paint a particular pattern. Such personal 'copyright' also extended to the paintings on shields which were unique assemblages of painted images and power objects from the natural world, such as animal skins, claws, or feathers [80].

Plains narrative painting is relatively flat, and semi-abstract in style [81]. Humans are depicted as modified stick figures, and events and actions are illustrated through selective use of details, such as individual hairstyles and weapons, and activities such as hand-to-hand combat or horse capture. A man wearing such a painted robe was publicly displaying his own personal history, and would use it as a visual aid in his autobiographical narrations. During the nineteenth century, the indigenous pictographic style was modified as Indian artists encountered

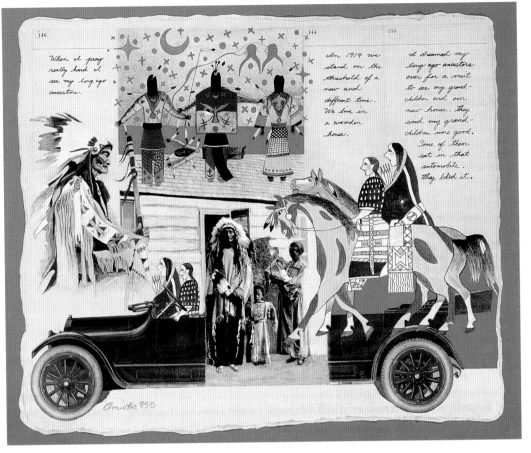

Within the illustration:

146

When I pray really hard I see my long ago ancestors.

144

In 1919 we stand on the threshold of a new and different time. We live in a wooden house.

150

I dreamed my long ago ancestors over for a visit to see my grand-children and our new house. They said my grand-children were good. Some of them sat in that automobile. They liked it.

Amiotte 95©

strong in Plains Indian painting of the last fifty years or so [**86, 146,** and **148**]. Contemporary Lakota artist Arthur Amiotte, for example, has found in the arts of the Reservation Era a rich vein of iconography to mine in his collage series. Using visual quotations from Fort Marion drawings, family history, and Lakota ritual practices, he continues the venerable male tradition of pictorial autobiography, injecting it with a touch of late twentieth-century wit and irony.

Paradoxically, while the late nineteenth century was a time which witnessed the radical diminishing of male artistic traditions, the Reservation Era became a time of richness in women's arts, a pheno-menon that can be understood as a response to the many forces that were threatening Plains cultures. As Marsha Bol has pointed out, in the 'enforced leisure' of reservation life, women had more time to de-vote to art, and the result was a tremendous blossoming of beadwork arts. Women's arts came to symbolize the ethnicity of the tribe, both for the people themselves and for outsiders, and they became, even more than before, a way of affirming the traditions of the group.

In many regions, beadwork designs became more complex. Items of clothing were lavishly covered with beads; all-over beading of vests,

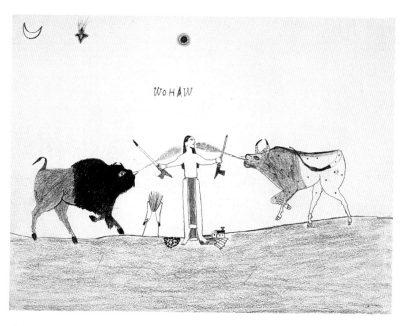

85 Wohaw (1855–1924), Kiowa

'Between Two Worlds' (pencil and crayon on paper), 1876

In an unmistakable depiction of his acute ambivalence at being caught between two ways of life, this Fort Marion artist depicts himself holding out a peace pipe to two animals—a domesticated beef cow, and a buffalo. One foot stands near a miniature buffalo herd and Kiowa tipi, but Wohaw's other foot is firmly planted in the tilled fields of a white settler's frame house. His actions are witnessed by the celestial bodies overhead. This image stands as the single most powerful metaphor and most poignant representation by a nineteenth-century Indian artist of the cultural schisms of that era.

sive interest in documenting scenes of traditional life, as if the artists were all too aware of how fragile some of these traditions were, and how rapidly they were changing.

Many warrior-artists drew pictorial histories in small books which they wore on their persons when going off to battle—in a miniaturization of their age-old convention of wrapping themselves in autobiographical hide robes. Some of these books were 'captured' on the battlefield, or taken from the bodies of dead warriors by white soldiers. Some army men had amicable relations with Indian scouts from friendly tribes, and commissioned these scouts to make drawings for them. For example, many works are known by Cheyenne and Arapaho scouts who worked for the US Army at Fort Reno and Fort Supply in the 1880s.

Most well known of the late nineteenth-century graphic arts are the hundreds of drawings made by Cheyenne and Kiowa warriors incarcerated from 1875 to 1878 at Fort Marion, Florida, far from their Southern Plains homeland [**85**]. As these men learned Euro-American pictorial conventions, their drawings became more detailed, utilizing perspective, overlapping and, sometimes, a landscape setting. They also provide a powerful and eloquent chronicle of dispossession, as these formerly free warriors pictorially record the details of their imprisonment—the manual labour, the army dress, the daily classes, and bible study.

As discussed further in Chapter 7, it was the work of these men, and the next generation of artists, including the prolific Kiowa artist Silverhorn (c.1861–c.1941), who provided a bridge to twentieth-century painting on the Great Plains. The legacy of ledger drawings remains

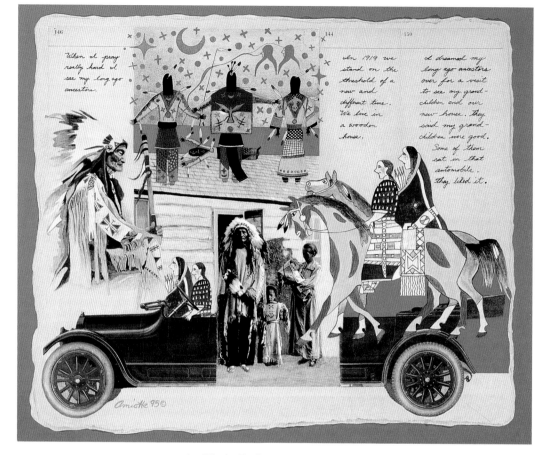

When I pray really hard I see my long ago ancestors.

In 1919 we stand on the threshold of a new and different time. We live in a wooden house.

I dreamed my long ago ancestors over for a visit to see my grand-children and our new house. They said my grand-children were good. Some of them sat in that automobile. They liked it.

strong in Plains Indian painting of the last fifty years or so [**86, 146,** and **148**]. Contemporary Lakota artist Arthur Amiotte, for example, has found in the arts of the Reservation Era a rich vein of iconography to mine in his collage series. Using visual quotations from Fort Marion drawings, family history, and Lakota ritual practices, he continues the venerable male tradition of pictorial autobiography, injecting it with a touch of late twentieth-century wit and irony.

Paradoxically, while the late nineteenth century was a time which witnessed the radical diminishing of male artistic traditions, the Reservation Era became a time of richness in women's arts, a phenomenon that can be understood as a response to the many forces that were threatening Plains cultures. As Marsha Bol has pointed out, in the 'enforced leisure' of reservation life, women had more time to devote to art, and the result was a tremendous blossoming of beadwork arts. Women's arts came to symbolize the ethnicity of the tribe, both for the people themselves and for outsiders, and they became, even more than before, a way of affirming the traditions of the group.

In many regions, beadwork designs became more complex. Items of clothing were lavishly covered with beads; all-over beading of vests,

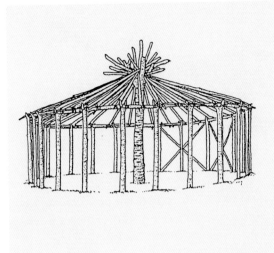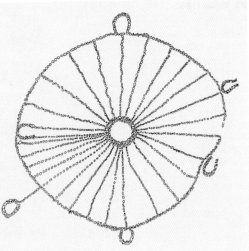

84

Comparative drawings of a
medicine wheel and a Sun
Dance enclosure

Big Horn Medicine Wheel
in Wyoming was built on a
mountain top, at an altitude
of more than 9,600 feet. It
may have served to mark the
summer solstice and other
astronomical sightings.
Modern Sun Dance or medi-
cine lodge enclosures are
modelled on such ancient
cosmograms.

Some Plains performance costume was highly idiosyncratic, for
it related to personal dreams, visions, and accomplishments. Other
aspects could easily be deciphered, for male warrior societies across
the Plains had recognizable codes of dress for different age grades
and achievement levels, and men often wore such war regalia when
participating in the Sun Dance and other ritual performances.

Art on the Great Plains from the Reservation Era to the present

After the Civil War in the 1860s, exploration and settlement of the
Great Plains rapidly increased, as did the escalation of US military
conflict with Plains peoples. Groups were forcibly resettled on to reser-
vations, their traditional ways of life fractured, especially for men. By
the late nineteenth century, the old ways of warrior societies and sea-
sonal migration were in tatters. People lived much more sedentary lives
on reservations. They were dependent on whites for much of their food
and most materials for clothing and shelter, since whites had hunted
the buffalo almost to the brink of extinction.

The Reservation Era of the late nineteenth and early twentieth cen-
turies was a time of profound cultural upheaval for all Plains people.
One would surmise that an era when the very foundations of culture
were under attack would fragment the arts as well. Indeed, it did
change the arts, and many men's artistic traditions went into rapid de-
cline as the men no longer needed the painted hide shirts that boasted
of their war exploits, the sacred painted shields to protect them in
battle, or the complex paraphernalia of the warrior societies. Men
did continue to record their deeds and their changing ways of life in
paintings on canvas or muslin, and in ledger drawings. In these works,
some continued the age-old practice of memorializing individual
achievements in hunting and warfare. Others show an almost compul-

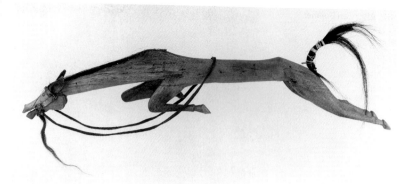

handsome horse effigies that were carried in dance performances [**83**], and whose streamlined forms and expressive quality of movement have greatly appealed to twentieth-century connoisseurs.

During the centuries before contact, Plains artists also created medicine wheels, monumental earthworks that we would today call land art. These were giant, round, solar symbols formed of boulders, and were probably used as ritual spaces. All Plains people affirm that it is through ceremony that humans become 'centred'. The antiquity of the circle as a sacred form is evidenced by the scores of medicine wheels that dot the landscape across the prairie, clustering most densely in the Canadian provinces of Alberta and Saskatchewan [**84**]. While they are hard to date, some show evidence of usage going back more than 3,000 years, suggesting that in ancient times, as today, peoples of the Plains gathered in ceremonial performances to mark the summer solstice. In the Sun Dance, humans celebrate their place in the universe, fulfil vows they have made, dance and sing, and mortify their flesh in sacrificial rites. A small number of men make vows to pierce or cut their chest, back, or arm flesh. Though described by outsiders as 'torture', this is perceived by the ritual performers as an affirmation of a profound unity among the powers of the world: man and his life's blood, the sun, and the Sun Dance pole that reaches from the interior of the earth up into the dome of the sky. The great ritual pole represents the axis at the centre of the world, around which all ceremony revolves. The Sun Dance enclosure, a circle made of tree limbs and branches cut in a ceremonial manner, defines the space in which the ceremony takes place [**84**].

In all ceremonial performances, including the Sun Dance, visual display of fine clothing, horse trappings and other art objects was an important aspect. While both men and women had important ritual roles to play, male roles were more public, and often involved impersonating game animals in a kind of ancient hunting magic. Aspects of this are seen in the *Okipa* of the Mandan, the *K'ado* of the Kiowa, and the *Massaum* ceremony of the Cheyenne, in all of which the fundamental importance of the buffalo to human life is affirmed.

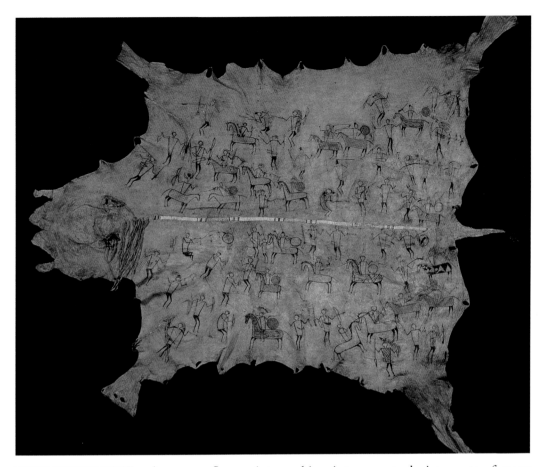

81 Mandan artist

Buffalo robe painted with
narrative scenes (hide,
porcupine quills, and
pigment), *c.*1800

The explorers Lewis and Clark
collected this painted hide in
1804, in what is today Central
North Dakota, and presented
it to President Thomas
Jefferson, under whose aus-
pices they conducted their
Western expedition. The indi-
genous men's painting style
of the Great Plains is well
represented in this ambitious
battle scene of some five
dozen figures. Semi-abstract
pictographic men and horses
range across the hide. With
the help of painted robes like
this, powerful warriors would
recount the histories of their
battles.

the group. Some pictographic winter counts depict events of many
decades, or even centuries.

War exploits and autobiographical episodes were sometimes
painted on the exterior of tipis [**78**]; alternatively, images from personal
dreams or visions might embellish the tipi [**79**]. Such imagery was very
much the personal property of one individual and, in effect, he held the
rights to such designs, although he might sell or bestow upon another
individual the right to paint a particular pattern. Such personal 'copy-
right' also extended to the paintings on shields which were unique as-
semblages of painted images and power objects from the natural world,
such as animal skins, claws, or feathers [**80**].

Plains narrative painting is relatively flat, and semi-abstract in style
[**81**]. Humans are depicted as modified stick figures, and events and ac-
tions are illustrated through selective use of details, such as individual
hairstyles and weapons, and activities such as hand-to-hand combat or
horse capture. A man wearing such a painted robe was publicly dis-
playing his own personal history, and would use it as a visual aid in his
autobiographical narrations. During the nineteenth century, the indi-
genous pictographic style was modified as Indian artists encountered

The Interior of the Hut of a
Mandan Chief (engraving with
aquatint, hand-coloured),
1836–43

Bodmer's detailed depiction of
the interior of an earth lodge
shows the four posts and
beams which support the
slanting roof poles. A skylight
allows for light, ventilation,
and the draughting of the
central fire. War paraphernalia
hangs from the pole on the
right, while a burden basket
and oar rest against the pole at
left. Even dogs and horses can
be kept snug against the harsh
Northern Plains winter within
the lodge. Early travellers to
the Plains remarked on the
orderliness of Mandan villages
where dozens of earth lodges
surround spacious plazas.

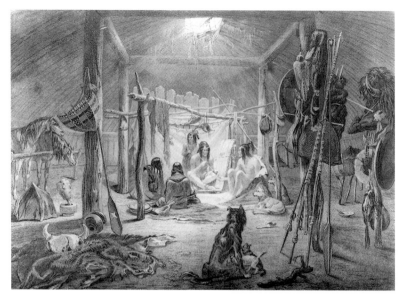

non-Indian artists like George Catlin (1796–1872) and Karl Bodmer
[**82** and **19**], and the books and prints circulated by traders, and ob-
served the level of detail and illusionistic renderings in these works.
Soon, Plains artists began to experiment, not only with European con-
ventions of perspective and details of portraiture, but with European
materials as well.

Pencils and paper were provided by explorers and traders early in
the nineteenth century and by military men and Indian agents in the
second half of the century. Some of the new materials used by Plains
graphic artists were trade items or discards. It is not uncommon to see
the lined pages of a ledger book, with its list of trading post supplies or
military scores in marksmanship, drawn over with images of warfare
and the hunt much like those which had long been painted on hides.
For this reason, the genre has often been nicknamed 'ledger book art'
although many drawings are, in fact, done in regular drawing books
and tablets rather than in lined ledgers (see, for example, **16** and **85**).
While artists continued to record traditional scenes of horse-capture
and armed combat, they also used this genre to chronicle their rapidly
changing lives, as will be discussed in the next section.

Another art form, sculpture, has often been overlooked in discus-
sions of the Plains. Yet Plains sculpture presents some compelling
forms, and has an ancient history, as archaeological artefacts of buffalo
effigies demonstrate.[11] In catlinite, a soft stone quarried principally for
the making of pipe bowls, Plains men fashioned human and animal
images. War clubs carved of wood and antler combined utility and ele-
gance, while the delicate faces of elk and birds often graced ceremonial
whistles. Spoons and feast bowls were carved of wood, or of steamed
and bent horn. Among the best known of Plains sculptures are the

dresses, moccasins, and cradles became common. The penchant for all-over beadwork extended to non-traditional items as well, especially in the early years of the twentieth century. Suitcases, handbags, and other manufactured items were lavishly beaded. Lakota artists were especially well known for this. Historical battles, names, dates, American flag iconography—all were incorporated into the artistic vocabulary of the Plains artist by the end of the nineteenth century [20].

As discussed in Chapter 3, the introduction of trade cloth, ribbon, and other manufactured goods modified traditional dress across North America in significant ways. On the Plains, calico fabric and men's tailored cloth coats appeared early in the nineteenth century among the goods of traders and visiting delegations. They later formed an important part of treaty payments made to Indian nations by the US Government. Such items so transformed traditional dress that army officer John Gregory Bourke wrote the following account of the visual impact of one of the last great Lakota Sun Dances in 1881.

As the crier began to proclaim the orders of the day, the Indians once more closed in spontaneously around him, forming a great ring 50 or 60 yards in diameter, and 8 or 9 persons deep, and aggregating several thousand men, women, and children. The display was no less brilliant than fantastic. Some were on foot, many on ponies, and quite a number in American country vehicles. Nothing could be added in the way of dazzling colors. Calico shirts in all the bright hues of the rainbow, leggings of cloth, canvas, and buckskin, moccasins of buckskin, crusted with fine beadwork were worn by all, but when it came to other garments no rule of uniformity seemed to apply. Many of the men and women had wrapped themselves in dark blue blankets with a central band of beadwork after the manner of medallions; others gratified a more gorgeous trade by wearing the same covering of scarlet or of scarlet and blue combined. A large fraction of the crowd moved serenely conscious of the envy excited by their wonderfully fine blankets of Navajo manufacture, while a much smaller number marched as proud as peacocks in garments of pure American cut.[12]

Although pleasure in the colours and patterns of trade cloth was one reason for changes in Plains clothing, far more tragic circumstances had already made the adoption of these materials a matter of necessity. In 1869 the transcontinental railroad was completed. Within fifteen years, the enormous herds of buffalo that had freely roamed the Plains had been hunted to the brink of extinction; the railroad made possible their slaughter on a scale never before possible. Within just a few years the major source of food, clothing, and shelter for Plains peoples virtually disappeared, at the same time as they were being defeated militarily by the US Army.

The Sun Dance was officially banned by the US Government in 1883 as part of the effort to 'civilize' the Indians, but it continued surreptitiously even after the ban. In the 1880s, as a replacement for the

festive, non-ceremonial aspects of the Sun Dance, summer celebra-
tions on the 4th of July, the US national holiday, began to be common.
These summer festivals, as well as the development of the powwow as
an inter-tribal dance competition, kept some aspects of traditional arts
alive during some extremely harsh decades in which the impulse of
the dominant society was to assimilate Indians and to encourage them
to leave ancient cultural traditions behind. Today, the Sun Dance is
practised as an enduring symbol of traditional values and ideals.

At the end of the nineteenth century, a religious cult known as the
Ghost Dance flowered briefly. This was an indigenous response to the
cultural holocaust taking place throughout the vast lands of the West.
Its immediate inspiration was a series of religious visions by Wovoka, a
Paiute holy man. In 1889 he proclaimed that if Indian people lived
peacefully, danced a new dance that he introduced called the Ghost
Dance, and sang the Ghost Dance songs, their world would be trans-
formed into an ideal place populated by buffalo herds and the ancestral
dead. Most importantly, white people, their goods, and the troubles
they had caused would disappear. This hopeful message spread across
many Western tribes, and was adapted according to the cultural prac-
tices of each group. Notably, the Ghost Dance movement also in-
corporated some features of Christianity, including recognition of a
'Messiah'. Hauntingly beautiful painted clothing was made for Ghost
Dance participants, which incorporated many celestial and avian sym-
bols. Among Arapaho adherents, the rejection of white men's goods
dictated that the Ghost Dance shirts and dresses should be made from
tanned deer skin [**87**], while most Lakota garments, in contrast, were
made of painted muslin. In keeping with ancient beliefs in the protect-
ive power of visionary imagery, the Lakota believed that these shirts
and dresses would render their wearers impervious to the bullets of
white soldiers. But when the Seventh Cavalry of the US Army
gathered at Wounded Knee Creek in South Dakota in December of
1890 and massacred more than 200 Lakota participants in the Ghost
Dance, it was clear that such a Messianic movement could not stave off
the brute force that backed up official US policies of assimilation.

To many, December 1890 marked the true end of an era on the
Great Plains. Yet cultural resistance, in the form of adherence to
Native artistic practices, has persisted as an important element in the
survival of Plains Indian cultures. Today, art remains a vital force in the
life of the people. The annual Crow Fair in Montana provides expert
beadworkers with an opportunity to sell their finest dance accessories
and horse paraphernalia. There has been a revival of quillwork,
particularly among the Lakota. All across North America, the
powwow remains an important venue for competitive dances and
costume-makers to exhibit and make money from their work, and to
transmit artistic traditions to the next generation (see **13**). In some

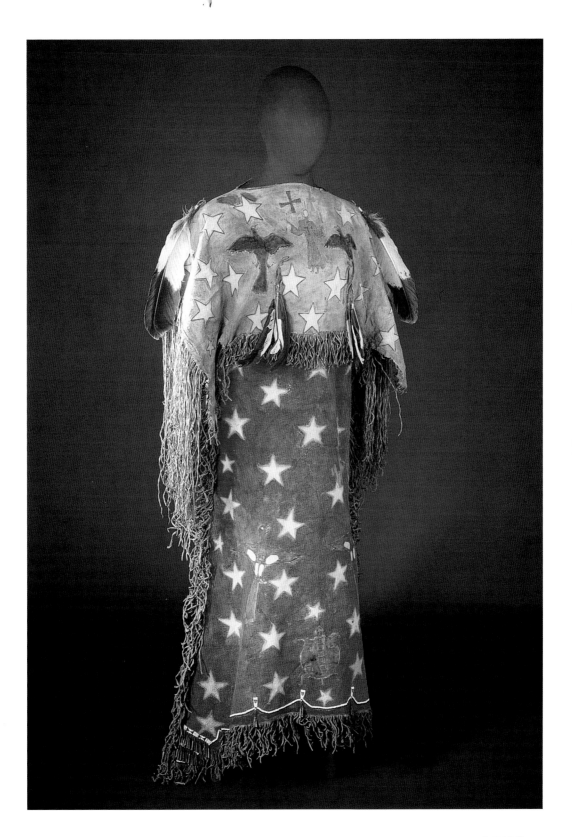

Métis Art

The term Métis refers to people of mixed heritage whose origins go back to strategic alliances made during the fur trade era between Scottish, English, and French traders and Cree and Ojibwa women. Skilled in the quill- and beadwork techniques perfected by their ancestors, Métis women also had access to European and North American floral embroidery patterns and materials such as silk thread. In the Red River Colony established in the 1820s at modern day Winnipeg, Manitoba, and later in other parts of the West and Sub-arctic, the daughters of Métis families also received direct needlework instruction at missionary schools.

Métis art, then, made by these women and their descendants, reflects the heterogeneous influences to which the artists were exposed. Métis artists specialized in clothing that combined European tailoring with indigenous modes of decoration: vests and frock-coats, buckskin trousers, half-leggings, bags, and pad saddles were embellished in fine quillwork, beadwork, and silk embroidery, usually in a distinctive floral style. Fur traders, Western travellers, and Indian people themselves eagerly acquired such new and stylish garb. Métis-style objects were widely disseminated from the Great Lakes, throughout the Plains, and into the Sub-arctic and were one of the most important artistic influences on the styles of clothing and embroidery that developed in those regions during the second half of the nineteenth century. The Red River Métis produced a great deal of this material. In their work, which derived from Saulteaux, Cree, Assiniboine, and Ojibwa techniques, floral imagery predominated.

In this image [**88**], Baptiste Garnier, a Métis who lived among the Sioux in the late nineteenth century, makes a statement about his own mixed ethnicity through the stylistic fusion of his handsome vest, tailored jacket and half-leggings.[13]

regions, even the Sun Dance is practised once again, and people are making fine ceremonial garb for its observance.

Like their foremothers of the eighteenth and nineteenth centuries, Plains beadwork artists today continue both traditional and innovative styles of beadwork. Stethoscopes for doctors at the Indian Health Service, Nike athletic shoes for young sportsmen, marker-holders for bingo-playing grandmothers—all are beaded in a dizzying array of traditional and contemporary patterns. As Lakota beadworkers are known to say, 'If it doesn't move, bead it!'

The Intermontaine region—an artistic crossroads

Like those of the Plains, Intermontaine or Plateau arts reflect a cosmopolitan mix of influences. Major ancient trading sites along the Columbia River and its tributaries brought together people and com-modities from the West Coast, the Sub-arctic, the Plains, and the Great Basin (see map). Dentalium shells from the West Coast were traded inland to the Plains through this region, while catlinite pipes were carried from the Eastern Plains. In the nineteenth century, white traders continued the annual multi-ethnic fairs. Both here and on the plains, the fur trappers held 'rendezvous' which became great centres

Photo of Baptiste Garnier in
Métis-style clothing, late
nineteenth century

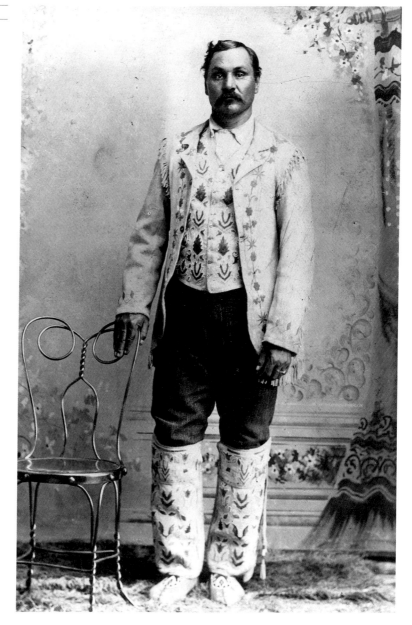

for the exchange of commercial goods and Native arts, further enrich-
ing the cultural mix with even more exotic materials and styles.

Inhabitants of the Intermontaine region speak diverse languages,
and include a number of groups, among them the Wasco, Coeur
d'Alene, Nez Perce, Yakima, and Cayuse. In Aboriginal times, people
here were seasonally migratory. Some depended on the bountiful
salmon of the great river systems. Plant roots were a staple of their sub-
sistence economy, used for food and as the raw materials for basketry.
The explorers Meriwether Lewis (1774–1809) and William Clark

89 Nez Perce artist

Twined bag (corn husks, commercial yarn), *c.*1910

Bold geometric designs characterize the twined corn-husk bags of the Intermontaine region. Generally a different yet complementary design is featured on the reverse.

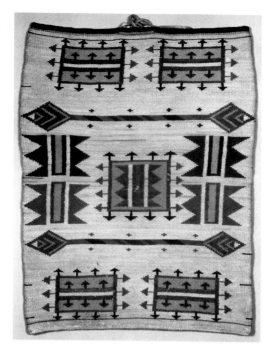

(1770–1838) reached this region in 1805; fur traders, missionaries and miners followed. As in much of North America, the nineteenth century was a time of staggering loss for the inhabitants of this region. Some 500 million acres of tribal land were lost to settlement by white farmers. Tribes were consolidated, and confined to reservations. Yet, this time of hardship was, paradoxically, a time of great artistry as well. Basketry and beadwork flourished, and they continue to do so today.

Plateau basketry is highly varied in media, technique, and style. Among the many types are the coiled cedar-root baskets of the Klikitat, the tule reed mats of the Yakima, and the round, twined baskets of the Wasco and Wishxam. One of the best-known genres is the flat, twined bag made by Nez Perce, Yakima, Cayuse, and Umatilla women [89]. They are usually called corn-husk bags, and indeed, the colourful designs in false embroidery (a technique of embellishment also known as external weft-wrap) have, in the last 100 years, often been crafted in strips of corn husk, which takes dye well. But corn was not native to this region; the original material used was the durable Indian hemp, or dogbane, which is a natural insect repellent. This feature must have been known to the women who chose it as the material for bags in which to store edible roots and many sorts of valuable goods.[14]

In the nineteenth century, such bags were quite large; today they are smaller and usually used as purses. Women's skill in twining hemp and corn husks was not limited to bags, however. Decorative horse gear, and ceremonial regalia such as dance aprons, leggings, and gauntlets

are all made out of this versatile material. These are reminiscent of work produced on the Great Plains in bold, geometric beadwork, but here both beadwork and plant fibre are the media for personal adornment.

All such objects are given in gift ceremonies that precede weddings, and are worn and displayed at inter-tribal festivities. Women of the Plateau continue to sell and trade these bags far and wide, as they have for countless generations. They are worn by other Indian peoples at powwows and dances, and have even turned up as medicine bundle containers among the Crow and Blackfeet.[15] In addition to the geometric-style bags, women also produce pictorial-style, twined designs. This dual interest in the pictorial and the geometric is also evident in the flat, beaded purses that are another lively art form of the Intermontaine region (see cover image). In the twentieth century, the imagery on such bags has ranged from familiar horse and Indian iconography, to nature scenes, to Mickey Mouse designs, to Iwo Jima memorials and other patriotic imagery.

The Far West: arts of California and the Great Basin

Women of the numerous tribes of the Far West were among the most technologically proficient basketmakers in the world. Basketry is a medium which favours rhythmic repetition of pattern, and complex schemes of rotational geometry, all of which were exploited to the maximum by the basketmakers of these areas. Limitations of space prevent us from discussing more than a modest sample of the richness of these fibre arts.

Pomo baskets

The name Pomo refers to some six dozen autonomous villages in the mountainous area north of San Francisco, California. Basketry was an essential feature of Pomo life until the early twentieth century; today only a small number of women still practise the art, although there has been a resurgence in the last two decades. The legacy of basketmaking has been handed down from mother to daughter for more than 400 years, for when Sir Francis Drake (1540–96) sailed into the bay at Point Reyes in 1579, a member of his expedition wrote in his journal that the local baskets were made 'of Rushes like a deep boat, and so well wrought as to hold Water. They hang pieces of Pearl shells and sometimes Links of these Chains on the Brims …; They are wrought with matted down of red Feathers in various Forms.'[16] He describes the unparalleled Pomo ceremonial basket [90], into which red feathers from woodpecker crests were woven to richly ornament the flat or conical exterior. Red woodpecker feathers are most highly valued, but green mallard feathers, black quail feathers, yellow meadowlark feathers, and blue jay feathers provide a broad colour palette. Abalone or clam-shell

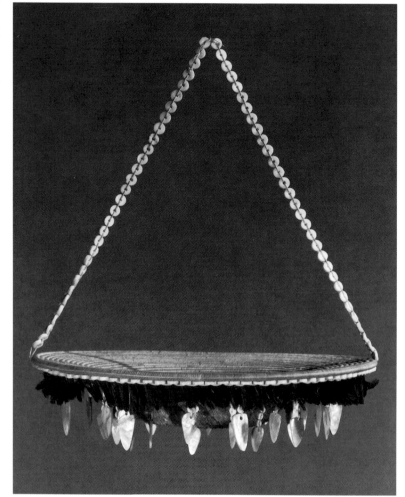

beads and pendants, painstakingly ground and polished by men, as well as brightly coloured trade beads, add to the three-dimensional design.

The feathered baskets are the most well known, but Pomo women have woven a variety of forms, both coiled and twined, all characterized by technical excellence and fine design. Slender willow stems form the foundation around which other fibres are woven. The light-coloured vessel wall is made mainly of sedge root fibres, while bulrushes or bracken fern dyed black in mud form the darker accents. One characteristic feature of Pomo twined baskets is a deliberate interruption of the design pattern as it spirals around the container. These irregularities may, at first glance, be taken for a miscalculation on the part of the artist as to how her stitch count will successfully complete a full pattern. In fact, this is a deliberate pattern break, called a *dau*. Like weavers in some other cultures, Pomo artists see this as a deliberate step away from perfection. Aesthetically, it functions like a jazz riff, inter-

rupting the main pattern. It is a distinctively Pomoan trait, not evident in the work of the nearby Yurok or Hupa weavers.

Among the Pomo, when a baby was born, the mother's female kin gave her a red feather basket [90]. The recipient, in turn, would present this basket to her mother-in-law, as part of a complex series of gift exchanges. The baby's first washing was done in a watertight basket adorned with shell beads, which remained a valued possession into adulthood. When an adolescent girl was isolated at the time of her first menstruation, she was given fine baskets for washing and eating in the house of confinement. She was also given formal instruction in basketmaking at this time. Marriage, like childbirth, was an important occasion for gift exchange. The man's family offered shell beads (a male art), while the woman's family offered fine baskets (a female art). At death, the body was piled with gifts, including the finest feathered baskets, and all was cremated.

During the second half of the nineteenth century, as Pomo people came into more direct contact with outsiders and their labour-saving goods, such as metal and china crockery, baskets declined in daily use. But basketmakers capitalized on their artistic talents and made many fine baskets for sale to outsiders. Western basketry was much in demand by collectors at the beginning of the twentieth century. Some patrons even formed exclusive contracts with basketmakers, promising financial support in exchange for their entire production of baskets. Wealthy California collector and dealer Grace Nicholson had such an arrangement with Pomo basketmaker Mary Benson, guaranteeing her an annual income of US$500 per year so that she could devote herself to basketry.[17]

While many California basketmakers had always made both large and tiny baskets, the external market encouraged extremes. Collectors vied for enormous baskets as well as diminutive ones. The tiniest Pomo baskets—so small that several could fit on a penny—were made as items of curiosity for sale. The largest ones took the idea of a traditional storage basket and accentuated its size; some were more than a metre in diameter. In both instances—the miniature as well as the gigantic—the artist pushed her technical capabilities to their maximum. Of concern to contemporary California basketmakers today is the increasing difficulty in getting access to the proper materials because of severe ecological changes, devastation of wetlands, and enforcement of private property laws which prevent them from harvesting the raw materials for their work.

Washoe baskets
Like the Pomo, the Washoe tribe of the Great Basin region of California and Western Nevada were traditionally hunters and gatherers. Contact with white settlers accelerated with the discovery of gold in

Photo of baskets made by Louisa Keyser, Washoe

This series of baskets was made by Louisa Keyser (*c.*1850–1925), the greatest Washoe basketmaker. Her innovations in traditional Washoe willow baskets, coupled with her knowledge of basketry patterns of other tribes, resulted in the 1890s in the distinctive globular form called the *degikup*.

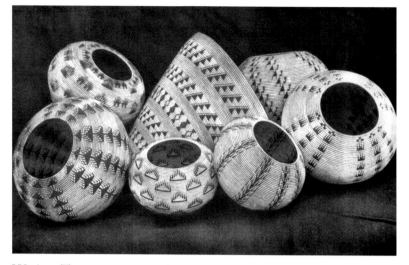

Washoe Territory in 1858. As miners and ranchers made permanent settlements, the game supply on which the Natives depended was greatly reduced. Consequently, Washoe men were hired as ranch hands and women as domestics, and Lake Tahoe, the scenic Washoe homeland, became a tourist resort.

From 1895 until about 1935, there was a great flowering of innovative basketry made by Washoe women for the commodity market. While many women made baskets, a few individual artists were responsible for the creative and technical innovations of this era. Pre-eminent among them was Louisa Keyser [**91**]. She created a tightly coiled circular basket form, often with incurving rim and decorative motifs coiled into the sides. Called the *degikup*, it has no exact precedent in traditional Washoe utilitarian basketry. These baskets were made by coiling rods made of willow shoots, and sewing them together with a flexible weft of willow branches. As in Pomo baskets, the decorative motifs are formed of dyed bracken fern roots.

We may think of aggressive marketing techniques as a feature of the late twentieth century, but Washoe baskets were marketed by Abe and Amy Cohn in their shops in Carson City and Lake Tahoe with great fanfare and great financial reward for the Cohns. Unfortunately, as part of their marketing strategy, the Cohns invented a romantic past for the Washoe in general and for Louisa Keyser in particular (whom they always promoted under the exotic-sounding invented name 'Dat So La Lee'). In a pattern similar to that of Pueblo potter Maria Martinez (see Chapter 2), this lionization of one particular artist caused the price of her works to skyrocket. In 1914, the Cohns sold one of Keyser's baskets for US$1,400, at a time when most well-made Washoe baskets sold for only a few dollars.[18] While the Cohns deserve credit for bringing this art form to the attention of the public, and for nurturing the talent of several weavers, until recently their propagandistic misinformation

obscured the real achievement inherent in this art form: it flourished at a time of great cultural upheaval for the Washoe, it was a crucial economic and artistic resource for Washoe women, and it was a truly creative response to processes which threatened to wipe out Washoe culture.

The North

5

A horned shaman, clad in fur garments, crouches in a dance position, hands on his hips. Perched on his legs, lap, torso, and shoulders are small birds and mammals. Astride his head stands a small spirit-helper in human form [111]. Inuit artist Jessie Oonark has captured the essential bond that links the human world with that of spirits and animals. According to stories told among Eskimo peoples, powerful earth-dwelling or sea-dwelling spirits have miniature animals that live on their bodies. These animals travel to the human world and allow themselves to be captured in the hunt, to sustain human life. Human beings have for thousands of years sought the co-operation of the animal spirits and honoured them by wearing small amulets carved in their images.

Such ritual and artistic traditions reflect beliefs, common throughout the Arctic and Sub-arctic regions of the North, in relationships of reciprocity and respect that bind animal and human populations to each other, and both to the land that nourishes them. Among the Dene, as a late nineteenth-century missionary pointed out, 'a hunter returning home empty-handed would not say, "I had no luck with bear or beaver," but rather "Bear or beaver did not *want* me".'[1] Such attitudes, fundamental to Northern ways of life, help to explain the purposes for which much visual art is made. Among both Arctic and Sub-arctic peoples the highest level of artistry has been committed to the ornamentation of clothing and equipment in order to please the animal spirits so that they will give themselves to the hunter and so that their protective powers can be transferred to humans [92]. Northern artists have drawn upon a wealth of animal materials in fashioning visually appealing clothing and utensils—including bark, wood, roots, salmon skin, walrus intestine, musk ox and moose hair, bird pelts, bone, antler, and ivory, as well as the more widely used hides of deer, caribou, and hare. Northern clothing arts demonstrate the remarkable patience, dexterity, and imagination of women in transforming a caribou hide, fifty yards of walrus intestine, or a hundred bird pelts into a garment of lasting use and beauty. Although these arts never died out in many places, they are practised by few people today. The late twentieth century has, however seen a renewal of many exacting techniques

Detail of 111

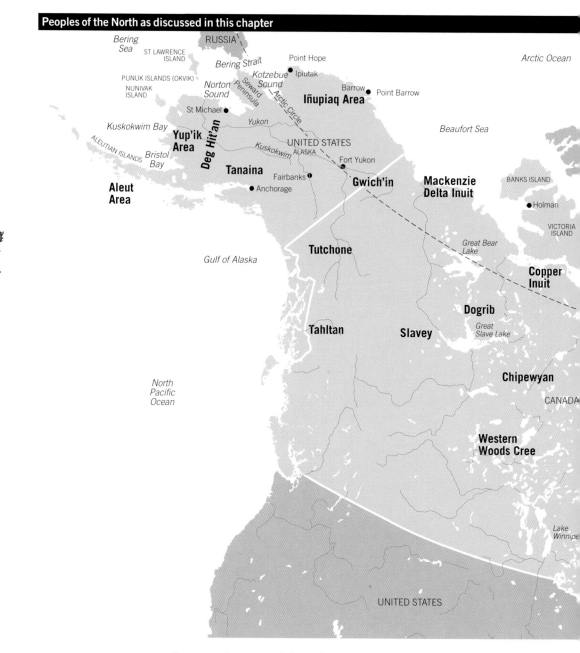

for preparing materials and sewing that had for some years been in decline.

The importance of hunting also helps to explain the centrality of shamanistic practices to Northern ritual-artistic expression. Specialist shamans engaged their powerful helper spirits in order to communicate with beings that control the animals—for example, Sedna, the undersea mistress of the Arctic sea mammals, or the Eastern Subarctic Master of Caribou who controls game animals on the land.

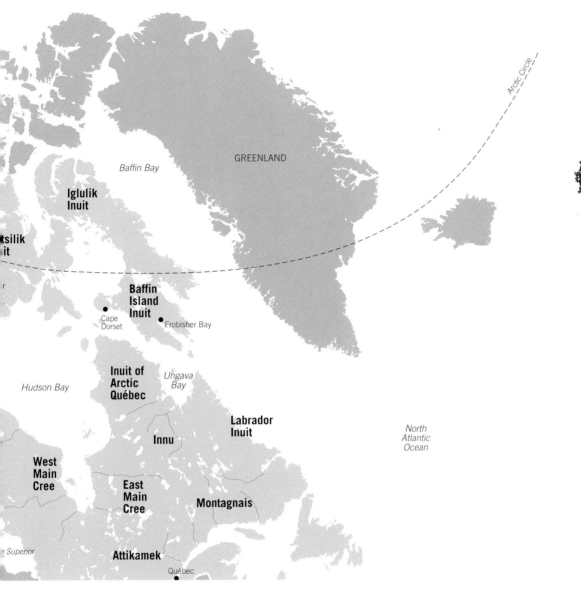

Across the North, shamans wore carved amulets and distinctive clothing for public performances that testified to their powers and visionary experiences. Yup'ik artists depicted the mystical journeys of shamans in carved and painted masks that have been greatly admired by many Western art lovers, especially during the 1930s and '40s [**105**]. (See also Chapter 1.) Alaskan Eskimos built large houses that could accommodate the entire populations of one or two villages to house the dances, singing contests and story-telling that occupied long Arctic winter

Quiver (beads, unsmoked
skin, red ochre, feathers),
before 1841

This is one of several extant
Dene quivers dated to the first
half of the nineteenth century
that display animals painted
in red ochre. The ornamen-
tation of hunting equipment
with animal representations
may have been a means of
honouring the animal spirits.
The use of symbolic abstract
patterns for such purposes is,
however, more typical of
Dene art.

nights. Today, visual arts continue to play important roles in the com-
munity festivals that have replaced these performances. In the Arctic,
commercial fine arts have become a source of economic subsistence
as well as a means for recording traditional beliefs and historical
memories.

Geography, environment, and language in the North

The Sub-arctic zone of the North stretches from Cook Inlet in the
west, east around the southern shores of Hudson and James Bays to the
Labrador Coast. It is a zone of boreal forest and taiga whose growing
season is too short for crop cultivation, but which is covered in forests
and lakes rich with animals, fish and plant life. North of the treeline is
the Arctic, the largest and the least populated region on the continent.
It extends from the Aleutian Islands and the Bering Strait, across
Alaska and Canada to Greenland, a span of more than 10,000 kilo-
metres. On Ellesmere Island and in the far north of Greenland are the
closest human habitations to the North Pole. Parts of the Arctic tundra
are home to musk oxen and migratory herds of caribou, but far fewer

plant and animal species can live there than elsewhere in North America. The most important sources of food, shelter, and clothing for Arctic peoples are fish and sea mammals, particularly seals, walruses and whales. Most Arctic communities are therefore orientated towards the coastal waters.

According to archaeological and anthropological evidence, the ancestors of the Sub-arctic and Arctic peoples arrived in North America at different times. The Sub-arctic was one of the last regions to be populated by Indian peoples before the ice cover cut off communication across the Bering Straits about 12,000 years ago. The ancestors of the Eskimo arrived more recently, about 4,000 years ago, after the receding glaciers again permitted people to cross from Northeastern Siberia into what is now Alaska and Canada. The migration of these Arctic hunters into a previously unoccupied area was made possible by their development of sophisticated fishing and hunting technologies that allowed them to harvest the Arctic sea mammals. Close cultural and linguistic ties link the Eskimo to the Chukchi and Evenk of Northeastern Siberia; the long history of regular contact among these peoples was interrupted during the Cold War but is now being resumed.

All the Arctic peoples speak languages belonging to the Eskimo-Aleut group. Within this family, Aleut, spoken by the peoples of the Aleutian Islands, is a distinct branch, as is Yup'ik, which is spoken by the Eskimos of Southwestern Alaska and also by Siberian peoples living on the Chukchi Peninsula. The languages of the Iñupiaq living along the Northern Bering Strait and Beaufort Sea, and those of the Canadian Inuit, belong to the same branch. Within each large division are diverse cultural groups, such as the Netsilik, Copper, Caribou, and eastern groups in Canada. In Alaska the term 'Eskimo' is generally used by all the Arctic peoples while in Canada and Greenland the name 'Inuit' ('the people' in the Inuktitut language) is preferred.[2]

The Cree peoples of the Eastern Sub-arctic, living in what is today Northern Labrador, Quebec and Ontario, speak closely related languages belonging to the Algonkian family.[3] They include the Innu (Naskapi), Montagnais, James Bay (or East Main) Cree, Attikamek (Tete de Boule), and Swampy (or West Main) Cree. The peoples of the Western Sub-arctic speak languages belonging to the Athapaskan family. There are about twenty-six distinct groups of Northern Athapaskan speakers, among them the Tanaina, Deg Hit'an (Ingalik), Tahltan, Gwich'in (Kuchin), Slavey, and Chipewyan. Although all these peoples refer to themselves in their own languages as *dene* or *dena* ('the people'), the collective name 'Dene' has become standard only in the Canadian Northwest Territories. In the United States, Athapaskan is more common.[4]

The time of first contact with Europeans varied greatly in different

parts of the Arctic and Sub-arctic. For two centuries following English explorer Sir Martin Frobisher's (1535–94) first contact with the Inuit of the Eastern Arctic in 1576, a series of other English explorers made sea and land journeys through the Arctic, motivated by the search for the Northwest Passage and the desire to stake territorial claims, but their journeys had little immediate impact on the indigenous people. The establishment of Russian settlements in 1741 in Southwestern Alaska brought fur traders and missionaries into the Western Arctic; the Danes and Norwegians established settlements in Greenland in the eighteenth century. Elsewhere in the Arctic regular contacts did not begin until a century later, when missionaries and whalers (who wintered over in the Arctic) established a more permanent white presence.

The Jesuits initiated missions to groups of eastern Cree in the Eastern Sub-arctic during the first half of the seventeenth century, and fur trading posts were established around Hudson's Bay later in that century. It was not until the late eighteenth century that the fur trade was extended into the Western Sub-arctic and parts of Alaska. The fur trade expanded during the nineteenth century, and whaling brought Europeans and Americans into the Arctic. Throughout the North, however, the greatest changes have come in the twentieth century. Discoveries of gold, other minerals, and oil brought foreigners to Alaska and the Canadian Yukon and Northwest Territories, and they eventually came to outnumber the indigenous peoples in some places. After World War II, the Canadian Government established permanent settlements and residential schools for the Inuit, changing their traditional nomadic life and (unintentionally) introducing tuberculosis and other diseases as well as new and detrimental forms of dependency.

Sub-arctic clothing: art to honour and protect

In the Sub-arctic, as in the Arctic, survival depended on the ability to make clothing that protected against the extreme climate, as well as on the hunter's ability to kill the animals that supplied the necessary hides. The Western tendency to separate utilitarian from artistic concerns, and acts of aesthetic self-expression from those of ritual observance, hinders an understanding of the inextricable interconnectedness of these factors in the creation and visual elaboration of Sub-arctic clothing. Scholars who study the Western Sub-arctic have stressed the protective function of clothing, not just against weather or mosquitoes, but also as a strategy for enhancing an individual's confidence and communicative power in relation to the game he sought. For some Sub-arctic peoples, too, the proper ritual-artistic treatment of a hide ensured its retention of some of the animal's own abilities. As an extension of this principle, there is evidence from the Dene that, over time, the wearer's powers came to permeate his or her clothing and could be transferred with the garment to another wearer.

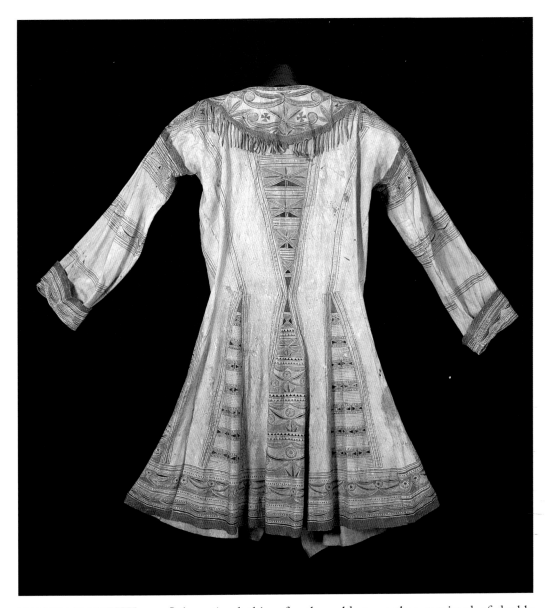

93 Innu (Naskapi) artist

Hunter's summer coat (caribou skin, sinew, fish-egg paint), c.1805

One of the most splendid of the 150 extant painted caribou-hide coats collected in Northern Quebec, this coat illustrates the skills in painting and quillwork that Innu women put into making clothing that would please the spirits of animals who gave themselves to humans.

Sub-arctic clothing for the coldest weather consisted of double layers of furred caribou hide clothing—the inner layer with the fur side against the body to trap heat and the outer layer with the fur outside to shed water and snow. The de-haired caribou skin clothing worn in warmer weather until the twentieth century by both Eastern Cree and Dene was often elaborately decorated. Autumn is also the time of the caribou hunt when, as we will see, ornamented clothing had ritual importance. Until the nineteenth century, the primary technique for decorating clothing among the Cree was painting using mineral pigments to produce a palette of red, black, and white.[5]

The distinctive painting style used by the Labrador Innu in the

early contact period features dense bands of parallel lines and the graceful, bilaterally symmetrical scroll motifs that anthropologist Frank Speck termed 'double curves' [**93** and **15**]. Artists used tools made of bone or antler, some of which had multiple prongs that allowed the artist to produced sets of evenly spaced parallel lines.[6] In a famous study carried out during the 1930s Speck reported Innu hunters' belief that, 'animals prefer to be killed by hunters whose clothing is decorated with designs' and that decoration also pleased the hunter's own inner 'soul-spirit'. In singing to game animals the hunter would say, 'you and I wear the same covering and have the same mind and spiritual strength'.[7] An Innu woman's painstaking painting of a caribou-skin summer coat was thus a ritual gesture of respect to the animal spirits and helped to ensure their continued co-operation. A similar general principle, articulated particularly clearly in Speck's ethnography, probably lies behind traditions of decorated clothing across the North.

The fitted cut and flared skirt of the Innu hunters' coats that were made until the beginning of the twentieth century is distinctive, and differs considerably from other Sub-arctic clothing. Dorothy Burnham has recently confirmed the theory that this cut was influenced by gifts of French clothing made to Native people early in the contact period, and that changes in cut between about 1700 and the early 1900s continued to reflect changes in European men's fashions. Most importantly, however, her analysis reveals the probable symbolic significance of the triangular gusset inserted into the back of the skirt, a feature which serves no functional purpose but was retained throughout the

94 James Bay Cree artist

Dolls (dolls of European manufacture, hide, porcupine quills, paint, cloth, red ochre, beads), *c*.1800

The dolls in this unique set are of European manufacture and can be dated to 1770–90. Their miniature garments were made by Cree women, probably as a commission for a European curiosity cabinet. They are the only known examples of the clothing worn at that time by James Bay Cree women and exactly match the written descriptions of mid-eighteenth-century fur traders.

two centuries of documentable development despite the many changes in cut that occurred. 'This gusset,' Burnham argues, 'which is shaped like a mountain peak, was the symbolic centre of the coat's power and … represents the Magical Mountain where the Lord of the Caribou lived and from the fastnesses of which the caribou were released to give themselves to the hunter.'[8] Her interpretation complements Ted Brasser's reading of the painted designs on an Innu shaman's hide robe as a conceptual map of the seasons and cosmic zones that order the cycle of plant, animal, and human life [15].

Although we have less information about painted clothing made by neighbouring Cree living around James Bay, it is reasonable to assume that similar beliefs and purposes informed its decoration. Nineteenth-century moosehide painted coats made by the James Bay Cree display a less fitted cut that Burnham believes was once also used by the Innu, and resemble the coats worn by the neighbouring Great Lakes Anishnabe. Ornaments and attached panels of netted, woven, and embroidered quill- and beadwork further enriched James Bay Cree clothing [7]. A unique pair of dolls dating to around 1800 displays both the way these ornaments were combined with clothing and the garments worn by women about 1800 [94]. All are painted with stripes and rectilinear patterns incorporating bands of repeated triangles and circles. Towards the middle of the nineteenth century, painted floral designs were added to this repertoire.

The Dene peoples of the Western Sub-arctic made caribou-hide clothing of markedly different cut and decorative approach. The two principal garments worn by both men and women were a long-sleeved tunic and one-piece moccasin-trousers. Mitts and hoods completed the outfit [95]. Dene women ornamented these carefully tailored garments with porcupine quills—dyed with plant and berry juices and woven or sewn to form geometric designs—and with fine, dense fringing, often threaded with silver willow seeds and wrapped with porcupine quills. Judy Thompson points out that the delicate ochre lines painted around the neck, wrists, seams, and hemline of many garments had practical uses as waterproofing and as tailoring marks, and that, because they also seem to mark 'vulnerable points' of the body, these ochre borders may also have afforded spiritual protection.[9] Like Cree women, Dene artists made a variety of ornaments using porcupine and bird quills, animal bones, antlers, teeth, and feathers to complement clothing ensembles. There is considerable evidence that such ornaments played an important role as ritual offerings and gift exchanges. Individuals were buried with their finest ornaments: one early source suggests that Dene people offered quilled ornaments to the spirits of those that they had killed in war; and young Dene women wore distinctive ornamental hoods at the onset of puberty to mark their ritual segregation.

95 Gwich'in (Kuchin) artist

Man's suit of clothes (tanned caribou or moose hide, trade beads, quills), late nineteenth century

When this man's suit was made, the traditional clothing ensemble it exemplifies had already gone out of style in many places. The finely tanned caribou hide garments are enriched by vegetable-dyed quill embroidery, quilled leg garters, and incised antler arm-bands. Subtle striped patterns are formed by the additions of beads and quill wrapping to the dense fringes.

The customs that surrounded Dene women's puberty and menstrual seclusion offer further insight into the high value placed on women's capacity to make rich ornaments for ritual and personal adornment. In traditional belief systems, the great power that manifests itself in women during menstruation (and especially at its first occurrence) can interfere with a hunter's success. Women therefore segregated themselves from their communities at such times and for a prolonged period at puberty. Puberty seclusion was also the time for perfecting the sewing skills a girl had started to acquire during her childhood. In 1983 Mary Wilson recalled her own experience many decades earlier.

Then you are introduced to sewing—crafts like embroidering, sewing with porcupine quills, and beading ... a very talented woman is chosen to start the first stitching. It seems like how you did during that time was the formation of your life as an adult ... Nothing was written or read, everything was oral, but even today I still remember all that was told to me when I, too, had to go through that phase of life, when I stepped into womanhood.[10]

Here, as in other regions of North America where menstrual seclusion was practised, the monthly periods of withdrawal provided opportunities for women to think creatively about ornamentation and to work uninterruptedly at sewing projects.

The cumulative effect of women's artistry in making clothing and the elaborate body decoration devised by wearers is vividly evoked in the inventory of the dress worn by young Slavey men as recorded in 1807 by a German fur trader named Wentzel:

[They] tie their hair, wear ornaments, such as feathers, beads in their ears, and paint or tattoo their faces ... Around their head, they wear a piece of beaver, otter or marten skin decorated with a bunch of feathers before and behind ... Their robes and capotes are ornamented with several bunches of leather strings garnished with porcupine quills of different colours, the ends of which are hung with beaver claws. About their neck they have a well-polished piece of caribou horn, which is white and bent around the neck; on their arms and wrists they tie bracelets and armbands made also of porcupine quills; around their waist they have also a porcupine quill belt curiously wrought and variegated with quills of different colours.[11]

Wentzel's presence in the North in the early nineteenth century heralded, however, the great changes that were soon to occur in the Western Sub-arctic (and that had already begun among the Eastern Cree) as a result of the arrival of fur traders and missionaries. As elsewhere, Sub-arctic artists immediately saw the potential of the glass beads, metals, and trade cloth the traders offered. They proved to be extremely demanding customers who would trade only for certain qualities and colours. Traders actively encouraged the new taste for imported goods in order to ensure their own access to furs, adopting such strategies as presenting the most important hunters with full suits of clothes and 'chief's coats'.

Depictions of the tattooing mentioned by Wentzel, as well as extant weapons, ladles, antler arm-bands, amulets and other early contact-period objects made by Dene men, display engraved abstract patterns of spurred lines, triangles, and hatching [96]. Scattered but highly suggestive evidence links some of these designs with representations of animal spirits. One late nineteenth-century observer, for example, affirmed the 'symbolical' meanings of certain stylized bone carvings, and provided a drawing of one 'intended to represent a beaver'. 'It will be remarked', he commented, 'that the design is highly conventionalized. Yet, even a child (of Dene parentage, of course) will recognize at once its significance.'[12] Missionaries and other whites regarded tattooing and traditional body decoration as uncouth and 'pagan', in part, perhaps, because they understood these sacred significations, and they actively tried to discourage or suppress them. By the end of the nineteenth century they had largely succeeded.

96 Dene artist

Ladle (mountain-sheep horn, red ochre), *c.*1776

The steaming and shaping of horn to produce ladles is an early Dene art form no longer practised. The delicate etched border, rubbed with red ochre, is representative of a style of abstract linear design that on some objects probably had symbolic and sacred significance. A similar spoon was collected by Captain Cook from the Tanaina in 1778.

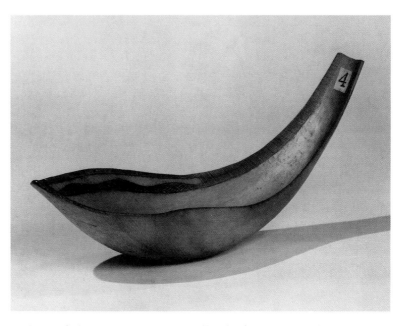

In the Sub-arctic as in the Woodlands, fur traders and missionaries brought with them a new floral design vocabulary that rapidly gained popularity during the first half of the nineteenth century in the Eastern Sub-arctic and during the second half of the century in the West. In the Western Sub-arctic the growth of the Métis presence was particularly important (see Chapter 4, p. 132). The movement into the region of Red River Métis from Manitoba in the 1880s swelled the numbers of already resident Métis who were descended from unions between fur traders and Dene women. The newcomers brought with them a refined and highly accomplished floral style executed in silk embroidery and beadwork, and they also further disseminated distinctive styles of bags (such as the eight-tabbed octopus bag) and tailored garments (such as a short, straight-cut man's jacket). Another important influence on changing artistic traditions was the establishment of schools by teaching orders of nuns. The Grey Nuns opened their first school at Fort Chipewyan in 1849. Here, and at other institutions, Native girls were given instruction in needlework and floral design.

It would be a mistake, however, to think of the transition to these new styles and object types as uniform or stylistically homogeneous. Artistic traditions changed most rapidly in areas close to fur trade forts; elsewhere older ways of making clothing and other objects remained unchanged for much longer. Distinctive regional beadwork styles replaced the regional styles of clothing and quillwork that preceded them; this stylistic specificity has recently become the subject of systematic art-historical study by Kate Duncan and others. Duncan's research has shown, for example, how Dene beadwork designs are built of a relatively small number of 'core' motifs that are elaborated, multi-

plied and recombined in a seemingly endless variety according to local and individual preferences and historical patterns of development. Some entirely new object types were made in beadwork. Sets of dog blankets elaborately beaded with floral designs—a Métis innovation—were adopted by the Dene during the fur trade period to dress dog teams as they approached fur trading forts [**97**].

Although floral beadwork appears to contrast so radically with earlier decorative styles, it continued to express aspects of traditional Subarctic world-views. Cath Oberholtzer's discussion of James Bay Cree beaded hoods further supports this argument. These hoods were made and worn by women during the eighteenth and the first half of the nineteenth century [**98**]. The fur trader James Isham described them in 1743 as made 'of Cloth which they sew behind and Reaches over their Shoulders, all these garments are worked full of Beads, porqu'pine Quil's and other ornaments'.[13] With their wide, dense borders of floral beadwork and bead fringing they are among the most elaborate and complex creations of Cree beadworkers. Women are most often recorded as having worn their hoods to church, but other information indicates that they also continued to serve traditional roles of pleasing the spirits of animals. Edward Nemegus (born about 1867) recalled watching his grandmother 'wearing her cap when watching beaver nets and at feasts, when his grandfather sang and drummed'.[14] Flowers, as plant forms, are part of the food chain so clearly recognized in Cree belief systems and in traditional Innu iconography. The notion that Cree artists used floral forms to affirm the vital importance of nature's cycle fits in with larger cultural patterns.[15]

In 1772 Samuel Hearne (1745–92), one of the first Europeans to

97 Gwich'in (Kuchin) artist

Dog blanket (velvet, beads), before 1912, Great Slave Lake–MacKenzie River area

The arrival of a dog team with its load of furs at a trading post was the occasion for a special visual display enlivened by the musical jingling of sleigh bells. Families stopped before reaching the fort to dress themselves, their dogs and their carioles with ribbon streamers and gorgeously beaded clothing and trappings.

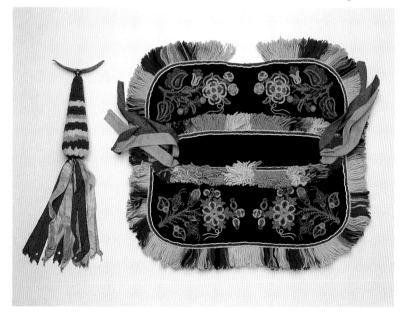

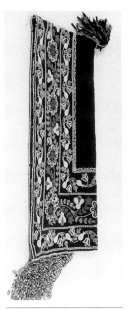

98 James Bay Cree artist

Hood, 1840–65

James Bay Cree floral bead-work displays a delicacy and a continuous, flowing line that contrasts with the bolder beadwork styles that developed later in the Western Sub-arctic. The characteristic separation of the floral motifs into three distinct zones may reflect in a general way the spatial (and possibly cosmo-logical) mapping found in earlier painted hide robes from the region.

travel across the Western Sub-arctic, came across a young Indian woman living on her own in the bush. Having escaped a Cree attack, she had lived for seven months through the long Sub-arctic winter, feeding, sheltering, and clothing herself. Hearne was most impressed, however, that, living all alone, she had exerted herself to make her clothing beautiful. 'It is scarcely possible to conceive that a person in her forlorn situation could be so composed as to contrive or execute anything not absolutely essential to her existence. Nevertheless, all her clothing, besides being calculated for real service, showed great taste, and no little variety of ornament.'[16] Few incidents reveal so dramatically the differences between European and Native world-views, or the importance of clothing as a vehicle of ritual-aesthetic expression in the lives of Sub-arctic people. The young Dene woman created beauty for herself and for a world animated by other non-human presences. She would also have been accustomed to taking advantage of solitude as an opportunity for artistic creativity. Though much has changed for Sub-arctic peoples since Hearne's journey, the importance of making beautiful clothing continues. With their needlework, women pay tribute to husbands and family members and to the land and its gifts to humans [**99**].

The Arctic

For centuries, until the establishment of permanent settlements by the US and Canadian Governments, most Arctic people lived in small no-madic bands that moved over the land in a seasonal rhythm following the migrations of animals. Many Arctic communities are orientated toward the coasts of the northern seas which people traversed in their skin-covered kayaks and larger umiaks. The materials provided by the environment differed from those available to the south. Walrus ivory, antler, bone, and small quantities of stone and wood provided artists with materials for carving. Both the size of the raw materials and the nomadic way of life made smallness of scale a virtue. In the Yup'ik area, large rivers bring bigger driftwood logs from the interior forests in the summertime, making feasible the carving of masks and other, larger, objects. This wood is seen as a gift from the water, since no large trees grow on this flat river delta. Many of these objects have survived in the northern permafrost, and the Arctic presents one of the richest and longest archaeological records in the world. During the past century, collections of Arctic materials have grown steadily as a result of archaeological research, demonstrating the antiquity of art and of hunting ideologies in the far north. In Alaska, in the historic period, thousands of masks and ivory carvings were collected by missionaries, explorers, and anthropologists, especially in the years after 1850. A brisk tourist trade in these items developed at the end of the nineteenth century, caused by the gold rush, the maritime trade, and successive

99

Verna Itsi and her daughter, Fort McPherson, Northwest Territories, 1991

Though not as common as in earlier days, the custom of carrying babies in decorated baby belts continues among Dene women. Verna Itsi wears one decorated with the colourful floral beadwork that has characterized Dene art since the mid-nineteenth century.

100 Okvik artist

Female figure (walrus ivory), c.100 BCE, Okvik, Punuk Island, Alaska

With her expressive face, incised torso, exaggerated genitalia, and legs ending in bear paws rather than human feet, this small figurine suggests an ancient ceremonialism concerned with human fertility and shamanic transformation.

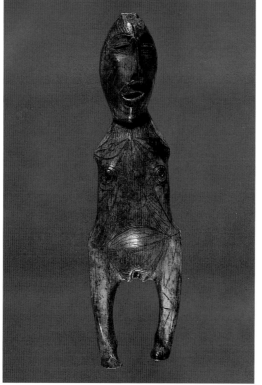

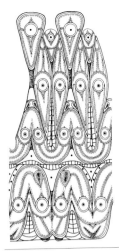

101

Semi-abstract engraved
patterns on a harpoon head,
*c.*100–400 CE, Old Bering
Sea style, Alaska

waves of tourism. Evidence is mounting that Eskimo carvers made many of the 'ethnological specimens' collected during the late nineteenth century specifically for sale.

Ancient artists of the Arctic

Successive waves of Eskimoan peoples have migrated from Siberia, across the Bering Strait to Arctic America during the last 10,000 years. People of the earliest 'Palaeo-Arctic Tradition' were sophisticated tool-makers, but not until after 500 BCE was advanced artistry in non-perishable materials widespread. Although archaeologists have divided the material record into numerous sub-types and regional traditions, in the limited space available here we can only hint at particular techniques and iconographic themes that have great longevity, and that suggest great time depth for cultural and religious practices.

Ancient ivory carvers not only made functional tools for hunting marine mammals, they also elaborated these tools, small-scale replicas, and amulets with incised and carved designs. In coastal regions of North and West Alaska, starting around 500 BCE this cultural complex is termed 'The Norton Tradition', or sometimes 'The Old Bering Sea Culture', with various names for different phases and regions. 'The Dorset Culture' is the name given to the civilization of skilled tool-makers, artists, and sea mammal hunters who flourished across Arctic Canada and Greenland. The Norton or Old Bering Sea Culture and the Dorset Culture are most likely part of one widespread tradition transmitted from west to east, and flourishing in the centuries from 500 BCE to 1000 CE.

One early site was Okvik, on a small island off the coast of St Lawrence Island in the Bering Sea, where archaeologists excavated several dozen small ivory figurines, mostly female, suggesting ceremonialism centring on a female supernatural with both human and animal characteristics [**100**]. Most have expressive faces, and lines incised on their bodies. One holds a bear cub, suggesting that she is an ancestral version of the Bear Mother, a supernatural figure of Arctic and Northwest Coast myth who gives birth to a child who transforms into a bear. Here and at numerous other sites were found large quantities of finely carved and incised ivory harpoon heads, shafts, and winged counterweights. Sinuous designs in semi-abstract style cover the surfaces of these objects, suggesting modern hunters' idea that animals allow themselves to be caught by beautiful implements is a belief of great antiquity in the Arctic [**101**].

At Ipiutak, a thriving community of several hundred households on the shore near Point Hope, Alaska, numerous carved and ornamented tools were found within the households, while burials of great hunters or shamans contained ceremonial replicas of tools, amulets of bears,

walruses, and loons, as well as unusual interlocking chains carved from a single walrus-ivory tusk. The most famous work of art from a burial at Ipiutak is a multi-part mask laboriously carved in ivory, on which low-relief animal heads are combined with the incised circles and curving lines which ornament so many tools and sculptures from the Norton Tradition [**102**].

Characteristic of Norton carving, as exemplified by the Ipiutak mask, is what has been called its 'polyiconic nature'.[17] A seal's head morphs into another form; seemingly abstract designs emerge as abstract faces and heads. This is true of Dorset carving as well [**17**] and persists in both Arctic and Northwest Coast carving styles to the

102

Burial mask (ivory), *c.*100 CE, Point Hope, Alaska, Ipiutak culture

Numerous heads and eyes animate the mask. Even the down-turned mouth with jet inlays representing labrets (jewellery that pierces the lip) reads as an upside-down face. This ivory mask may have had wood or other perishable materials covering the cheeks and eyes of the wearer.

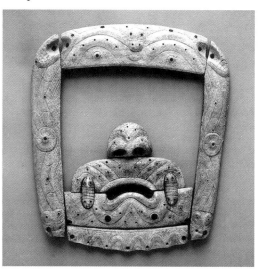

103 Thule artist

Comb (ivory), Thule period, Eastern Canadian Arctic, Inuit

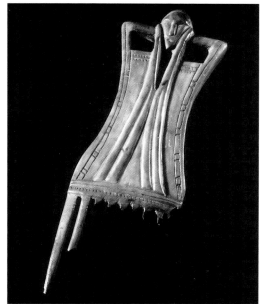

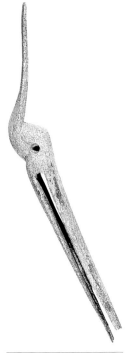

104

Ivory carving of a loon
head from an Ipiutak burial,
*c.*100 CE, Point Hope, Alaska,
Ipiutak culture

Loon imagery is ubiquitous
in the art of ancient Alaska.
At Ipiutak, many burials
contained carved ivory
replicas of loon heads. The
loon, an expert diver, guides
the shaman who penetrates
diverse worlds and sees things
not apparent with ordinary
human sight. In Eskimo myth,
these birds restore the sight
of the blind.

present [**122**]. George Swinton has posited a 'common ancestry of Okvik, Ipiutak, Dorset, ancient Aleut, as well as early Northwest Coast art' in the world-view and art of ancient Siberian hunting peoples.[18]

In the ancient art of the Arctic we find a legacy of fine carving that lasted for some fifteen centuries. All are small-scale and portable, as befits a migratory culture of hunters. The most elegant forms appear in the coastal regions of Arctic Alaska, at sites such as Okvik and Ipiutak, where complex geometric patterning is combined with sleek, sculptural forms. In Dorset art of the Canadian Central Arctic, there is not the same luxurious elaboration of both instrumental and ceremonial goods. Fewer items were carved, and they were crafted with a rough, expressive naturalism [**17**, **103**] echoed in some modern Inuit carving of the same region. The polar bear seems to have been the predominant animal in Dorset ideology; ivory carvings of swimming polar bears, with rather crude incising marking its skeletal structure (in a shamanic type of x-ray vision, perhaps), are found in diverse regions of the Canadian Arctic. In addition to ivory carving, more items of wood, antler, and stone carving occur here than in the Alaskan Arctic.

After 1000 CE, another wave of Eskimoan culture, known as the Thule, arose in the Bering Sea region and quickly spread from west to east across the Arctic. In the East, where Dorset people had been isolated from their Bering Sea relatives for as long as a millennium, the Thule immigrants quickly displaced or absorbed them. Thule people were successful whale hunters; even their architecture reflects this, for they used enormous whale ribs as the framing for the roofs of their turf-covered houses. Modern Arctic peoples are the direct descendants of the Thule, and historical traditions of carving and engraving walrus ivory grew directly out of Thule precedents.

While it is sometimes dangerous to use modern historic data (what archaeologists call 'ethnographic analogy') to interpret archaeological materials, it seems clear that the religious ideologies of Arctic peoples have great temporal depth and coherence across vast distances. Despite the fact that successive waves of people—from the earliest Palaeo-Arctic peoples, to the Dorset, to the Thule and their descendants—settled the North over several thousand years, we find a remarkable uniformity in the conceptual underpinnings of their art: a concern with human-animal relationships, from the success of the hunt to the success of the shaman's journey to the world of the spirits.

A highly elaborated ceremonial and artistic life that centred on shamanism was shared on both sides of the Bering Sea. An early female shaman's grave at Ekven on the Chukchi Peninsula, Siberia, contained men's and women's tools, masks, drums, and other goods.[19] Studies of Siberian and North American Eskimo shamanism in the nineteenth and early twentieth centuries has shed light on the practices

Mask of diving loon (wood, paint, owl feathers), before 1892, St Michael, Alaska

The human appendages perhaps indicate the loon's identification with the shaman as he moves between worlds. The carved loon head opens to reveal a small human face.

of ancient hunters of the Arctic. The ivory chains and loon heads found at Ipiutak [104] have parallels in ancient and historic Siberia, where metal chains and amulets were part of shamanic ceremonial equipment. Loon imagery, ubiquitous at Ipiutak in 100 CE, was still carved on Yup'ik masks further south in Alaska some 1,800 years later [105]; in the last years of the twentieth century, drum dancers in the Western Canadian Arctic were wearing actual loon beaks as part of their caps during winter ceremonial dances that remind humans of their profound ties with animals. Neither the nineteenth-century Yup'ik nor the twentieth-century Canadian Inuit dancers would have had trouble recognizing the power of a loon skull with inlaid ivory and jet eyes buried with an Ipiutak shaman nearly two millennia earlier. The Dorset carver who fashioned the tube ornamented with interlocked walrus heads [17] could easily have bridged 1,500 years and 6,000 kilometres to understand the sympathetic magic that drew the

marine mammals to the visor-clad hunter [**109**] in his kayak in Bristol Bay. The Aleut artist who carved the walrus heads and abstract amulets affixed to his visor was, nearly 2,000 years later, indirectly heir to the tradition of carving and incising walrus ivory with geometric spirals, circles, and other curvilinear designs at Ipiutak and Okvik. In both cases, the intent was to attract walruses by carving inplements in a pleasing manner.

Historic arts of the Arctic

Clothing made from animals is important throughout North America, but nowhere is it as fundamental to survival as in the Arctic North. Eskimo and Aleut bands have endured thousands of years of arduous winters due to the skill of male hunters and female clothing specialists. Three-thousand-year-old bone needles perfectly preserved in the Canadian High Arctic hint at the facility with sewing the skins needed to survive an Arctic winter.[20] Today, the Arctic, while still distant and harsh, is connected to the world economy through airstrip, satellite dish, and computer hook-up, and its people rely on Gore-tex and fibre-fill parkas as well as fur garments. When eighteenth- and nineteenth-century whalers and explorers went north, they had much to learn from native people about northern survival. One of the first things they recognized was the superiority of native garments to their own.

Three examples of Arctic clothing highlight women's artistry in media which include skins of caribou, seal, and walrus, fur of numerous mammals, feathers, skins, and beaks of puffins, cormorants, auklets and other birds, salmon and pike skins, and even walrus and seal intestine [**106, 107, 108**]. The tailored, slip-on parka, usually with a hood, is worn across the entire Arctic. Distinctive tailoring and

106 Iglulik Inuit artist

Shaman's garments, late nineteenth century, Eastern Canadian Arctic

The collector of this garment recounted that Qingailisaq, a shaman, commissioned this outfit to commemorate his encounters with magic caribou people. Its elaborately scalloped, striped, and fringed borders as well as the figural imagery on both front and back make it a unique outfit.

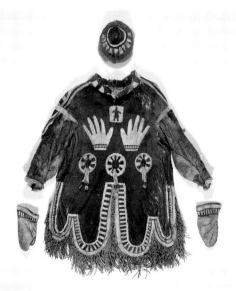

Niviatsianaq in her beaded
amautiq (parka), *c*.1900,
Canadian Arctic, Inuit

Niviatsianaq of Southampton
Island on the west side of
Hudson's Bay was one of the
most exceptional of the late
nineteenth-century northern
artists who produced
innovative work in hide and
beads. She has decorated
her parka in remarkably
detailed fringes and emblems,
including a compass rose and
a lady's high-heeled boot
on the chest. Her braids are
wrapped in decorative
patterns, and her face shows
the traditional tattoo designs
worn by Inuit women.

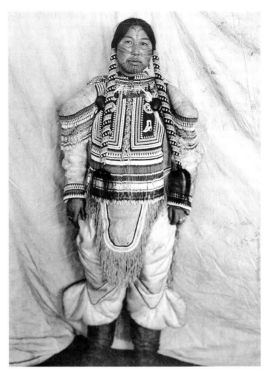

decorative patterns characterize different regions. Inuit women of the Canadian Arctic, for example, generally cut their own parkas with generous hood-like pouches large enough to hold a baby. (This can be seen in the sculpture in **112**.) Sometimes, contrasting colours of animal fur were inset into garments for decorative effect [**106**]. During the winter, the furry side of the garment would be worn on the inside, to hold in body warmth, and even two such layers might be worn.

While such garments were refined and modified over the centuries, some of the most dramatic modifications took place in the late eighteenth and nineteenth centuries. When trade beads became available, women here, like those across lower regions of North America, adeptly incorporated them into a traditional repertoire. Beaded parkas became popular in the Hudson's Bay region in the nineteenth century and remain so today [**107**]. Lightweight fur-trimmed cloth parkas, or parka covers, called 'Mother Hubbards', became popular in Alaska early in the twentieth century, and are still worn. Fine work in skin and hide has been experiencing a revival all across the North, as young women have begun to realize that a vast storehouse of technical knowledge was in danger of dying out with their grandmothers.

Among the most ingenious uses of animal products for human clothing is the working of gutskin (the tough, dense, inside layer of walrus or seal intestine) for waterproof garments. The Aleut are especially renowned for their gutskin parkas, but these were made and worn by Siberian and Alaskan Eskimos too. Extraordinarily flexible, and

weighing just a few ounces, a gutskin parka could be worn over a
regular fur parka when extra protection was needed. Constructed by
seamstresses to protect their male relatives while hunting in icy waters,
some gutskin parkas were constructed to be lashed to the opening of
the kayak to form an impenetrable barrier protecting both the wearer
and the boat's interior. Women would themselves wear gutskin parkas,
not only for rain protection but also to protect their clothing while
butchering animals.

A late eighteenth-century innovation was the gutskin cape, tailored
in the style of a Russian Navy officer's greatcoat [**108**]. Over 100 feet of
intestine can be garnered from one walrus, and about half as much
from a seal, so one or two animals would provide enough material for a
cape. There was evidently a prodigious trade in such capes in the nine-
teenth century, reflecting the merger of an effective indigenous
technology with an introduced clothing form to produce an object
widely traded and admired. Today, some Aleut, Yup'ik, and Iñupiaq
women still work with gutskin.

Just as ivory artefacts signalled the importance of animals and their
powers in the human realm, so too did skin clothing reflect this pre-
occupation. As Valerie Chausonnet has noted,

Animal skin, transformed into a second skin for humans by the work of the
seamstresses, still maintained its animal identity. From the killing of an animal
through the tanning, cutting, and sewing of its skin into a piece of clothing,
the qualities and characteristics attributed to it in life were maintained
and passed on to the wearer of the finished garment. This important spiritual

principle linked animals, hunters, and seamstresses together in an intricate and circular set of relationships.[21]

Male hunters procured the animals and female artists transformed them into clothing that was both physically and spiritually protective. Moreover, respect for the living animal also dictated respect for each of its component parts after death. Rita Pitka Blumenstein, a contemporary Yup'ik artist, relates:

In respect for the fish and the seal, you use every bit of it: the head, the insides, the bones, and the skin of the fish. And then whatever we don't eat goes to the dogs. The bones go back to the river or the lake, wherever you caught it from. If they're from the ocean, you take them there. That will ensure more fish in the next years. If it's a seal, same way. The bladder goes back to the sea. The seals will come back. You bury the bones near the sea so you won't find them floating all over the beach. I appreciate very much the respect for things when I was growing up. So you use every bit of it—the bones for tools, the insides for clothing, eat the kidneys and liver and the meat. Use the seal oil also. The stomach is used for storing the seal oil and for when you gather salmonberries. The skin you use for parkas, mittens, or mukluks. The bones you use for scrapers, runners for sleds and for tanning. The whiskers are used for toothpicks, and the faces are used for ornaments. The bladder goes back to the sea.[22]

Among the Yup'ik, sending the bladder back to the sea was part of an elaborate performance that involved carved and painted masks. Indeed, masking was more highly developed in the Yup'ik region than anywhere else in the Arctic. As discussed for other regions of North America, these masks can best be understood in the context of dance, gesture, song and drumming, as well as in the context of pan-Arctic beliefs about souls. Most Arctic peoples believe that all the world is animate, and that animals have souls or spirits (*inua* in the Iñupiaq language, *yua* in Yup'ik). Some masks represent the animal spirits encountered by shamans; other masks worn by non-shamanic dancers depict animal spirits in the broader sense. As Dorothy Jean Ray has described it, these did not represent a single animal, 'but the vital force representing a chain or continuum of all the individual spirits of that genus which had lived, were living, or were to live. Therefore, when a human face or representative part of it such as a mouth or an eye was placed on a seal spirit mask, it did not represent an individual seal, but an abstraction of the entire genus of the seal's spirit.'[23]

The Bladder Festival, which opened the winter ceremonial season, ensured success in hunting by memorializing all of the game animals killed in the previous year. Because the animal's soul was thought to reside in its bladder, the bladders of game animals were saved, inflated, painted, and hung in the ceremonial house, then released back to the sea to transmit a message of homage and respect to the living seals. As Ray points out, however, propitiating the game animals was not the

only reason for community performance: 'The complicated staging and long practicing for dancing roles were perfected by performers for human as well as spiritual critics. The various long winter festivals, although aimed primarily at fusing the spiritual world with the earthly one, were in many cases ... occasions of great importance to the solidarity of intertribal relations, and all entertainment was prepared with that in mind.'[24] As on the Northwest Coast, winter festivals were the opportunity for lavish gift-giving and displays of generosity (see Chapter 6).

Yup'ik masks exist in a remarkable variety for they represent not only idiosyncratic visions by particular shamans but also the great freedom of expression afforded to individual carvers. Collecting cottonwood or spruce limbs that had floated down-river from the vast forests of the interior, they would carve and paint the masks, and adorn them with flexible willow-root hoops, as well as feathers. (Today, in the resurgence of carving taking place in some Yup'ik villages, some maskmakers carve replicas of the feathers of birds that are protected by US environmental laws, while others, asserting that laws concerning religious freedoms supersede environmental laws, claim the right to hunt the birds they need for the making of masks.)

Yup'ik women rarely wore masks, except in the case of female shamans; female dancers often wore, and still wear, 'finger masks' carved of wood and adorned with feathers to accentuate their delicate hand gestures.

Unlike masks in some other parts of Native North America—such as Pueblo masks whose power and sacredness require that they be hidden, nourished, and refurbished from year to year, or Northwest Coast masks which are the prized property of individuals or clans—Yup'ik masks were normally made for one occasion, then destroyed or abandoned. Explorers and traders thus found it easy to buy masks, and in this way thousands of Yup'ik masks were collected by agents for the Smithsonian Institution as well as several European museums.

Yup'ik and Aleut carvers sometimes used steamed bent-wood technology, like their Tlingit and Haida neighbours to the south (see Chapter 6). Bent-wood containers and hats were popular nineteenth-century forms [109]. While these distinctive visor-shaped painted or decorated hats are commonly thought to be Aleut in style, in fact, they were made and worn throughout the Yup'ik area as well.

During the historic era, Canadian Inuit carvers, like their Dorset and Thule predecessors, continued to make amulets and equipment of ivory. In addition, they carved small-scale models of kayaks, animals, and human figures to market to northern explorers and traders. But such carvings for the tourist trade were much more plentiful in coastal Alaska, where the sheer volume of whalers, explorers, gold-seekers, and tourists caused an explosion in arts for the curio trade. Thirty

Aleut-style visored hat (wood, ivory), c.1820, Norton Sound, Alaska

In this hat, the semi-abstract bird heads and the long, pointing walrus tusks set up a pleasing rhythm that echoes the long, angled shape of the hat itself.

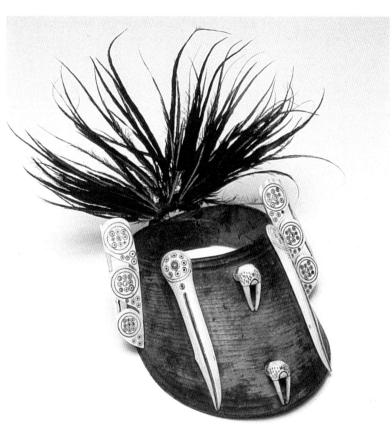

thousand prospectors arrived in Alaska in 1900 alone; they and the tourists who followed wanted souvenirs of their northern visit. Male ivory carvers and female basket weavers were happy to provide such commodities. Aleut basketmakers, to mention just one example, made small, elegant baskets for the Russians and subsequent visitors. Their chief characteristic was the fineness of weave. Successive waves of smallpox and influenza decimated the Aleut population; their capture and evacuation during World War II was responsible for almost extinguishing their artistic traditions. Today, only a small number of weavers and carvers work in the old style.

By far the most widespread artefacts made for sale were ivory carvings which grew out of an indigenous Iñupiaq tradition of carving walrus tusks and engraving them with small-scale pictographic scenes. The bowl drill, an indigenous tool for carving the obdurate ivory, was often etched with such depictions, including scenes of animals, hunting parties, and village life. Tusks were carved into non-functional pipes, walking-stick handles, and cribbage boards [**110**]. Small pieces of ivory were fashioned into buttons, miniature tools, salt and pepper shakers, and jewellery. Nome was, and remains, the centre of this northern carving style.

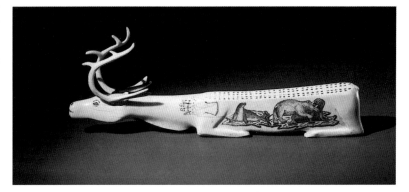

One other distinctive North Alaskan art form worthy of mention is the baleen basket.[25] Made for the tourist trade after 1915, it too, like so many northern arts, evinces a remarkably ingenious use of animal products. Baleen, the giant, fingernail-like plates that hang from the mouth of whales in order to filter the tiny plankton they eat, was harvested and torn into thin strips. Men in northern coastal communities began to weave baskets of these strips, and carved ivory knobs for the lids. Elsewhere in the Arctic, basketry was a women's art, as it was over most of North America, but here, as an introduced art form, it developed principally as a male occupation, possibly because its materials were so strongly identified with whalers and ivory carvers.

Contemporary arts in Arctic Canada and Alaska

Many Canadian Inuit continued their traditional nomadic way of existence until the 1950s when famine, disease, and poverty forced them to settle into permanent villages set up by the government. The modern practice of making sculpture, prints, and drawings for sale to outsiders was soon established in these settlements. For around fifty years now, in many Arctic communities the making of art has become a defining feature of Inuit life. In most instances, art has been marketed through a local community co-operative. The Inuit co-operative movement started in the 1950s in response to the breakdown of the traditional Inuit economy and the ensuing reliance on a cash-based system. Its initial leaders were, for the most part, the most successful male hunters and trappers—that is, those who were formerly among the highest-status members of a relatively egalitarian society.[26] By featuring consensus, limited hierarchy, and group effort, the co-op continues traditional Inuit ideals. Art co-ops were among the first to be created, although in many communities fishing and other activities are far more profitable.

Since the 1960s, several communities have issued their own annual editions of art prints. The West Baffin Eskimo Co-operative at Cape Dorset, the oldest and most famous, has marketed annual editions since 1959, with a cumulative production of over 2,000 different images

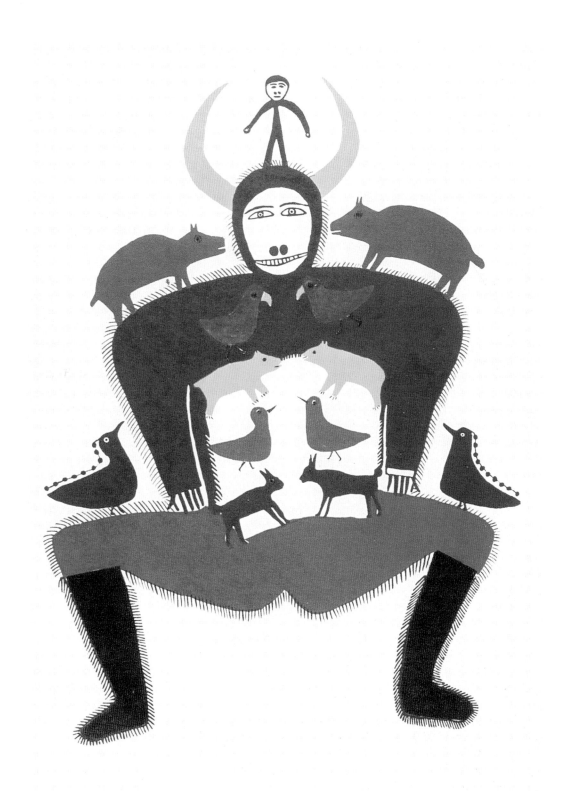

Jessie Oonark has achieved spectacular recognition for her work. One of the most renowned Inuit graphic artists, she was elected to membership of the Royal Canadian Academy of Arts in 1975, and was awarded the Order of Canada, the country's highest recognition of achievement by a citizen, in 1984. Oonark was born around 1906 on the west side of Hudson's Bay, and moved to the settlement of Baker Lake in the 1950s, where she lived until her death in 1985 [**111**]. Her strong graphic talent was recognized by outsiders in the late 1950s, and her drawings were sent from Baker Lake to Cape Dorset to be made into prints, for at that time, Dorset was the only settlement issuing prints. Later, Oonark's singular talent was rewarded by an art adviser at Baker Lake who gave her her own studio, reminding us of Virginia Woolf's famous dictum that a female artist needs a room of her own to create. She was also awarded a small salary to free her creativity from economic constraints—she had been working as a janitor in the village school. Oonark went on to become a major force in the development of the graphic arts programme at Baker Lake in the 1960s and '70s, producing hundreds of drawings from which over a hundred prints were made.

Accomplished in the old-time arts of skin and hide sewing, she also became active in the development of modern textile arts at Baker Lake, making felt and wool wall-hangings which depict the same imagery found in her prints and drawings.

All of her children are artists as well. The two most celebrated, her daughters Victoria Mamnguksualuk (b. 1930) and Janet Kigusiuk (b. 1926), have contributed many prints to the annual Baker Lake print editions since 1971, as well as producing original drawings and wall-hangings.

(in editions of fifty or fewer). In Cape Dorset, graphic artists generally sell their drawings to the co-op. From a large inventory of drawings, the co-op staff decide which images to print in a particular year. Several printmaking techniques are used, including stencil, etching, engraving, lithography, and an unusual stone-cut method that is unique to the Inuit: in a process analogous to the Japanese woodcut, it involves cutting the image right into the stone block from which the prints are to be made. Other communities, such as Baker Lake and Holman, followed Cape Dorset's lead in printmaking. Among the foremost artists at Baker Lake was Jessie Oonark [**111**].

The development of Inuit stone carving followed a different course [**112**]. According to Nelson Graburn, in the mid-1950s when the Hudson's Bay Company posts in the North began to buy carvings, many buyers strategically bought works only from the most successful trappers, in order to ensure that the Hudson's Bay Company would hold a monopoly on the skins as well. This tactic disenfranchised women from earning money through carving.[27] To this day, only a small number of women pursue active careers as carvers, although many have tried their hand at it. One of the few women who has achieved acclaim in this medium is Ovilu Tunnillie, who began to carve as a teenager under her father's tutelage, and is well known today for her sleek, highly polished works of art [**113**]. Today, sculpture is

often marketed to the outside world in a less institutionalized way than prints, with individuals sometimes selling their own work to tourists and galleries, rather than through middlemen or the co-op.

For centuries, across the Arctic, women worked in soft materials—animal skins, grass basketry, and cloth—while most carvers and mask-makers were male. There are no inherent social ideas about gender in graphic arts, an introduced medium, and female artists among the Canadian Inuit have achieved an unparalleled level of participation and recognition in the aforementioned graphic arts. Women's facility with different aspects of the graphic arts process—from drawing on paper, to cutting stencils, to printing multiple images—has often been attributed to the similarities of these processes to traditional female arts of skin-sewing and clothing manufacture. Through cutting, insetting, and appliquéing skin and cloth, women were accustomed to using outline patterns, and two-dimensional forms, and took readily to graphic arts.

In contrast to most ethnic art traditions marketed to the Western world, Inuit art has, since the late 1950s, been presented to outsiders as art made by particular individuals. Most sculpture has the artist's name incised on the stone; all prints are signed with the name of the artist upon whose drawing the print is based, and sometimes the printmaker is given credit as well. The subject matter of such art is, by an overwhelming margin, depictions of traditional life of hunting, skin-sewing, and living in igloos.

Contemporary Inuit prints and sculpture have sometimes been criticized as being not 'real' indigenous art, but merely touristic productions introduced by outsiders, with no basis in traditional Inuit life.

112 Johnnie Inukpuk (1930–84), Inuit

'Mother and Child' (stone, walrus ivory inlay), 1953, Inukjuk, Arctic Quebec, Canada

A classic early piece of vigorous contemporary stone carving, this small (6") sculpture depicts a mother at work while her baby nestles inside the voluminous hood of her parka.

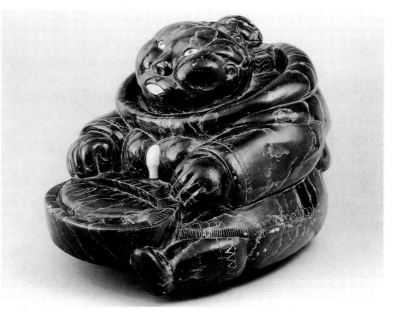

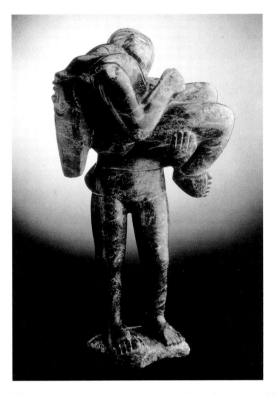

113 Ovilu Tunnillie (b. 1949), Inuit

'Woman Passed Out' (green stone), 1987, Cape Dorset, Canada

Very few Inuit artists address indigenous social problems in their work; here, the artist comments on the effects of alcoholism in northern communities.

Yet it is important to recognize that these arts, like many made in indigenous communities across North America, are multi-vocal, simultaneously fulfilling the differing needs of Native artist and non-Native audience. For much of the southern audience which buys them, the works of art depicting traditional Inuit life-ways fulfil a need for a fictive 'Other' who exists in a world we nostalgically see as primordial and unspoiled. This is, indisputably, part of what has made contemporary Inuit art an annual multi-million-dollar industry. But at the same time, it is important not to lose sight of the fact that at Cape Dorset, for example, a community of a few hundred people has produced over 100,000 drawings for only small financial reward, over a forty-year time span. Only 2 per cent of the drawings have been used in prints, so clearly something in the endeavour fulfils local needs as well. By using the visual arts as one mode for defining their identity in a rapidly changing modern world, Inuit artists insist on the persistence of their own unique cultural identity. To represent the past, and to inscribe one's place in it, are fundamental to art making. It may be that, in romanticizing their own history, Inuit artists are taking part in a historicizing impulse that is common in many cultures.

Moreover, as discussed above, women's participation in the movement of artistic co-operatives across the North is an important aspect of modern Arctic life. Unexpected changes ensue in the process of artistic interaction between traditional societies and the modern

Western world, when new materials, new markets, and new artistic processes are introduced. Occasionally, women's artistic and economic positions within their cultures are strengthened because outside markets clamour for their arts. In North America, this has occurred in the marketing of Pueblo pottery, Navajo weaving, and Inuit graphic arts. Unfortunately, throughout much of the so-called third and fourth worlds, it is much more common that colonization and the resulting interference in indigenous artistic and economic systems by outsiders (with their Eurocentric and male-defined models) have directly caused the erosion of women's status and economic position. For this reason, the Inuit example is a particularly salutary one. An artistic climate exists that successfully combines Inuit artistic genius, economic self-determination, traditional modes of decision-making, and Southern marketing techniques.

So far, two generations have participated in sculpture and graphic arts production across the Canadian Arctic. Among a younger generation, there are several sculptors who have studied at art schools, and have received a recognition within Canadian art that transcends their affiliation as Inuit artists. A generation of artists, in their twenties and thirties at the time of writing, is experimenting with more modern modes of art production, such as video, which has the prospect of communicating, through the Inuit Broadcasting Corporation, to communities across the North.

In Alaska, contemporary art has developed in several directions.

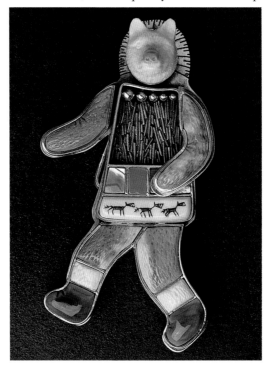

114 Denise Wallace (b. 1957), Chugash-Aleut

Wolf Transformation pin/pendant (silver, etched fossilized walrus ivory, mother of pearl, and stone), 1988

Contemporary jeweller Denise Wallace, though raised in Seattle, draws upon her maternal Aleut heritage. Having learned metalworking at the Institute of American Indian Art in Santa Fe, she combines a Southwestern-style expertise in stone and silver with the Arctic imagery that was her ancestral birthright. Building upon northern themes of transformation, many of her pieces (produced in collaboration with her husband, lapidary artist Samuel Wallace) transform from pins to pendants. In some cases, elements are removable, or open to reveal a different face within.

Because Alaska is not as isolated as the Canadian Arctic, Alaskan artists have been in contact with each other and with outsiders for more than two centuries. Many contemporary arts, such as masks and painted drums, are made for community use. Ivory carving and basketry, both of which are still viable arts, developed out of the booming souvenir trade a century ago, and still serve an outside market. Experiments in painting and large-scale sculpture were, at first, dependent on just a handful of art school-trained artists. Ronald Senungetuk (Iñupiaq, b. 1933), who studied at the Rochester Institute of Technology, began a Native Arts Program at the University of Alaska at Fairbanks in 1965, which trained many Alaska Native artists. It is now run by painter Alvin Amason (Aleut, b. 1948). A number of Alaska Native artists attended the Institute of American Indian Art in Santa Fe (see Chapter 7). These include Aleut artist Denise Wallace [114], and Iñupiaq artists Melvin Olanna (1941–91) and Lawrence Ahvakana (b. 1946), both sculptors.

While a modest printmaking programme based on Canadian Inuit prototypes was briefly tried in the 1960s, it did not catch on. Compared to Canada, there are fewer institutional channels for marketing Native art in Alaska. The Alaska State Council on the Arts has underwritten a Master Artist and Apprenticeship Program which reaches into Native communities. Notably, some of the regional Native Corporations in Alaska have been patrons for art projects, as has the state government, which in 1975 instituted a 'Percent for Art' programme which has placed Alaska Native art in airports, federal offices, and other public buildings.

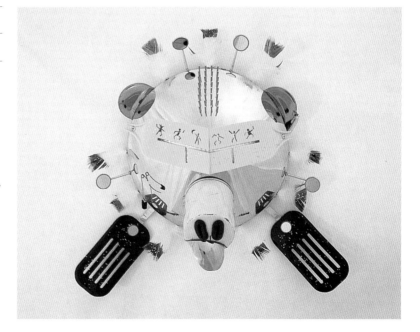

115 Lawrence Beck (1938–94), Yup'ik

'Punk Nanuk Inua' mask (mixed media), 1986

This Punk Polar Bear Spirit Mask reveals what is truly traditional in contemporary Native art: the unendingly creative use of materials. A clear descendant of an ancient Yup'ik mask-making tradition, it is also a proto-typically postmodern work, with its hip improvisational wit, and its appropriation of dental tools, automotive oil filters, kitchen spatulas, and safety pins to fashion a spirit mask appropriate for the end of the millennium.

Not surprisingly, much of the work by contemporary Alaskan artists carries on a dialogue with works of the past, sometimes through innovative uses of traditional materials or iconographies. In other instances, as in the work of Lawrence Beck [115], innovative materials present a centuries-old iconography. Rather than continuing to use highly regulated natural materials for art-making (some of which come from endangered species) like ancestral Yup'ik mask-makers (compare 105), Beck turned to the recycling of modern materials to demonstrate that a twentieth-century artist can address tradition creatively through materials of the consumer environment.

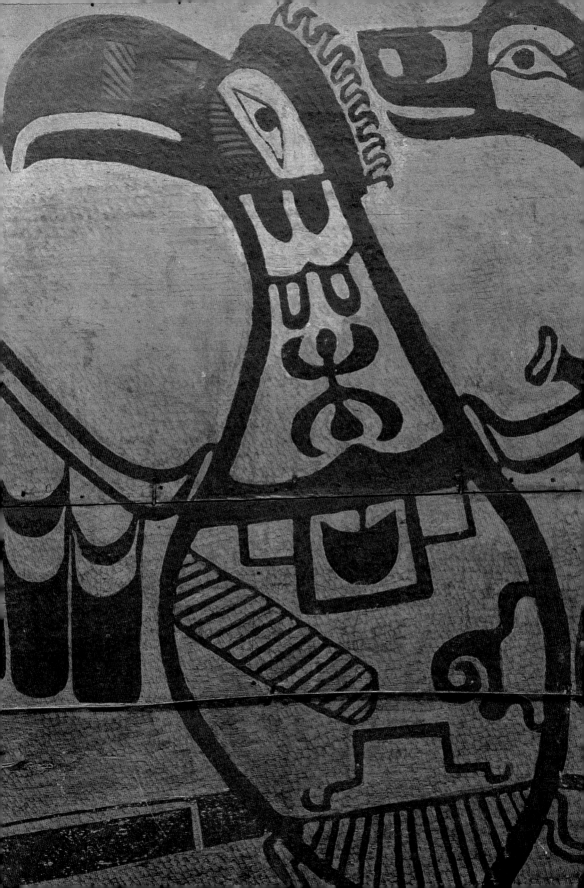

The Northwest Coast

Origins

In Bill Reid's monumental sculpture 'The Raven and the First Men' the artist portrays the Haida culture hero Raven in the act of discovering the first men inside a clam shell [**116**]. In a typically tricksterish act, Raven opens the clam shell and coaxes the little beings out into the world. In due course, to add to the interest of his experiment, Raven flings chitons at the groins of these first men, and out of this encounter come the men and the women who are the ancestors of humankind.

In Reid's representation of ancient Haida truth, people emerge, by virtue of Raven's curiosity, not, as in the Judeo-Christian tradition, into a perfect Eden which they must forfeit for their own sin of curiosity, but directly into the mixture of wonder, confusion, pleasure and pain that characterizes life on earth. Reid has written evocatively of these first Haida and the world they made:

No timid shell dwellers these, children of the wild coast, born between the sea and the land, to challenge the strength of the stormy North Pacific and wrest from it a rich livelihood. Their descendants would build on its beaches the strong, beautiful homes of the Haidas and embellish them with the powerful heraldic carvings that told of the legendary beginnings of the great families, all the heroes and heroines, the gallant beasts and monsters that shaped their world and their destinies. For many, many generations they grew and flourished, built and created, fought and destroyed, lived according to the changing seasons and the unchanging rituals of their rich and complex lives.[1]

In Reid's masterpiece the central image is of the trickster, the 'huge and cocky Raven squatting possessively over his prize', as Doris Shadbolt has described him.[2] It sets before us two key aspects of Northwest Coast world-view and art, a strong sense of the paradoxical nature of the human condition, and an awareness of possibilities for transformation hidden within the mundane. The unanticipated and remarkable resurgence of traditional Northwest Coast art during the second half of the twentieth century might itself be considered to exemplify these qualities, since it is part of a new creative epoch born out of the extreme disruption of colonialism. 'The Raven and the First Men' is both old and new. It employs the instantly recognizable

Detail of 124

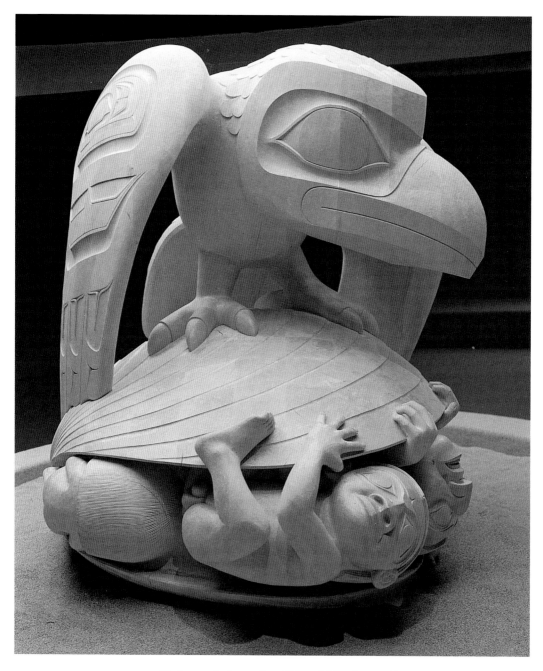

stylistic vocabulary of traditional Northwest Coast art, yet it is without precedent. It illustrates a traditional Haida story, yet the scene it shows is unknown in previous Northwest Coast visual art. It is monumental in scale, like historic totem poles and architectural sculpture, yet it is conceived as a free-standing and self-contained work of art in the manner of Western sculpture.

The role of art in the contemporary politics of identity has deep

'The Raven and the First Men'
completed in 1983

Reid has used Northwest
Coast formline style with equal
versatility in the miniature
scale of jewellery and the
monumental scale of public
sculpture. In one of his best-
known works he exploited
the expressive capacities
of Haida art to imagine the
emotional responses of the
first humans as they emerged
from a clam shell on to the
surface of the earth.

roots on the Northwest Coast, where visual art has long been a key means of expressing group identity and political power. As we will see in this chapter, throughout the region, but particularly in the northern and central areas from which the best-known art comes, visual art and performance are integral to the narration of family histories. Inherited images, known as crests, symbolize these histories. When they are properly presented and witnessed at ritual celebrations known as pot-latches, the crests and their stories explain, validate, and reify the tradi-tional social order, and affirm the acquisition of power by members of high-ranking families and the ownership of land.

In the 1950s, when Reid first began to study the art of his ancestors, artists and scholars, as well as First Nations chiefs and elders, assumed that the traditional pre-contact ways of life and art had vanished for-ever under the impact of colonialism and Western scientific rational-ism. Even a sympathetic ethnologist such as Philip Drucker, who in his standard 1955 ethnography acknowledged the remarkable factual accuracy of orally transmitted family histories, felt obliged to except 'the occasional supernatural events that they recount'. These, he stated, 'we may regard as a sort of literary trimming'[3]—a phrase that would not have been applied to similar stories of transformations and miracles that occur in the Bible and European art. The changes that have since occurred can be measured by the fact that, forty years later, the right of Nisga'a chiefs 'to tell their *Adaawak* [oral histories] relating to their *Ango'oskw* [family hunting, fishing, and gathering territories] in accordance with the *Ayuuk* [Nisga'a traditional laws and practices]' was written into a document to be used in establishing their propri-etary rights over everything from chiefly titles, houses, totem poles, and masks to lands and fishing rights.[4] As in other parts of the continent, then, late twentieth-century indigenous visual expression and post-colonial politics are often tightly bound together.

The Northwest Coast culture area is defined as a narrow strip of coastal land and adjacent islands some 1,500 miles long. It extends south from the Copper River in Southern Alaska to the Oregon–California border, and eastwards to a nearly continuous series of inland mountain ranges that cut off the region from the rest of the continent. The region's geography has largely isolated it, especially in the north, undoubtedly contributing to the coherence of Northwest Coast artistic traditions. Access to the interior, however, is offered by several large rivers, notably the Skeena in Northern British Columbia, the Fraser in the southern part of the province, and the Columbia River in the state of Washington. These and other rivers have permitted migration, trade, and cultural exchange with Native peoples to the east, relatively limited in the north and more extensive in the south.

According to archaeologists, humans first settled on the northern coast at the end of the last glaciation, about 10,500 years ago, when the

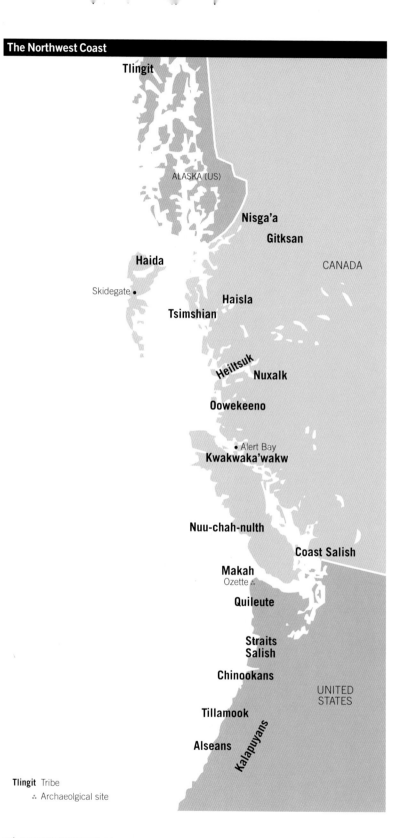

Tlingit

ALASKA (US)

Nisga'a

Gitksan

Haida

CANADA

Skidegate •

Haisla

Tsimshian

Heiltsuk

Nuxalk

Oowekeeno

• Alert Bay

Kwakwaka'wakw

Nuu-chah-nulth

Coast Salish

Makah

Ozette ⸪

Quileute

Straits
Salish

Chinookans

UNITED
STATES

Tillamook

Kalapuyans

Alseans

Tlingit Tribe
⸪ Archaeolgical site

retreating ice opened a corridor to the north. By about 12,000 years ago
people coming into the southern area had moved into the Puget Sound
area in Northern Washington State, drawn by the region's extraordin-
arily rich and reliable resources of fish, sea mammals, game and vegeta-
tion. It is probable that, by 5,000 years ago, the ancestors of nearly all of
the contemporary peoples of the coast had arrived.

At the time of European contact in the late eighteenth century, the
indigenous population of the coast may have numbered as many as
200,000,[5] making the Northwest Coast one of the most densely popu-
lated regions in the world where subsistence was based on fishing,
hunting, and gathering rather than on farming. Paramount among
these resources are the great numbers of salmon that swim up coastal
rivers each summer and which, historically, people harvested using a
number of different technologies, including harpooning and the build-
ing of elaborate weirs across river beds. The eulachon or candle fish
was especially prized for its rich oil, and sea mammals were widely
hunted throughout the region. Certain Nuu-chah-nulth, Makah,
Quileute and Quinault families of Southern Vancouver Island and
Northwestern Washington also hunted whales. The remarkably
versatile properties of the red and yellow cedar were fully exploited
throughout the Northwest Coast. It was by far the most important
source of wood for carving utensils and art objects and for building the
large multi-family plank houses constructed throughout the region
[117]. Shredded cedar bark, woven into capes, blankets and skirts, was
also the major material used in clothing everywhere but in the south,
where land animals were more widely hunted and hide was readily
available.

The linguistic diversity of the Northwest Coast suggests that its
modern inhabitants are descended from ancestral groups who entered

the region at different times and from different directions, attracted by its moderate rainforest climate and its rich food base. In historic times, at least forty-five different languages belonging to thirteen separate language families have been spoken by Northwest Coast peoples. (In contrast, in the whole of the vast Woodlands region there are only two language families.) Although the regional commonalities of belief and lifestyle that developed on the coast are more geographically than language based, an awareness of linguistic relationships is important in tracing older, pre-contact histories of artistic development.

Scholars commonly describe Northwest Coast art in terms of three sub-areas or 'style provinces' defined both by internal stylistic similarities and by similar ceremonial and spiritual contexts for art.[6] In the northern province, much visual art has historically been used for the display of family crests and in more specialized shamanistic practices. This region includes the Tlingit of Southern Alaska, the Haida of the Queen Charlotte Islands and Southern Alaska, the Tsimshian-speaking peoples (who include the Nisga'a of the lower Nass River, the Gitksan of the Skeena, and the coastal Tsimshian), as well as the Haisla who are linguistically related to the Kwakwaka'wakw. Up and down the coast, winter was the season when people were freed from the work of food harvesting to engage themselves in ritual renewal and celebration. In the northern and central regions these ceremonials feature not only crest displays on architectural carving and clothing, but also elaborate masquerades and theatrical performances during which the origin stories of family prerogatives are re-enacted. The central style province includes the Salish-speaking Nuxalk (Bella Coola), and most of the peoples whose languages belong to the Wakashan family: the northern Heiltsuk, Oweekeno and the Kwakwaka'wakw, and the closely related Nuu-chah-nulth, Ditidaht, and Makah.

In the southern region, the maintenance of social hierarchy through art and ceremonialism is less stressed, although potlatching and power or supernatural display are present. The more lengthy period of contact and the early white settlement of the area disrupted traditional ritual and artistic activity earlier and the region therefore produced less sculpture and painting during the period of active collecting. The peoples of the southern Northwest Coast have for centuries had steady trading contacts with Native peoples to the east. The vision quest and the cultivation of personal guardian spirits is important for southern coastal peoples, just as it is among their trading partners on the Plateau and Plains, and is enhanced by visual artistic expression. Although wood carving is highly developed in the south, basketry and textiles are also major art forms [118, 127]. The southern province is the most culturally and linguistically diverse, including the Coast and Straits Salish-speaking peoples on whose ancient homelands are located the modern cities of Vancouver, Seattle, and Victoria, and a number of

smaller groups to the south including Chinookans, Tillamook, Kalapuyans, and Alseans in Washington and Oregon.

The main features of Northwest Coast art and society have a long history of formation that reaches back at least 4,500 years. Archaeological research on the coast is relatively recent compared to other parts of North America, and although new information continues to come to light it is still fragmentary for most areas. Some of the richest and most exciting discoveries have been made in southern British Columbia and northwestern Washington, and these testify to five millennia of continuous development of artistic traditions in the region. A brief account will document the archaic style that appears to underlie all of Northwest Coast art as well as the time depth that also lies behind the nineteenth- and twentieth-century arts of other parts of the coast.

Artfully worked stone, bone, and antler objects began to appear in archaeological sites along the Fraser River in southern British Columbia between 3500 BCE and 1500 BCE. The people of the Pebble Tool Tradition, as archaeologists have named it, are probably ancestral to the modern Coast Salish, Nuu-chah-nulth and Kwakwaka'wakw nations of the central province. The archaeological evidence suggests that these people held potlatch-like feasts and that some individuals wore lip ornaments known as labrets. Both features suggest social systems marked by clear distinctions of status or class similar to those of post-contact times. They began to engrave geometric designs on some of their tools and to sculpt other objects such as hand mauls (tools used to split planks) into artistically worked forms, some of them representational. The introduction of tool types such as ground stone chisels and adze blades indicates the existence of plank houses and wood carving. Weaving and basketry found in Fraser River delta wet sites (which preserved them from decay) date back to 2500 BCE. By about 800 BCE, elements of the formline style (see below) were already

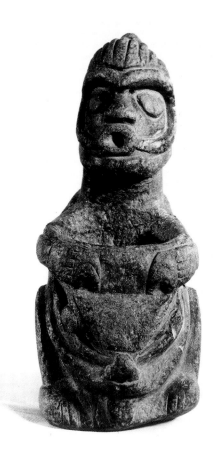

present in the art of the Coast Salish of the Fraser River delta (modern-day Vancouver).

By the first millennium BCE some remarkable stone carvings were also being produced in the Fraser River area, including bowls and effigies that feature animal and human forms that conceptually resemble those carved in wood in the historic period. One of the most complex of these sculptures, produced during the Marpole phase (400 BCE to 400 CE) is carved in the form of a seated human figure whose lap or abdomen forms a bowl-like receptacle [**119**]. About sixty-five have been found. Some modern elders identify these archaeological carvings as medicine bowls of a type used in girls' puberty ceremonies. The ethnologist Wilson Duff suggested that there may also be a conceptual similarity between these bowls and the feast dishes and other carvings of the post-contact Kwakwaka'wakw.[7]

A remarkable site uncovered in the 1960s and '70s has given us by far the most vivid picture of the art and life of peoples of the region two centuries before contact. The site, known as Ozette, is on the Olympic Peninsula, on the land of the Makah. Some time around 1500 CE a mudslide covered part of a village, preserving from decay four plank houses and over 50,000 objects, including many made of perishable

materials such as wood and basketry that would not ordinarily have survived. The larger carved objects from Ozette include wooden boxes, a large bowl carved in the effigy of a human being, whale-bone clubs, and weavings [**125**]. They revealed the existence by 1500 (and undoubtedly many years prior to that) of an elaborate inventory of decorated objects on the south central Coast and of highly refined artistic styles which varied within a single community from abstract to naturalistic modes as they have in historic times.[8] Archaeological research on the northern Coast has also revealed the use of figurative effigies during the first millennium BCE, some depicting animals familiar from historic-period art and oral tradition, such as the raven. According to George MacDonald's[9] archaeological research, by about 1000 CE all the main stylistic elements and object types of the historic northern art were already in place.

The early contact period

European explorers began to visit the Northwest Coast during the late eighteenth century, two centuries after Native–European contact had begun on the Atlantic Coast. An active trade rapidly developed up and down the coast organized around the market for sea-otter pelts, which the merchant captains could sell in China at enormous profit. Preservation of the oldest examples of post-contact art are owed to these explorers and traders, many of whom participated in the period vogue for the collecting of 'curiosities'. Some of the most important information comes from the more systematic collections made by scientific expeditions like those of Captain James Cook (1778) and Captain Alejandro Malaspina (1791). Cook, who visited the Nuu-chah-nulth (Nootka) in 1778, made the single largest extant collection, now housed in several European museums.[10] It contains examples of blankets (some of which may be Salish), hats, combs, rattles, wooden heads and masks (some of which may be Kwakwaka'wakw), weapons, and whalebone clubs.

The resemblances between many of the Cook pieces collected on southern Vancouver Island and those uncovered at Ozette are striking, and attest not only to the close cultural links between the Makah and the Nuu-chah-nulth but also the stability of the arts and cultures of this region over more than three centuries. The strength of these tradi-tions can be appreciated by imagining a parallel: a Makah explorer arriving in Siena in 1778 and finding people creating art in the mode of Donatello or Botticelli. The early expeditions also left us sketches and water-colours that offer precious glimpses of house interiors and of the visual arts that enriched everyday life, such as figuratively carved houseposts, basketry, weaving, and finely carved wooden storage boxes. The collections and descriptions of the late eighteenth and early nineteenth centuries do not, however, present a complete record of the

visual culture of the Northwest Coast because the traders were often not present during the winter when the most important ceremonial cycles took place, and most therefore missed the masked performances and displays of crest art presented at that time.

The trade in sea-otter fur that lasted until about 1810, the commerce in land-based fur that went on until the end of that century, and increasing white settlement introduced into the life of the Northwest Coast a mixture of new conditions that were rapidly to destabilize cultural patterns of long standing. Most radically and most tragically, death from disease on a scale never before experienced affected all parts of the coast during the late eighteenth and the nineteenth centuries. Within a hundred years the population declined by over 80 per cent, from an estimated 200,000 at contact to only 40,000 around 1900. It is hard to imagine, here as for other regions of North America, the sheer extent of the loss or its effects on the survivors. Disease killed many people who held cultural knowledge, and who would normally have inherited important rank and privilege, leaving more distant relatives to succeed. At the same time, the fur trade made easier and faster the process of accumulating the goods needed to hold potlatches (the great feasts where chiefly power is publicly acknowledged). The cessation of warfare and the greater numbers of marriages between members of different nations also created new needs for the performance of rituals and related displays of art and cultural property that are necessary to the legitimation of wealth and status on the Northwest Coast. Together, these various factors probably led to more lavish and more frequent potlatches than had previously been held, fostering misconceptions and engendering hostility among white settlers. As we will see, potlatching soon came into such direct conflict with the Victorian values of the colonists that the Canadian and American Governments sought to suppress it entirely, the Canadian by the passage of a law in 1885 (see Chapter 1, p. 11).

Yet for much of the nineteenth century, trade and contact also created the conditions for an extraordinary artistic creativity in this region as elsewhere on the continent at similar historical moments. The new European manufactured goods added to the inventory of materials and tools available to artists, while the merchant seamen and other early collectors constituted a new consumer group whose demands, expectations, and exotic visual culture stimulated invention and innovation. A number of trade materials were enrichments of those already in use. Vermilion from China produced a more brilliant red than native ochres and cinnabar, and Hawaiian and Californian abalone shell contributed a more colourful and plentiful source that was preferred to the paler-hued local variety. Metal that drifted ashore from Asian shipwrecks had been available in small quantities before European contact, and had been used to make tools and ornaments. The greater availability of

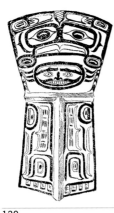

metal and metal tools after contact seems to have resulted in the enlargement of the size of some kinds of carvings, such as totem poles. It also enhanced the importance and numbers of the shield-shaped plaques known as coppers that embody a family's wealth when presented at potlatches [120]. Other materials, such as trade cloth, mother-of-pearl buttons and silver coins, stimulated the creation of entirely new art forms for internal consumption: the button blanket, and engraved silver bracelets [18, 135]. In contrast, the demand for curios sparked new productions of objects expressly designed for sale to travellers and tourists.

Styles and techniques

'What must astonish most,' wrote the French Captain Marchand in 1801, 'is to see paintings every where [sic], every where sculpture, among a nation of hunters.' The same observer also noted—unusually for a European of the period—that Northwest Coast art was 'not deficient in a sort of elegance and perfection'.[11] As Marchand's remarks suggest, it was easier for Western viewers to recognize Native American objects as 'art' when they made use of the same genres and media—sculpture and painting—as those privileged in Western art, a factor that has continued to play a role in the great popularity of Northwest Coast art among non-Native art lovers. The unique manner of representing animals and humans in Northwest Coast art has also continued to attract the attention of Western connoisseurs. The consistent system of stylization and composition used in painting, carving and textiles was analysed by Bill Holm, an artist and an art historian, in a landmark 1965 book, *Northwest Coast Art: An Analysis of Form*. He based his study on the arts of the northern region (Haida, Tlingit, and Tsimshian) where the possibilities of this 'formline style', as it has come to be called, had been most fully worked out in the centuries before contact. There is a tendency in the literature on Northwest Coast art, both explicit and implicit, to identify the northern formline style as the highest achievement of the whole region. It will be useful to summarize Holm's research and analysis of the formline style before turning to a discussion of the problematic nature and ethnocentric bias of such relative judgements.

By the middle of the twentieth century far fewer artists who had been trained in the traditional apprenticeship system remained on the coast. Holm's aim was to determine inductively the 'rules' and general principles followed by traditional artists through the study of thousands of historic examples of northern Coastal art. He identified, first of all, three basic approaches to the overall representation of an animal or human: the *configurative* [135], in which a being was shown in profile in a relatively straightforward manner; the *expansive*, in which some body parts were omitted or redistributed; and the *distributive*

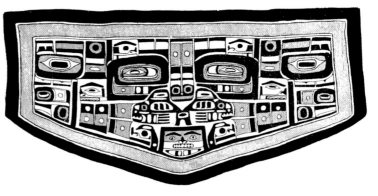

121

Chilkat blanket

An example of a *distributive* composition on a dancing blanket woven of mountain-goat wool and yellow cedar bark. Made by the Tlingit, these blankets were traded widely and worn by people of high rank. Precise icono-graphic meanings for the designs have not been established.

122 Tsimshian (?) artist

Bentwood chest (painted cedar), pre-1862, Fort Simpson, British Columbia

Chests are used to store important possessions like masks and ceremonial clothing. They were commonly exchanged among northern coastal peoples, for example as parts of the dowries of highborn women, and it is thus often difficult to deter-mine their place of origin. The design of this box is analysed in a drawing made by Bill Holm, reproduced as **123**.

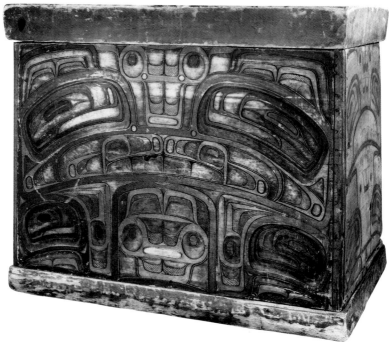

[**121, 122**], in which a radical rearrangement of the features and limbs occurred, usually filling the whole space in a compositionally satisfying manner but rendering the subject of the representation difficult to identify. Among his most important findings was the identification of the three design units that are the building blocks of Northwest Coast compositions, the 'ovoid' (a slightly squared-off oval with a concave bottom contour), the 'U-form', and the 'formline'. An artist's equip-ment included sets of different-sized templates of ovoids and U-forms which he traced on to the design field without prior sketches but with such precision that the spaces between the main design units emerge as a continuous flowing line, termed by Holm the 'primary form line'. (Recent research by Bill McLennan also shows that a great deal of painting was done freehand.)[12] This line lies on the surface plane and is almost always painted black in two-dimensional compositions. It is a

flowing contour whose width widens and narrows as it changes direction and encounters other lines. Subsidiary design areas are linked by a red 'secondary formline', and a third infilling of negative spaces between the two formlines may be added and painted blue or blue-green. The tertiary lines are often carved out in shallow relief [**123**].

Holm concluded that, even when an artist was making a three-dimensional object, such as a box, a spoon handle or a totem pole, he first conceived of the design in two dimensions and then mentally 'wrapped' it around the three-dimensional surface before carving it out in relief. It is particularly easy to visualize this process in relation to the design of decorated bowls and boxes which are used for feasts and for storing important possessions, and which constitute one of the most important genres of Northwest Coast art. A box is constructed from a single plank into which wedge-shaped cuts, or kerfs, are made where the corners will occur. The plank is then steamed, bent at right angles and sewn with spruce root along the open edge. In formline-style art, the two sides of a being may be displayed on opposite sides of a bowl or a box, or laid out as mirror images on a flat surface according to a characteristic convention known as 'split representation' [**135**].

The monotony that might result from the strict limitations that the formline style imposes on practitioners (who were, up until the twentieth century, men) is avoided by a number of other design strategies also identified by Holm. Although compositions are largely symmetrical, for example, the Northwest Coast artist characteristically avoids both absolutely parallel lines and true concentricity in the placement of ovoids and other forms. He also calibrates nicely the curving shapes of

123

Formline design from carved and painted chest illustrated in **122**

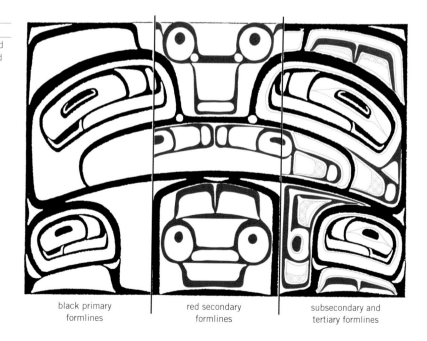

black primary formlines

red secondary formlines

subsecondary and tertiary formlines

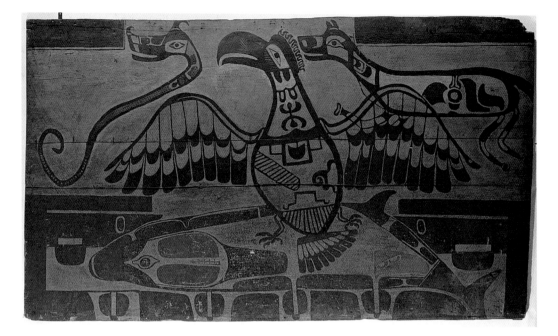

124 Nuu-chah-nulth artist

House screen, c.1850, British
Columbia

This famous screen, displayed
at potlatches and other
important occasions, contains
a central image of Thunder-
bird catching Killer Whale,
with Wolf and Lightning
Snake in the upper corners.
It represents an Opetchesaht
(Nuu-chah-nulth) chief's
crest story of an ancestor's
encounter with a supernatural
being while checking his
salmon traps.

his design units and formlines to fall between the extremes of angular-
ity and curvilinearity. The formline style is a highly disciplined mode
of graphic representation that eliminates all extraneous elements. Yet it
also lends itself to subtle invention and variation. The hands of indi-
vidual artists can be detected by attending to such details as the precise
degree of off-centredness with which the artist avoids an exact concen-
tricity in the placement of the pupil within the eyeball, or in the subtle
differences in the ways in which each artist proportions and contours
his U-forms, ovoids and formlines. The study of individual artists'
styles is an area of expanding research among Northwest Coast artists
and scholars.[13]

The limited number of basic design units also gives rise to a charac-
teristic representational feature of Northwest Coast art. Because the
same or similar design units are used for different body parts—a
U-form for a fin or a tail, an ovoid for an eye or joint—the style lends
itself to the creation of visual puns in which a particular form can be
read simultaneously as part of two different, overlapping images.
Northwest Coast artists have exploited this capacity to the full, using it
to play on fundamental philosophical perceptions of structural duali-
ties, the deceptiveness of appearances, mythic processes of transforma-
tion, and the paradoxical coexistence of two truths at a single juncture
of time and space.[14] The contemporary Haida artist Robert Davidson
speaks of the explorations of fundamental cosmological principles that
occur in the working out of formline compositions. He has described,
for example, his conversations with apprentices while creating an
important housefront painting: 'All the time we were working on it, I

stressed the importance of space, how one line relates to another line, or how the ovoid related to the U-shape, or how the ovoid relates to the space around it. And I talked about the balance, and how fragile things were.'[15] [**143**].

The earliest objects that can firmly be identified as coming from the Kwakwaka'wakw and Nuxalk of the central coast were collected in the mid-nineteenth century, and these show an extensive use of the conventions of the formline style. Yet archaeological evidence suggests that the arts of the central province were formerly more like those of other Wakashan speakers such as the Nuu-chah-nulth. In two-dimensional painted designs this 'archaic' style, which is still evident in Coast Salish and Nuu-chah-nulth art, displays tendencies towards elegant simplifications of form verging on abstraction [**124**]. In many three-dimensional objects this art displays more angular transitions of plane and a tendency to flatness that contrasts with the deeper relief characteristic of more northerly carving traditions. Although ovoids and U-forms are present in southern province art, their use is more limited and they tend to be realized as more regular geometric forms. Other characteristic linear motifs, such as crescent and 'T' shapes are, however, important design elements, incised into surfaces to define facial features and limbs and used decoratively in repeated groupings [**125**]. In his analysis of northern coastal arts Holm also identified 'slits' and 'resultant forms' that occur in between the main design units as important design elements. Scholars conclude that, during the nineteenth century, the northern style was spreading south, aided both by long-standing customs of commissioning works of art to be made by well-known artists from neighbouring tribes and by more recent increases in inter-tribal marriages involving transfers of crests, ceremonial privileges and art treasures. The process of stylistic transfer, however, was far from

125 Makah artist

Side of carved chest (western red cedar), sixteenth century, Ozette site, Washington

The panel from a kerfed box found at Ozette represents the 'archaic' relief carving style used by peoples of the central coast and Vancouver Island before the mid-nineteenth century. In this style, in contrast to that of the north, the eyebrows and mouth are more squared off, the ovoid of the iris more rounded, and the features are accented by characteristic deeply excavated triangle and crescent forms.

Oil dish (alder or yew, glass beads), nineteenth century, Washington

At potlatches Northwest Coast peoples used dishes carved as animal effigies to drink oolichan oil and other luxurious foods. This outstanding example of southern coastal carving, collected among the Quinault and exhibited at the 1893 Chicago World Columbian Exhibition, may represent a sea monster.

mere copying; it generated new styles with their own unique features. In contrast to Haida or Tlingit art, for example, Kwakwaka'wakw carving of the second half of the nineteenth century is renowned for its more organic, fully sculptural volumes, its bold but less systematic use of formline design, and its bright polychrome surfaces which make lavish use not only of the red, black, and blue-green of the north but also of white, yellow, cobalt and green [136 and 1].

Western connoisseurship and Northwest Coast art

In this analysis, the formline style emerges as a local development within a broader stylistic complex, albeit one of great refinement and aesthetic power. Yet it has had a disproportionate dominance in the literature on Northwest Coast art that can be compared to the dominance of Florentine art in the literature on the early Italian Renaissance. This focus on the northern style has frequently led to a mapping of margin and centre that reflects Western rather than indigenous perspectives on quality and aesthetics. In a 1930 monograph on the Coast Salish, for example, Erna Gunther and Hermann Haeberlin stated: 'The Puget Sound people represent a very marginal development in the art of wood working, having essentially the forms used to the north, but none of the artistic finish or even fine technical skill.'[16] Statements such as these employ the coded evolutionist language of Victorian anthropology—now long rejected by social scientists— according to which the possession of artistic styles and genres similar to those of the West was taken as an indicator of the overall superiority of a people's level of civilization. The changeability of Western aesthetic judgements should, if nothing else, alert us to the dangers of failing to recognize the way in which Western evaluations of Northwest Coast and other non-Western art have reflected and served to validate corresponding shifts in Western taste. In 1949, for example, the art

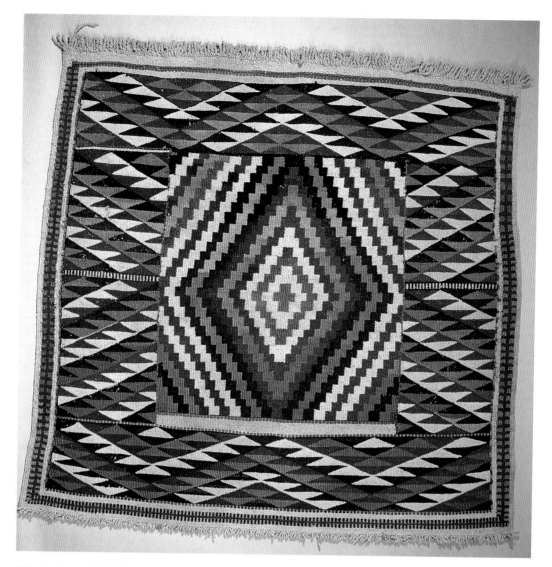

127 Coast Salish artist

Blanket (mountain-goat wool),
c.1840

Among the most luxurious
weavings made by the
nineteenth-century Coast
Salish were plain, striped,
and geometrically patterned
blankets woven of mountain-
goat wool and plant fibre.
Used as robes, bed coverings
and potlatch gifts, they invite
comparison with Navajo
blankets but never became
the objects of extensive
commoditization.

historian Paul Wingert (whose tastes were informed by modernist
Western art and Primitivism) provided a fresh appreciation of south-
ern coastal carving [**126**]. Arguing that it displayed a 'mature and
highly sophisticated art style', he reversed the earlier pronouncements
of Gunther and Haeberlin.[17]

Comparative judgements of the importance of an art tradition are
also influenced by a gendered and hierarchical Western classification
of artistic media. If textile traditions, rather than carving, are taken as a
measure of the degree of artistic development, then the southern
coastal peoples would be regarded as the more accomplished. The
colourful, geometric blankets of mountain-goat wool woven by Coast
Salish peoples during the nineteenth century and revived recently, for
example, rival those of the Navajo [**127**]. Moreover, two of the most

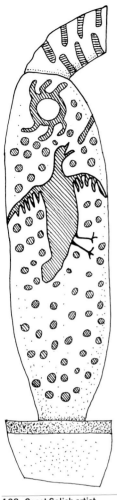

128 Coast Salish artist

Line drawing of Spirit Canoe board, 1920

This board was used in a Coast Salish Spirit Canoe Ceremony at Tolt, Washington.

important and iconographically elaborated types of Salish wood carvings, spindle whorls and mat creasers, are implements used in weaving. To be drawn into such comparisons, however, is precisely to fall into the trap we should seek to avoid. Visual arts are related both to the distinctive historical exchanges that have occurred over time in a given area and also to the contexts of expression that are important in that place. The remainder of this chapter underlines this general point by looking at a series of contexts that promote the production of visual art on the Northwest Coast, and illustrates them through examples of particular regional traditions in which these contexts are especially important.

Shamanism

Shamanism, as noted in Chapter 1, is a system of religious practice in which an individual enters into a trance state in order to contact other-than-human spirits. In many societies specialist shamans use their connections to powerful helper spirits on behalf of community members for healing, controlling weather, locating animals, or success in warfare. As Esther Pasztory has pointed out, aesthetic quality and visual art are not essential to the efficacy of shamanistic practice.[18] Drums and rattles, for example, which are used by shamans around the world to induce a trance state and to summon spirit helpers, are most often undecorated. Two Northwest Coast art traditions, the Straits Salish and the Tlingit, are not only exceptions to this general pattern but also provide two contrasting examples of the use of visual art in shamanistic practice.

Among the Straits Salish of Puget Sound, visual aids are used by ordinary people in the tending of the individual guardian spirits they acquire through vision quests as well as by specialist shamans. The forms of the visual 'props' made by both are similar, although used in different rituals and for different purposes. As in the Plains and Woodlands, people traditionally acquired guardian spirits during puberty seclusion, and these bestowed abilities, such as exceptional skill in basketry or in the hunting of certain animals. An individual's guardian spirit is traditionally believed to travel around the world each year. Its annual return at the time of the winter ceremonial season causes its owner to fall ill, and friends and family gather to restore health by helping him or her perform the spirit's songs and dances. These spirit dances are traditionally the central events of the winter ceremonials, and participants wear elaborately beaded clothing and head-dresses. In another ceremony, the Spirit Canoe Ceremony, which is more properly translated 'Spirits-Curing-in-a-Line', a group of shamans make use of special boards painted with animal motifs and patterns of dots whose semi-abstract shapes recall the forms of the spirit helpers [128]. In this ritual a group of shamans journeys into the

129 Tlingit artist

129 Tlingit artist

Shaman's mask (wood and pigment), third quarter of the nineteenth century

The mask comes from the grave house of Setan, and was collected between 1884 and 1893 by George Emmons. It is a fine example of the abilities of Haida and Tlingit carvers to render the human visage in a highly naturalistic manner, capturing with great subtlety the organic modulations and volumes of the face. The image might represent one of the shaman's helper spirits or, possibly, one of his patients.

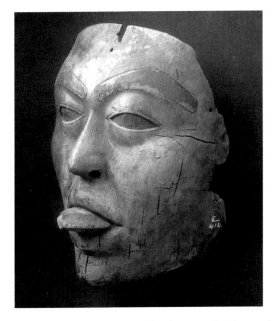

underworld to recover the lost soul whose absence has caused the patient's illness. The house is mystically transformed, in part with painted boards representing spirits encountered on the voyage, which are sometimes arranged to demarcate the shape of a canoe. Such visual aids are not created to be permanent works of art. Rather, because of the potentially dangerous spirit power they contain, they can be used only once before being discarded. Visual art in this context is a secondary adjunct to the singing that is the central focus of the ritual.[19]

Among the Tlingit, as among the Coast Salish, specialist shamans used their extraordinary powers of communication with the spirit world for healing. They also conducted important rituals on behalf of the community, such as the annual First Salmon Ceremony, a ritual intended to influence the return of the salmon to village fishing grounds. Nowhere else on the Northwest Coast, as Aldona Jonaitis has shown, did the artistic elaboration of the shaman's paraphernalia reach so high a level as among the Tlingit. The drums, rattles, and ivory and bone amulets they used were as skilfully painted and carved as the regalia of chiefs. Alone among the Northwest Coast tribes, Tlingit shamans also used sets of masks to represent their *yek* or helper spirits, among whom the land otter, bear, and devilfish were particularly important [**129**].[20] Tlingit shamans also wore beautifully carved pendants and amulets attached to their clothing, which they might lend to a patient to help effect a cure. Both amulets and a widely used type of rattle, carved as a raven with figures on its back, often feature scenes that graphically depict the magical acts of which the shaman was capable—transformation, communication with animal spirits, and the torture of witches [**130**].[21] Because of the powers with which all these objects

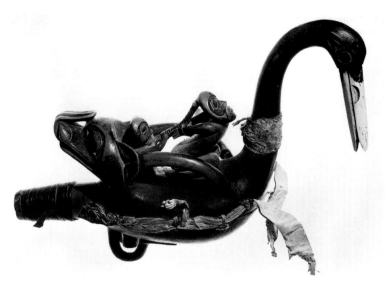

were imbued they posed a danger to ordinary people after the shaman's death and were either buried with the body in a remote location or placed near his body where his heir might retrieve them later. A guardian figure might sometimes be placed nearby. Tlingit shamans' equipment has come into museums primarily through its unauthorized removal from graves by determined collectors.

The shaman's rattle described above is identical to a type carried by chiefs throughout the northern and central coast. The shared symbolism of the rattle is just one example of a larger body of shared iconography by means of which the extra-human power associated with the shaman is extended to those who wield 'secular' rather than spiritual or 'sacred' power. (The difficulty in imposing the Western dichotomy of sacred/secular on many non-Western peoples is notorious. The use of these words is an imperfect translation of a distinction we might more properly imagine as a continuum shading from the highly spiritual to the mundane, with a large area of overlap in the middle.)

The shared iconography of shamanistic and chiefly art can be detected in many important types of objects. The representation of special powers of vision, fundamental to the shaman's work, becomes in Northwest Coast art a kind of general metaphor for power. The graphic representation of visionary power as a face with large circular eye sockets is, for example, the dominant image of the numerous rock-art sites found on the coast, usually located along river banks and probably associated with shamanistic rituals connected to fishing. As Claude Levi-Strauss suggested in his structuralist study of Northwest Coast masks, two masks that are important in certain families—the *swaixwe* of the Coast Salish and the *dzonoqua* used by their Kwakwaka'wakw neighbours—both feature exaggerated eye forms:

131 Northern Northwest Coast artist

Paired stone masks (basalt, green stone), dates unknown

These masks were collected in Tsimshian territory in the late nineteenth century, but could have been carved a century or more earlier.

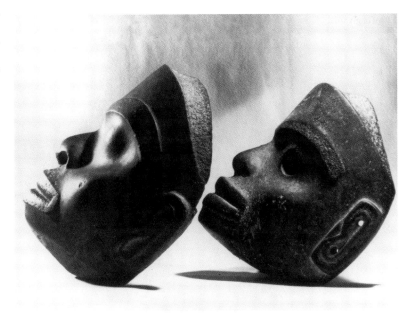

protruding cylindrical stalks in the case of the *swaixwe*, and gaping empty eye sockets in that of the *dzonoqua*. These resemble the eye forms seen in rock art, and extend a shamanistic metaphor of special sight into a 'secular' and political context of power.[22] An extraordinary early masterpiece of stone carving collected among the Tsimshian (but possibly made by a Tlingit artist) can probably also be interpreted within this iconographic tradition. The pair of stone masks were made to fit one inside the other [131]. While the eye sockets of the outer mask are smoothed over and opaque, those of the inner mask are pierced with two round holes, a sculptural invention that captures the intensity and the inward-looking nature of visionary experience. The anthropologist Marjorie Halpin has suggested that they may have been worn as *naxnox* masks by high-ranking Tsimshian chiefs in rituals performed just before potlatches to demonstrate the possession of supernatural powers. Scholars have also pointed out that the initiation rites through which the offspring of prominent families inherit special powers (as exemplified by the discussion of the Hamatsa Society below) feature a symbolic death or disappearance, trance states, spirit possession, and rebirth similar to those experienced by the shaman in the acquisition of his powers. Drucker pointed out that the crest system is based on a kind of inheritance of spirit helpers. Shamanism, in contrast, requires the direct acquisition of spirit helpers through the vision quest. In both cases, however, the use of such powers is expected to be socially constructive and sanctioned; the chief, for example, exercises his powers and control over food resources on behalf of his dependants, while the shaman heals or communicates with animals to help the hunter.

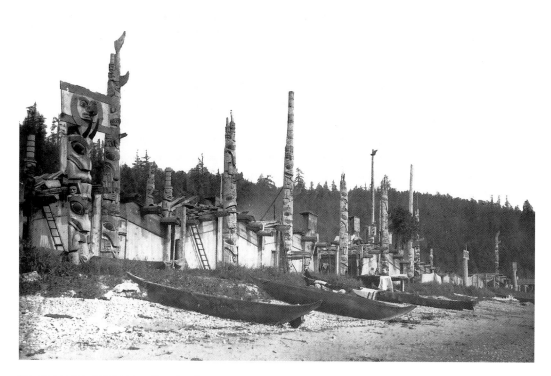

Photograph of Skidegate, 1878

Photographic and postcard views of Northwest Coast villages were favourite tourist collectibles during the late nineteenth century. The village of Skidegate was one of the two Haida villages that remained occupied after the devastations of the epidemics of the 1860s, and its display of poles was especially dense as a result. Haida poles are often topped by the Three Watchmen wearing stacked hat rings representing potlatches given by the family.

Crest art

As we have seen, the building blocks of Northwest Coast style are the individual design units described above, while many important individual iconographic motifs appear to be derived from shamanistic concepts of power. The larger and more familiar units of visual art, especially on the northern and central coast, are the more complex groupings of humans and animals known as crests. Crests are often compared to the heraldic devices displayed by aristocratic European families on their coats of arms, a comparison which has merit for a number of reasons. Both coats of arms and crests are exclusive designs that can only be used by their rightful owners, powerful families who control land and resources. As in European heraldry, too, Northwest Coast families usually own more than one crest image, acquired over the generations through marriage or conquest in war. Through shared crests, families recognize different levels of relationship. Some peoples, too, are subdivided into two large subdivisions, or moieties, such as the Haida eagle and raven, or into several clans, such as the Tsimshian eagle, raven, wolf, and killer whale. A family's crests include those of the moiety or clan as well as those it owns individually; no two families will possess exactly the same set of crests. Finally, as with European coats of arms, crests were displayed on a Northwest Coast family's house, on the canoes in which its members travelled, and on a wide range of other possessions as a way of advertising the status and identity of family members.

The most famous and dramatic mode of crest display is the crest or 'totem' pole, a tall pillar of cedar that can reach a height of 60 feet.[23] As Marjorie Halpin has explained, there are five distinct kinds of crest poles serving specific architectural and functional purposes: 1) interior house posts that support roof beams; 2) house frontal poles placed along the central axis of the outside façade and often containing an opening used as a ceremonial entrance; 3) memorial or commemorative poles, usually erected by the successor to a title to commemorate his predecessor; 4) welcome figures, placed on the beachfront to greet visitors; and 5) mortuary poles, made to support grave boxes usually placed in front of a house. As previously noted, it is likely that crest poles became larger and more numerous during the nineteenth century because of the increased wealth, competitiveness, and access to metal tools that resulted from European contact. The fronts of Northwest Coast houses were built in a line along river or sea shores. During the second half of the nineteenth century the dense rows of house fronts, soaring poles and painted crest designs ornamenting many villages became a favourite subject for photographers and tourists, eventually making the totem pole a rival to the feathered war bonnet as a continent-wide symbol of 'Indianness' [132].

The analogy between Northwest Coast crests and European heraldry tells only a part of the story of the meaning of crests. When a Tsimshian chief recounts his *Adaawk* (oral history), he is at the same time claiming a complex of interdependent possessions: crests, names, titles of chieftaincy, rights to dwell in a certain house, stories, songs, dances, and visual images, as well as rights to certain lands, fishing areas, and hunting grounds. On one level, the crest explains how all these things were initially bestowed by non-human beings in the early time of the world, when humans and animals could more easily pass in and out of each other's domains. The stories often celebrate the daring and courage of an ancestor who was able to enter the other domain and bring home rewards still enjoyed by his or her descendants. To depict these encounters, artists use devices such as visual punning and split representation to give concrete form to the notions of transformation, fluidity, and doubled reality that characterize primordial time.

The story of the Dog Salmon Pole from the Gitksan (Tsimshian) village of Gitwangak (Kitwanga) on the Skeena River illustrates the way this system of visual image and oral tradition works [133]. Because the crest poles at Gitwangak have been much studied by ethnographers, their imagery is unusually well documented. (For the majority of poles now in public collections, the detailed stories have been lost, although individual beings can often be identified.) The Dog Salmon Pole honours Tewalas, a great warrior and fisherman, and commemorates his encounter with the Dog Salmon. In 1925 the name Tewalas belonged to a woman, Mrs Augustus Sampere—a not unusual

133

Dog Salmon crest pole

occurrence, for many Northwest Coast peoples have systems either of matrilineal, ambilineal, or bilateral descent. Harlan Smith recorded one story of how the first Tewalas (which he transcribed as 'Duwallis') speared a giant dog-salmon and then

was dragged out of his canoe and taken down to the dog-salmon's village under the waters of the Skeena River. ... After spending two years in the dog-salmon's village, Duwallis returned to Kitwanga knowing the habits of the dog-salmon so well that he could catch them whenever he wished. Thus he became rich and powerful, but he died fighting bravely against the Indians of Kitselas who split him in two.

In Marius Barbeau's 1929 version, Tewalas first cures the salmon chief of an infirmity:

The live salmon, in gratitude, appeared to him as human beings in a canoe, at the river's edge, and took him to their home down the river. They led him into three huge houses of the Salmon tribe; on the front of one was painted the dog-Salmon. ... The salmon in those houses behaved as human beings. When the time for the salmon run arrived the young man was provided with a fish garment and, changing into a salmon, he swam up the river with the school of salmon until he reached the canyon, at the edge of which stood his home village. There his uncle Raraotsen caught a gigantic salmon which he could barely drag out of the water. In its body he discovered his nephew, who had disappeared several moons before. The Dog-salmon thereafter became the family crest.

Barbeau also noted that the Dog Salmon crest has been represented as a *naxnox* mask in a dramatic performance connected with the assumption of chiefly status.[24]

The exceptionally finely carved pole representing the Dog Salmon crest shows Tewalas three times. At the top of the pole he lies along the salmon holding his fish spear; the salmon's fin projects from behind his head, a visual merging that foretells events to come. In the middle and bottom sections Tewalas is shown again, cleft in two down the centre to commemorate his heroic death in war. Another salmon fin projects from the cleft. In the bottom we see a large dog-salmon swallowing Tewalas, whose split head emerges from the salmon's mouth at the base. As in the narrative structure of medieval saints' lives, three sequential moments in the story are depicted. Through superimpositions of animal and human forms the carver has also expressed compositionally the core theme of transformational power contained in Northwest Coast crest stories.

It is common to state that the carving of new totem poles came to an end around the turn of the century. Yet during the middle decades of this century, in Gitwangak and a few other places on the Northwest Coast, several forces converged to ensure the preservation of some poles and their stories: Native determination to defend their traditions

The History of a House

The house of a prominent Northwest Coast family is an architectural, sculptural, and painterly manifestation of its history. A house also, of course, *has* a history in the sense that its specific renderings arise from the visual experience of particular times and places. Few houses illustrate these convergences better than the one built about 1890 by the Nuxalk chief Clellamin at the village of Qwemqtc (Bella Coola)[**134**].[25]

The house represents Nusq'alst, the supernatural founder of Clellamin's family, who descended to earth from the world above and became the mountain bearing his name. We do not know what the houses representing Nusq'alst looked like in earlier centuries, but the late nineteenth-century house clearly reflects a trip to Germany made by a group of Nuxalk in 1885. Invited by the Jacobson brothers, collectors of Northwest Coast art and ethnology, the Nuxalk danced for German audiences, while the fourteen German towns they visited provided an architectural spectacle for their eyes, details of which were incorporated into the house built after their return. The towers topped with gold balls (representing rocks to which Nuxalk tied their canoes at the time of a great flood), the blue and white stripes (representing the snow on the mountain peak), and the dormer windows (through which peek animals who inhabit the mountain) also recall northern European houses.

Chief Clellamin's house no longer stands at Quemqtc. It was, however, replicated from historical photographs and surviving sculptures for the Canadian Museum of Civilization in the 1980s by Nuxalk carver Glenn Tallio and others. On the Northwest Coast, the authenticity of such replicas depends not on the physical survival of objects but on the valorization of remembered images by those who have inherited the rights to them. The contemporary house suggests other kinds of historical convergence. The visit of the Nuxalk to Berlin inspired the young Franz Boas to make North American ethnology his life's work, and his legacy of meticulous ethnological recording and museum anthropology has facilitated the work of contemporary Northwest Coast artists and scholars in their work of replication and recovery.

134

House of Chief Clellamin (reconstructed), Grand Hall, Canadian Museum of Civilization

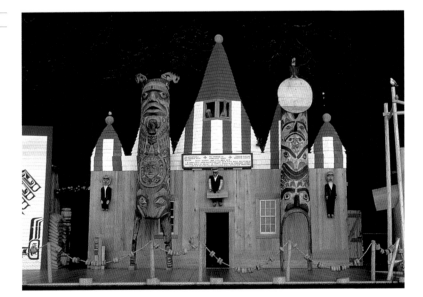

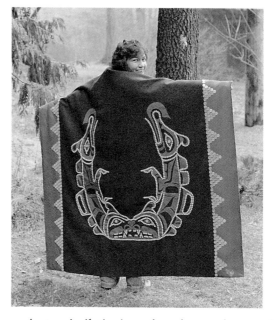

Photo of Shirley Hunt Ford
wearing a button robe,
Kwakwaka'wakw 1985

The process of commissioning
and making this blanket
involved carefully considered
collaborations among
members of the Hunt family,
an eminent family of chiefs
and artists. The *Sisiutl*, or
supernatural double-headed
serpent, displayed on this
blanket, is a crest brought into
the family by Shirley Hunt's
grandmother, Grace Nelson.

against assimilationism, the salvage ethnography of museum anthropologists, and the desires of the tourist industry and government for economic development. When in 1936 a flood of the Skeena River washed away totem poles in a number of Gitksan villages the people set about restoring them. In the mid-1940s potlatches were held in the villages when the poles were raised again.[26] At the same time ethnologists at the National Museum of Canada collaborated with the Canadian Pacific Railroad to restore and move poles at Gitwangak to new places more accessible to tourists. A similar, economically motivated restoration project for Alaskan Tlingit poles took place during the 1930s under a New Deal programme, the Civilian Conservation Corps.[27] Although most people thought, until recently, that the social and political system the poles symbolize was no longer valid, these tourist-orientated ventures have nevertheless contributed to the survival of historical memory in Native communities and to the many contemporary reaffirmations of its continuing relevance in modern Northwest Coast life.[28]

The potlatch

In addition to the carving of crest poles, powerful Northwest Coast families also display their crests on objects that are visible only on ceremonial occasions, such as clothing, dance screens, and masks. The complete set of crests belonging to a family will be represented individually, for example, on its clan hats, on head-dresses known as frontlets, and button blankets [**135**]. The most important occasion for such displays is the potlatch [**18**]. Potlatches include feasts at which rights to the inheritance of wealth and power are displayed and validated. A

great family shows its worthiness to inherit and hold titles by lavish feasting, by generous distribution of gifts to guests, and by exhibiting its crests while dramatically re-enacting or telling their stories. The precise occasions for holding a potlatch vary from one people to another. Among the Kwakwaka'wakw, for example, potlatches are occasions, in the words of Kwakwaka'wakw anthropologist and curator Gloria Cranmer Webster, for 'naming children, mourning the dead, transferring rights and privileges, and, less frequently, marriages or the raising of memorial totem poles'.[29]

The Kwakwaka'wakw potlatch has been much celebrated because it features some of the most dramatic and theatrically sophisticated masked performances to be found on the Northwest Coast. It was very well documented at the turn of the twentieth century, furthermore, in the ethnographic accounts and collections made by Franz Boas and his associate, George Hunt, son of a Tlingit mother and a Hudson's Bay Company employee who was raised among the Kwakwaka'wakw. Tradition has it that the Kwakwaka'wakw acquired a number of masks and dances from the Heiltsuk to the north, but the creation of an unparalleled array of visual forms and dramatic techniques with which to display these dance privileges was a local development. Boas and

136 Kwakwaka'wakw artist

Wolf transformation mask (wood, twine, animal hide, pigment), late nineteenth century

Transformation masks make vivid the many incidents of shape-changing recounted in the stories Northwest Coast families tell to explain the origins of their privileges. Systems of levers and pulleys allowed the dancer to reveal new configurations of painted and carved panels and to illustrate the way a mythological being had shed its animal skin to reveal a human aspect.

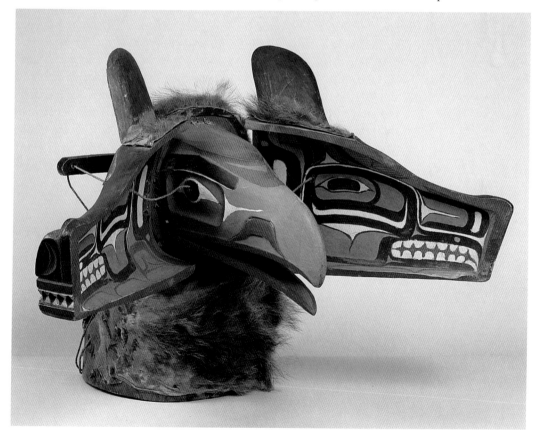

Hunt's collections include a wealth of carved masks, puppets, props, and dance screens used to tell crest stories and to initiate high-ranking people into the Hamatsa and other élite dancing societies. In masquerades the themes of spirit possession, transformation, and the domestication of power acquired from the spirit world are given a new temporal and spatial reality, adding further kinetic and dramatic dimensions to the painterly and sculptural techniques of representation already described. The highly realistic dramas included events in which (by pre-arrangement) masked beings appeared to draw blood and cut bits of flesh from audience members in the graphic display of their dangerous powers, and others in which people were apparently dismembered before the eyes of the spectators, only to return reassembled. Magical transformations from animal to human were made vivid by transformation masks, constructed with hidden strings manipulated by the masker [**136**].

Initiation into the élite Hamatsa society is a featured element of potlatches held at the time of the *Tseka* cycle, the first of the two ceremonial cycles of the Kwakwaka'wakw winter ceremonial season. As we have already seen in the context of Straits Salish shamanism, winter is a time when the presence of supernaturals is more apparent in the villages, and the Kwakwaka'wakw ceremonials thus illustrate the general Northwest Coast seasonal pattern. The first sign that the *Tseka* winter cycle is to occur is the disappearance from the village of the high-born young men who have inherited the privilege of Hamatsa membership. They have been captured by the cannibalistic Hamatsa spirits who live in the far north with their leader *Baxwbakwalanuxwsiwe*. Their return as initiates, endowed with new powers, is the highlight of the *Tseka* cycle. The companions of *Baxwbakwalanuxwsiwe* are impersonated by maskers wearing giant headpieces

137

Photo of Hamatsa masks dancing at potlatch, 1983, Alert Bay, British Columbia

Two of the bird beings who are the attendants of *Baxwbakwalanuxwsiwe* (Cannibal-at-the-North-End-of-the-World) and who capture Hamatsa Society novices at the beginning of the initiation period dance are shown here at a potlatch given by Tlakwagila (W. T. Cranmer). Crooked Beak of Heaven, with his great recurved beak, stands in the foreground, and the long-beaked *huxwhukw* is behind him.

138 Kwakwaka'wakw artist

Dzonoqua feast dish (wood), *c.*1900, Fort Rupert, British Columbia

Feast dishes carved in the image of the wild woman of the forest are visual metaphors of the *dzonoqua* as wealth-giver and nourisher, for guests at a potlatch consumed quantities of rich foods from dishes that represented the parts of her body.

representing up to four different species of man-eating birds [**137**]. Their masks have great snapping beaks and they dance to display the destructive power the initiates have acquired during their absence. Boas describes them moving among the spectators, biting and drawing blood. It is the role of the women of the society to tame and control the initiates, a process expressed in the slow, potent movements of the dance, so that the initiates' new powers become socially constructive rather than destructive. The elders wear head rings made of shredded red cedar bark, symbolizing the *Tseka* season, and carrying significations of the human realm and social order. By the end of the initiation the new members, too, have exchanged their wild hemlock branches for cedar bark rings. Although some of the other dances described by Boas have not been performed for many years, the Hamatsa performance remains a vital part of Kwakwaka'wakw ceremonial life.

At the heart of central and northern Northwest Coast potlatches is a series of great wealth-givers, supernaturals who are capable of bestowing on those who succeed in besting them extraordinary treasures of copper, dances, food, and goods of all kinds. They tend to appear, in particular, at potlatches held for funerals and marriages, because these are prime occasions for the transfer of wealth. The *Gonak'Adet* of the Tsimshian and Haida is one such wealth-giver, a fabulous being that lives under the water and controls the salmon. Among the Kwakwaka'-wakw peoples the wealth-giver par excellence is the *dzonoqua*, a hairy and wild cannibalistic woman who lives in the woods and wanders around seeking children to eat, a pack basket on her back to hold her prey. The mask that represents her is black, with hollowed-out cheeks, bearskin eyebrows, empty holes for eyes and thick pursed lips through which her impersonator emits the *dzonoqua*'s characteristic howling sound. Yet *dzonoqua*, too, is a source of treasure, especially copper. Her identity as a source of good things is expressed metaphorically by huge feast dishes carved in her image [**138**]. Among the Coast Salish the *swaixwe* is also a giver of wealth, although it is not, like the other two, a chiefly prerogative but an inherited privilege whose dance is a purification ritual that cleanses a place of bad spirits (see note 22) [**139**].

During the middle and second half of the nineteenth century, as permanent white settlement of the Northwest Coast expanded, competing religious and political systems increased the pressure on the traditional institutions of Northwest Coast life and art. Missionaries as well as government officials mounted direct attacks on the potlatch because Victorian society disapproved of the munificent displays and (apparent) wasting of wealth that was required to maintain the prestige of great families. In 1885 the Canadian Government outlawed the potlatch, thus threatening with a single act the system that guaranteed the survival of indigenous political authority, oral history, and traditional art. It was not until 1951 that this ban was effectively dropped. Despite

**139 Lawrence Paul
Yuxweluptun (b. 1957),
Cowichan-Okanagan**

'Scorched Earth, Clear-cut
Logging on Native Sovereign
Land, Shaman Coming to Fix'
(acrylic on canvas), 1991

Yuxweluptun uses the formal
vocabulary of traditional
Northwest Coast painting
in a highly innovative way
to make easel paintings that
address such issues as the
appropriation of Native lands
and the despoiling of the
environment. In this painting,
whose bitterly ironic title
refers to destructive logging
practices, the figure of a
shaman is symbolized by
the wearing of a traditional
swaixwe mask.

the repressive policies that remained in force during the first half of the
twentieth century, many Northwest Coast peoples found ways to con-
tinue potlatching. Yet, by the early 1900s, it appeared both to non-
Natives and also to many Natives that the richly expressive system that
had developed on the Northwest Coast over many millennia was
rapidly coming to an end. During the second half of the twentieth
century, however, Northwest Coast people reversed this history in a
remarkable reassertion of cultural and artistic energy.

Art, commodity, and oral tradition

The history of Haida art illustrates with particular starkness the threat
posed to traditional artistic heritages during the second half of the
nineteenth century. However, it also demonstrates the important role
that commoditized production of curios and souvenirs has played in
maintaining fragile links to ancient artistic heritages. In their own
right, furthermore, these art commodities have been the site of much
innovation and creativity.

Living in their remote island villages on the Queen Charlotte
Islands, the Haida were less affected by the epidemics that broke out
periodically in mainland communities during the first half of the nine-
teenth century. But in 1862 a group of Haida who had been visiting
Victoria were infected with smallpox. Forced by the authorities to re-

turn home, they introduced the disease to the Haida villages and, within a year, all but 1,200 of the population of approximately 9,000 Haida were dead. Most Haida villages had to be abandoned and the survivors, regrouped directly under the eyes of missionaries and government agents, found it impossible to carry on their traditions. Almost all public forms of ceremonial life ceased and, with them, the carving of works of art.

Earlier in the century, however, during the height of the fur trade, the Haida had invented a new art form to meet outside demands for collectable curios. The Queen Charlottes are the site of a quarry producing a unique type of black carbonaceous shale known as argillite.[30] It is a relatively soft material that is suitable for carving, although great skill is required to produce sharp lines and fine detail. Argillite can take a high polish, but is too brittle to be useful for utensils. In pre-contact times it was little used except to make the occasional labret, or lip plug. However, during the 1820s, according to the research of Macnair and Hoover, the Haida began to use argillite to make ceremonial pipes for their own use, a number of which soon turned up in European curio collections. In rapid succession over the next two decades, Haida artists developed a series of entirely new curio forms, including a non-functional form of 'panel pipe' featuring tiers of intertwined animals and figures, often connected to each other by extended tongues similar to those seen on raven and oystercatcher rattles. Some of these pipes depict Europeans and portions of their ships, and free-standing European figures were also made. Round and oval platters ornamented with floral motifs and compass-work testify to the interest Haida artists took in foreign decorative arts. Ornamental gun fittings, carved wooden and meerschaum pipes, sailor's scrimshaw, and imported dinnerware all provided other points of departure for Haida artists.

After the 1860s, however, when the normal outlets for the visual representation of crest stories and other traditional images were closed off, the imagery of argillite carvings began to change further. Haida carvers continued to carve elaborate plates, platters, and candlesticks that imitate the contours of European china and metalwork, but they began to add figures from traditional Haida stories, many of which had not previously been depicted in a fully narrative manner. The popular story of the Bear Mother, for example, which tells of a woman kidnapped by a supernatural bear who bore twin half-bear children, is associated with a crest belonging to Tsimshian families. The story is represented on totem poles as a single figure, usually of a bear with some human attributes. Depictions of the story in argillite are much more explicit and expressive; in one figure the Bear Mother's pain as she nurses her half-bear children is vividly shown in the expression on her face.[31] Carvers also used argillite to make miniatures of the totem poles and other ceremonial objects they could no longer carve at full

Photo of Charles Edenshaw
displaying argillite carvings,
*c.*1880, Haida

Edenshaw, or Daa-x-iigang,
was a consultant to ethno-
logists and one of the most
famous carvers of his time,
working in argillite, wood,
silver, and ivory. He became
a chief in 1885, just as the
ban on the potlatch was taking
effect. Although he carved
for Haida patrons, he is best
known for the models and
miniatures he made for out-
siders, objects that combine
classic Haida formline style
with originality and innovation.

size. These commoditized arts were avidly collected by the tourists who stopped at the Queen Charlottes on the newly popular boat trips up the Inside Passage to Alaska, but they also served important needs of the Haida themselves, keeping traditional stories and art styles alive. Indeed, one of the greatest Haida carvers of the Victorian period, Charles Edenshaw, made some of his finest works in argillite [**140**]. The legacy he and other late nineteenth-century artists left proved critical to the twentieth-century revival of Haida art by artists like Bill Reid, Edenshaw's great-nephew, and Robert Davidson, his great-grandson.

Northwest Coast art in the twentieth century

During the first half of the twentieth century a number of Northwest Coast artists continued to make traditional art for use in potlatches. They and others also used traditional imagery to make model totem poles and other miniatures for the souvenir trade. Ellen Neel's (1916–66) model poles and innovative scarves heralded the taking up of traditionally male art forms by women artists. During this period, as we have seen, museums continued to collect crest poles, many of which had fallen and were being allowed to decay. By the 1950s a number of poles that had been placed outdoors at the University of British Columbia were showing such bad signs of weathering that the curator of the University's Museum of Anthropology, Audrey Hawthorn, engaged Mungo Martin, a Kwakwaka'wakw carver and one of the few living artists trained in the traditional apprenticeship system, to come to Vancouver and undertake the restoration. This project soon led to commissions for new carvings, and to further projects of similar kinds at the British Columbia Provincial Museum in Victoria. Martin took apprentices such as Henry Hunt, Tony Hunt, and Douglas Cranmer, and initiated the training of a new generation of Northwest Coast

carvers. He also collaborated with Bill Reid, who, born and raised in Victoria, had been a radio announcer by profession and had also trained as a maker and designer of modern jewellery. Reid's interest in the Haida art of his ancestors led him first to teach himself to make traditional Haida jewellery, and then wood carving, by studying museum collections, ethnographic literature, and family heirlooms made by Edenshaw and others.

With these events and in the climate of liberalism, anti-racist activism, and movements of national liberation that characterized the 1960s, a new era of art-making opened on the Northwest Coast, an era in which many traditional forms have been made again and others reinvented to fill the gaps colonial repression created in use and memory. The vital link between ritual celebration and art was also reasserted in these years. The potlatch held in 1953 by Mungo Martin for the newly completed big house that he and his apprentices had built for the British Columbia Provincial Museum (now the Royal British Columbia Museum) openly, for the first time since the 1885 law was passed, was a sign of the end of official repression. The new era included not only the carving of traditional architectural sculpture and other masks but also new genres like printmaking and public sculptures such as 'The Raven and the First Men' [116]. Native and non-Native patronage overlap in interesting ways in relation to contemporary and historical genres. Some carved masks continue to display inherited family privileges at potlatches, while others are collected and marketed as 'fine art' by urban art galleries.

In 1970 'Ksan, an art school and cultural centre, was established at Hazelton, British Columbia, in Gitksan territory. Artists who had worked on the Vancouver and Victoria museum projects came to

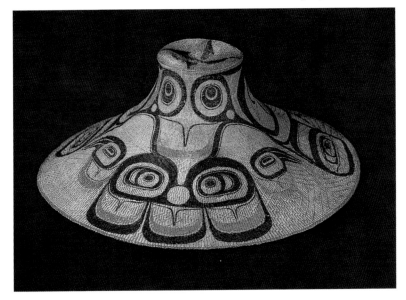

141 Isabella Edenshaw (c.1858–1926) and Charles Edenshaw (c.1839–1920), Haida

Clan hat, late nineteenth century

Hats were the single most important items of dress among Northwest Coast people. Those worn at potlatches displayed the crests belonging to the owners. Following the traditional gendered division of labour, Isabella Edenshaw wove this hat with consummate evenness and technical skill and her husband Charles painted the design.

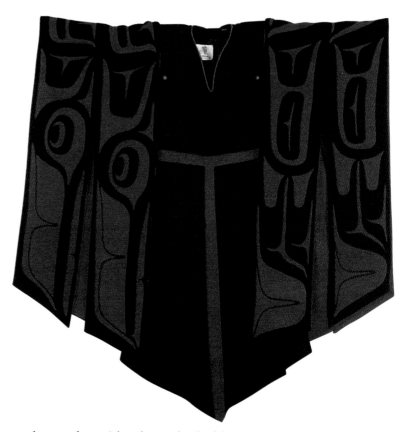

**142 Dorothy Grant
(b. 1956) and Robert
Davidson (b. 1946), Haida**

Hummingbird copper dress
(wool/cashmere, beads, hand
appliqué), 1989

The formline designs on the
haute couture clothing des-
igned by Dorothy Grant in the
1980s were drawn by Robert
Davidson and appliquéd in
a technique borrowed from
button blankets. The design
on this dress is based on a
Haida copper bearing a
hummingbird crest.

teach, together with others who had been pursuing similar projects.
'Ksan was important not only in disseminating the skills honed by the
pioneering generation of Kwakwaka'wakw and Haida artists, but also
in stimulating the renewal of local art traditions. Nuu-chah-nulth
artists such as Ron Hamilton (b. 1948), Art Thompson (b. 1948) and
Joe David (b. 1946), Tsimshian artists like Walter Harris (b. 1931) and
Norman Tait (b. 1941), and Coast Salish artists such as Stan Green and
Susan Point (b. 1952) have all worked to re-establish the integrity of
their own distinctive stylistic and iconographic traditions.

Point's work as both a carver and a printmaker also suggests the
changing relationship of gender to artistic genre that has been a feature
of the second half of the twentieth century. Men and women have
always collaborated in the creation of art on the Northwest Coast.
Charles Edenshaw painted the finely woven clan hats made by his wife
Isabella [141], while male painters designed the pattern boards used
by virtuoso female weavers in the creation of Chilkat blankets [121].
More recently, Haida artist Robert Davidson has created formline
designs for the high-fashion clothing produced by Dorothy Grant
[142]. Until the second half of the twentieth century, however, the
medium in which a male or a female artist worked was largely regu-
lated by convention. Men carved and painted, while women wove and

sewed. The Haida carver Frieda Diesing (b. 1925) and the Gitksan artist Doreen Jensen (b. 1933), both students at the 'Ksan school, were instrumental in redefining the roles of both men and women artists. The work of contemporary artists, crossing the old gender boundaries, and making use of concepts and media from Western art, has come to equal or even surpass that of their illustrious forebears.

The Twentieth Century: Trends in Modern Native Art

7

Questions of definition

Fundamental questions of definition continue to hamper our understanding of the 'modern' and the 'contemporary' in Native art, the subject of this chapter. To be judged 'modern', must a work be produced in Western art media and formats, or should all forms of art made by Native people during the past century be included, whether in 'craft' or 'fine art' media? If expressed in Western media, must the works deal with 'contemporary' issues or should art about traditional heritage and belief be included? Is professional art-school training and familiarity with current idioms of modernism or postmodernism a necessity, or are apprenticeship and the use of historicist styles acceptable? Other unresolved issues also complicate questions of definition. To be judged 'Native', must the work be by an artist whose Native status is legally recognized by the US or Canadian Government? The application of a 1990 US law that legislates such a definition has resulted in such absurdities as the exclusion of celebrated Cherokee artist Jimmie Durham from recent exhibitions. In the following pages we include visual expressions created by persons of Native or part-Native ancestry whose artistic concerns have been formed by their identification with Native communities.

Questions of stylistic labelling are, of course, made more difficult by the debates that surround definitions of modernism and postmodernism themselves.[1] Generally, however, Western modernism has involved the rejection of the faithful illusionistic rendering of forms in space in favour of flatness of surface and, often, the abandonment of figuration in favour of abstraction and expressionism. It is characterized by reflexivity about the elements of which art is made and by an emphasis on individual freedom of self-expression. As we will see, Native artists became interested in these problems in the middle of the twentieth century, four decades after the birth of modernism in Europe and North America. Because of this time-lag their work was initially received as provincial and historicist.[2]

The movement in art which began in the late 1970s, usually characterized as 'postmodernism' has, however, ruptured the progressivist expectation that art develops over time in a linear fashion as the result

Detail of 156

of a sequence of formal stylistic inventions. With this change has come a decentring of the particular sequences demonstrated by the history of Western art, a reorientation that has begun to 'decolonize' art history. Postmodernism has, thus, established a climate in which it is possible to reposition the work of Native modernists within a much longer engagement with Western visual arts. In this chapter we will use the term 'modern' somewhat differently than do historians of Western art. For Native art, we propose, the modern is defined not by a particular set of stylistic or conceptual categories, but by the adoption of Western representational styles, genres, and media in order to produce works that function as autonomous entities and that are intended to be experienced independently of community or ceremonial contexts.

This set of parameters has a number of virtues. First, it helps us to understand the social and economic contexts that have shaped the particular histories of engagement that unfolded during the twentieth century, both as artefacts of the continuing colonialist control over Native peoples' lives and as the result of the interventions of particular non-Native patrons. Equally importantly, these parameters promote an appreciation of the excitement and creativity generated by Native and non-Native artists' explorations of the convergences between indigenous and modernist visual arts. The story of these convergences has most often been told as a series of 'discoveries' of 'affinities' between tribal and modern art made by Western Primitivists. As this chapter demonstrates, the discovery of affinities has been just as inventive on the other side of the mirror. It is, finally, important to point out what is omitted by our criteria. During the twentieth century Native artists have continued to develop the formal and technical traditions invented by their ancestors, and to make art within and for their own communities [1]. But the practises of many of these 'traditional' artists also extend into cosmopolitan, urban art worlds. The work of Haida artist Robert Davidson [143], for example, includes ceremonial masks and painted dance drums as well as prints that participate in a fully modernist and reflexive consideration of the properties of form and spatial composition. Community-based and outsider-orientated artistic projects have often overlapped. Davidson's masks and prints can be found on the walls of art galleries and in the living rooms of non-Native collectors, but the masks are also worn and the prints used on invitations to potlatches. Many other 'contemporary–traditional' arts have been discussed in previous pages; this chapter supplements those discussions, it does not supplant them.

Commoditization and contemporary art

The history of modern Native art is part of a larger history of Native peoples' commoditization of their arts. The new dimensions of visual culture discussed in this chapter have developed in large part because

**143 Robert Davidson
(b. 1946), Haida**

'Reflections', 1976

Davidson has worked in
the full range of traditional
Northwest Coast media
including jewellery, carving,
hide, and textiles. His graphic
works push the limits of the
formline style, revealing
its capacity to explore
relational qualities of forms
in space. This important early
print is based on a greeting
card made for Christmas
1975 entitled 'Negative and
Positive'.

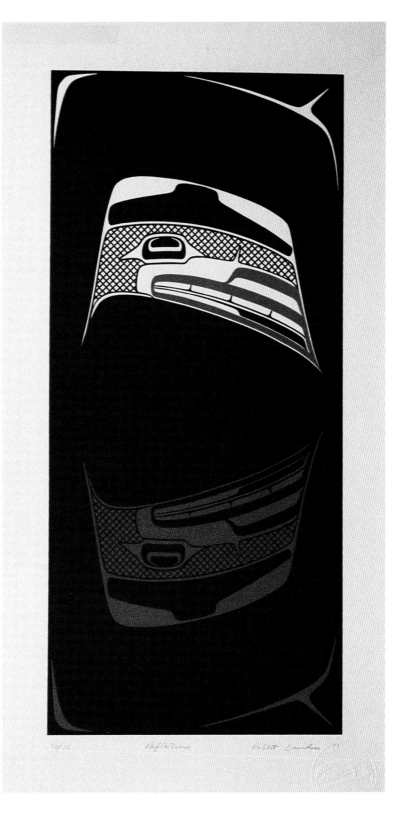

of the expansion of non-Native patronage for Native art, both individual and institutional, during the late nineteenth and twentieth centuries. As detailed in earlier chapters, extensive patronage of Native artists developed in conjunction with two conjoined phenomena of industrial capitalism: the rapid expansion of consumer culture, and the growth of tourism. During the Victorian era, and especially as a result of the Arts and Crafts Movement of the late nineteenth century, Native-made objects became increasingly popular in the decoration of the North American parlour. At the same time, Native people, denied their hunting and farming lands, turned increasingly to the production of art commodities for their very survival. With great ingenuity they designed objects that were saleable to and comprehensible by the non-Native viewer, and that also expressed indigenous cultural and aesthetic principles.

The modern trade in Native art turns on this aspect of doubleness. On the one hand, the market for Indian art grew in tandem with the entrenchment of assimilationism and the dogma of the Vanishing Indian. Yet, on the other hand, the commodity most desired by buyers —themselves displaced and alienated by many aspects of industrialization and urbanization—was 'Indianness' itself. Many of the most important white patrons and buyers of Native objects shared an 'anti-modernist' intellectual formation that, according to T. J. Jackson Lears, reached its height between 1880 and 1920.[3] They romanticized the Indian as still connected to Nature and to local community, ties that many non-Natives believed to have been broken by urbanization and industrialization. Buyers of Native-made objects, whether 'crafts' or 'fine art', sentimentalized and romanticized their acquisitions as precious traces of lost authenticity.

For Native artists, the increased commerce in art stimulated by these attitudes provided one of the few safe spaces for the expression of Native identity and the articulation of traditional beliefs and values. The same assimilationist policies that so gravely threatened their cultural survival also led to the establishment of Indian schools, some of which provided instruction in Western art techniques and led eventually to the establishment of specialized institutions for the training of Native artists. In the early twentieth century these three factors—the expansion of the market, the anti-modernist orientation of non-Native consumers, and scattered but crucial opportunities for training in Western art—came together to create the conditions for the full-scale emergence of a Native tradition of fine arts.

As many Native critics point out, non-Native patronage has been a mixed blessing. Individual patronage, on the one hand, has all too often stimulated the production of repetitive and stereotypical images of the Indian as noble savage, tragic warrior, or new-age mystic—a phenomenon whose continuing vitality is evident at powwow booths

and commercial art galleries from Ontario to Santa Fe. Institutional patronage, on the other hand, has imposed arbitrary hierarchies and systems of classification that disrupt Native unities of thought about objects and about the visual as an integral part of culture. Until the 1970s few art galleries—and virtually no large urban art museums—collected or displayed twentieth-century Native art. For the most part, ethnographic museums, too, rejected works in Western media; they saw them as inauthentic and acculturated. Those that did buy prints, paintings or sculptures tended to value them as ethnographic documentation of traditional beliefs and lifestyles.

Moments of beginning

Producing art for outsiders involves a series of discrete reorientations, transpositions and inventions. The initial act is the decision to address a viewer outside one's culture. One of the first such moments must have occurred in 1540, when the Spanish conquistador Coronado, marching north from Mexico into the Pueblo world, wrote in a letter to Viceroy Mendoza, 'I have commanded them to have cloth painted for me with the animals they know in that country . . . they quickly painted two for me, one of the animals, and the other of birds and fishes.'[4] Such events must have occurred over and over again during the early contact years, and they must often have entailed alterations in indigenous representational conventions. From the earliest moments of contact, too, examples of Western pictorial depiction were provided by the newcomers. During the seventeenth century the Jesuit missionaries in New France used pictures as a preferred strategy in their efforts to convert Native people, and there is much evidence that these printed and painted images exerted a strong attraction. Picture frames have been found in seventeenth-century Iroquois graves, though the prints they once contained have long disintegrated. Within a few years of the re-establishment of a Catholic mission among the Michigan Odawa in the mid-nineteenth century, local converts were drawing scenes of their traditional dances and of the torments of hell on the paper pages of a notebook.[5]

We do not know whether the Pueblo artists who drew animals for Coronado altered their accustomed style of composition and representation in order to make their images comprehensible to the foreigner. Certainly such changes as the adoption of a groundline, elements of perspectival drawing and more naturalistic and descriptive graphic styles were occurring two and a half centuries later when Plains artists such as Wohaw, working in 1875 while imprisoned at Fort Marion, made paintings of traditional life and of his contemporary experiences to sell to the tourists who visited the fort [85]. Many contemporary Native artists consider these ledger artists the first modernists.

Cheyenne-Arapaho artist Edgar Heap of Birds, a descendant of one of the Fort Marion artists, has written:

These imprisoned artist/warriors began to use contemporary forms to communicate with the white public, as a way of defending Native peoples. Older modes of physically violent warfare were left behind in order to articulate the public message, thus ensuring survivability for the warrior and his family while voicing opposition to white domination.[6]

Such changes have been taken by other scholars to mark the beginning of modern Native art. For Jackson Rushing the beginning came in 1901, when a Navajo artist, Api Begay, made 'paintings on paper that were derived from traditional culture and intended for consumption by a non-Native audience'; for Bruce Bernstein it came in 1908, when archaeologist Edgar Lee Hewett encouraged men from the Pueblo of San Ildefonso to make similar paintings.[7]

Inherent in the arguments of Heap of Birds, Rushing, and Bernstein is a common set of criteria for modern Indian art: the intended audience includes those outside the community, the issue of communication with those outsiders is a critical part of the discourse, and issues of cultural survival combined with resistance to white domination are at the forefront. The exact moment when Native artists put pen or paintbrush to paper in order to inscribe indigenous pictorial histories, or visual records of social change, differs from region to region. As Coronado's letter suggests, the first experiments with pictorial recording usually came soon after contact. However, the impulse towards historical narrative in art and the involvement of groups of artists rather than isolated individuals seems to arise later, in conjunction with perceptions of rapid change and impending loss. In the Canadian Arctic, for example, a whole new art emerged in the decades after 1950 in response to the rapid changes that occurred when formerly nomadic bands were settled in permanent villages, as discussed in Chapter 5. At such moments the encouragement and intervention of non-Native artists or teachers has often been of critical importance.

We have chosen an 1821 water-colour by Dennis Cusick, a Tuscarora Iroquois artist from New York State, as a point of departure for our discussion of modern Native art [144]. Cusick depicts the interior of the Seneca Mission schoolhouse, where the teacher instructs a group of some sixty children. The imagery of bookcases, a chalkboard covered in examples of fine penmanship, and a prominent inscription of bible verses would have suggested to a contemporary white viewer that the conversion of the Indian was well under way. Yet this image, like much Indian painting produced in the decades since, may have carried a double message. To an Iroquois audience, the clothing of the children, particularly the *gustoweh* head-dresses worn by the young men, is a signal that this young generation remains Iroquois despite its accept-

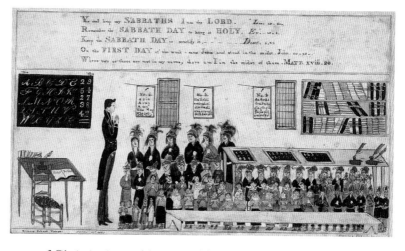

144 Dennis Cusick
(1799–*c*.1822), Tuscarora

'Scene of Indian Life: Keep
the Sabbath' (watercolour
on paper), 1821

The drawings and woodcuts
of Dennis Cusick and his
brother David are early
examples of the appropriation
of Western pictorial formats
by Native artists to record
oral traditions and to depict
contemporary life. This
scene from the missionary
school the artist attended at
the Buffalo Creek Reservation
in New York testified to
the success of missionary
efforts when exhibited to
non-Native supporters.

ance of Christianity and literacy.[8] The pictorial message is essentially the same one that Wohaw sought to convey a half-century later in his famous 'Wohaw in Two Worlds', and that continues to be inscribed in much twentieth-century Indian art. As Rushing has explained, 'there was often an intersection between what patrons valued about Native culture and what artists wanted to signify to the dominant culture about themselves'.[9] Until recently, however, few scholars have focused on the multivalency of early pictorial works.

We do not position the Cusick painting at the start of our history of modern Native art in order to enshrine it as 'the first' in a new canon, but only to make the point that the pictorial arts which are so well documented for the Plains in the late nineteenth century, and the Southwest at the beginning of the twentieth, have precursors in the East that are considerably earlier, although less well known. More importantly, these incidents strongly suggest that the adoption of a Western pictorial language was a product of colonialism as inevitable as the adoption of the French, English, or Spanish language.

The Southern Plains and the Kiowa Five

The Plains was perhaps the only region of North America where historical narrative had long been a part of the indigenous artistic tradition. As discussed in Chapter 5, Lakota, Cheyenne, Kiowa, and other Plains men had for centuries chronicled their exploits in paintings on hide. With the advent of European trade, paper and pens became part of the intercultural encounter between US soldiers, white traders, and Native men. The transition from painting narrative scenes on buffalo hides to drawing them on paper that occurred throughout the Great Plains in the second half of the nineteenth century did not disrupt the value placed on these drawings as records of personal history.

The ledger-book tradition of painting on paper that became established in the third quarter of the nineteenth century has a direct

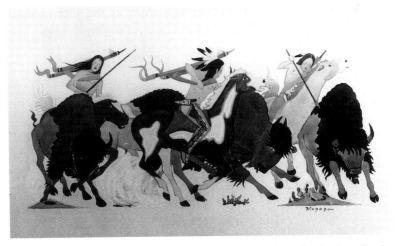

connection to some of the early developments of easel painting. In the
1890s, Kiowa artists such as Ohettoint (1852–1934)—who had been a
Fort Marion prisoner—his younger brother Silverhorn, and Arapaho
artist Carl Sweezy (1879–1953) drew for anthropologist James Mooney,
who was endeavouring to record the rapidly disappearing aspects of
Southern Plains cultures. Such men kept the pictorial impulse alive
on the Great Plains, and served as direct inspiration for the first
generation of twentieth-century painters.

Silverhorn was an especially prolific artist, whose legacy of hun-
dreds of drawings, ranging from simple portrait-like images, to scenes
of combat, to complex narratives illustrating Kiowa myths,[10] was
influential upon the next generation of Southern Plains painters. This
group, known as the 'Kiowa Five', included Silverhorn's nephew
Stephen Mopope [145], as well as Jack Hokeah (1900–69), Monroe
Tsatoke (1904–37), Spencer Asah (1906–54), and James Auchiah
(1906–74). Their story began in 1914, when Sister Olivia Taylor, a
Choctaw, taught art to Hokeah, Asah, and Mopope at St Patrick's
Mission School in Anadarko, Oklahoma. Soon thereafter, a teacher
who worked for the Indian Agency gave informal art lessons to these
young men for several years. She finally arranged classes for the men
who would become known as the Kiowa Five (along with one woman,
Lois Smoky (1907–81), whose work never achieved the same fame as
that of the Kiowa Five) under the direction of Professor Oscar
Jacobson at the University of Oklahoma in 1927 and 1928.

The works of the Kiowa Five grew out of their traditional artistic
heritage, as well as their own experience as competitive dancers. Many
of the paintings depict individual figures, often male, posed in a dance
position. The Kiowa Five synthesized their own historical and artistic
traditions with a modern, flat, decorative style [145]. Through
Professor Jacobson's intercession, some three dozen of their water-
colours were widely circulated throughout the US and Europe,

culminating in a show at the International Folk Art Congress in Prague, former Czechoslovakia, in 1929.

An important centre for the further development of Southern Plains painting was Bacone College, near Muskogee, Oklahoma, which had been established as an Indian college in 1880. Three of the most famous Native artists of this region headed the art department from the 1930s to the 1970s: Acee Blue Eagle (Creek/Pawnee, 1907–59), Woody Crumbo (Potawatomi, 1912–89), and Richard West (Cheyenne, 1912–96). It was here and at the Studio School in Santa Fe that a 'traditional style' of Native American painting was born.

The Southwest and the 'Studio' style

Unlike the Plains region, there was no indigenous tradition of pictorial narrative in Pueblo or Navajo art. Yet at the beginning of the twentieth century, artists in several Pueblos began to experiment with such imagery. An anthropologist working at Hopi in 1899 commissioned Kachina drawings from several Hopi men.[11] A few years later, at San Ildefonso Pueblo, Alfredo Montoya (?–1913), Crescencio Martinez (c.1879–1918), Julian Martinez (c.1879–1943), and Awa Tsireh (1898–1955) began to make paintings for sale to outsiders, sometimes under the sponsorship of local museums and anthropologists. After 1918, The Santa Fe Indian School, a regional boarding school, also became a centre for Indian painting. Hopi artist Fred Kabotie [30] was one of several Pueblo artists whose work was championed by an active local non-Indian community of artists and literati, a group that exhibited the anti-modernist sensibility described by Lears.

The event that was to legitimate and consolidate Native painting as a larger movement was the establishment of a formal art programme at the Santa Fe Indian School in 1932. 'The Studio School', as it was called, was designed for high-school-age students, and was directed for its first five years by Dorothy Dunn. A non-Native art teacher from Kansas, Dunn believed that there was an 'authentically Indian' way to paint. She encouraged the students to derive their inspiration from the great artistic traditions that were their heritage—abstract forms painted on pottery, figurative rock art, and geometric beadwork and basketry patterns. Dunn intentionally did not offer technical lessons in perspectival drawing or colour theory, preferring that the students' natural ability and remembrance of their cultural traditions form the basis for their work.

During a time when the overriding impulse in the dominant culture was towards assimilation and obliteration of Indian traditions, Dunn's teaching was, in some ways, a remarkably non-authoritarian approach to Native art pedagogy. It resulted, however, in a large body of work that was rather uniform in its decorative, two-dimensional approach to genre scenes. Many of the students painted images of traditional life—

146 Pablita Velarde
(b. 1918), Santa Clara
Pueblo

'Pueblo Craftsmen, Palace
of the Govenors', 1941

One of the first female
students at the Studio School
in Santa Fe (1932–6), Velarde
painted numerous scenes of
village life and depictions of
traditional stories during her
long life as an acclaimed artist.
Here she has recreated a
scene familiar to inhabitants of
Santa Fe for over 100 years—
Native artists who sit within
the shady portals of a large
building on the town square,
selling pottery and jewellery.

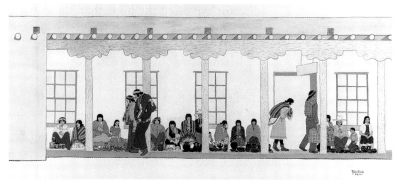

Pueblo potters or ceremonial figures, Navajo social dances or horse-men, or animals in an idealized landscape. Some of these young students were undoubtedly homesick for these very events of daily life; others, like Pablita Velarde, believed that these 'memory paintings' would help preserve a way of life that was rapidly changing [146]. In subsequent years the Studio School was criticized for its fossilization of Indian art within a narrow stylistic mould. Yet for its era, it was a remarkable experiment which produced an entire generation of Indian artists who, in turn, served as role models for the next two generations. Some never diverged from the artistic path which was laid out in their student years at the Studio School. Others, as we shall see, went on to transform Indian art at mid-century into a more complex and varied artistic corpus.

The display and marketing of American Indian art: exhibitions, mural projects, and competitions

The work pouring out of Oklahoma and Santa Fe found a ready commercial market. It was also championed in North America and Europe through a series of exhibits and publications which established it as the normative style for Indian painting in the years between 1930 and 1960. The Exposition of Indian Tribal Arts opened in New York in 1931 and toured the US and Europe. It provided the first large-scale exposure for the new Indian painting, which was critically acclaimed as an important new American art form. The 1939 Golden Gate International Exposition in San Francisco featured Indian paintings alongside works in more traditional media and was seen by over a million visitors, spreading awareness of the new Indian art nationwide.[12]

In 1941, the Museum of Modern Art in New York gave over its entire three floors to 'Indian Art of the United States', setting the definitive seal of art-world approval on Native American art. Traditional works were presented in austere art-museum installations [9], causing many viewers to consider such objects as art rather than ethnographic specimens for the first time. The new Indian painting was displayed conspicuously on the first floor of the museum, and the exhibit's

director expressed the hope that 'the down-town galleries will swing into line and accompany our exhibit with sales exhibits that should create a new steady market for Indian paintings in the east'.[13]

Many of the Native artists who had trained in the Oklahoma and Santa Fe schools showed their work in these exhibitions. The museum display of easel paintings alongside pottery, beadwork, and silver-smithing established the new work as continuous with 'authentic' historic artistic traditions. These projects, however, could not fully position modern Native painting within the most prestigious Western category of 'fine art'. The language of presentation remained patroniz-ing, and the stylistic conventions that had been established for Indian painting associated it with categories of the folk and the naive that, like tribal art, remained tied to a discourse of Primitivism.[14] Finally, the governments and foundations that underwrote these exhibitions were motivated by economic development agendas; their promotion of modern Indian art as accessories to interior decoration diluted efforts to have it seen as 'fine art'.

Another important source of patronage for Native painters during the 1930s and '40s was mural projects for public buildings inspired by the populist Mexican muralist movement of the 1920s; by 1930 the celebrated Mexican artists Diego Rivera (1886–1957) and José Clemente Orozco (1883–1949) were painting murals in the United States. The Works Progress Administration (WPA), a 'New Deal' programme designed by the US Government to provide work for artists during the Great Depression of the 1930s, employed white, black, and Native American artists to paint public murals for modest wages. Studio School graduates Tonita Peña (1893–1949), Pablita Velarde, Oscar Howe, and several of the Kiowa Five received commis-sions to paint murals at schools, libraries, post offices, and other public buildings in the West and Southwest as well as in the Department of the Interior building in Washington, DC.[15] An important body of paintings and murals was made by Seneca artist Ernest Smith under a New Deal-inspired project at the Rochester Museum of Science, whose intention was to revive and preserve Iroquois arts [44]. The ex-hibits of 1931–41, the mural projects, and other New Deal initiatives such as totem pole restoration projects in Southern Alaska, all fostered a notion of Indian art as essentially American. At a time of war and extreme cultural destabilization in Europe, the United States was asserting its independence and affirming its indigenous roots through its celebration of Native art.

Art historians recognize the formative role of patrons in shaping art traditions around the world, from Taizu's patronage of calligraphy and printing in Song Dynasty China during the tenth century, to Pope Alexander VII's patronage of Bernini in seventeenth-century Rome. Within a colonialist paradigm, however, the effects of patronage are

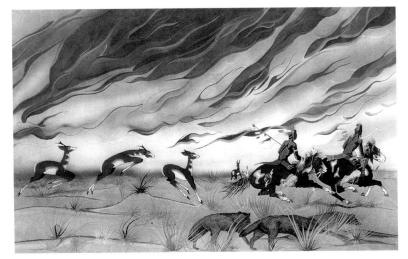

more problematic. The economic imbalances inherent in such situations give patrons the power to define authenticity and to determine value according to their own culture-based criteria rather than those of the artists. The juried competitions and exhibitions held at the Philbrook Museum in Tulsa, Oklahoma between 1946 and 1979 illustrate particularly well how this process worked. The Philbrook Annual Exhibition quickly became an important venue for the display of contemporary Native work, and artists from many tribes vied for acceptance as well as for prizes. The exhibits often travelled through the US and Latin America, providing further exposure for the successful entries. Despite these benefits, the Philbrook shows became a conservative force in the development of twentieth-century Native art because they imposed a prescribed set of stylistic and iconographic criteria for what was admissible as 'Indian Painting'. Romanticized images painted in the flat, decorative style made popular during the 1920s and '30s, and perpetuated by artists such as Blackbear Bosin [147] continued to be considered the epitome of modern Indian art. It should be noted that in some cases it was non-Native teachers and patrons who promoted such work; in other cases, the teachers (at the Studio School and at Bacone) or the exhibit jurors (at Philbrook) were Native artists themselves.

Native American modernisms, 1950–80

One of the best-known graduates of the Studio School, the painter Oscar Howe, played an important role in forcing a reconsideration of what modern Indian art might be. After leaving the Studio, he achieved immediate recognition for his paintings of Sioux traditional dances and activities. In the WPA-sponsored mural he painted for the Carnegie Library in Mitchell, South Dakota, in 1940 he combined the spareness and linearity of Studio style with Lakota symbolic

geometries. After serving in Europe during World War II, Howe went on to earn both a BA and an MFA in painting and began teaching at the University of South Dakota. In the 1950s he began to work in a highly innovative modernist style [**148**]; his figures of Sioux dancers, riders, and tableaux from mythic narratives, caught or exploded in a picture plane fractured into numerous facets, move the representations in the direction of abstraction.

These paintings defied the sedate predictability of most Indian painting of its era. When Howe entered one of his works for the 1958 Philbrook Annual it was rejected. He responded with a letter to the curator which we might characterize as the first manifesto of Indian modernism and artistic autonomy:

Who ever said that my paintings are not in traditional Indian style has poor knowledge of Indian art indeed. There is much more to Indian art than pretty, stylized pictures. . . . Are we to be held back forever with one phase of Indian painting, with no right for individualism, dictated to as the Indian always has been, put on reservations and treated like a child, and only the White Man knows what is best for him? Now, even in Art, 'You little child do what we think is best for you, nothing different.' Well, I am not going to stand for it.[16]

Howe's protest caused the Philbrook to rethink its rigid categories, opening the competition to a wider range of works, and paving the way for institutional support for the individualism and full-blown modernism of the Indian art of the 1960s.

148 Oscar Howe (1915–83), Yankton Sioux

'Rider' (casein), 1968

Howe's rigorous explorations of planar space helped to move Native American painting beyond a simple transcription of visual reality into a more complex examination of pictorialism and abstraction. This grew out of Native American metaphysical concerns as well as European artistic experiments in Cubism.

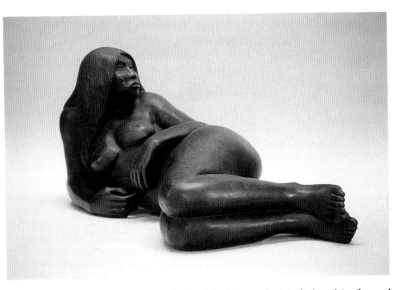

Howe vociferously rejected the label 'neo-Cubist' that his formal experiments suggested to many viewers. He argued that his artistic experiments were a logical outgrowth of the Sioux artistic and mythic tradition, and he referred to his multi-faceted pictorial surfaces as a spiderweb linked to the Sioux trickster/spider and shape-changer Iktomi. In one myth, Iktomi gives colours as gifts to a number of supernaturals; perhaps both the forms and the colours in Howe's work make reference to this mythic character.[17] Yet a painter who had travelled in Europe in the 1940s, and had earned an MFA in painting in the 1950s, was surely not uninterested in European experiments in the dismemberment of planar space. Howe's explanations of his artistic efforts by means of a Sioux epistemology should be understood as a political statement about the primacy of his own culture's intellectual and artistic traditions in his formation as an artist.

Like Howe, the Cochiti Pueblo painter Joe Herrera (b. 1923) moved from traditional roots in the life of a Native community and from a training in Studio-style art to grapple with issues of form and content being widely explored by twentieth-century Western artists. The ceremonies and arts of two different Pueblos were vividly present in Herrera's early life. Born at his father's village of Cochiti, in New Mexico, Herrera also spent time with his mother's relatives at San Ildefonso. He has recalled helping his mother's cousin, the pre-eminent potter Maria Martinez, and watching her husband Julian Martinez paint on her pots the traditional geometric San Ildefonso designs. Herrera's own mother, however, had the most profound influence on his art. Tonita Peña was the most prominent woman among the first two generations of water-colour painters. As a child of five, her son swatted the flies away from her paint dishes as she worked, and was rewarded with a little bit of paint with which to experiment.[18]

From Peña, and from his own early training at the Studio School with its second director, San Juan Pueblo artist Geronima Montoya (b. 1915), Herrera learned the flat, opaque, water-colour style.

It was at the University of New Mexico, as a student of Raymond Jonson between 1950 and 1953, that Herrera achieved his breakthrough synthesis of modernist and Pueblo abstraction [35]. Describing the relationship between the two traditions, Herrera observed that while 'Klee sought to see the wonders of nature through the eyes of aborigines and children, and attempted to combine their freshness of vision with his own cultivated knowledge, I attempted the reverse, bringing the innovations and intellectual constructs of modern art to bear on traditional Pueblo imagery.'[19]

A third artist whose modernism, like that of Howe and Herrera, resists easy categorization, is the sculptor Allen Houser. His work reveals multiple sources of inspiration, both modernist and Native. Also trained as a painter at the Studio, Houser turned to sculpture later, around the time that he received a Guggenheim Fellowship in 1949 [149]. Unlike Howe, who denied his engagement with European artistic movements, Houser's work was a deliberate visual conversation with the work of other sculptors. Some of his large-scale abstract pieces in marble or bronze recall works by Henry Moore (1898–1986) or Barbara Hepworth (1903–75). Others are lyrical, almost romantic evocations of Apache dancers, female figures, or medicine men.

These three examples make clear that the Native engagement with twentieth-century art produced a number of 'modernisms' rather than a single monolithic style. Each artist's œuvre, furthermore, reveals a unique negotiation of particular Native traditions and modernist models. As Joseph Traugott has observed, the facile identification of Native American works with the particular styles of modern art they have appropriated, 'mask[s] the power of these images to transcend cultural boundaries' and 'limit[s] this work by condescendingly appending them to the dominant tradition rather than viewing the work as a synthesis that transcends Euro-American cultural traditions'.[20]

The single most important institutional force in the development of modernist Native American art was the Institute of American Indian Arts (IAIA) in Santa Fe, founded in 1962 on the site of Dorothy Dunn's Studio School. The groundwork for the new school was laid at a series of conferences and workshops held in Arizona between 1959 and 1962. Funded by the Rockefeller Foundation, they were designed to develop a more systematic approach to modern Indian art. The ethos of self-determination that was integral to the general consciousness of the 1960s clearly marked the formation of the IAIA. Native educators designed the curriculum to incorporate indigenous ways of teaching, and prominent Native artists formed the school's faculty. Allan Houser and the painter Fritz Scholder were among its most

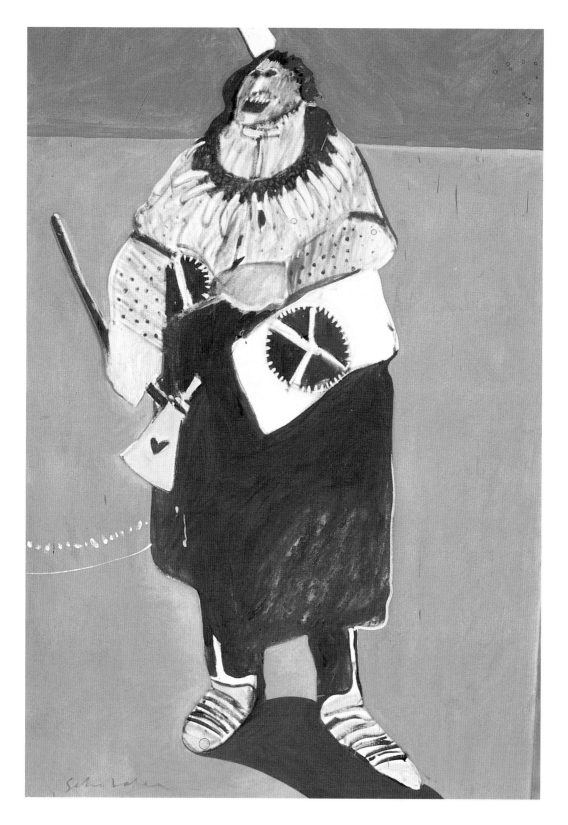

150 Fritz Scholder
(b. 1937), Luiseño

'Screaming Indian #2' (oil on canvas), 1970

In his many portraits of Native people Scholder draws out the psychic cost of the gap between romantic and backward-looking popular stereotypes of Indians and the actualities of their daily lives. His modernist isolation and expressive, gestural renderings of the human figure suggest comparison to the art of Francis Bacon. Scholder's images, however, play off modernist existential angst against the tragic experience of indigenous people. They often employ a sardonic humour in their revelations of the absurdities of Native people's lives in the twentieth-century world.

influential teachers, inculcating ideas of individual artistic freedom, and training many of the most notable American and Canadian Native artists of the 1960s, '70s and '80s.

The new positioning of contemporary Native art that the IAIA achieved was signalled by an important exhibition that took place in 1972 at the National Collection (now the National Museum) of American Art in Washington, DC. The show, 'Two American Painters', exhibited the work of Fritz Scholder [150] and Scholder's former IAIA student, T. C. Cannon [5]. The title, a play on 'Three American Painters', a landmark exhibition of avant-garde abstract art held in 1965,[21] heralded the organizers' intention to situate contemporary American Indian art directly in the mainstream of American art. Both Scholder's expressionist style and Cannon's pop-art imagery, however, were deployed in order to explore a politics of identity that was new to both Native and non-Native art. Both artists reclaimed and subverted the stereotypical, pervasive images of 'Indianness' familiar from the nineteenth-century paintings of Bodmer and Catlin, the photographs of Edward Curtis (1868–1952), and Hollywood movies. The feather-bonneted Plains warriors hold ice-cream cones and wear sunglasses; they hang reproductions of van Gogh on the walls of their modern living rooms; they live, destroyed by alcohol and poverty, on the street. Scholder's and Cannon's explorations in irony and kitsch opened up a new phase of contemporary art that has been developed further in the paintings, prints, and mixed media works of artists such as George Longfish (Seneca/Tuscarora, b. 1942), Harry Fonseca (Maidu, b. 1946), Carl Beam [158], Lawrence Paul Yuxweluptun [139], Gerald McMaster [11] and Jimmie Durham, and in more recent photographic work by artists such as Hulleah Tsinhnahjinnie (Seminole/Creek/Navajo, b. 1954), and Shelley Niro [151].

Their figurative art, with its searching and often biting critique of the position of Native people in contemporary society, was not the only focus chosen by the new Indian modernists. During the 1970s and '80s

151 Shelley Niro (b. 1954),
Mohawk

'The Iroquois is a Highly Developed Matriarchal Society', from 'Mohawks in Beehives' series (hand-tinted photo), 1992

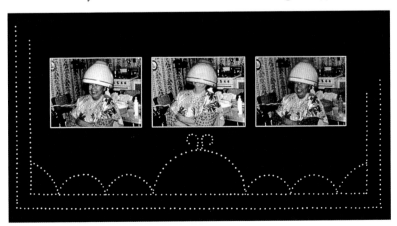

Native artists in the United States and Canada used the more open definitions of Native art to move in a number of different directions. Artists such as George Morrison [152], Truman Lowe (Winnebago, b. 1944), Jaune Quick-to-See Smith (Flathead/Cree/Shoshone, b. 1940), Kay WalkingStick [153], Alex Janvier [156], Robert Houle, Emmi Whitehorse, and others pursued the possibilities offered by abstraction for the exploration of other kinds of aesthetic and iconographic problems.

For Navajo artist Emmi Whitehorse [154], the process of making paintings is connected in essential ways to her ancestors' making of dry painting and weavings [40, 41]. To beautify the world through the weaving of a blanket or through the precise laying out of a pictorial design in coloured sands is highly valued in Navajo society, as discussed in Chapter 2. While Whitehorse's work may not, superficially, look like the traditional art of her ancestors, she credits her grandmother, a weaver, with having the most influence on her as an artist:

I sort of align myself with her in some of her working processes. I don't know what I'm going to be painting and I don't know what the finished product is going to end up looking like . . . and my grandmother worked in that same fashion. She had nothing to go by when she worked at her loom. The bottom part would have a pattern, but the top part would just be all open space, so everything had to be figured out immediately as she worked. That's the same way that I work.[22]

Whitehorse sees her practice as different from that of most non-Native painters: 'I work against that Western tendency to schematize. For example, I work with no top or bottom to the canvas. I work flat on the floor or on a table top, whereas another painter might work standing at an easel, using a brush, in a rigid fashion, I have never used a paintbrush in my life.'[23] While she sometimes uses Native imagery in her work (a weaver's comb, a bird, an arched pattern from a Navajo wedding basket), she does so principally to explore their formal rather than their symbolic properties.

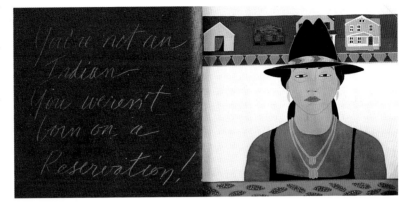

**153 Kay WalkingStick
(b. 1944), Cherokee/
Winnebago**

'You're not an Indian.
You weren't born on
a Reservation!', from
Talking Leaves, 1993.

The self-portrait is a genre
that lends itself to the
investigation of the politics
of identity. In Cherokee
painter Kay WalkingStick's
book of self-portraits the
artist juxtaposes self-portraits
painted in the Santa Fe
Studio style with hurtful
comments stored up over
many years. Sources of
authentic identity are also
present in the traditional
ribbonwork and clan
designs and in the abstract
paintings—more typical of
WalkingStick's work—that
appear on many of the pages.

A similar set of conceptual rather than formal connections links the photography of Jolene Rickard [**155**] to earlier generations of women artists from her community. In photographic collages and installations made during the 1980s and '90s she has associated her own photographic practice with the manipulations of light and texture and the representations of cosmological space and spirituality of earlier generations of Iroquois beadwork artists.

Institutional frameworks and modernisms in Canada

There was no equivalent to the Studio School or to the IAIA in Canada, nor did defined art movements analogous to those of the Southern Plains and Southwest emerge until the 1960s. During the first half of the century, rather, several artists in different parts of the country pursued highly individual projects using visual art as a means of recording cultural knowledge and history. These artists would provide important role models for the Native artists who came to maturity in the 1960s and '70s. Gerald Tailfeathers (Blood, 1925–75) was influenced both by the style of twentieth-century Southern Plains painters and by the romantic depictions of the Old West by artists such as Charles Russell. His accomplished, historically accurate pictures of Plains Indian life were part of an investigation of earlier ways of life for which he carried out meticulous research in ethnographic collections.[24]

Alex Janvier [**156**] was one of the first Canadian Native artists to be trained in a professional art school, as well as the first to embrace abstraction. Born on the Le Goff Reserve in Alberta, he was sent away to residential school at the age of eight. His early interest in painting was encouraged at school, and government officials made an exception to their normal practice of placing Native students in commercial or technical art programmes to enable him to earn a diploma in fine art from the Alberta College of Art in 1960. Influenced by Klee and Kandinsky, Janvier developed a lyrical, linear abstract style expressive of the rhythms of the Alberta landscape and incorporating elements of abstract patterning from traditional hide painting, bead- and quillwork.

Typically for Native artists of his generation—though not for non-Native contemporaries during the 1970s—Janvier gave these abstract works ironic and allusive titles such as 'The True West', and 'Sun Shines, Grass Grows, Rivers Flow' (an ironic borrowing of a phrase used in Indian treaties). These titles connect his abstract compositions to the confrontational political climate of the era, as does his practice of signing his works with his treaty number, a quintessential symbol of the repressive government controls to which Indians were subjected.

For other Canadian Native artists, the creation of visual art was inseparable from the task of recording an endangered heritage of Native spiritual belief, oral tradition, and history. By the mid-twentieth century the effects of fifty years of enforced residential schooling had deprived a whole generation of their Native languages, rupturing relationships with parents and grandparents. For many Native artists the need to record the knowledge possessed by the older generations was an absolute priority. Among these writer-artists was George Clutesi (Nuu-chah-nulth, 1905–88). Disabled by an injury in the 1940s and encouraged by the noted painter Emily Carr (1871–1945), Clutesi wrote and illustrated a valuable book on the potlatch[25] as well as making pictures of contemporary themes such as Native life in the city. During the 1950s northern Ontario Ojibwa artist Norval Morrisseau [**157**] also began to collect and record traditional narratives. His book, *Legends of My People, the Great Ojibwa*, edited by one of his mentors, the amateur archaeologist and artist Selwyn Dewdney, was published in 1965. Morrisseau is generally regarded as the founder of a new art movement, sometimes called the Woodlands School, although the artists prefer the term 'Anishnabe painting'. In this art, traditional sacred iconography that had historically been painted on rock faces and incised on the birchbark scrolls of the *Midewiwin* Society (see Chapter 3)

was reinscribed in the Western media of easel painting and print-making. Morrisseau has stated that, 'all my painting and drawing is really a continuation of the shaman's scrolls'.[26]

As an aspiring artist, Morrisseau first painted his representations of traditional spirituality and history on the insides of birchbark baskets and other souvenir commodities. Encouraged to adopt Western media and formats by several white artist-patrons trained in Western modernism, he began to make paintings on flat panels of birchbark, on brown craft paper and on canvas. Morrisseau became nationally known almost overnight after his first, enormously successful exhibition in a Toronto art gallery in 1962. Journalists and buyers interpreted his work as a direct survival of ancient Ojibwa shamanistic art.[27] In fact, Morrisseau is better characterized as a brilliant innovator who created a new kind of art out of inherited traditions and a modernist–primitivist painterly vocabulary, both informed by the artist's highly individual aesthetic sensibility and his need to resolve his dual religious heritage. He adopted, for example, his intensely hued palette in direct contradiction to the advice of Dewdney to use the 'earth colours' of his ancestors [**157**]. The originality of his formal and iconographic syntheses of the traditional and the personal, and his great commercial success inspired—directly and indirectly—a whole

generation of young Anishnabe painters to take up the brush and the
pen, including such artists as Carl Ray (1943–78), Jackson Beardy
(1944–84), Roy Thomas (b. 1949) and Blake Debassige [**14**].

After World War II, Native political activism had entered a new,
more aggressive phase both in the US and Canada. During the '60s,
Native cultural initiatives gained support from the liberal climate of
the era and from the radical politics engendered by the civil rights
movement and global movements of national liberation. In the mid-
1960s, as Expo 67, the Montreal World's Fair, was being planned,
Native cultural advocates and artists successfully manoeuvred for a
separate 'Indians of Canada Pavilion'. This moment marks the first
time that Native people had taken control of the representation of their
own cultures in a major international exhibition. The interior of the
Pavilion housed a revisionist and, in places, overtly confrontational
exhibition of the history of Aboriginal people in Canada. Outside it
displayed an ambitious programme of commissioned contemporary

Native art from across Canada, including works by Tailfeathers, Clutesi, Morrisseau, Janvier, and nine other artists.[28]

During the 1960s and '70s a number of local initiatives inspired and fostered the careers of a diverse and talented group of young Native artists. In 1972, shortly before his untimely death, the charismatic artist and poet Sarain Stump (Cree, 1945–74) founded the Ind[ian]art Program at the Saskatchewan Indian Cultural College (now the Indian Federated College) in Regina. This programme was important to the artistic formation of a number of artists who were to come to prominence in the 1980s, including Gerald McMaster [11], Edward Poitras (Plains Cree, b. 1953), and Bob Boyer (Métis, b. 1948), and led to the later formation of a specialized Native studio art curriculum under Boyer's direction.

Concurrently, other Canadian Native artists were studying at non-Native art schools. The late modernist visual languages in which they were trained provided the foundation for the new postmodern and anti-colonial rhetorical strategies they would develop during the 1980s. Joane Cardinal Schubert (Blackfoot, b. 1942) studied at the Alberta College of Art, going on to create a powerful, politically charged body of painting and installation art that confronts the viewer with the historical violence done to Aboriginal people's bodies, their connections to land and their cultural heritages. Carl Beam [158] studied art at the University of Victoria, and Jane Ash Poitras [159] trained at the University of Alberta and Columbia University. Both have adopted compositional collage as a means of examining, through prints, paint-

158 Carl Beam (b. 1943), Ojibwa

'Columbus Chronicles' (photo-emulsion, acrylic, pencil on canvas), 1992

Beam has written of his Columbus Project, 'My work is only my own personal record of going through time, a sequence of events.' His art is characterized by juxtapositions of images from Western and Native history and from two different but co-existent systems for knowing and for regulating life. The drips, scratches and washes that partially overlay and obliterate his images signify the erosions of time and memory.

ings, and mixed media works, the relationships that exist among seemingly incompatible knowledge systems—Aboriginal understandings of nature and Western science; shamanistic and Christian spirituality —as well as relationships between autobiography, family history, and official narratives of the past.

Robert Houle studied art education at McGill University. He was attracted as a student to the formal language of abstraction, and particularly to the art of Barnett Newman and the New York Abstract Expressionists. Houle responded in particular to their use of abstraction as a means of exploring the spiritual, seeing in their work what the artists themselves had stated rather than the reading given to it by the more recent formalist school of critics surrounding Clement Greenburg. He was also returning a compliment; during the 1940s the Abstract Expressionists had studied and celebrated Native American art for the access it gave to the spiritual.

Another formative influence on Houle came about as a result of a contract he received while still a student in the early 1970s that sent him to Santa Fe to study the IAIA with a view to establishing a similar school in Canada. The school, Manitou College at La Macaza, Quebec, opened in 1972 and left a legacy that extended far beyond its four years of operation. The influence of one Manitou College teacher, the Mexican artist Domingo Cisneros (b. 1942), on the Native art students who came into contact with him there has been particularly

important. Cisneros' approach, as Tom Hill has noted, was to 'take his students back to their traditional and shamanic roots'[29] through actual experience of life in the woods and by encouraging them to use as artistic materials the bones and other natural materials of fundamental significance to shamanic systems.

Houle wrote eloquently of the links between Aboriginal and modernist spirituality in art in the introductory essay to an important show he curated in 1982, 'New Work for a New Generation'. If Oscar Howe's letter of twenty-five years earlier had been a manifesto of the Native artist's appropriation of a modernist freedom of individual expression, then Houle's essay was a manifesto of modernism's universalism and trans-cultural potential. He celebrated the Native artists in the show for their invention of a new 'language of magic and symbolism' grounded in ancient shamanistic practice.[30] He also insisted on the importance of the Native artist's engagement with the contemporary world. A commitment to the 'polemics of modern art,' he wrote, was 'crucial to the reconstruction of cultural and spiritual values eroded by faceless bureaucracy and aetheistic technology'. He also turned the Primitivist appropriation of tribal art on its head, writing of the Native artists that, 'Being modernists, they carry the privilege of appropriating bits of their traditional and contemporary cultures to form an amalgam strictly reflective of their own identity.'[31]

During the 1970s, following the success of the Expo 67 Pavilion project and in a climate of plentiful government funding, the Canadian Government and Aboriginal communities began a number of important initiatives. Of particular importance to the development of art was the establishment of cultural centres on Native reserves (see Chapter 1, p. 11). Two of these have played a particularly important role in the development of Native art. The Ojibwa Cultural Foundation on Manitoulin Island in Lake Huron organized a series of summer workshops in traditional culture and art during the late 1970s and early '80s that brought together established artists with aspiring young artists, providing inspiration and training for young Anishnabe painters such as Blake Debassige [14], Leland Bell (b. 1953) and James Simon Mishibinijima (b. 1954). Under the direction of Seneca artist and curator Tom Hill, the Woodland Cultural Centre Museum on the Six Nations (Iroquois) reserve in Brantford, Ontario, initiated a series of annual exhibitions in 1975 that has remained one of the most important venues for contemporary Native art.

Postmodernism, installation, and other post-studio art

In his 1982 essay Robert Houle had complained of the lack of patronage for Native modernists, particularly from museums that were still applying ethnographic criteria to their work. This 'reluctant patronage [was] unable to understand the new work as a genuine indigenous

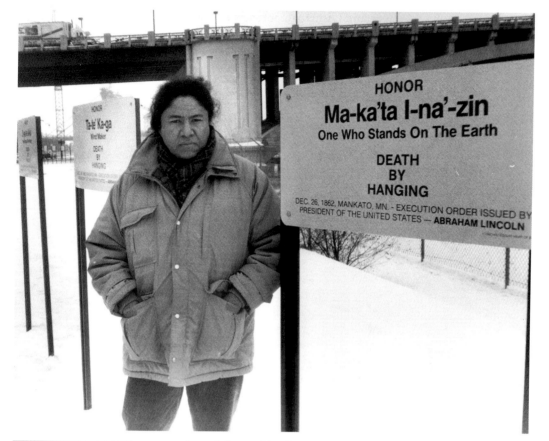

160 Edgar Heap of Birds (b. 1954), Southern Cheyenne/Arapaho

'Building Minnesota' (mixed media installation), 1990

This temporary installation comprised 40 printed metal signs, each commemorating the names (in Dakota and in English) of Native men hanged by order of the US Government as a consequence of their participation in the Sioux Uprising of 1862. Like Maya Lin's famous Vietnam War Memorial in Washington, DC, it served as a place of mourning and remembrance to which people brought gifts and offerings.

expression of, for, and by Canadian, American and Mexican Indians'.[32] During the 1980s modernist and postmodernist Native artists in the US and Canada lobbied hard to have their work shown in and collected by major fine art institutions. The need to counter ethnographic and popular stereotypes of Indians led some artists to use ironic and critical strategies deriving from pop art and related movements to draw attention to the gap between stereotyped constructions of Native identity and actual twentieth-century Native lives—especially those lived by the growing numbers of Native people living in cities [**153**]. During this period, too, Native artists became increasingly interested in installation and other post-studio art forms such as site-specific works, video art, and performance art. Houle's lobbying continued during his brief period as the first curator of Contemporary Indian Art at the National Museum of Man (now the Canadian Museum of Civilization) in the late 1970s. Under his successor, Plains Cree artist Gerald McMaster, the Museum has collected and exhibited the expanding corpus of contemporary Canadian Native Art. A graduate of the Institute of American Indian Arts, McMaster's sharply ironic and critical postmodernist work in painting and installation has complemented the work he has done as a curator. On the one hand, such formats resist

the commoditization that blunts the edge of an art work intended as political critique. On the other hand, these contextualizing formats allowed for the investigation and partial replication of the rituals and ceremonials of which historic Native arts were part. For example, the ritually active potential of installation is made evident in a 1996 piece by Colleen Cutschall, 'Sons of the Wind' [71]; (see discussion in Chapter 4).

The site-specific works of Hachivi Edgar Heap of Birds comprise one of the most extensive and influential achievements in this genre, suggesting comparisons with the work of non-Native artists Barbara Kruger (b. 1945) and Jenny Holzer (b. 1950). Heap of Birds appropriates modern popular-culture media usually used for consumerist commercial campaigns—the billboard, the electronic light signage board, the bus advertising placard, and the roadside sign—to memorialize those whose lives and culture have been consumed by the westward expansion of European peoples across the North American continent.

In 'Building Minnesota' [160], an installation erected on the banks of the Mississippi River in Minneapolis, Heap of Birds constructed a war memorial honouring forty Dakota men who were hanged in the 1860s for rebelling when their families were starving on reservation lands. Large grain storage tanks across the river from the site evoked the tragic irony of this historical episode in a region which even then was shipping grain downriver to other white settlements and fast becoming the 'breadbasket' of America. During the 1980s and '90s Heap of Birds was regularly invited to construct site-specific installations at museums across the United States. He used these opportunities to address the specific historical realities of the Indian peoples who lived in each region. By providing his audience with both historical documentation and a public art context in which to engage with the issues, Heap of Birds makes a politically meaningful art that links the past with the present.

Unlike Heap of Birds, who makes paintings as well as on-site installations, the Ojibwa artist Rebecca Belmore decided to work only in post-studio media. In a 1992 installation piece, 'Mawa-che-hitoowin: A Gathering of People for Any Purpose' [161], the artist constructed a plywood floor painted with flowers that suggested both old linoleum and the flitting shadows on a forest floor. On it she arranged a circle of chairs taken from her own kitchen and the living spaces of the women who are closest to her. The work was spare, quiet, and minimalist; it issued a tacit invitation to sit down, to put on the earphones dangling over each chair-back, and to listen to the voices of Belmore's female community talking about their lives as Native women in Canada—their struggles, their joys, and the sources of their strength. Using the testimony of individual voices, the recitation of oral traditions, and the Aboriginal tradition of talking in council and

161 Rebecca Belmore (b. 1960), Ojibwa

'Mawa-che-hitoowin: A Gathering of People for Any Purpose' (mixed media), 1992

Belmore's installation consisted of a circle of chairs taken from her own kitchen and those of female friends and relations. Earphones placed on the chairs allowed visitors to join the circle and listen to the stories and experiences of Native women in Canada. The work recreated in the National Gallery of Canada the traditional Native space of the circle as a place to listen, talk, and reach understanding.

listening to elders, the artist welcomed visitors into the circle of the Native community. For Belmore, the interactive potential of the installation offered a positive strategy with which to address stereotyping, racism, and the price paid by the victims of these evils.

Belmore's installation was a centrepiece of 'Land/Spirit/Power', an exhibition of contemporary Native art from the United States and Canada held at the National Gallery of Canada in 1992, the 500th anniversary of Columbus' arrival in the Americas. The show, the first comprehensive exhibition in a large national art gallery, signalled the more inclusive orientation that the artistic achievements—and the lobbying—by Native people had established. Two other major exhibitions held during that year, however, addressed the heavy legacy of history still to be overcome. 'Indigena' was curated by Gerald McMaster and Lee-Ann Martin at the Canadian Museum of Civilization in Ottawa, and 'The Submuloc Show/Columbus Wohs' was curated by Jaune Quick-to-See Smith for the Native artists' organization Atlatl. As the reverse letterings in the title of the latter suggest, both exhibitions were public expressions of grief for the immensity of loss and suffering endured by indigenous peoples, intended to counter official government plans to treat the anniversary as a celebration. But both exhibitions were also celebrations, as Quick-to-See Smith noted in her Curatorial Statement, of Native artists' continued visual creativity even in the darkest moments of those centuries.

Both shows evinced the new possibilities added to Native artists'

range by their involvement with contemporary art forms. As Quick-to-See Smith wrote:

Though they still exhibit beauty, color, design and humor, the major difference in these pieces is that they also contain written text. Now, the works directly address the issues of the day through the vernacular of the day by using pop images akin to magazine ads, billboards, video, photography and politics.[33]

The positioning of work by contemporary Native artists in major urban galleries contrasts with these institutions' exclusion of art made by the generation that preceded them. How significant is the change? Has postmodernism opened the door to a truly de-centred and post-colonial representation of the visual aesthetic expressions of the indigenous peoples? Has modernism's colonizing representation of those arts as Primitive Art or scientific specimen been replaced by a non-colonizing postmodernism? Or, as some critics allege, are we witnessing a neo-Primitivist moment that remains appropriative in terms of power relations and Eurocentric in terms of critical discourse?

A number of Native artists and critics point out problematic aspects of the new inclusiveness, arguing that, like so many colonial and neo-colonial impositions, the de facto segregation imposed by Western art collecting institutions has been a divisive force in Native cultural life. As Métis filmmaker Loretta Todd has argued:

By reducing our cultural expression to simply the question of modernism or postmodernism, art or anthropology, or whether we are contemporary or traditional, we are placed on the edges of the dominant culture, while the dominant culture determines whether we are allowed to enter into its realm of art.[34]

The divisions between fine art and craft continue to operate, and professional art school training continues to be regarded as a 'higher' qualification than traditional apprenticeship. With the acceptance of some kinds of contemporary art, other kinds have become less visible. Paintings and sculptures that examine oral traditions are shown much less often than those that address current issues of politics and identity. And the Western privileging of visual experience continues to segregate material objects from the contexts that give them meaning in Native communities. The very category 'art', that remains so closely identified to the notion of the autonomous, material object, fragments the integrity of Native expressive systems in which material objects act, as Mohawk historian Deborah Doxtator has argued, as connective points among peoples and as metaphors for ideas central to Native cultures. 'The relatively recent categorization of art forms such as basket, bead and quill as art objects within an hierarchical Euro-North American art aesthetic,' she writes, 'side-steps the recognition of Native aesthetics and conceptual systems as viable ways of understand-

ing art.' To Doxtator belong the last words of this survey, for they map a path into the future of Native art in the twenty-first century:

If tradition or valued knowledge is made up of these visual and concrete metaphors and our varied interpretations of them, then continuity depends not upon exact sameness of form or interpretation, but on the process of continued interaction with these powerful cultural metaphors. Visual artists have continued to refer to these metaphors in their work whether they have created in the styles of what art historians have called the 'Woodland School' or the 'modernist' style for the simple reason that visually these metaphors remain culturally very powerful to us.[35]

Notes

Full citations for abbreviated notes can be found in the Bibliographic Essay for that chapter unless otherwise indicated.

Chapter 1

1. 'Basket, Bead and Quill, and the Making of "Traditional" Art' in *Basket, Bead and Quill* (Ontario, 1996), 11.
2. 'A Structural Approach to Esthetics: Toward a Definition of Art in Anthropology', *American Anthropologist* 60/4, 702–14. See also Robert Plant Armstrong, *The Affecting Presence: An Essay in Humanistic Anthropology* (Urbana, Ill., 1971).
3. See for example, Franz Boas, *Primitive Art* (New York, 1955 [1927]), Ruth Bunzel's *The Pueblo Potter* (New York, 1929), and Evan Maurer's 'Determining Quality in Native American Art', in Edwin L. Wade (ed.), *The Arts of the North American Indian: Native Traditions in Evolution* (New York, 1986).
4. Gloria Cranmer Webster, 'The U'mista Cultural Centre', *The Massachusetts Review*, 31/1–2, 135.
5. 'Four Northwest Coast Museums: Travel Reflections', in Ivan Karp and Steven D. Lavine (eds), *Exhibiting Cultures: The Poetics and Politics of Museum Display* (Washington, DC, 1991), 212–54.
6. The American law, the Native American Graves Protection and Repatriation Act, or NAGPRA, was passed in 1990. The Canadian policy is outlined in *Turning the Page: Forging New Partnerships Between Museums and First Peoples* (Ottawa, 1992).
7. This collection, made by John Bargrave, a Canon of Canterbury Cathedral, is discussed by Stephen Bann in *Under the Sign: John Bargrave as Collector, Traveler, and Witness* (Ann Arbor, MI, 1994).
8. See Batkin, *Pottery of the Pueblos of New Mexico, 1700–1940*, cited in the Bibliographic Essay for Chapter 2.
9. For an account of the 'Exhibition of Canadian West Coast Art' at the National Gallery of Canada in Ottawa (1927), see Diana

Nemiroff's 'Modernism, Nationalism and Beyond', in *Land Spirit Power: First Nations at the National Gallery of Canada* (Ottawa, 1992), 17–26. For the 'Exposition of Indian Tribal Arts', held in New York City in 1931, see Molly H. Mullins, 'The Patronage of Difference: Making Indian Art "Art, Not Ethnology"' in George Marcus and Fred Myers (eds), *The Traffic in Culture: Refiguring Art and Anthropology* (Berkeley, 1995), 166–98. For the Museum of Modern Art's landmark 'Indian Art of the United States' (1941), see W. Jackson Rushing, 'Marketing the Affinity of the Primitive and the Modern', and René d'Harnoncourt 'Indian Art of the United States', in Janet Catherine Berlo (ed.), *The Early Years of Native American Art History* (Seattle, 1991).
10. See Jackson Rushing, *Native American Art and the New York Avant Garde*, cited in the Bibliographic Essay for Chapter 7.
11. See Martin Jay, *Downcast Eyes: The Denigration of Vision in Twentieth-Century French Thought* (Berkeley, 1994).
12. See *Native American Expressive Cultures*, *Awkwekon Journal* 11/3 (special issue, 1994), and Gerald McMaster and Lee-Ann Martin (eds), *Indigena: Contemporary Native Perspectives* (Vancouver, 1992).
13. In Canada, for example, until 1985 the children of white fathers and Native mothers were legally regarded as white (and lost their treaty rights), while those of Native fathers and white mothers were considered Native. In the US the ancestry necessary for enrolment is determined by the individual tribes according to the 'blood quantum' or percentage of a person's Indian ancestry each establishes.
14. In the US, for example, the Indian Arts and Crafts Act of 1990 made illegal the identification of an artist as a Native American in a venue supported by federal funds unless he or she is an enrolled member of a tribe. Since tribes vary widely in the percentage of Native ancestry required for enrolment, and since numerous Native communities are still

struggling for legal recognition, laws such as this further complicate problems of identity.

15. The last residential school in Canada was not closed until 1982.

16. On residential schools see J. R. Miller, *Shingwauk's Vision: A History of Native Residential Schools* (Toronto, 1996), and Basil Johnson, *Indian School Days* (Norman, Okla., 1995), and Brian W. Dippie, *The Vanishing American: White Attitudes and US Indian Policy* (Kansas, 1991), chapters 8 and 15.

17. Quoted in Dippie, ibid., 263.

18. 'Ojibwa Ontology, Behavior, and World View', in A. Irving Hallowell, *Contributions to Anthropology* (Chicago, 1976), 362.

19. Esther Pasztory, 'Shamanism and North American Indian Art', in Zena Pearlstone Mathews and Aldona Jonaitis (eds), *Native North American Art History* (Palo Alto, Calif., 1982), 7–30.

20. Lincoln, Nebr., 1990.

21. We have borrowed this phrase from the book title *Creativity Is Our Tradition: Three Decades of Contemporary Indian Art at the Institute of American Indian Art*, edited by Rick Hill (Santa Fe, 1992).

22. For more information on Maximilian's visit and Bodmer's paintings see John Ewers, *Views of a Vanished Frontier* (Omaha, Nebr., 1984), and Chapter 1 of Lynne Spriggs's doctoral dissertation, *Nitzitapi: Portraits and Reflections of a People Called Blackfeet* (New York, 1995).

23. See Dan L. Monroe (ed.), *Gifts of the Spirit: Works by 19th Century and Contemporary Native American Artists* (Salem, Mass., 1996), 195.

24. See King, 'Tradition in Native American Art', 70.

25. Speck, *Naskapi: The Savage Hunters of the Labrador Peninsula*, 199.

26. Ruth Landes, *The Ojibwa Woman* (New York, 1938), 155.

27. See Simmons, *Colleen Cutschall: Voice in the Blood*, as cited in the Bibliographic Essay for Chapter 7.

Chapter 2

1. As quoted in undated interview with Nancy Gillespie, Contemporary Artists' Archives, Heard Museum, Phoenix, Ariz.

2. Brody, *The Anasazi*, 116.

3. See Moulard, 'Form, Function, and Interpretation of Mimbres Ceramic Hemispheric Vessels'.

4. See Jonathan Haas et al., 'Historical Processes in the Prehistoric Southwest', in Gumerman and Gell-Mann, *Understanding Complexity in the Prehistoric Southwest*.

5. Much of the factual information in this section is drawn from Gutiérrez, *When Jesus Came, The Corn Mothers Went Away*.

6. Wright, *Pueblo Cultures*, 7.

7. Jesse Green (ed.), *Zuni: Selected Writings of Frank Hamilton Cushing* (Lincoln, Nebr., 1979), 47–50.

8. Bunzel, *Zuni Katcinas*, 848.

9. Wright, *Pueblo Cultures*, 15.

10. Dennis Tedlock, 'Zuni Religion and World View', *Handbook of North American Indians*, Vol. 9, 507.

11. Dockstader, *The Kachina and the White Man*, 98.

12. See Matilda Coxe Stevenson, *The Zuni Indians*, 23rd Annual Report of the Bureau of American Ethnology (Washington DC, 1904), 374. Will Roscoe in *The Zuni Man-Woman* offers an in-depth discussion of We'wha. Batkin's *Pottery of the Pueblos of New Mexico*, 19–22, discusses We'wha and other men-women, as well as the role of men in some Pueblos as pottery painters in the twentieth century.

13. Peterson, *The Living Tradition of Maria Martinez*, 175.

14. Peterson, *Lucy M. Lewis*, 122.

15. Peckham, *From the Earth*, 47.

16. See Jackson Rushing, 'Jackson Pollock and Native American Art', Chapter 6 of *Native American Art and the New York Avant-Garde*.

17. Marsha Gallagher, 'The Weaver and the Wool', *Plateau Magazine* 52(4), (Flagstaff, Ariz., 1981).

18. For a history of this phenomenon, see Rodee, *Old Navajo Rugs*.

19. See Witherspoon, *Language and Art in the Navajo Universe*.

20. Ibid., Chapter 4.

Chapter 3

1. J. J. Cornplanter, *Legends of the Longhouse* (Ontario, 1986, reprint of 1938 edn), 15.

2. David W. Penney, 'Continuities of Imagery and Symbolism in the Art of the Woodlands', in Brose et al. *Art of the Ancient American Woodland Indians*, 150.

3. Although Poverty Point, like nearly all such sites, has been greatly altered over time, especially by the activities of farmers and developers, its highest mound still stands 70 feet high and measures 640 feet across.

4. Silverberg, *Mound Builders of Ancient America*, 280.

5. See Plate 43 in Brose et al.

6. The suggestion was made by Bradley Lepper, cited in David Hurst Thomas, *Exploring Ancient Native America: An Archaeological Guide* (New York, 1994), 133.

7. For a study of demographic losses that accepts higher rather than lower numbers see Henry F. Dobyns, *Their Numbers Became Thinned* (Knoxville, Tenn., 1983).

8. The term Muscogulge is used by ethnohistorians to refer to the fifty or so remnant Mississippian groups in Alabama, Georgia, and Florida who re-formed themselves into new nations during the eighteenth century.

9. Conch shell cups were still being used in the historic period as containers for a purifying ritual drink.

10. See Brown, 'The Falcon and the Serpent', in Levenson (ed.), *Circa 1492*, 529–34.

11. See Brown, 'Spiro Art and Its Mortuary Contexts', in Benson (ed.), *Death and the Afterlife in Pre-Columbian America*, 1–32.

12. See Swanton, *The Indians of the Southeastern United States*, 160.

13. See Downs, *Art of the Florida Seminole and Miccosukee Indians*.

14. See W. A. Kenyon, *The Grimsby Site: A Historic Neutral Cemetery* (Toronto, 1982).

15. See White, *The Middle Ground*.

16. The largest single body of early contact-period Northeastern art survives in France, in the Musée de l'Homme. It is largely an amalgamation of individual curiosity collections (including that of the French royal family) confiscated during the French Revolution, at which time the objects were separated from any documentation that had existed. For a discussion of related issues of identification see Phillips, *Patterns of Power*.

17. White, op. cit., 16.

18. We are grateful to Morgan Baillargeon of the Canadian Museum of Civilization for sharing his important unpublished research on the aesthetics of hide tanning.

19. See Orchard, *Beads and Beadwork of the American Indians*, and *Techniques of Porcupine Quillwork*. See also Bebbington, *Quillwork of the Plains*, as cited in the Bibliographic Essay for Chapter 4.

20. John Clarence Webster (ed.), *Relation of the Voyage to Port Royal in Acadia or New France* (Toronto, 1933), 167.

21. *Travels through the States of North America, and the Provinces of Upper and Lower Canada, During the Years 1795, 1796, and 1797* (London, 1807), II, 227.

22. *The Backwoods of Canada, being Letters from the Wife of an Emigrant Officer* (London, 1836), 169.

23. Ibid., 168–9

24. See Phillips, *Trading Identities,* Chapter 5.

25. Quoted in Gerald McMaster's unpublished Master's Thesis, 'Beaded Radicals and Born-Again Pagans: Situating Native Artists within the Field of Art' (Ottawa, 1994), 169.

Chapter 4

1. Personal communication to Janet Catherine Berlo from Arthur Amiotte, summer 1995.

2. Brasser, in *The Spirit Sings*, 101, as cited at the beginning of the Bibliographic Essay.

3. Berlo, 'Dreaming of Double Woman', as cited in the Bibliographic Essay for Chapter 1.

4. See Marriott, 'The Trade Guild of the Southern Cheyenne Women'. Marriott conducted her fieldwork in 1937. Some of what she says was corroborated in Grinnell's work, based on his fieldwork at the end of the nineteenth century. See Grinnell, *The Cheyenne Indians*, Vol. 1: 159–69 and 224–35.

5. See Grinnell, 'The Lodges of the Blackfeet'.

6. Grinnell, *The Cheyenne Indians*, 159, 161.

7. Personal communication from art historian Barbara Loeb, a scholar of Crow beadwork, to Janet Catherine Berlo, January 1989.

8. Gilman and Schneider, *The Way to Independence*, 53.

9. In Royal Hassrick, *The Sioux* (Norman, Okla., 1964), 42–4.

10. Alice Marriott and Carol Rachlin, *Dance Around the Sun: the Life of Mary Little Bear Inkanish* (New York, 1977) 5, 52; and Brasser, *The Spirit Sings*, 116.

11. See Ewers, *Plains Indian Sculpture*, plate 1.

12. John Gregory Bourke, diary entry for 20 June, 1881, page 1460, original manuscript at the Library of the US Military Academy, West Point, New York.

13. See Brasser, 'In Search of Métis Art'.

14. See Chapter 6 in Schlick, *Columbia River Basketry*.

15. Lynette Miller, 'Flat Twined Bags of the Plateau', MA thesis (Seattle, 1986), 72.

16. As cited in McLendon and Holland, 'The Basketmaker', 109.

17. Ibid., 112.

18. See Cohodas, 'Louisa Keyser and the Cohns', *passim*.

Chapter 5

1. Father Morice, quoted in Judy Thompson, 'No Little Variety of Ornament: Northern Athapaskan Artistic Traditions', in *The Spirit Sings*, 140, as cited at the beginning of the Bibliographic Essay.

2. While there is a sizeable population of indigenous heritage in Greenland, most Greenland Inuit have, for 250 years, lived

in communities formed of the intermarriage with Danish/Norwegian settlers; they are known as *Kalaalit* and all their art will not be covered here.

3. Cree languages spoken in Northern Ontario are very close to Ojibwa. The language is often referred to by Native speakers as 'Ojicree'.

4. Two other branches of the Athapaskan language family are the western branch, including Haida and Tlingit (which separated about 1,600 years ago), and the southern branch, including Navajo and Apache (which separated about 600 years ago).

5. On Innu clothing the fish roe used as a binder for the pigment has in ageing turned the white to yellow.

6. The techniques of hide painting known from the Eastern Sub-arctic were probably widespread in the East at the time of contact, when a number of Jesuit observers described the striped patterns that ornamented Northeastern clothing.

7. Speck, *Naskapi: The Savage Hunters of the Labrador Peninsula*, 199, 72.

8. Burnham, *To Please the Caribou*, 13.

9. Thompson, 'No Little Variety of Ornament', 151, see also 148.

10. Quoted in Thompson, *From the Land*, 7.

11. Ibid., 32.

12. Quoted in Duncan, *Northern Athapaskan Art*, 30. See also Thompson, 'No Little Variety of Ornament', 141–3.

13. Quoted in Oberholtzer, 'Together We Survive', 60.

14. Told to ethnologist Regina Flannery, quoted in Oberholtzer, 'Together We Survive', 62. Oberholtzer cites other similar examples from the memoirs of missionary John Horden, 74.

15. See Cath Oberholtzer, 'Embedded Symbolism: The James Bay Beaded Hoods', *Northeast Indian Quarterly* 8/2 (1991), 18–27.

16. Samuel L. Hearne, *A Journey from the Prince of Wales in Hudson's Bay to the Northern Ocean*, as quoted in Collins et al., *The Far North*, 287.

17. Fitzhugh and Crowell, *Crossroads of Continents*, 117.

18. William E. Taylor and George Swinton, 'The Silent Echoes: Prehistoric Canadian Eskimo Art', *The Beaver* 298 (1967), 35.

19. Fitzhugh and Crowell, op. cit., 126.

20. McGhee, *Ancient People of the Arctic*, 41.

21. Fitzhugh and Crowell, op. cit., 212.

22. As quoted by Pat Hickman, *Innerskins and Outerskins: Gut and Fishskin* (San Francisco, 1987), 19.

23. Dorothy Jean Ray, *Eskimo Masks: Art and Ceremony* (Seattle, 1967), 10.

24. Ibid., 49.

25. All material in this passage draws upon Molly Lee's *Baleen Basketry of the North Alaskan Eskimo* (Barrow, Alas., 1983).

26. Nelson H. H. Graburn, 'Traditional Economic Institutions and the Acculturation of Canadian Eskimos', *Studies in Economic Anthropology* AS7 (1971), 107–21.

27. Nelson H. H. Graburn, 'Eskimo Art— the Eastern Canadian Arctic', in Graburn (ed.), *Ethnic and Tourist Arts*, as cited in the Bibliographic Essay for Chapter 1.

Chapter 6

1. 'The Haida Legend of the Raven and the First Humans as retold by Bill Reid', Museum Note No. 8 (Vancouver), 4.

2. Shadbolt, *Bill Reid*, 140.

3. Philip Drucker, *Indians of the Northwest Coast*, 112–113.

4. Preamble, *Nisga'a Treaty Negotiations Agreement in Principle*, issued jointly by the Government of Canada, the Province of British Columbia and the Nisga'a Tribal Council, 15 February, 1996. This principle was upheld by a landmark 1997 Canadian Supreme Court Decision.

5. Robert T. Boyd, 'Demographic History, 1774–1874', *Handbook of North American Indians*, Vol. 7 (Washington, DC, 1990), 135.

6. This summary is based on Holm's more detailed account in 'Art', in ibid., 604–6.

7. See 'The World is as Sharp as a Knife: Meaning in Northern Northwest Coast Art' in Carlson (ed.), *Indian Art Traditions of the Northwest Coast*, 215–16.

8. Richard Daugherty and Janet Friedman have noted a general pattern of correlation at Ozette between 'realistic representational art and secular functions on the one hand, and conventionalized art and ceremonial use on the other'. See 'An Introduction to Ozette Art', in Carlson (ed.), Ibid., 195.

9. See 'Prehistoric Art of the Northern Northwest Coast', in Carlson (ed.), Ibid. 215–16.

10. The largest collection is in the British Museum; others are in the Museum für Völkerkunde, Vienna, the National Museum of Ireland, the Cambridge University Museum of Archaeology and Ethnology, the Museo Nazionale Etnographico in Florence, and museums in Cape Town and Berne.

11. Quoted in Holm, *Northwest Coast Indian Art*, 5–7.

12. Bill McLennan's work with infrared

photography shows that the painted lines did not follow the templates exactly. Rather the template outlines were used as a general guide in creating the overall composition. Bill McLennan and Karen Duffek, *The Transforming Image* (forthcoming).

13. Robin Wright, at the time of writing, is preparing a study of the Haida artist Gwaythil; see also references to Bill Holm's work on Willie Seaweed and Charles Edenshaw in the bibliographic essay to this chapter. Collaborative work by Bill McLennan, Pam Brown, Martha Black, and the Heiltsuk Cultural Centre has led to the identification of works by Captain Carpenter (1840–1930). See n. 12.

14. See Duff, *images stone b.c.* and his essay, 'The World is as Sharp as a Knife: Meaning in Northern Northwest Coast Art', in Carlson (ed.), op. cit., 57

15. From a 1982 interview quoted in Thom (ed.), *Robert Davidson: Eagle of the Dawn*, 85. The housefront is a memorial to Davidson's great-grandfather, Charles Edenshaw.

16. *The Indians of Puget Sound*, 34.

17. Wingert, *American Indian Sculpture*, 6.

18. Esther Pasztory, 'Shamanism and North American Indian Art', in Pearlstone Mathews and Jonaitis (eds), *Native North American Art History*, 7–30, as cited at the beginning of the Bibliographic Essay.

19. Andrea Laforet's analysis of unpublished interviews conducted by James Teit in the early 1900s shows that although encounters with guardian spirits had both visual and auditory aspects, the *song* sung by the spirit was the enduring component (personal communication, 1997).

20. This discussion is based on Jonaitis' work, which focused on the important collections in the American Museum of Natural History. Jonaitis notes that the small 'subsidiary' effigies are attached only to masks used by shamans, which are otherwise indistinguishable from those worn at potlatches. See *The Art of the Northern Tlingit*, 28.

21. Historically, there have been women shamans among the Tlingit as among other Northwest Coast peoples, although most shamans were men.

22. *The Way of the Masks*. A mask bearing spoke-like eyes, the *swaixwe* is the only masked dance privilege inherited among high-ranking Salish families. Many Salish people today prefer the reproduction of its image to be carefully controlled; the representation of the mask by the contemporary Salish artist Lawrence Paul Yuxweluptun has therefore been used to illustrate this chapter.

23. The use of the word 'totem' is inaccurate in the description of Northwest Coast poles as it refers to the belief, common among many Native American peoples, that a group of people is descended from a common animal ancestor. As explained below, on the Northwest Coast most of the relationships symbolized in crest designs have to do with transfers of power between animal and human beings rather than actual descent.

24. Quoted in George F. MacDonald, *The Totem Poles and Monuments of Gitwangak Village* (Ottawa, 1984), 79–80.

25. This account is based on the summary provided by Andrea Laforet in *The Book of the Grand Hall* (Ottawa, 1992), 36–7.

26. We are grateful to Marjorie Halpin and Margaret Anderson for sharing information from the edition of William Beynon's unpublished account of these events they are preparing for publication.

27. In Alaska, poles were removed from Sitka and other sites and re-erected in 'totem parks' at Saxman, Totem Bight, and Klawock. In some instances the restoration was carried out by carvers from other villages, resulting in alterations that permanently changed their meaning. See Polly and Leon Gordon Miller, *Lost Heritage of Alaska: The Adventures and Art of the Alaskan Coastal Indians* (New York, 1967), 262–3.

28. The Dog Salmon Pole, which was originally carved about 1860, stood on its original site along the river until 1926 when it was restored by the National Museum of Canada and the Canadian National Railways. In 1936, when the river bank was eroding, it was moved to a different location. By 1961 it had fallen down. It was purchased by the National Museum in 1970 and taken to Ottawa, Canadian Museum of Civilization #34595; a fibreglass replica was erected at Gitwangak (MacDonald, op. cit.).

29. 'The Contemporary Potlatch', in Jonaitis (ed.), *Chiefly Feasts*, 229.

30. Argillite is similar in its properties to catlinite, the red-coloured mineral found in one Minnesota quarry used by Great Lakes and Plains Indians to make pipe bowls.

31. See Macnair and Hoover, *The Magic Leaves*, 162, fig. 171.

Chapter 7

1. A useful introduction to the competing claims made for modern art is 'Modernism and Modernity: An Introductory Survey' by Pam Meecham and Paul Wood, in Liz Dawtry, Toby Jackson, Mary Masterton, Pam Meecham, Paul Wood (eds),

Investigating Modern Art (New Haven, 1996), 1–33.

2. See Gerhard Hoffmann, 'Frames of Reference: Native American Art in the Context of Modern and Postmodern Art', in Wade (ed.), *The Arts of the North American Indian*, for a discussion of these issues.

3. T. J. Jackson Lears, *No Place of Grace: Antimodernism and the Transformation of American Culture, 1880–1920* (New York, 1981).

4. As cited in Dunn, 1968, 96, from Bureau of American Ethnology Annual Report 14, 561–2.

5. See François-Marc Gagnon, *La Conversion par l'Image: Un aspect de la mission des Jésuites auprès des Indiens du Canada au XVIIe siècle* (Montreal, 1975); and Christian Feest, 'The Arbre-Croche Sketchbook', in *Beadwork and Textiles of the Ottawa* (Harbor Springs, Mich., 1984), 60–83.

6. Heap of Birds, in Jeanette Ingberman, *Claim Your Color: Hachivi Edgar Heap of Birds* (New York, 1989), 22.

7. J. J. Brody calls some of the turn-of-the-century artists in the American Southwest 'proto-modern', reserving the term modern for the commissions given to the San Ildefonso artists by Hewitt around 1918. See Bernstein and Jackson Rushing, *Modern by Tradition*, 27, 4; and Brody, *Indian Painters and White Patrons*, 73–117.

8. See Sherry Brydon, 'Ingenuity in Art: The Early-Nineteenth-Century Works of David and Dennis Cusick', *American Indian Art Magazine* 20/2 (spring 1995), 60–9.

9. Bernstein and Rushing, op. cit., 54

10. See, for example, Candace Greene, 'Silverhorn', in Berlo (ed.), *Plains Indian Drawings, 1865–1935*, 165–7, as cited in the Bibliographic Essay for Chapter 5, and Greene in Evan Maurer, *Visions of the People: A Pictorial History of Plains Indian Life* (Minnesota, 1992), 162–5.

11. See Jesse Walter Fewkes, *Hopi Kachinas Drawn by Native Artists*, 21st Annual Report of the Bureau of American Ethnology (Washington, DC, 1903).

12. Robert F. Schrader, *The Indian Arts and Crafts Board* (Albuquerque, 1983), 195–6.

13. René d'Harnoncourt letter, 23 December, 1941, as quoted by W. Jackson Rushing, in 'Marketing the affinity of the Primitive and the Modern: René d'Harnoncourt and "Indian Art of the United States"', in Berlo (ed.), *The Early Years of Native American Art History*, 214, as cited in the Bibliographic Essay for Chapter 1.

14. See Robert John Goldwater, *Primitivism in Modern Painting* (New York, 1938).

15. Tonita Peña and Pablita Velarde worked together on murals at the Santa Fe Indian School; Velarde painted others at Bandelier National Monument in New Mexico; Kiowa Five painters did murals at the Oklahoma Historical Society in Oklahoma City, the Post Office in Anadarko, Oklahoma and the Department of the Interior; and Oscar Howe painted a mural in the Carnegie Library in Mitchell, South Dakota.

16. As quoted in Frederick Dockstader, *Oscar Howe: A Retrospective Exhibition* (Tulsa, Okla., 1982), 19.

17. We are grateful to Lakota artist Arthur Amiotte, who studied with Oscar Howe, for this information about the spiderweb. For a discussion of Iktomi and the colours, see William K Powers, *Oglala Religion* (Lincoln, Nebr., 1975), 79.

18. As quoted in Tryntje Van Ness Seymour, *When the Rainbow Touches Down* (Phoenix, Ariz., 1987), 149.

19. Unpublished interview, on file at the Native American Artists Resource Collection, The Heard Museum, Phoenix, Arizona.

20. Joseph Traugott, 'Native American Artists and the Postmodern Cultural Divide', *Art Journal* 51/3 (1992), 43.

21. The show included Frank Stella, Jules Olitski, and Kenneth Noland and was organized by Michael Fried for the Fogg Art Museum at Harvard University.

22. Lawrence Abbot (ed.), *I Stand in the Center of the Good* (Lincoln, Nebr., 1994), 289.

23. Ibid., 287.

24. Some of Tailfeathers' sketches of historical objects are in the collection of the Glenbow Museum in Calgary, Alberta.

25. *Potlatch* (Sidney, British Columbia, 1969).

26. Quoted in Sinclair and Pollock, *The Art of Norval Morrisseau*, 26.

27. See Valda Blundell and Ruth B. Phillips, 'If it isn't Shamanic is it Sham?', *Anthropologica* 25/1 (1995), 117–32.

28. See Sherry Brydon, 'The Indians of Canada Pavilion at Expo 67', *American Indian Art Magazine* 22/3 (summer 1997), 55–62.

29. Tom Hill, 'Beyond History', in *Beyond History*, 10.

30. The artists came from both the US and Canada: Abraham Anghik, Carl Beam, Bob Boyer, Domingo Cisneros, Douglas Coffin, Larry Emerson, Phyllis Fife, Harry Fonseca, George C. Longfish, Leonard Paul, Edward Poitras, Jaune Quick-to-See Smith, Randy Lee White, Dana Williams, and Houle himself.

31. Robert Houle, 'The Emergence of a New

Aesthetic Tradition', in *New Work for a New Generation*, 3.

32. Ibid., 4.

33. Jaune Quick-to-See Smith, *The Submuloc Show/Columbus Wohs: A Visual Commentary on the Columbus Quincentenial from the Perspective of America's First People*, 111

34. Loretta Todd, 'What More Do They Want?', in Gerald McMaster and Lee-Ann Martin (eds), *Indigena: Contemporary Native Perspectives*, 75.

35. Deborah Doxtator, *Basket, Bead and Quill* (Thunder Bay, Ontario, 1995), 17.

List of Illustrations

The publisher would like to thank the following individuals and institutions who have kindly given permission to reproduce the illustrations listed below.

Fe (Arthur Seligman Estate), Canadian Museum of Civilization, Hull, Quebec.

46. Conceptual drawing of map of the Iroquois Confederacy as a longhouse. Diagram after P. Nabokov and R. Easton, *Native American Architecture* (Oxford, 1989), 85. © 1990 Peter Nabokov and Robert Easton. Used by permission of Oxford University Press.

47. Adena artist: 'The Berlin Tablet', Early Woodland Period, 500 BCE–1 CE. Diagram after David W. Penney, 'The Adena Engraved Tablets: A Study of Art and Prehistory', in Zena Pearlstone Matthews and Aldona Jonaitis, *Native North American Art History: Selected Readings* (Palo Alto, Calif., 1982), 260, after an original engraving.

48. Adena artist: Human effigy pipe, Early Woodland Period, 500 BCE–1 CE. Original drawing by Emma Phillips after artefact © Ohio Historical Society, Columbus.

49. Hopewell artist: Hand-shaped mica ornament, Middle Woodland Period, 200 BCE–400 CE. Sheet mica. 29 × 16 cm. Ohio Historical Society, Columbus © Dirk Bakker, photographer/photo © 1997 The Detroit Institute of Arts, Mich. (WL-114).

50. Havana Culture artist: Beaver effigy platform pipe, Middle Woodland Period, 100 BCE–200 CE. Pipestone, river pearl and bone. H. 4.5 × L. 11.6 cm. The Thomas Gilcrease Institute of American History and Art (Gilcrease Museum), Tulsa, Okla. (21.1140)/photo Dirk Bakker.

51. Rock painting, Misshipeshu, Agawa site, Lake Superior. Drawing after Selwyn Dewdney, *Dating Rock Art in the Canadian Shield Region* (Toronto, 1970), 42, fig. 15.

52. Cahokia, 900–1200 CE. Drawing after William N. Morgan, *Prehistoric Architecture of the Eastern US* (Cambridge, Mass., 1980), 50. © William N. Morgan.

53. Mississippian artist: Copper breastplate from Lake Jackson site, Safety Harbor Culture, Florida. Drawing after Calvin Jones, Courtesy of the Florida Division of Historical Resources, Tallahasee: Mallory McCane O'Connor, *Lost Cities of the Ancient Southeast* (Gainsville, Fla., 1995), fig. 64.

54. Mississippian artist: Marine-shell effigy bowl, 1350–1500 CE. Terracotta. H. 7.6; diameter 29.2 cm. Courtesy Temple Mound Museum, Fort Walton Beach, Fla. © Dirk Bakker, photographer/photo © 1997 The Detroit Institute of Arts, Mich. (WL-151).

55. Mississippian artist: 'Big Boy' effigy pipe, 1200–1350 CE. Bauxite. 27.5 × 23 cm. University of Arkansas Museum, Fayetteville © Dirk Bakker, photograph/photo © 1997 The Detroit Institute of Arts, Mich. (WL-128).

56. Choctaw artist: Beaded sash, before 1812. Stroud cloth and beads. 128.7 × 9.5 cm. Denver Art Museum, Denver, Col. (1939.31), purchased from Maynard Dixon.

57. Clara Darten: Nested covered baskets, 1904. Woodsplints and dye. Hampton University Museum, Hampton, Va./photo Scott Wolff, Virginia Beach, Va. (04.1696.2–04.1696.12)

58. Florence I. Randall: Seminole Women at Musa Isle Indian Village, 1930. Photograph. The Historical Museum of South Florida, Miami, Fla. (1985. 73. 2).

59. Eastern Great Lakes artist: Ball-headed club, seventeenth or early eighteenth century. Wood, shell beads and bone (?) inlay. L. 58 cm. The Horniman Museum, London (27.4.61/35).

60. Anishnabe artist: Double-headed drum, late eighteenth century. Hide, wood, red ochre. Diameter 48 cm. Stadtliches Museen Braunschweig, Germany.

61. Virginia Algonkian artist: Deerskin robe, 'Powhatan's Mantle', before 1638. Hide and marginella shell. L. 213 cm. Ashmolean Museum, Oxford.

62. Techniques of porcupine quillwork and beadwork. Drawings after William Orchard, *Beads and Beadwork of the American Indians* (New York, 1929) figs 127 and 128; and *The Technique of Porcupine Quill Decoration Among the Indians of North America* (New York, 1916), figs 8, 13, and 17.

63. Mesquakie artist: Blanket with ribbon appliqué, c.1880. Wool cloth, silk ribbon, German silver brooches. L. 142.9 × W. 156.8 cm. Courtesy of the National Museum of the American Indian, Smithsonian Institution, NY (14/1158).

64. Delaware artist: Bandolier bag, c.1850–70. Wool and beads. 39.4 × 37.5 cm; total L. 1194 cm. The Philbrook Museum of Art, Tulsa, Okla., Roberta Campbell Lawson collection, Gift of Mr and Mrs Edward C. Lawson (1946.19.5).

65. Kimberly Ponca Stock: Wearing blanket, 1981. Broadcloth, ribbon, beads, satin, and Velcro. 179 × 156.2 cm. Lost and Found Traditions Collection, Natural History Museum of Los Angeles County, Anthropology Section. The Lost and Found Traditions Collection is a gift of the American Federation of Arts made possible by the generous support of the American Can Corporation, now Primerica/photo Bobby Hanson.

66. Anishnabe (probably Odawa) artist: Twined medicine bundle cover, c.1800–9. Nettlestalk fibre, animal hair, wool yarn, and

pigment. 46 × 36 cm. National Museum of
Ireland, Dublin.

67. Anishnabe artist: Shoulder bag, *c.*1760–84.
Deer skin, moosehair, porcupine quills, metal
cones, and deer hair. Bag, 19 × 23 cm; strap
(doubled) 54 × 3.5 cm. Musée d'Yverdon,
Yverdon-les-Bains, Switzerland.

68. Sophia Smith with a bandolier bag, 1890s.
Photograph. Whipple Collection, Minnesota
Historical Society, St Paul, Minn.

69. Huron-Wendat artist: Moccasins, 1832.
Deer hide and moosehair. 24 × 7.5 × 8 cm.
Bernisches Historisches Museum, Bern,
Switzerland, collected by A. A. Von Pourtalés
at Niagara Falls.

70. Christiana Morris: Quilled bark-covered
Canadian wood cradle, *c.*1868. Morris cradle
decorated with birch bark, porcupine quills,
and dye. 93 × 60 × 68 cm. DesBrisay Museum
and National Exhibition Center, Bridgewater,
Nova Scotia, Gift of Winfred Theodore
'W. T.' Ritcey.

71. Colleen Cutschall: 'Sons of the Wind',
1992. Sauna tubing, chipboard, acrylic, and
papier mâché. Each pillar, 285 × 60 × 60 cm.
Courtesy of the artist.

72. Shell gorget, pre-contact. Photo courtesy
of the Royal Ontario Museum, Toronto,
Ontario © Royal Ontario Museum.

73. Cheyenne artist: Dragonfly hair
ornaments, *c.*1880. Rawhide, pigment,
feathers, and buttons. 33 × 25 and 63 × 13.5 cm
(including trailing feathers). National
Museum of the American Indian, New York.

74. Lakota artists: Man's war shirt, *c.*1870.
Tanned hide, porcupine quills, human hair,
pigment, trade beads, and sinew. L. 94 cm.
Masco Corporation. Taylor, Mich.

75. Cheyenne artist: Parfleche, before 1875.
Rawhide and pigment. 67.3 × 39.4 cm.
Founders Society Purchase with funds from
Flint Ink Corporation/photo © 1997 The
Detroit Institute of Arts (1988.39).

76. Crow artist: Beaded horse collar, *c.*1890–
1900. 96.5 × 37.5 cm. Denver Art Museum,
Denver, Col. (BCr-8-PD), purchased from
Babbitt Bros.

77. Kiowa artists: Three beaded cradles,
*c.*1900. Left, 120 × 32 cm; middle, 119 × 34 cm;
right 106 × 34.5 cm. Haffenreffer Museum of
Anthropology, Brown University, Bristol, RI.
(69.10683; 75.158; 61.339).

78. Kiowa artists: Black Leggings tipi of the
Kiowa warrior society, 1980s. Photograph.
Department of Anthropology, National
Museum of Natural History, Smithsonian
Institution, Washington, DC/photo Dolores
Twohatchet.

79. Kiowa artists: Underwater Monster tipi.

Drawing after Ewers, *Murals in the Round:
Painted Tipis of the Kiowa and the Kiowa-Apache
Indians* (Washington, DC, 1978), fig. 29.

80. Arapoosh (Sore Belly): War shield, *c.*1820.
Buckskin, rawhide, pigments, stork feathers,
deer tail, and flannel. Diameter, 61.5 cm.
Courtesy of the National Museum of the
American Indian, Smithsonian Institution,
NY (11/7680).

81. Mandan artist: Buffalo robe painted with
narrative scenes, *c.*1800. Hide, porcupine
quills, and pigment. 238.8 × 266.7 cm. Peabody
Museum of Archaeology and Ethnology,
Cambridge, Mass.

82. After Karl Bodmer: The Interior of the
Hut of a Mandan Chief, 1836–43. Engraving
with aquatint, hand-coloured. 41.4 × 54 cm.
Josyln Art Museum, Omaha, Nebr., Gift of
the Enron Art Foundation.

83. Lakota artist: Horse effigy dance stick,
1880s. Painted wood, leather (ears and reins),
and horsehair (mane and tail). L. 94.6 cm.
South Dakota State Historical Society, Pierre,
S. Dak./photo Paul Jones.

84. Comparative drawings of a medicine
wheel and a Sun Dance enclosure. Drawing
after Michael Coe, Dean Snow, and Elizabeth
Benson, *Atlas of Ancient America* (Oxford,
1986), 65.

85. Wohaw: 'Between Two Worlds', 1876.
Pencil and crayon on paper. 22.2 × 28.6 cm.
Missouri Historical Society, St Louis, Mo.
(1882.18.32).

86. Arthur Amiotte: 'The Visit', 1995.
Collage. Gift of Mrs Cornelius Vanderbilt
Whitney. Buffalo Bill Historical Center,
Cody, Wyo.

87. Arapaho artist: Ghost Dance dress, 1890s.
Deerskin and pigments. Field Museum of
Natural History, Chicago, Ill.(Neg. No.
#A113021c)/photo Diane Alexander White

88. Baptiste Garnier in Métis-style clothing,
late nineteenth century. Photograph. © Amon
Carter Museum, Fort Worth, Tex.,
Brininstool Collection (P1967.1268).

89. Nez Perce artist: Twined bag, *c.*1910. Corn
husks and commercial yarn. 33.7 × 35.6 cm.
Denver Art Museum, Denver, Col. (Neg. No.
1938.776), purchased from Grace Nicholson.

90. Mary Posh: Pomo feathered basket, *c.*1905.
Willow shoots, sedge root, woodpecker and
quail feathers, clamshell and abalone beads,
and twine. H. 5 cm; diameter 24 cm.
University of Pennsylvania Museum,
Philadelphia, Pa. (7823).

91. Baskets by Louisa Keyser. Photo E. H.
Curtis, from E. H. Curtis *The North American
Indian* (1909).

92. Tanaina artist: Quiver, before 1841. Beads,

unsmoked skin, red ochre, and feathers. Musée d'Ethnographie, Ville de Geneva, Switzerland.

93. Innu (Naskapi) artist: Hunter's summer coat, *c*.1805. Caribou skin, sinew, fish-egg paint. L. 108 cm. Photo courtesy Royal Ontario Museum, Toronto, Ontario (32113) © Royal Ontario Museum.

94. James Bay Cree artist: Dolls, *c*.1800. Dolls of European manufacture, hide, porcupine quills, paint, cloth, red ochre, and beads. Left, H. 35.5 cm; right, H. 33 cm. The Horniman Museum, London (1976/459–460)/photo Ron Marsh.

95. Gwich'in (Kuchin) artist: Man's suit of clothes, late nineteenth century. Tanned caribou or moose hide, trade beads, and quills. 114 cm; 88 cm; 24 cm. University of Pennsylvania Museum, Philadelphia, Pa. (Neg. No. 7739a; 7739b; 7740)/photo Harmer Frederick Schoch.

96. Dene artist: Ladle, *c*.1776. Mountain-sheep horn and red ochre. L. 22.5 cm. Museum of Archaeology and Anthropology, Cambridge University.

97. Gwich'in (Kuchin) artist: Dog blanket, before 1912. Velvet, seed and metal beads. L. 46.5 cm McCord Museum of Canadian History, Montreal, Quebec (ME966xIII.1).

98. James Bay Cree artist: Hood, 1840–65. 50 × 25.5 cm. Canadian Museum of Civilization, Hull, Quebec.

99. Verna Itsi and her daughter, Fort McPherson, Northwest Territories, 1991. Photograph. Canadian Museum of Civilization, Hull, Quebec/photo Judy Thompson.

100. Okvik artist: Female figure, *c*.100 BCE. Walrus ivory. H. 17 cm. University of Alaska Museum, Fairbanks, Alaska (UA 71.9.1).

101. Semi-abstract engraved patterns on a harpoon head, *c*.100–400 CE. Drawing after William W. Fitzhugh and Aron Crowell, *Crossroads of Continents: Cultures of Siberia and Alaska* (Washington, DC, 1988), fig. 137.

102. Burial mask, *c*.100 CE. Ivory. Courtesy Department of Library Services, American Museum of Natural History, New York (60.1.7713).

103. Thule artist: Comb, Thule Period. Ivory. 11 × 4 cm. Eskimo Museum, Churchill, Manitoba/photo Robert R. Taylor.

104. Ivory carving of a loon head from an Ipiutak burial, *c*.100 CE. Courtesy Department of Library Services, American Museum of Natural History, New York (Neg. No. AMNH K13965).

105. Yup'ik artist: Mask of diving loon, before 1892. Wood, paint, owl feathers. H. 80 cm.

Sheldon Jackson Museum, Sitka, Alas. (II.G.11)/photo Ernest Manewal.

106. Iglulik Inuit artist: Shaman's garments, late nineteenth century. 95.5 × 52 cm. Courtesy Department of Library Services, American Museum of Natural History, New York (Neg. No. AMNH #2A13526).

107. Niviatsianaq in her beaded *amautiq* (parka), *c*.1900. Photograph. 95.5 × 52 cm. National Archives of Canada, Ottawa, Ontario.

108. Aleut artist: Gut cape, before 1850. Woollen yarn, human hair, cotton string, sea-lion oesophagus membrane, and walrus intestine. L. 119 cm; H. of collar, 9 cm. National Museum of Finland, Helsinki (VK 283)/photo Matti Huuhka.

109. Yup'ik artist: Aleut-style visored hat, *c*.1820. Wood and ivory. L. 33 cm. Canadian Museum of Civilization, Hull, Quebec (IV.E.92).

110. Iñupiaq artist: Cribbage board in the shape of a caribou, 1890s. Walrus ivory. L. 29.2 cm. National Museum of the American Indian, New York.

111. Jessie Oonark: 'A Shaman's Helping Spirits', 1971. Stone cut and stencil. 94 × 64 cm. Inuit Art Section, Department of Indian and Northern Affairs, Hull, Quebec.

112. Johnnie Inukpuk: 'Mother and Child', 1953. Stone with walrus ivory inlay. H. 15.2 cm. Reproduced with permission of La Fédération des co-operativs du Nouveau Québec.

113. Ovilu Tunnillie: 'Woman Passed Out', 1987. Green stone. 48 × 28 × 25 cm. Courtesy of the artist (West Baffin Co-operative) and Canadian Museum of Civilization, Hull, Quebec (IV.C.5501).

114. Denise Wallace: Wolf Transformation pin/pendant, 1988. Silver, etched fossilized walrus ivory, mother of pearl, and stone. DW Studio, Inc., Santa Fe, N. Mex.

115. Lawrence Beck: 'Punk Nanuk Inua' mask, 1986. Dental tools, oil filter, plastic and metal spatulas, safety pins. 45 × 46.4 × 16 cm. Anchorage Museum of History and Art, Anchorage, Alas./photo Chris Arend Photography, Anchorage, Alas.

116. Bill Reid: 'The Raven and The First Men', 1983. Courtesy of the Museum of Anthropology, University of British Columbia, Vancouver/photo Bill McLennan.

117. Architectural drawing of house, Haida. Courtesy of Gordon Miller, reproduced from George MacDonald, *Haida Monumental Art: Villages of the Queen Charlotte Islands* (Vancouver, 1983), 19.

118. Salish Artist: Basket, late nineteenth century. Cattail leaves and grass. 37 × 31 × 27 cm. Courtesy of the Thomas Burke Memorial

Washington State Museum, Seattle, Wash. (I.507)/photo University of Washington, Seattle.

119. Proto-Salish culture artist: Bowl in the form of a seated human figure, 1–500 CE. Soapstone. H. 38.1 cm. Royal British Columbia Museum (Cat. No. PN 21193).

120. Copper. Drawing after Helen Codere (ed.), *Kwakliutl Ethnography* (Chicago, 1966).

121. Chilkat blanket. Drawing after George T. Emmons, 'Basketry of the Tlingit' and 'The Chilkat Blanket' reprinted in a single volume (Sitka, Alas., 1993), 390, fig. 583a.

122. Tsimshian (?) artist: Bentwood chest, pre-1862. Painted cedar, carved in relief, kerfed and pegged. L. 38 cm. Department of Anthropology, National Museum of Natural History, Smithsonian Institution, Washington, DC (Cat. No. #638).

123. Formline design from Bentwood chest. Diagram after box (Cat. No. #638) in Smithsonian Institution, Washington DC.

124. Nuu-chah-nulth artist: House screen, c.1850. Wood. 298.5 × 173.1 cm. Courtesy Department of Library Services, American Museum of Natural History, New York (Neg. No. AMNH 3730).

125. Makah artist: Side of carved chest, sixteenth century. Western red cedar. Makah Cultural And Research Center, Neah Bay, Wash.

126. Quinault artist: Oil dish, nineteenth century. Alder or yew, and glass beads. Whole object, 30.5 × 22.9 cm; bowl, W. 22.9 × Depth 8.9 cm. Whitman College Collection, Gift of Mr and Mrs M. Eells (1906), Museum of Anthropology, Whitman College, Walla Walla, Wash. (1243).

127. Coast Salish artist: Blanket, c.1840. Mountain goat wool. 152 × 154 cm. Department of Anthropology, Smithsonian Institution, Washington, DC (Cat. No. 1891A).

128. Coast Salish artist: Spirit Canoe board, 1920. Drawing after photo by J. D. Leechman in the Burke Museum (# L.3911/3) published in Robin Wright (ed.) *A Time of Gathering* (Seattle, Wash., 1991), 37.

129. Tlingit artist: Shaman's mask, late nineteenth century. Wood and traces of black and blue-green pigment. H. 21.6 cm. Courtesy Department of Library Services, American Museum of Natural History, New York (Neg. No. AMNH #2A12602).

130. Tlingit artist: Oystercatcher rattle, c.1830–50. Wood, ermine skin, bird skin, bone, rawhide, and pigments. 30 × 44.5 × 8.5 cm. The Art Museum, Princeton University, Princeton, NJ, on permanent loan from the Department of Geological and Geophysical Science.

131. Northern Northwest Coast artist: Paired stone masks. Basalt and green stone. Diameter 22.9 cm. Canadian Museum of Civilization, Hull, Quebec, and Musée de L'Homme, Paris/photo Canadian Museum of Civilization.

132. Skidegate, British Columbia, 1878. Photograph. National Archives of Canada, Ottawa, Ontario.

133. Dog Salmon crest pole. Canadian Museum of Civilization (#34595)/drawing by Robert McMillan.

134. Glenn Tallio: Nuxalk (Bella Coola), House of Chief Clellamin, (reconstructed), after a late nineteenth century photograph. Architectural sculpture. Grand Hall, Canadian Museum of Civilization, Hull, Quebec.

135. Shirley Hunt Ford wearing a button robe, 1985. Photograph. Photo Alexis MacDonald-Seto.

136. Kwakwaka'wakw artist: Wolf transformation mask, late nineteenth century. Wood, twine, animal hide, and pigment. H. 45 cm. Courtesy Department of Library Services, American Museum of Natural History, New York (Neg. No. #2381).

137. Hamatsa dancers (with masks) at William Cranmer's potlatch, Alert Bay, Canada, 1983. Photograph. Courtesy of U'mista Cultural Centre/photo Vickie Jensen.

138. Kwakwaka'wakw artist: *Dzonoqua* feast dish, c.1900. Wood. L. 270.8 cm; H. 59.8 cm. American Museum of Natural History, New York (16/9013–14).

139. Lawrence Paul Yuxweluptun: 'Scorched Earth, Clear-cut logging on Native Sovereign Land, Shaman Coming to Fix', 1991. Acrylic on canvas. 196.6 × 276.5 cm. National Gallery of Canada, Ottawa, Ontario (36950).

140. Charles Edenshaw displaying argillite carvings, c.1880. Photograph. Canadian Museum of Civilization, Hull, Quebec (88926).

141. Isabella Edenshaw (weaver) and Charles Edenshaw (painter): Clan hat, late nineteenth century. Royal British Columbia Museum, Victoria, BC (Cat. No. 7954).

142. Dorothy Grant and Robert Davidson: Hummingbird copper dress, 1989. Wool/cashmere, beads and hand appliqué. Canadian Museum of Civilization, Hull, Quebec/photo Robert Kinney.

143. Robert Davidson: 'Reflections', 1976. Courtesy the artist and The Museum of Anthropology, University of British Columbia.

144. Dennis Cusick: 'Scene of Indian Life: Keep the Sabbath', 1821. Watercolour on paper. 10.8 × 18.4 cm. Private Collection.

145. Stephen Mopope: 'Buffalo Hunt', c.1930–40. Watercolour on paper. 32.4 × 22.2 cm. The Museum of Northern Arizona, Flagstaff, Ariz.

146. Pablita Velarde: 'Pueblo Craftsmen, Palace of the Governors', 1941. Casein. The Thomas Gilcrease Institute of American History and Art (Gilcrease Museum), Tulsa, Okla. (37.565).

147. Blackbear Bosin: 'Prairie Fire', c.1953. Watercolour on paper. 51.4 × 84.1 cm. The Philbrook Museum of Art, Tulsa, Okla., Museum purchase (1953.7).

148. Oscar Howe: 'Rider', 1968. Casein. 44.5 × 66 cm. University Art Galleries, University of South Dakota, Vermilion, S. Dak. © Adelheid Hose, 1983.

149. Allan Houser: 'By the Water's Edge', 1987. Bronze. Allan Houser Inc.

150. Fritz Scholder: 'Screaming Indian #2', 1970. Oil on canvas. 152.4 × 106.7 cm. Courtesy Private Collection and the Wheelwright Museum.

151. Shelley Niro: 'The Iroquois is a Highly Developed Matriarchal Society' from 'Mohawks in Beehives' series, 1992. Hand-tinted photograph. 96 × 53 cm. Courtesy the artist and the Indian Art Centre, Department of Indian and Northern Affairs, Hull, Quebec.

152. George Morrison: 'Collage IX: Landscape', 1974. The Minneapolis Institute of Art, Minneapolis, Minn.

153. Kay WalkingStick: 'You're not an Indian.', 1993. Oilstick and gouache. 55.9 × 111.8 cm. Courtesy the artist © Kay WalkingStick 1993/photo Bill McLennan.

154. Emmi Whitehorse: 'Chanter', 1991. Oil on paper mounted on canvas. 99.5 × 71.1 cm. The Saint Louis Art Museum, St Louis, Mo., purchase Museum Shop Fund (37.1991).

155. Jolene Rickard: 'Sky Woman Looks Back', 1995. One part of a transparency, red whip, and steel installation. H. 20.3; diameter 106.7 cm. Courtesy the Artist.

156. Alex Janvier: 'No One Understands Me', 1972. Acrylic on canvas. 96.5 × 127 cm. Courtesy the Artist and The Indian Art Center, Department of Indian and Northern Affairs, Hull, Quebec.

157. Norval Morrisseau: 'The Storyteller: The Artist and his Grandfather', 1978. Acrylic on canvasboard. Each panel, 176.3 × 96.6 cm. The Indian Art Center, Department of Indian and Northern Affairs, Hull, Quebec.

158. Carl Beam: 'Columbus Chronicles', 1992. Photo-emulsion, acrylic, pencil on canvas. National Gallery of Canada, Ottawa, Ontario (37009).

159. Jane Ash Poitras: 'Up All Night Girl', 1982. Multi-coloured print. 111.5 × 86 cm. Courtesy the Artist and The Indian Art Center, Department of Indian and Northern Affairs, Hull, Quebec.

160. Edgar Heap of Birds: 'Building Minnesota', 1990. Mixed media installation. Courtesy the Artist.

161. Rebecca Belmore: 'Mawe-che-hitoowin: A Gathering of People for Any Purpose', 1992. Mixed media installation. National Gallery of Canada, Ottawa/School for Studies in Art and Culture, Carleton University, Ottawa.

The publisher and authors apologize for any errors or omissions in the above list. If contacted they will be pleased to rectify these at the earliest opportunity.

Bibliographic Essay

General Works

This bibliographic essay, divided by chapter and by topic within each chapter, is not meant to be exhaustive. We have tried to indicate some of the most important and useful sources for each region. The bibliographies within works cited will provide further resources. These chapter-by-chapter essays should be used in conjunction with the chapter footnotes, which provide specific references to facts presented in the text.

The literature on Native American art is extensive but uneven; until recently it did not exist as a separate category of study. Much information on art is hidden within more general ethnological and archaeological studies. Important general references for the study of Native North American art history include *The Handbook of North American Indians*, published by the Smithsonian Institution in Washington, DC (1978–present). Most of these volumes are organized by region (i.e. the Great Basin, the Northwest Coast, the Arctic). A projected volume on Technology and the Visual Arts (16) had not been published at the time of writing. Many recent periodicals include essays on North American Indian Art. Only one, *American Indian Art Magazine*, published in Phoenix, Arizona (1975–present) is devoted exclusively to the field. Short essays by numerous scholars of Native art are included in Volume 22 of Jane Turner (ed.), *Dictionary of Art* (New York, 1996), 543–679. A fine bibliography of works published before 1938 was compiled by Anne D. Harding and Patricia Bolling, *Bibliography of Articles and Papers on North American Indian Art* (New York, 1969, originally published Washington, DC, 1938). Carl Waldman and Molly Braun, *The Atlas of the North American Indian* (New York, 1985) is a good introduction to culture areas and mapping, while Duane Champagne's (ed.) *The Native North American Almanac: A Reference Work on Native North*

Americans in the United States and Canada (Detroit, 1994) provides scores of short essays on history, art, politics, education, and economy. Judith Nies, *Native American History* (New York, 1996) lays out important events in a timeline fashion, chronologically linking Native American achievements with great events in world history. We have relied heavily upon this source for our own timeline.

Archaeology

An excellent recent survey of the archaeology of North America is provided by Brian M. Fagan, *Ancient North America: The Archaeology of a Continent* (London and New York, 1991, 2nd edn 1995).

Architecture

A fine, profusely illustrated survey of architecture has been written by Peter Nabokov and Robert Easton, *Native American Architecture* (Oxford, 1989). Contemporary architecture by and for Native peoples is covered by Carol Krinsky in *Contemporary Native American Architecture* (Oxford, 1996).

Survey texts and exhibition catalogues

In this field, a great deal of scholarship is disseminated through exhibition catalogues. Important volumes that survey large parts of the continent are listed here. Influential early ones include Oliver LaFarge, et al., *Introduction to American Indian Art* (Glorieta, N. Me., 1985), first published in 1931 to accompany the important Exposition of Indian Tribal Arts in New York; George Vaillant, *Indian Arts in North America* (New York, 1939), an important early attempt at a comprehensive scholarly treatment of Native American objects as art; and Frederic H. Douglas and René D'Harnoncourt, *Indian Art of the United States* (New York, 1941).

Influential exhibition catalogues from the 1970s are Ralph T. Coe, *Sacred Circles: Two Thousand Years of North American Indian Art*

(London, 1976, Kansas City, Mo., 1977), and Walker Art Center, *American Indian Art: Form and Tradition* (New York, 1972). Especially useful are Evan M. Maurer, *The Native American Heritage: A Survey of North American Indian Art* (Chicago, 1977), and the Glenbow Museum's *The Spirit Sings: Artistic Traditions of Canada's First Peoples* (Toronto, 1987). The American flag as an iconographic motif is considered in the well-illustrated volume by Toby Herbst and Joel Kopp, *The Flag in American Indian Art* (Cooperstown, NY and Seattle, 1993).

Many important exhibition catalogues focus on one institution's collection. Judy Thompson, *The North American Indian Collection. A Catalogue* (Berne, Switzerland, 1977), features important early material from diverse regions of North America. Richard Conn, *Native American Art in the Denver Art Museum* (Denver, 1979) provides a scholarly look at a significant collection. The collections at the Philbrook Museum are considered in John A. Mahey and Rennard Strickland, *Native American Art at Philbrook* (Tulsa, Okla., 1980), and Edwin L. Wade, *The Arts of the North American Indian: Native Traditions in Evolution* (New York, and Tulsa, Okla., 1986). The latter is particularly noteworthy for its fine essays by some of the foremost scholars in the field.

A sample of the vast holdings of the National Museum of the American Indian was first published by Frederick Dockstader, *Indian Art in America: The Arts and Crafts of the North American Indian* (Greenwich, Conn., 1961), and more recently by Native scholars in Tom Hill and Richard W. Hill, Sr (eds), *Creation's Journey: Native American Identity and Belief* (Washington, DC, 1994). Objects collected by Stewart Culin are featured in Diana Fane, Ira Jacknis, and Lise M. Breen, *Objects of Myth and Memory: American Indian Art at The Brooklyn Museum* (New York and Seattle, 1991). A small sampling of an important early collection is published in Dan L. Monroe, et al., *Gifts of the Spirit: Works by 19th Century and Contemporary Native American Artists* (Salem, Mass., 1996).

An important compendium of thirty essays was assembled by Zena Pearlstone Mathews and Aldona Jonaitis, *Native North American Art History: Selected Readings* (Palo Alto, Calif., 1982). More recent survey texts include Peter T. Furst and Jill L. Furst, *North American Indian Art* (New York, 1982), with many beautiful colour illustrations, and Christian F. Feest, *Native Arts of North America* (London

and New York, 1980, updated edition 1992), the latter organized not by region but by artistic medium. Art-historical methodology as applied to Native art is addressed by Joan Vastokas, 'Native Art as Art History: Meaning and Time from Unwritten Sources', *Journal of Canadian Studies* 21/4 (1986–7) and Ruth Phillips, 'What is "Huron Art"?: Native American Art and the New Art History', *Canadian Journal of Native Studies* 11/2 (1989).

Chapter 1. Introduction

What is art? Western discourses and Native American objects and modes of appreciation: curiosity, specimen, artefact, and art

History of collecting

A good starting point for reading about curiosity collecting in early modern Europe is Oliver Impey and Arthur McGregor (eds), *The Origin of Museums: The Cabinets of Curiosities in Sixteenth- and Seventeenth-Century Europe* (Oxford, 1985). For Native American objects specifically see, Christian F. Feest, 'The Collecting of American Indian Artifacts in Europe, 1473–1750', in Karen Ordahl Kupperman (ed.), *America in European Consciousness, 1493–1750* (Chapel Hill, NC, 1995). On the Western museum and non-Western objects see Sally Price, *Primitive Art in Civilized Places* (Chicago, 1989), Michael M. Ames, *Cannibal Tours and Glass Boxes: The Anthropology of Museums* (Vancouver, 1992), and Arthur C. Danto, 'Artifact and Art', in The Center for African Art, *Art/artifact: African Art in Anthropology Collections* (New York, 1988). An especially important volume is Ivan Karp and Steven D. Lavine (eds), *Exhibiting Cultures: The Poetics and Politics of Museum Display* (Washington, DC, 1991). On ethnological collection see Curtis M. Hinsley, Jr's study of the Smithsonian Institution, *Savages and Scientists: The Smithsonian Institution and the Development of American Anthropology, 1846–1910* (Washington, DC, 1981); and George Stocking (ed.), *Objects and Others: Essays on Museums and Material Culture* (Madison, Wis., 1985). For an important study of Stewart Culin and Native American objects see Diana Fane et al., *Objects of Myth and Memory*, cited above.

Because the field of Native American art history, as a subdiscipline of art history rather than anthropology, is so young, there have been few historiographic efforts as yet. The essays collected by Janet Catherine Berlo (ed.) in *The Early Years of Native American Art History* (Seattle, 1992) are an initial step in that direction.

Issues of museum representation and ethics have been at the forefront of discussion of Native arts in the 1990s. See for example, Janet Catherine Berlo and Ruth B. Phillips, 'Our (Museum) World Turned Upside-Down: Re-Presenting Native American Arts', *Art Bulletin* 77/1 (1995), 6–10; James Clifford, *Routes: Travel and Translation* (Cambridge, Mass., 1997); Ruth B. Phillips, 'Fielding Culture: Dialogues between Art History and Anthropology', *Museum Anthropology* 18/1 (1994), 39–46, and W. R. West, 'Research and Scholarship at the National Museum of the American Indian: The New Inclusiveness', *Museum Anthropology* 17/1 (1993), 5–8.

W. Rubin (ed.), *'Primitivism' in Twentieth Century Art: Affinity of the Tribal and the Modern* (New York, 1985), and W. Jackson Rushing, *Native American Art and Culture and the New York Avant-Garde, 1910–1950* (Austin, 1995), both consider the intersection of Native and non-Native artistic worlds. A superb look at the ethics and mechanics of repatriation is provided by W. L. Merrill, E. J. Ladd, and T. J. Ferguson, 'The Return of the *Ahayu:da*: Lessons for Repatriation from Zuni Pueblo and the Smithsonian Institution', *Current Anthropology* 34/5 (1993), 523–67. Important publications on collaborations between Native and non-Native peoples include Assembly of First Nations, *Turning the Page: Forging New Partnerships between Museums and First Peoples* (Ottawa, 1992); T. Nicks, 'Partnerships in Developing Cultural Resources: Lessons from the Task Force on Museums and First Peoples', *Culture* 12/1 (1992), 87–94; and Judith Ostrowitz, 'Trail Blazers and Ancestral Heroes: A Museum Collaboration', *Curator* 36/1 (1993), 50–65.

Commoditization, tourism and Native art
On objects as commodities see Arjun Appadurai (ed.), *The Social Life of Things: Commodities in Cultural Perspective* (Cambridge, 1986). On tourist art see Nelson Graburn's classic introductory essay in *Ethnic and Tourist Arts: Cultural Expressions from the Fourth World* (Berkeley, 1976); and Dean MacCannell, *The Tourist: A New Theory of the Leisure Class* (New York, 1976). Many of the essays in Ruth B. Phillips and Christopher B. Steiner (eds), *Unpacking Culture: Art and Commodity in Colonial and Postcolonial Worlds* (Berkeley, 1998) deal with Native American topics. See also Ruth B. Phillips, 'Why Not Tourist Art?: Significant Silences in Native American Museum Collections', in G. Prakash (ed.), *After Colonialism: Imperial*

Histories and Post-Colonial Displacements (Princeton, N J, 1994).

What is an Indian?
For discussions of stereotyping from a Native point of view see Deborah Doxtator, *Fluffs and Feathers: An Exhibit on the Symbols of Indianness* (Ontario, 1988) and Fritz Scholder, *Indian Kitsch: The Use and Misuse of Indian Images* (Phoenix, Ariz., 1979). For literary stereotypes see Robert F. Berkhofer, Jr, *The White Man's Indian* (New York, 1978); and in popular culture, Raymond William Stedman, *Shadows of the Indian: Stereotypes in American Culture* (Norman, Okla., 1982); Daniel Francis, *The Imaginary Indian: The Image of the Indian in Canadian Culture* (Vancouver, 1992); and S. Elizabeth Bird (ed.), *Dressing in Feathers: The Construction of the Indian in American Popular Culture* (Boulder, Col., 1996).

Cosmology, religion, and shamanism
There is a growing literature on Native American spirituality by Native writers. Older studies by non-Natives include: Ake Hultkrantz, *The Religions of the North American Indians* (Berkeley, 1967), or the shorter version, *Native Religions* (New York, 1987). See also Mircea Eliade, *Shamanism: Archaic Techniques of Ecstasy* (New York, 1964). A classic introduction to shamanistic art in the Americas is Anne Trueblood Brodzky, Rose Danesewich, and Nick Johnson (eds), *Stones, bones and skin: Ritual and Shamanic Art* (Toronto, Ontario, 1977), with particular attention to Joan Vastokas' fine essay 'The Shamanic Tree of Life'. Esther Pasztory covers some of the same ground in 'Shamanism and North American Indian Art', in Mathews and Jonaitis, *Native North American Art History*, cited above, under General Works.

Creativity is our tradition: innovation and tradition
Contemporary arts in traditional formats are the subject of Ralph T. Coe, *Lost and Found Traditions: Native American Art 1965–1985* (Seattle, 1986). For an insightful analysis of the notion of tradition see Jonathan King, 'Tradition in Native American Art', in Wade (ed.), *The Arts of the North American Indian*, cited above.

Gender and the making of art
Relatively few studies integrate the role of gender in art-making. Janet Catherine Berlo, 'Dreaming of Double Woman:

The Ambivalent Role of the Female Artist in North American Indian Mythology', *American Indian Quarterly* 17/1 (1993), 31–43, discusses traditional stories that shed light on women's artistic roles. Will Roscoe has considered trans-gender 'males' and women's arts in *The Zuni Man-Woman* (Albuquerque, 1991), and 'We'wha and Klah: The American Indian Berdache as Artist and Priest', *American Indian Quarterly* (spring 1988), 127–50. A good example of an analysis of gender domains is Alice Schlegel, 'Male and Female in Hopi Thought and Action', in Alice Schlegel (ed.), *Sexual Stratification: A Cross-Cultural View* (New York, 1977).

Chapter 2. The Southwest
General and introductory texts
In addition to Volumes 9 (1979) and 10 (1983) of *The Handbook of North American Indians*, two recent fine introductions to the cultures of the Southwest are Thomas E. Sheridan and Nancy J. Parezo (eds), *Paths of Life: American Indians of the Southwest and Northern Mexico* (Tucson, Ariz., 1996), and Stephen Trimble, *The People: Indians of the American Southwest* (Santa Fe, 1993). Andrew Hunter Whiteford et al., *I am Here: Two Thousand Years of Southwest Indian Art and Culture* (Santa Fe, 1989) provides a catalogue of an important institutional collection of Southwestern art. An exhaustive, two-volume bibliography of the arts of the Southwest has been assembled by Nancy J. Parezo, Rebecca Allen, and Ruth M. Perry, *Southwest Native American Arts and Material Culture: A Guide to Research* (two vols, New York, 1991).

The ancient world
A classic, brief introduction to the Anasazi, Mimbres, and Hohokam is H. M. Wormington, *Prehistoric Indians of the Southwest* (Denver, 1975), originally published in 1947. More recent efforts include J. J. Brody's *The Anasazi: Ancient Indian People of the American Southwest* (New York, 1990) which is well illustrated and considers all of the arts and Michael A. Adler (ed.), *The Prehistoric Pueblo World, A.D. 1150–1350* (Tucson, Ariz., 1996). An excellent introduction to the Anasazi of Chaco Canyon is David Grant Noble (ed.), *New Light on Chaco Canyon* (Santa Fe, 1984). D. G. Noble (ed.), *The Hohokam: Ancient People of the Desert* (Santa Fe, 1991) provides a brief introduction to the Hohokam. The classic archaeological site report for one of the principal Hohokam sites is Harold S. Gladwin, et al., *Excavations at Snaketown:*

Material Culture (Tucson, Ariz., 1938, repr. 1965).

Anasazi and Mimbres pottery
Mimbres pottery has been discussed in numerous publications of the past two decades, among them J. J. Brody, Catherine J. Scott, and Steven A. LeBlanc, *Mimbres Pottery: Ancient Art of the American Southwest* (New York, 1983), J. J. Brody and Rina Swentzell, *To Touch the Past: The Painted Pottery of the Mimbres People* (New York, 1996), and Barbara L. Moulard, 'Form, Function and Interpretation of Mimbres Ceramic Hemispheric Vessels', in Janet Catherine Berlo and Lee Anne Wilson (eds), *Arts of Africa, Oceania, and the Americas* (Englewood Cliffs, N J, 1993). Archaeological aspects of these wares are discussed in Patricia A. Gilman, Veletta Canouts, and Ronald L. Bishop, 'The Production and Distribution of Classic Mimbres Black-on-White Pottery', *American Antiquity* 59/4 (1994), 695–709. Anasazi pottery is covered in detail in Brody's *The Anasazi*, cited above.

The colonial era
An excellent introduction to the social dynamics of the colonial era is Ramón A. Gutiérrez, *When Jesus Came, the Corn Mothers Went Away: Marriage, Sexuality, and Power in New Mexico, 1500–1846* (Stanford, Calif., 1991). His bibliography provides numerous other sources. For colonial architecture, especially mission churches of the Pueblos, see George Kubler, *The Religious Architecture of New Mexico: In the Colonial Period and Since the American Occupation* (Albuquerque, 1940).

Ancient and modern architecture
Neil M. Judd's study of the largest ancient Pueblo structure at Chaco Canyon, *The Architecture of Pueblo Bonito* (Washington, DC, 1964), remains a classic. It has been updated by Stephen H. Lekson, *Great Pueblo Architecture of Chaco Canyon, New Mexico* (Albuquerque, 1986). The interconnections among the various architectural groups at Chaco Canyon is succinctly discussed by Stephen K. Lekson, Thomas C. Windes, John R. Stein, and W. James Judge, 'The Chaco Canyon Community', *Scientific American* 259/1 (July 1988), 100–9, while the astronomical features of Anasazi architecture are summarized by Ray A. Williamson, Howard J. Fisher, and Donnel O'Flynn, 'Anasazi Solar Observatories', in Anthony F. Aveni, *Native American Astronomy* (Austin,

Tex., 1977). Victor Mindeleff's *A Study of Pueblo Architecture in Tusayan and Cibola* (Washington, DC, 1989), originally published in 1891, provides an in-depth look at Zuni architecture. Peter Nabokov's *Architecture of Acoma Pueblo: The 1934 Historic American Buildings Survey Project* (Santa Fe, 1986) provides detailed ground plans of the house-blocks of that Western Pueblo, while Ward Alan Minge, *Acoma: Pueblo in the Sky* (Albuquerque, 1991) surveys the archaeology and history of Acoma. Vincent Scully's *Pueblo: Mountain, Village, Dance* (New York, 1972) is a well-illustrated survey by an architectural historian who takes into account environmental and cultural factors in architectural construction. William Morgan, *Ancient Architecture of the Southwest* (Austin, Tex., 1994) provides site plans of most archaeological and historic Pueblos.

Pueblo ritual and performance arts

Fundamental early works, since reprinted, include Ruth Bunzel, *Zuñi Katcinas: An Analytical Study* (Glorieta, N. Mex., 1984), first published in 1932, and Jessie Walter Fewkes, *Tusayan Katcinas and Hopi Altars* (Albuquerque, 1990). Important works on Hopi Kachina imagery include Frederick J. Dockstader, *The Kachina and the White Man: The Influences of White Culture on the Hopi Kachina Cult* (Albuquerque, 1985, originally published in 1954); Barton Wright, *Kachinas: a Hopi artist's documentary* (Flagstaff, Ariz., 1973); Dorothy K. Washburn (ed.), *Hopi Kachina: Spirit of Life* (Seattle, 1980); and Alph H. Secakuku, *Following the Sun and Moon: Hopi Kachina Traditions* (Flagstaff, Ariz., 1995). Recent studies of Kachina imagery and meaning include Polly Schaafsma (ed.), *Kachinas in the Pueblo World* (Albuquerque, 1994) and E. Charles Adams, *The Origin and Development of the Pueblo Katsina Cult* (Tucson, Ariz., 1991). Barton Wright provides a fine introduction to the complex topic of Pueblo religious iconography in *Pueblo Cultures* (Leiden, 1986), while Hopi religious iconography is covered by Armin W. Geertz, *Hopi Indian Altar Iconography* (Leiden, 1987). Jill D. Sweet looks at humorous aspects of ritual performance in 'Burlesquing "The Other" in Pueblo Performance', *Annals of Tourism Research* 16 (1989), 62–75.

Pueblo pottery

The literature on Pueblo pottery is extensive. An exhaustive bibliographic survey can be found in Parezo et al. (cited in the introduction to this essay). Ruth Bunzel, *The Pueblo Potter: A Study of Creative Imagination in Primitive Art* (New York, 1972, originally published New York, 1929) provides an influential early study of Pueblo pottery and artistic creativity. The historic period is ably covered by Jonathan Batkin in *Pottery of the Pueblos of New Mexico, 1700–1940* (Colorado Springs, 1987), while Stewart Peckham, *From the Earth: The Ancient Art of Pueblo Pottery* (Santa Fe, 1990) covers both ancient and modern wares. Two works which include extensive interviews with contemporary potters are Stephen Trimble, *Talking with the Clay: The Art of Pueblo Pottery* (Santa Fe, 1987) and Milford Nahohai and Elisa Phelps, *Dialogues with Zuni Potters* (Zuni, N. Mex., 1995).

Edwin L Wade, 'Straddling the Cultural Fence: the Conflict for Ethnic Artists within Pueblo Societies', in Wade (ed.), *The Arts of the North American Indian* (cited above, under General Works) examines issues of gender in the production of pottery, particularly at San Ildefonso Pueblo. Studies of individual potters and families include Alice Marriott, *Maria: The Potter of San Ildefonso* (Norman, Okla., 1948); Susan Peterson, *Lucy M. Lewis* (Tokyo, 1985), *The Living Tradition of Maria Martinez* (Tokyo, 1977), and *Maria Martinez: Five Generations of Potters* (Washington, DC, 1978); and Barbara Kramer, *Nampeyo and Her Pottery* (Albuquerque, 1996). Barbara Babcock provides a penetrating critique of the photographic and literary industry that surrounds the most famous twentieth-century Native artist in 'Marketing Maria: the Tribal Artist in the Age of Mechanical Reproduction', in Brenda Jo Bright and Liza Bakewell (eds), *Looking High and Low: Art and Cultural Identity* (Tucson, Ariz., 1995). The classic volume *Seven Families in Pueblo Pottery* (Albuquerque, 1974) has been updated and expanded in Rick Dillingham, *Fourteen Families in Pueblo Pottery* (Albuquerque, 1994).

Pueblo painting, textiles, and aesthetics

Wall painting and pottery painting are covered in J. J. Brody's *Anasazi and Pueblo Painting* (Albuquerque, 1991). Frank C. Hibben, *Kiva Art of the Anasazi at Pottery Mound* (Las Vegas, 1975), covers mural painting. A fine introduction to Pueblo textiles is provided by Kate Peck Kent, *Pueblo Indian Textiles: A Living Tradition* (Santa Fe, 1983). Barbara Tedlock, 'The Beautiful and the Dangerous: Zuni Ritual and Cosmology as an Aesthetic System',

in Berlo and Wilson, *Arts of Africa, Oceania, and the Americas* (cited above) provides subtle insights into Zuni aesthetics.

Navajo and Apache performance and ritual arts

Navajo sandpainting and religion have been the topic of numerous studies. Among the most useful are Sam D. Gill, *Songs of Life: An Introduction to Navajo Religious Culture* (Leiden, 1979), Gladys A. Reichard, *Navajo Medicine Man Sandpaintings* (New York, 1977), and Franc Johnson Newcomb and Gladys A. Reichard, *Sandpaintings of the Navajo Shooting Chant* (New York, n. d. [1937], New York, 1975). An in-depth look at one ceremonial cycle is provided by Leland C. Wyman, *Blessingway* (Tucson, Ariz., 1970), while Charlotte J. Frisbie and David P. McAllester (eds), *Navajo Blessingway Singer: The Autobiography of Frank Mitchell, 1881–1967* (Tucson, Ariz., 1978) provides an auto-biography of a Navajo practitioner. Franc Johnson Newcomb's study of Hosteen Klah, *Hosteen Klah: Navajo Medicine Man and Sand Painter* (Norman, Okla., 1964), illuminates the relationship between sandpainting and weaving. Contemporary uses of sandpainting are examined in Nancy J. Parezo's *Navajo Sandpainting: From Religious Act To Commercial Art* (Tucson, Ariz., 1983). Apache masquerades are succinctly analysed by Ronald McCoy, 'GAN: Mountain Spirit Masks of the Apache', *American Indian Art Magazine* 10/3 (summer 1985), 52–8, while Keith H. Basso, 'The Gift of Changing Woman', *Bureau of American Ethnology Bulletin* 196 (Washington, DC, 1966), covers all aspects of the Western Apache puberty ceremonies of which these masquerades form a part.

Navajo weaving

Gladys A. Reichard's *Weaving a Navajo Blanket* (New York, 1974), first published as *Navajo Shepherd and Weaver* (New York, 1936), provides an early look at the technical aspects of weaving, as does Noel Bennett and Tiana Bighorse, *Working with the Wool: How to Weave a Navajo Rug* (Flagstaff, Ariz., 1971). Anthony Berlant and Mary Hunt Kahlenberg's *Walk in Beauty: The Navajo and Their Blankets* (New York, 1977) is an important early exhibition catalogue which was instrumental in the recognition of the aesthetics of this art form.

Other useful catalogues include Nancy J. Blomberg, *Navajo Textiles: The William Randolf Hearst Collection* (Tucson, Ariz., 1988), and Eulalie H. Bonar (ed.), *Woven by the Grandmothers: Nineteenth-Century Navajo Textiles from the National Museum of the American Indian* (Washington, DC, 1996). Books that focus on pictorial weavings include Frederick J. Dockstader, *The Song of the Loom: New Traditions in Navajo Weaving* (New York, 1987), and Tyrone Campbell and Joel and Kate Kopp, *Navajo Pictorial Weaving, 1880–1950* (New York, 1991). A fine collection of contemporary weavings is presented in Ann Lane Hedlund, *Reflections of the Weaver's World: The Gloria F. Ross Collection of Contemporary Navajo Weaving* (Denver, 1992). The relationship between weaving and other arts to Navajo epistemology is covered by Gary Witherspoon, *Language and Art in the Navajo Universe* (Ann Arbor, Mich., 1977). Kate Peck Kent's *Navajo Weaving: Three Centuries of Change* (Santa Fe, 1985) is an excellent introduction to all aspects of the medium. Marian Rodee's *Old Navajo Rugs: their Development from 1900 to 1940* (Albuquerque, 1981) discusses the development of regional styles.

Southwestern baskets

Two volumes provide exemplary introductions to all Southwestern basketry traditions, including the Hopi, Navajo, Pima, Papago, and others: Clara Lee Tanner, *American Indian Baskets of the Southwest* (Tucson, Ariz., 1983) and the more recent Andrew Hunter Whiteford, *Southwestern Indian Baskets: Their History and Their Makers* (Santa Fe, 1988).

Navajo and Pueblo jewellery

Archaeological materials are covered in E. Wesley Jernigan, *Jewelry of the Prehistoric Southwest* (Santa Fe and Albuquerque, 1978). The classic introduction to historical silver-smithing is John Adair, *The Navajo and Pueblo Silversmiths* (Norman, Okla., 1944). Clara Lee Tanner's *Southwest Indian Craft Arts* (Tucson, Ariz., 1968) provides an introduction to jewellery, pottery and textiles; her *Prehistoric Southwestern Indian Craft Arts* (Tucson, Ariz., 1976) covers the earlier materials. Work by the famous contemporary Hopi jeweller is featured in Erin Younger, *Loloma: A Retrospective View* (Phoenix, Ariz., 1978).

Chapter 3. The East
General works

Volume 15, *Northeast* of the *Handbook of North American Indians* (1978), edited by

Bruce G. Trigger, is the fundamental reference work. In the absence of the forthcoming *Handbook of North American Indians* volume on the Southeast, the best general reference work remains John R. Swanton's classic *The Indians of the Southeastern United States*, Bureau of American Ethnology Bulletin 137 (Washington, DC, 1946, repr. 1979). A good summary of the historic sources on cosmology and spiritual belief in the Northeast is found in Christian Feest's *Indians of Northeastern North America* (Leiden, 1986). See also Irving Hallowell's classic essay 'Ojibwa Ontology, Behavior, and World View', in his *Contributions to Anthropology* (Chicago, 1976). These should be read alongside the works of Native writers such as Basil Johnston's *Ojibwa Heritage* (Toronto, 1976) and *Ojibwa Ceremonies* (Lincoln, Nebr., 1982).

For an overview of the Great Lakes region see David Penney, *Art of the American Indian Frontier* (Seattle, 1992); for the Northeast and Great Lakes see Ted J. Brasser, *'Bo'jou, Neejee!': Profiles of Canadian Indian Art* (Ottawa, 1976) and Ruth B. Phillips, 'Like a Star I Shine', in the Glenbow Museum, *The Spirit Sings* (cited above), and J. C. H. King, *Thunderbird and Lightning* (London, 1982). General discussions of techniques and regional styles of beadwork and quillwork can be found in William Orchard's *The Technique of Porcupine Quill Decoration Among the Indians of North America* (Ogdon, UT, 1984), first published in 1916, and *Beads and Beadwork of the American Indians: A Study Based on Specimens in the Museum of the American Indian, Heye Foundation* (New York, 1929).

The East in the pre-contact period

The best and most beautifully illustrated general work is David Brose, James A. Brown, and David Penney, *Ancient Art of the American Woodland Indians* (Detroit, 1985). A discussion of the successive interpretations of mound builder cultures is offered in Robert Silverberg, *Mound Builders of Ancient America: The Archaeology of a Myth* (Greenwich, Conn., 1968). For a recent interpretation of mound builder sites see Maureen Korp, *The Sacred Geography of the American Mound Builders* (New York, 1990). For site maps and concise descriptions of pre-contact earthen constructions, see William N. Morgan, *Prehistoric Architecture in the Eastern United States* (Cambridge, Mass., 1980).

A useful, comprehensive work on Mississippian art and architecture is Mallory McCane O'Connor, *Lost Cities of the Ancient Southeast* (Gainesville, Fla., 1995). See also

essays by Robert L. Hall, Malcolm C. Webb, and David H. Dye and Camille Wharey in Patricia Galloway (ed.), *The Southeastern Ceremonial Complex: Artifacts and Analysis* (Lincoln, Nebr., 1989). On Mississippian iconography see James A. Brown's contributions to Brose et al. (above) and two other important articles by the same author: 'The Falcon and the Serpent: Life in the Southeastern United States at the Time of Columbus', in Jay Levenson (ed.), *Circa 1492* (Washington, DC, 1991) and 'Spiro Art and its Mortuary Contexts', in Elizabeth Benson (ed.), *Death and the Afterlife in Pre-Columbian America* (Washington, DC, 1975). Philip Phillips and James A. Brown, *Pre-Columbian Shell Engravings From the Craig Mound at Spiro, Oklahoma—Part 1* (Cambridge, Mass., 1978) documents fully one artistic genre from a major site. Additional visual documentation is offered in Emma Lila Fundaburk and Mary Douglas Foreman, *Sun Circles and Human Hands: The Southeastern Indians—Art and Industry* (Luverne, Ala., 1978). On Florida Mississippian art see Barbara A. Purdy and Roy C. Craven, Jr, *Indian Art of Ancient Florida* (Gainesville, Fla., 1996), and Marrion Spjut Gilliland, *Material Culture of Key Marco* (Gainesville, Fla., 1975).

The Atlantic Northeast: New England and the maritimes

Two essential essays on early contact-period visual culture by George R. Hamell are 'Trading in Metaphors: the Magic of Beads', in Charles F. Hayes, III (ed.), *Procedings of the 1982 Glass Trade Bead Conference* (Rochester, NY, 1983) and 'Strawberries, Floating Islands, and Rabbit Captains: Mythical Realities and European Contact in the Northeast During the Sixteenth and Seventeenth Centuries', *Journal of Canadian Studies* 21/4 (1986–7). See also Frank Speck, 'The Double-Curve Motive in Northeastern Algonkian Art', in Mathews and Jonaitis (eds), *Native North American Art History* (cited above), and Frank Speck's book *Penobscot Man* (Philadelphia, 1940). Other useful studies include Gaby Pelletier, *Abenaki Basketry* (Ottawa, 1982); Ted J. Brasser, *Riding on the Frontier's Crest: Mahican Indian Culture and Culture Change* (Ottawa, 1974); Ruth Holmes Whitehead, *Elitekey: Micmac Material Culture from 1600 AD to the Present* (Nova Scotia, Halifax, 1980), and *Micmac Quillwork—Micmac Techniques of Porcupine Quill Decoration: 1600–1950* (Nova Scotia, Halifax, 1982); and Russell G. Handsman and Ann McMullin (eds), *A Key into the Language of Wood Splint Basketry* (Washington, Conn.,

1987). For an examination of one birchbark artist, see Joan Lester, *History on Birchbark: The Art of Tomah Joseph* (Providence, RI, 1992).

The Great Lakes

For historical context see Helen Hornbeck Tanner (ed.), *Atlas of Great Lakes Indian History* (Norman, Okla., 1987) and Richard White, *The Middle Ground: Indians, Empires, and Republics in the Great Lakes Region, 1650–1815* (Cambridge, 1993). A sampling of ethnological monographs that contain substantive information about art and material culture includes Frances Densmore, *Chippewa Customs* (Washington, DC, 1929); Alanson Skinner, 'Social Life and Ceremonial Bundles of the Menominee Indians', *Anthropological Papers of the American Museum of Natural History* 13/1 (1913), 1–165; and Walter J. Hoffman, 'The Midewiwin or "Grand Medicine Society" of the Ojibwa', *Seventh Annual Report of the Bureau of American Ethnology* (Washington, DC, 1891). See also Sylvia Kasprycki, 'Sirens, Tapirs, and Egyptian Totems: Toward an Interpretation of Menominee Religious Iconography', *Archiv für Volkerkunde* 48 (1994).

Iroquoian peoples

Important works on history and ethnography include Bruce G. Trigger, *The Children of Aataentsic: A History of the Huron People to 1660* (Kingston, Ontario, 1987); Dean R. Snow, *The Iroquois* (Oxford, 1996); Anthony F. C. Wallace, *The Death and Rebirth of the Seneca* (New York, 1969); and Frank G. Speck, *Midwinter Rites of the Cayuga Long House* (Lincoln, Nebr., 1995). The founding work of material culture study in general and of Iroquois art in particular is Lewis Henry Morgan, *League of the Iroquois* (Secaucus, NJ, 1972, first published in 1851) and the edition of his reports and unpublished papers by Elisabeth Tooker, *Lewis H. Morgan on Iroquois Material Culture* (Tucson, Ariz., 1994). Masking traditions are covered in detail by William Fenton, *The False Faces of the Iroquois* (Norman, Okla., 1987). Classic earlier studies are the much reprinted Carrie Lyford, *Iroquois Crafts* (United States Department of the Interior, 1945; repr. Oshweken, Ontario, 1982); and Frank Speck, *The Iroquois: A Study in Cultural Evolution* (Bloomfield Hills, Mich, 1975). See *Council Fire: A Resource Guide* (Brantford, Ontario, 1989) for a good introduction to *wampum*, written from an Iroquois point of view. See also 'The Case for Wampum: Repatriation from the Museum of the American Indian to the Six Nations

Confederacy; Brantford, Ontario, Canada' by George H. J. Abrams in Flora E. S. Kaplan (ed.), *Museums and the Making of 'Ourselves'* (Leicester, 1994).

For regional treatments of art and material culture see Flint Institute of Arts, *The Art of the Great Lakes Indians* (Flint, Mich., 1973); David. W. Penney (ed.), *Great Lakes Indian Art* (Detroit, 1989); Carolyn Gilman, *Where Two Worlds Meet: The Great Lakes Fur Trade* (St Paul, Minn., 1982); Ruth B. Phillips, *Patterns of Power: The Jasper Grant Collection and Great Lakes Indian Art of the Early Nineteenth Century* (Kleinburg, Ontario, 1984), and *Trading Identities: The Souvenir in Native North American Art from the Northeast, 1700–1900* (Seattle, 1998); and Leonardo Vigorelli, *Gli Oggetti Indiani Raccolti Da G. Costantino Beltrami* (Bergamo, Italy, 1987).

For more specific studies of particular media, object types or local traditions see the Science Museum of Minnesota, *Straight Tongue: Minnesota Indian Art from the Bishop Whipple Collections* (St Paul, Minn., 1980); Grand Rapids Public Museum, *Beads: Their Use By Upper Great Lakes Indians* (Grand Rapids, Mich., 1977); George P. Horse Capture (ed.), *Native American Ribbonwork: A Rainbow Tradition* (Cody, Wyo., 1980); Gaylord Torrence and Robert Hobbs, *Art of the Red Earth People: The Mesquakie of Iowa* (Iowa City, 1989); two books issued by the Harbor Springs Historical Commission, *Beadwork and Textiles of the Ottawa* (1984) and *Ottawa Quillwork and Birchbark* (Harbor Springs, Mich., 1983); and Thomas Vennum, Jr, *The Ojibway Dance Drum: Its History and Construction* (Washington, DC, 1982). See also Selwyn Dewdney, *The Sacred Scrolls of the Southern Ojibway* (Toronto, Ontario, 1975). Rock art is surveyed by Selwyn Dewdney and Kenneth E. Kidd in *Indian Rock Paintings of the Great Lakes* (2nd edn, Toronto, Ontario, 1973) and more rigorously studied in Joan Vastokas and Romas Vastokas, *Sacred Art of the Algonkians: A Study of the Peterborough Petroglyphs* (Peterborough, Ontario, 1973).

Historic Southeast

Archaeological evidence of contact is covered by Jerald T. Milanich and Susan Milbraith (eds), *First Encounters: Spanish Explorations in the Caribbean and the United States, 1492–1570* (Gainesville, Fla., 1989). See also Walter L. Williams (ed.), *Southeastern Indians: Since the Removal Era* (Athens, Ga., 1979), and J. Leitch Wright, Jr, *Creeks and Seminoles* (Lincoln, Nebr., 1986). Useful information on art is

included in *Persistence of Pattern in Mississippi Choctaw Culture* (Jackson, Miss., 1987). Dorothy Downs, *Art of the Florida Seminole and Miccosukee Indians* (Gainesville, Fla., 1995) provides an important overview of these Florida Indians.

Chapter 4. The West

Although this bibliographic essay is divided into three sections: the Great Plains, the Intermontaine Region, and the Far West, a number of important exhibition catalogues on the Plains also include material from the Intermontaine region. Most of the material on contemporary Plains artists can be found in the essay for Chapter 7.

The Great Plains

Among the most important of the numerous exhibition catalogues are Evan Maurer, *Visions of the People: A Pictorial History of Plains Indian Life* (Minneapolis, Minn., 1992), Richard Conn, *Circles of the World* (Denver, 1982), and *A Persistent Vision: Art of the Reservation Days* (Denver, 1986), Barbara A. Hail, *Hau, Kóla* (Bristol, RI, 1980), and David W. Penny, *Art of the American Indian Frontier* (cited in bibliographic essay for Chapter 3, above). In addition, Richard A. Pohrt, *The American Indian/The American Flag* (Flint, Mich., 1975) is especially strong on Plains material. Ted J. Brasser, *'Bo'jou, Neejee!'* (cited in bibliographic essay for Chapter 3, above) includes important early Northern Plains material.

A good introduction to the archaeology of the Great Plains is Karl H. Schlesier, *Plains Indians, A. D. 500–1500: The Archaeological Past of Historic Groups* (Norman, Okla., 1994), whose bibliography cites many earlier works. See also Liz Bryan, *The Buffalo People: Pre-historic Archaeology on the Canadian Plains* (Edmonton, Alberta, 1991). Janet D. Spector, *What This Awl Means: Feminist Archaeology at a Wahpeton Dakota Village* (St Paul, Minn., 1993) provides a worthwhile experiment in feminist archaeological interpretation. Clothing is examined by Mary Jane Schneider, 'Plains Indian Clothing: Stylistic Persistence and Change', *Bulletin of the Oklahoma Anthropological Society* XVII (November 1968), 1–55, while her 'Plains Indian Art', in W. Raymond Wood and Margot Liberty (eds), *Anthropology on the Great Plains* (Lincoln, Nebr., 1988) is a succinct overview of the topic.

For studies of art within particular ethnic groups, see Carolyn Gilman and Mary Jane Schneider, *The Way to Independence: Memories of a Hidatsa Indian Family, 1840–1920* (St Paul,

Minn., 1987) and Arthur Amiotte, 'An Appraisal of Sioux Arts', in Arthur Huseboe (ed.), *An Illustrated History of the Arts in South Dakota* (Sioux Falls, S. Dak., 1989). Crow and Blackfeet traditions are considered in Peter J. Powell (ed.), *Crow Indian Art From The Goelet and Edith Gallatin Collection of American Indian Art* (Chicago, 1988), and John C. Ewers, *Blackfeet Crafts* (Stevens Point, Wis., 1986), originally published in 1945.

Women's arts

Specialized studies of quillwork, beadwork, ribbonwork, and quilting include the following: Mary Jane Schneider, 'Women's Work: An Examination of Women's Roles in Plains Indian Arts and Crafts', in Patricia Albers and Beatrice Medicine (eds), *The Hidden Half: Studies of Plains Indian Women* (Washington, DC, 1983) offers a useful overview. Gaylord Torrence provides an exhaustive examination of women's painting traditions in *The American Indian Parfleche: A Tradition of Abstract Painting* (Des Moines, Ia, 1994). Studies of quill and beadwork technique and style can be found in Carrie A. Lyford, *Quill and Beadwork of the Western Sioux* (Boulder, Col., 1979), first published in 1940, as well as Orchard's two volumes cited in the bibliographic essay for Chapter 3. See also William Wildschut and John C. Ewers, *Crow Indian Beadwork: A Descriptive and Historical Study* (New York, 1959), and Julia M. Bebbington, *Quillwork of the Plains/Le 'travail aux piquants' des indiens des plaines* (Calgary, 1982). Peter J. Powell, 'Beauty for New Life: An Introduction to Cheyenne and Lakota Sacred Art', in Evan M. Maurer, *The Native American Heritage* (cited at the beginning of this essay), discusses the complementarity of male and female arts. Women's artistic guilds are studied by Alice Marriott, 'The Trade Guild of the Southern Cheyenne Women', *Bulletin of the Oklahoma Anthropological Society* 4 (1956), 19–27. George Bird Grinnell, in Volume I of *The Cheyenne Indians: History and Society* (Lincoln, Nebr., 1972, first published New Haven, Conn., 1923), was the first to discuss these societies in detail. Architecture of the Plains and Intermontaine region is ably surveyed by Nabokov and Easton (cited at the beginning of this essay).

Men's arts

Garrick Mallery, 'Picture-Writing of the American Indians', *Tenth Annual Report of the Bureau of Ethnology 1893* (Washington,

DC, 1888–9, repr. in two volumes, New York, 1972), and James Mooney, 'Calendar History of the Kiowa Indians', *17th Annual Report of the Bureau of American Ethnology* (Washington, DC, 1898, repr. 1979), were the first to survey pictorial arts (including pictographic calendars). Ernst Vatter, 'Historienmalerei und Heraldische Bilderschrift der Nordamerikanischen Prairiestamme', *IPEK: Jahrbuch für Prähistorische & Ethnographische Kunst* (1927), 44–81, provided another important early analysis of figural painting, focusing on hides. This was followed by John Ewers' pivotal study of the subject, *Plains Indian Painting: A Description of an Aboriginal American Art* (Palo Alto, Calif., 1939); his *Murals in the Round: Painted Tipis of the Kiowa–Apache Indians* (Washington, DC, 1978) is useful as well. Anne Vitart and George Horse Capture illustrate an important early collection in the Musée de l'Homme of painted hides from diverse regions in *Parures d'Histoire: Peaux de Bisons Peintes des Indiens d'Amérique du Nord* (Paris, 1993). Tipi painting is covered by Marsha C. Bol, ' "All Around Rise Hundreds of Habitations of Buffalo Skin, Some … Covered with Fantastic and Primitive Paintings": The Painted Tepee of the Lakota People', in Meliha S. Duran and David T. Kirkpatrick (eds), *Archaeology, Art and Anthropology: Papers in Honor of J. J. Brody, The Archaeological Society of New Mexico*, 18 (1992), 23–38. Candace S. Greene and Thomas Drescher's article, 'The Tipi With Battle Pictures: The Kiowa Tradition of Intangible Property Rights', *Trademark Reporter* 84/4 (1994), 418–33, sheds light on pictorial practices and property rights to painted designs. John C. Ewers examines carving in wood and stone in *Plains Indian Sculpture: A Traditional Art from America's Heartland* (Washington, DC, 1986). Ancient land art is discussed in John A. Eddy, 'Medicine Wheels and Plains Indian Astronomy', in Anthony Aveni (ed.), *Native American Astronomy* (Austin, Tex., 1977).

Art on the Great Plains from the Reservation Era to the present

Works from this era are represented in many studies cited above. The changes in men's artistic traditions are discussed in Janet C. Berlo (ed.), *Plains Indian Drawings, 1865–1935: Pages from a Visual History* (New York, 1996) which offers a profusely illustrated survey of Plains drawings on paper. Its bibliography provides exhaustive coverage of earlier works;

among the most important are Helen Blish, *A Pictographic History of the Oglala Sioux* (Lincoln, Nebr., 1967), and Karen Daniels Petersen's *Plains Indian Art From Fort Marion* (Norman, Okla., 1971) which is the definitive study of the Southern Plains Indians who worked in a Florida prison from 1875–78. Joyce Szabo, *Howling Wolf and the History of Ledger Art* (Albuquerque, 1994) provides a detailed look at the corpus of works by one Cheyenne artist. The social meaning of Lakota beadwork as relating to gender roles has been insightfully discussed by Marsha Clift Bol, 'Lakota Beaded Costumes of the Early Reservation Era', in Berlo and Wilson (eds), *Arts of Africa, Oceania, and the Americas* (cited above). Contemporary powwow costume was chronicled by George P. Horse Capture in *Pow Wow* (Cody, Wyo., 1989). In addition to the works on ribbon appliqué cited in the section for Chapter 3, see also Alice Marriott, 'Ribbon Appliqué Work of North American Indians, Part 1', *Bulletin of the Oklahoma Anthropological Society* 6 (March 1958), 49–59. The production of pieced quilts by Plains Indian women is discussed by Patricia Albers and Beatrice Medicine, 'The Role of Sioux Women in the Production of Ceremonial Objects: the Case of the Star Quilt', in Patricia Albers and Beatrice Medicine (eds), *The Hidden Half: Studies of Plains Indian Women* (Washington, DC, 1983) and Florence Pulford, *Morning Star Quilts* (Los Altos, Calif., 1989).

Numerous publications consider the transmission of goods between Native and European cultures. Among the most useful are John C. Ewers et al., *Views of a Vanishing Frontier* (Lincoln, Nebr., 1984) and James A. Hanson, 'Laced Coats and Leather Jackets: The Great Plains Intercultural Clothing Exchange', in Douglas H. Ubelaker and Herman J. Viola (eds), *Plains Indian Studies: A Collection of Essays in Honor of John C. Ewers and Waldo R. Wedel* (Washington, DC, 1982). Métis art is discussed by Ted Brasser, 'In Search of Métis Art', in Jacqueline Peterson and Jennifer Brown (eds), *The New Peoples: Being and Becoming Métis in North America* (Winnipeg, 1985). Art objects and artefacts associated with the late nineteenth-century Ghost Dance are documented in Ellen Bradbury, Eileen Flory and Moira Harris, *I Wear the Morning Star: An Exhibition of American Indian Ghost Dance Objects* (Minneapolis, Minn., 1976). An insightful indigenous perspective on the modern Sun Dance can be gained from Arthur Amiotte, 'The Lakota Sun Dance: Historical and

Contemporary Perspectives', in Raymond J. DeMallie and Douglas R. Parks (eds), *Sioux Indian Religion: Tradition and Innovation* (Norman, Okla., 1987).

The Intermontaine region

Jacqueline Peterson, with Laura Peers, *Sacred Encounters: Father DeSmet and the Indians of the Rocky Mountain West* (Norman, Okla., 1993) includes art made by the indigenous inhabitants of this region as well as representations of these people by outsiders. Lillian A. Ackerman (ed.), *A Song to the Creator: Traditional Arts of Native American Women of the Plateau* (Norman, Okla., 1995) covers basketry, hidework, quillwork, and beadwork. Salish beadwork and other art forms are surveyed by George Horse Capture and Richard A. Pohrt, *Salish Indian Art, From the J. R. Simplot Collection* (Cody, Wyo., 1986). An exceptionally clear outline of the various basketry traditions of the Oregon and Washington Plateau is provided by Mary Dodds Schlick, *Columbia River Basketry: Gift of the Ancestors, Gift of the Earth* (Seattle, 1994). A pictorial survey of twined, corn-husk bags can be found in Natalie Linn, *The Plateau Bag: A Tradition in Native American Weaving* (Johnson County, 1994). Gloria A. Lomahaftewa's *Glass Tapestry: Plateau Beaded Bags from The Elaine Horwitch Collection* (Phoenix, Ariz., 1993) is a well-illustrated survey of beaded bags. Many artistic traditions of the Plateau region of Washington State are covered by Robin K. Wright in *A Time of Gathering: Native American Heritage in Washington State* (Seattle, 1991).

The Far West: California and the Great Basin

Alfred L. Kroeber's *Handbook of the Indians of California*, Bulletin 78 of the Bureau of American Ethnology (Washington, DC, 1925, repr. in 1976), remains a useful source on the ethnography of this region, updated by Volume 8 of *The Handbook of North American Indians* (1978). Rock art is covered by Robert Heizer and C. William Clewlow, *Prehistoric Rock Art of California* (Ramona, Calif., 1973). Chumash rock art is surveyed by Campbell Grant, *The Rock Paintings of the Chumash* (Berkeley, 1965); its relationships to astronomy are explored by Travis Hudson and Ernest Underhay, *Crystals in the Sky: An Intellectual Odyssey Involving Chumash Astronomy, Cosmology, and Rock Art* (Ramona, Calif., 1978).

The ethnography of the Great Basin is covered in Volume 11 (1986) of *The Handbook of North American Indians*. Great Basin rock art is covered by Campbell Grant, James W. Baird, and J. Kenneth Pringle, *Rock Drawings of the Coso Range* (China Lake, Calif., 1968) and Polly Schaafsma, 'The Rock Art of Utah from the Donald Scott Collection', *Papers of the Peabody Museum of Archaeology and Ethnology* 65 (Cambridge, Mass., 1971).

By far the most numerous works devoted to indigenous arts of the Far West concern basketry. A concise survey is provided by Albert B. Elsasser, 'Basketry', in Volume 8 of *The Handbook of North American Indians*. Lila O'Neale's classic 'Yurok-Karok Basket Weavers', *University of California Publications in American Archaeology and Ethnology* 32 (1932, repr. Berkeley, 1995), is a superb study of technique and ethno-aesthetics. A fine museum collection of Karuk baskets is documented in Virginia M. Fields, *The Hover Collection of Karuk Baskets* (Eureka, Calif., 1985). Miwok and Paiute baskets are discussed by Craig D. Bates and Martha Lee, *Tradition and Innovation: A Basket History of the Indian of the Yosemite-Mono Lake Area* (Yosemite, Calif., 1990). Dorothy K. Washburn, 'Dealers and Collectors of Indian Baskets at the Turn of the Century in California: Their Effect on the Ethnographic Sample', *Empirical Studies of the Arts* 2/1 (1984), 51–74, considers issues of collecting.

Pomo baskets

The literature on Pomo baskets is extensive. A classic study by a practitioner is Elsie Allen's *Pomo Basketmaking: a supreme art for the weaver* (Happy Camp, Calif., 1972). Greg Sarris's *Mabel McCay: Weaving the Dream* (Berkeley, 1994) is a memoir/biography of a famous Pomo weaver. Sally McLendon and Brenda Holland, 'The Basketmaker: The Pomoans of California', in Anna Roosevelt and James G. E. Smith (eds), *The Ancestors: Native Artisans of the Americas* (New York, 1979) survey Pomo baskets in comprehensive fashion. Deliberate design irregularities are discussed in Barbara Winthur, 'Pomo Banded Baskets and their Dau Marks', *American Indian Art Magazine* 10/4 (1985).

Washoe baskets

Marvin Cohodas examines aspects of Washoe basketry in 'Washoe Innovators and their Patrons', in Edwin Wade (ed.), *The Arts of the North American Indian* (cited above), *Degikup: Washoe Fancy Basketry, 1895–1935* (Vancouver, 1979) and 'Louisa Keyser and the Cohns:

Mythmaking and Basket Making in the American West', in Janet C. Berlo (ed.), *The Early Years of Native American Art History* (cited in the bibliographic essay for Chapter 1, above).

Chapter 5. The North
General works
Volumes in the *Handbook of North American Indian* series which consider these regions are Volume 6 (Sub-arctic, 1981) and Volume 5 (Arctic, 1984). Two excellent exhibition catalogues which cover Alaskan arts (including the Northwest Coast as well as the Arctic and Sub-arctic) are Henry B. Collins, et al., *The Far North: 200 Years of American Eskimo and Indian Art* (Bloomington, Ind., and Washington, DC, 1973) and William W. Fitzhugh and Aron Crowell, *Crossroads of Continents: Cultures of Siberia and Alaska* (Washington, DC, 1988). An important early collection of historic material, including exceedingly fine clothing, is published by Pirjo Varjola, *The Etholén Collection: The ethnographic Alaskan collection of Aldolf Etholén and his contemporaries in the National Museum of Finland* (Helsinki, 1990).

The Sub-arctic
Barbara Hail and Kate C. Duncan, *Out of the North* (Bristol, RI, 1989) considers large areas of the North comprehensively, focusing on the later nineteenth century.

Western Sub-arctic arts: An excellent survey of early contact-period art is provided by Judy Thompson in 'No Little Variety of Ornament: Northern Athapaskan Artistic Traditions' in *The Spirit Sings* (cited in the bibliographic essay for Chapter 1, above). The fur trade era is the focus of Kate C. Duncan's equally rigorous study, *Northern Athapaskan Art: A Beadwork Tradition* (Seattle, 1989). See also Duncan's *A Special Gift: The Kutchin Beadwork Tradition* (Seattle, 1988) for a focused study of one Dene people. Judy Thompson's *From the Land: Two Hundred Years of Dene Clothing* (Ottawa, 1994) is an important contribution. See also *The Athapaskans: Strangers of the North* (Ottawa, 1974) based on the collections of the Canadian Museum of Civilization and the Royal Scottish Museum; Judy Thompson's *Pride of the Indian Wardrobe: Northern Athapaskan Footwear* (Toronto, 1990) which provides a rounded discussion and a clear typology of different moccasin styles; and Trudy Nicks, *The Creative Tradition: Indian Handicrafts and Tourist Art* (Edmonton, Alberta, 1982)

which addresses the commoditization of art among the Dene and neighbouring peoples. Cornelius Osgood, *Ingalik Material Culture*, Yale University Publications in Anthropology No. 22 (New Haven, Conn., 1940) provides important documentation on a Northern Athapaskan group whose masking tradition shares many features with its Yup'ik neighbours.

Eastern Sub-arctic arts: Lucien Turner's 'Ethnology of the Ungava District, Hudson Bay Territory', in *11th Annual Report of the Bureau of American Ethnology* (Washington, DC, 1894) contains essential data on art; on spiritual beliefs as a context for art, see Frank Speck's *Naskapi: The Savage Hunters of the Labrador Peninsula* (Norman, Okla., 1935, repr. 1977) and Adrian Tanner, *Bringing Home Animals: Religious Ideology and Mode of Production of the Mistassini Cree Hunters* (New York, 1979). On Innu (Naskapi) hide painting see Dorothy K. Burnham's *To Please the Caribou: Painted Caribou-Skin Coats Worn by the Naskapi, Montagnais, and Cree Hunters of the Quebec-Labrador Peninsula* (Toronto, 1992); and Alika Podolinsky Webber, 'Ceremonial Robes of the Montagnais-Naskapi', *American Indian Art Magazine* 9/1 (1993), 60–9, 75–7. The best available study of the art of the James Bay Cree is Cath Oberholtzer, 'Together We Survive: East Cree Material Culture', PhD Dissertation (Hamilton, Ontario, 1994). Ted Brasser's essay 'Pleasing the Spirits: Indian Art around the Great Lakes', in *Pleasing the Spirits: A Catalogue of a Collection of American Indian Art* (New York, 1982) and his *'Bo'jou Neejee!'* (cited in the bibliographic essay for Chapter 4, above) provide insightful discussions on the interpretation of Cree art.

Arctic
A relatively small number of books consider art of the Arctic as a totality rather than by sub-region. A fine introduction to the theme of shamanism as depicted in arts across the Arctic is Jean Blodgett, *The Coming and Going of the Shaman: Eskimo Shamanism and Art* (Winnipeg, 1978). Joan M. Vastokas, 'Continuities in Eskimo graphic style', *artscanada* (December 1971/January 1972), 69–83, examines the graphic arts of all periods across the Arctic. I. Kleivan and B. Sonne, *Eskimos: Greenland and Canada* (Leiden, 1985) survey religion of the Central and Eastern Arctic, with particular attention to iconographic traditions.

Ancient art of the Arctic

Palaeo-Eskimo (Dorset and pre-Dorset) culture is surveyed in a lucid fashion by Robert McGhee, *Ancient People of the Arctic* (Vancouver and Ottawa, 1996). An important early site report for the Western arctic is Helge Larsen and Froelich Rainey, *Ipiutak and the Arctic Whale Hunting Culture*, Anthropological Papers of the American Museum of Natural History 42 (New York, 1948), while for Northern Greenland, Eigil Knuth, *Archaeology of the Musk-Ox Way*, Contributions de Centre d'Études Arctique et Finno-Scandinaves No. 5 (Sorbonne, Paris, 1967) is crucial. Arctic Canada is covered in depth by Moreau S. Maxwell, *Prehistory of the Eastern Arctic* (Orlando and London, 1985). An insightful conversation between an archaeologist and an art historian is recorded in William E. Taylor and George Swinton, 'The Silent Echoes: Prehistoric Canadian Eskimo Art', *The Beaver* 298 (1967), 32–47.

The Historical Era

The pan-Arctic tradition of making of clothing from fishskin and seal intestines is discussed in Pat Hickman's *Innerskins and Outerskins: Gut and Fishskin* (San Francisco, 1987). Good introductions to Arctic clothing traditions can be found in Gudmund Hatt, 'Arctic Skin Clothing in Eurasia and America: An Ethnographic Study' (translated by Kirsten Taylor), *Arctic Anthropology* 5/2 (1969), 3–132, and Judy Hall, Jill Oakes, and Sally Qimmiu'naaq Webster, *Sanatujut. Pride in Women's work: Copper and Caribou Inuit Clothing Traditions* (Ottawa, 1994). Bernard Saladin d'Anglure, 'Ijiqqat: voyage au pays de l'invisible inuit', *Études/Inuit/Studies* 7/1 (1983), 67–83 uses one Canadian Arctic shaman's coat as an entry into a mythic worldview. Yup'ik skin sewing is examined in Marie Meade, 'Sewing to Maintain the Past, Present and Future', *Études/Inuit/Studies* 14/1–2 (1990), 229–39.

Alaska: Edward Nelson's *The Eskimo About Bering Strait* (Washington, DC, 1983, originally published 1899) illustrates much of the vast collection of Alaskan art he acquired for the Smithsonian. Ivory carving is covered by J. G. E. Smith, *Arctic Art: Eskimo Ivories* (New York, 1980) and William Fagg, *Eskimo Art in the British Museum* (London, 1972). The University of Pennsylvania Museum's collection is published in Susan A. Kaplan and Kristin J. Barsness (eds), *Raven's Journey: The World of Alaska's Native People* (Philadelphia, 1986).

Dorothy Jean Ray's *Eskimo Masks: Art and Ceremony* (Seattle, 1967) was the first work to bring together material from diverse sources on this important Yup'ik art form. The definitive work on Yup'ik masks of Southwest Alaska, which includes much information on dance and cultural context, is Ann Fienup-Riordan, *The Living Tradition of Yup'ik Masks: Agayuliyararput, Our Way of Making Prayer* (Seattle, 1996). Dorothy Jean Ray analyses sculpture in graveyards of Southwest Alaska in 'Mortuary Art of the Alaskan Eskimos', *American Indian Art* 7/2 (1982), 50–7. Aleut bentwood hunting hats are analysed in great detail in Lydia T. Black, *Glory Remembered: Wooden Headgear of the Alaska Sea Hunters* (Juneau, Alas., 1991) which includes a reprint of the original 1930 work on the topic by Sergei Vasil'evich Ivanov, 'Aleut Hunting Headgear and Its Ornamentation'. Iñupiaq basketry is introduced by Molly Lee, *Baleen Basketry of the North Alaskan Eskimo* (Barrow, Alas., 1983). Dorothy Jean Ray's *Artists of the Tundra and the Sea* (Seattle, 1961, paperback edn with corrections, 1980) examines Iñupiaq ivory carvers. Two important works on the reception of Northern arts include Elizabeth Cowling, 'The Eskimos, the American Indians, and the Surrealists', *Art History* 1/4 (December 1978), 484–99, and Molly Lee, 'Appropriating the Primitive: Turn-of-the-Century Collection and Display of Native Alaskan Art', *Arctic Anthropology* 28/1 (1991), 6–15.

Canada and Labrador: There are few specific works on historic Canadian Inuit art. A brief introduction is provided by Jean Blodgett, 'The Historic Period in Canadian Eskimo Art', in Houston, *Inuit Art: An Anthology*, cited below. A great deal of fine material can be found in the early ethnographies. Among the best are the volumes of the Danish 'Fifth Thule Expedition', especially Knud Rasmussen's: 'Intellectual Culture of the Iglulik Eskimos', *Report of the Fifth Thule Expedition 1921–24*, 7/1 (1929); 'Intellectual Culture of the Hudson Bay Eskimos', *Report of the Fifth Thule Expedition 1921–24*, 7/3 (1930); 'The Netsilik Eskimos: Social Life and Spiritual Culture', *Report of the Fifth Thule Expedition 1921–24*, 8/1–2 (1931); and 'Intellectual Culture of the Copper Eskimos', *Report of the Fifth Thule Expedition 1921–24*, 9 (1932) (all published in Copenhagen). Frank Speck, 'Eskimo Carved Ivories from Northern Labrador', *Indian Notes* 4 (1927), and 'Collections from Labrador Eskimo', *Indian Notes* 1/4 (1924), considers Arctic material from Labrador.

Greenland: Because Greenland was colonized so early, there is not the same richness of materials available from the past two centuries as there is for Canada and Alaska. In English, surveys of Greenlandic Eskimo art and culture are to be found in the essays in *The Handbook of North American Indians*, Volume 5. Bodil Kaalund, *Grønlands kunst: Skulptur, burgskunst, maleri* [The Art of Greenland: Sculpture, Crafts, Painting] (Copenhagen, 1979, translation, Berkeley, 1983) provides a survey of Greenlandic art, in all media, while *Prøver af Grønlandsk tegning og trykning 1857–61* [Examples of Greenlandic Drawing and Printing 1857–61] (Copenhagen, 1980) provides facsimile drawings and prints assembled by Hinrich Rink in the mid-nineteenth century. Catherine Enel, 'Signification sociale d'un artisanat touristique au Groenland oriental', *Études/Inuit/Studies* 5/2 (1981), 125–42, surveys contemporary art made for a tourist market.

Contemporary arts in Arctic Canada and Alaska

A landmark catalogue that surveys pan-Arctic contemporary arts is Jan Steinbright (ed.), *Arts from the Arctic: An Exhibition of Circumpolar Art by Indigenous Artists from Alaska, Canada, Greenland Sampi (Lapland), Russia* (Anchorage, Alas., 1993).

There is an enormous literature on twentieth-century arts of the Canadian Arctic. An important periodical in this field is *Inuit Art Quarterly* (Ottawa, 1986–present). The Inuit Art Documentation Center at the Department of Northern Affairs, Hull, Quebec, distributes a massive Inuit Art Bibliography. A useful compendium of essays is Alma Houston (ed.), *Inuit Art: An Anthology* (Winnipeg, 1988).

General works on diverse media include Bernadette Driscoll, *The Inuit Amautik: I Like My Hood To Be Full* (Winnipeg, 1980), and Jean Blodgett, *Grasp Tight the Old Ways* (Toronto, 1983). Sculpture is particularly well surveyed in George Swinton, *Sculpture of the Eskimos* (Toronto, 1972). An early article that placed the contemporary carving movement in the North into a historical context was Charles A. Martijn, 'Canadian Eskimo Carving in Historical Perspective', *Anthropos* 59 (1964), 546–96. Marybelle Myers, 'Inuit Arts and Crafts Co-operatives in the Canadian Arctic', *Canadian Ethnic Studies* XVI, 3 (1984), 132–52, considers the sociocultural place of carving in the co-operative

structure, while Nelson H. H. Graburn considers aspects of aesthetics and meaning in 'Nalunaikutanga: Signs and Symbols in Canadian Inuit Art and Culture', *Polarforschung* 1 (1976), 1–11, and 'Some Problems in the Understanding of Contemporary Inuit Art', *Western Canadian Journal of Anthropology* IV, 3 (January 1975), 63–72. He surveys the contemporary sculpture and printmaking movements in 'Eskimo Art—the Eastern Canadian Arctic', in Nelson H. H. Graburn (ed.), *Ethnic and Tourist Arts: Cultural Expressions from the Fourth World* (Berkeley, 1976).

Scholarly works devoted to individual artists include Marie Routledge and Marion E. Jackson, *Pudlo: Thirty Years of Drawing* (Ottawa, 1990); Darlene Wight, *Out of Tradition: Abraham Anghik/David Ruben Piqtoukun* (Winnipeg, 1989); Jean Blodgett and Marie Bouchard, *Jessie Oonark: a Retrospective* (Winnipeg, 1986); and Jean Blodgett, *Kenojuak* (Toronto, 1985).

Studies that pay attention to women's roles in artistic production include Odette Leroux, Marion E. Jackson, and Minnie Aodla Freeman (eds), *Inuit Women Artists* (Vancouver, Quebec, and Seattle, 1994) and Janet C. Berlo, 'Inuit Women and Graphic Arts: Female Creativity and its Cultural Context', *Canadian Journal of Native Studies* 9/2 (1989), 293–315. Inuit women's work in cloth is surveyed by Sheila Butler, 'Wall Hangings from Baker Lake', in Alma Houston (ed.), *Inuit Art: An Anthology* (cited above).

Serious studies of Inuit graphic arts include Helga Goetz, *The Inuit Print* (Ottawa, 1977); Jean Blodgett, *In Cape Dorset We Do It This Way: Three Decades of Inuit Printmaking* (Ontario, 1991); Jean Blodgett, *North Baffin Drawings* (Toronto, 1986); Marion E. Jackson and Judith Nasby, *Contemporary Inuit Drawings* (Guelph, Ontario, 1987); Janet Catherine Berlo, 'Drawing (Upon) the Past: Negotiating Identities in Inuit Graphic Arts Production', in Ruth Phillips and Christopher Steiner (eds), *Unpacking Cultures* (cited above, in the bibliographic essay for Chapter 1); and Janet Catherine Berlo, 'Portraits of Dispossession in Plains Indian and Inuit Graphic Arts', *Art Journal* 49/2 (summer 1990), 133–41.

The literature on twentieth-century Alaskan art is smaller. A useful periodical is the *Journal of Alaska Native Arts* published in Fairbanks by the Institute of Alaska Native Arts. The groundbreaking *Eskimokunstler* by

Hans Himmelhaber (Zürich, 1938, published in English as *Eskimo Artists* in 1987) was the first look at technique and method. A survey of twentieth-century arts is provided by Margaret B. Blackman and Edwin S. Hall, Jr, 'Alaska Native Arts in the Twentieth Century', in Fitzhugh and Crowell, *Crossroads of Continents* (cited above). Four Native Alaskan artists are profiled in Suzi Jones (ed.), *The Artists Behind the Work* (Fairbanks, Alas., 1986). Important works by Dorothy Jean Ray include *Aleut and Eskimo Art: Tradition and Innovation in South Alaska* (Seattle, 1981), and *Eskimo Art, Tradition and Innovation in North Alaska* (Seattle, 1977). Contemporary interpretation of historic traditions is featured in Lynn Ager Wallen, *Bending Tradition* (Fairbanks, Alas., 1990). Contemporary mask-making is documented in Maurine Miller, *Alaskameut* (Fairbanks, Alas., 1978) and Jan Steinbright (ed.), *Alaskameut '86: An Exhibition of Contemporary Alaska Native Masks* (Fairbanks, Alas., 1986). Aleut art, both historic and modern, is considered in Lydia T. Black, *Aleut Art* (Anchorage, Alas., 1982). Women's arts of Alaska have received much less scholarly attention than the male arts of ivory-carving and mask-making. Doll-making is surveyed by Suzi Jones (ed.) in *Eskimo Dolls* (Anchorage, Alas., 1982).

Chapter 6. Northwest Coast
Introductory works
Volume 7 (1990) of the *Handbook of North American Indians* should be consulted for a thorough introduction to the histories and cultures of Northwest Coast peoples. An important anthology of articles on Northwest Coast art spanning pre-contact to contemporary eras is Donald N. Abbott (ed.), *The World is as Sharp as a Knife: An Anthology in Honour of Wilson Duff* (Victoria, British Columbia, 1981). The best general discussion of art is Bill Holm's article on 'Art' in Volume 16 of the *Handbook of North American Indians* (cited above). An early, but still useful survey is Robert Inverarity, *Art of the Northwest Coast Indians* (Berkeley, 1950). Marjorie Halpin's *Totem Poles: An Illustrated Guide* (Vancouver, 1981) provides an admirably clear key to understanding use and imagery. Erna Gunther's *Art in the Life of the Northwest Coast Indians* (Oregon, 1966) is a comprehensive discussion of the contexts of material culture and art paired with a catalogue and illustrations of the Portland Museum's Rasmussen Collection. It was not until the 1960s that art museums began to exhibit Northwest Coast objects as works of art. The first such exhibition was *Arts of the Raven: Masterworks by the Northwest Coast Indian*, a catalogue by Wilson Duff, Bill Holm, and Bill Reid (Vancouver, 1967). Key subsequent exhibition publications include Allen Wardwell's *Objects of Bright Pride: Northwest Coast Indian Art from the American Museum of Natural History* (New York, 1978); Bill Holm's *Spirit and Ancestor: A Century of Northwest Coast Art at the Burke Museum* (Seattle, 1987), essential for the unparalleled scholarly knowledge of the author's commentaries; and Peter L. Macnair, Alan L. Hoover, and Kevin Neary, *The Legacy: Continuing Traditions of Canadian Northwest Coast Indian Art* (Victoria, British Columbia, 1980), which broke new ground with its integrated discussion of historic and contemporary art. Related to this discussion is Margaret B. Blackman's 'Creativity in Acculturation: Art, Architecture and Ceremony from the Northwest Coast', *Ethnohistory* 23/4 (autumn 1976), 387–413.

Pre-contact art
Specific treatments of art are few. The most important single volume is Roy Carlson (ed.), *Indian Art Traditions of the Northwest Coast* (Burnaby, British Columbia, 1982), which surveys the state of archaeological research in articles by individual specialists. Knut R. Fladmark's *British Columbia Prehistory* (Ottawa, 1986) discusses the origins of art in a broader archaeological context. Wilson Duff's catalogue, *images stone b.c.* (Saanichton, British Columbia, 1975), a frank attempt to read meaning in the bold, often sexual imagery of pre-contact art, is stimulating but highly subjective.

Artistic style
Robin Wright's articles 'Northwest Coast Carving and Sculpture' and 'Northwest Coast Painting' in *The Dictionary of Art* (cited at the beginning of the essay, above) offer succinct and clear overviews of Northwest Coast style provinces. On Northwest Coast basketry see Andrea Laforet 'Regional and Personal Style in Northwest Coast Basketry', in Frank W. Porter III (ed.), *The Art of Native American Basketry: A Living Legacy* (New York, 1990).

An early formulation of stylistic analysis is Herman Haeberlin's article, 'Principles of Esthetic Form in the Art of the North Pacific Coast', *American Anthropologist* 20 (1918), 258–64; and Leonard Adam's attempt to relate Northwest Coast stylistic conventions to those of Asia and the Pacific Rim, 'North-West American Indian Art and Its Early Chinese Parallels', *Man* 36 (1936), 8–11.

Aldona Jonaitis discusses Boas' theories of Northwest Coast art and artistic style in *A Wealth of Thought: Franz Boas on Native American Art* (Seattle, 1995). The classic contemporary formulation is Bill Holm, *Northwest Coast Art: An Analysis of Form* (Seattle, 1965). Paul S. Wingert offers an appreciation and analysis of art from the southern province in *American Indian Sculpture: A Study of the Northwest Coast* (New York, 1949). Macnair's essays in *The Legacy* (cited above) offer important discussions of the differences in regional styles.

Potlatch

The most comprehensive and satisfactory treatment of the role of art in potlatching is the very fine exhibition catalogue edited by Aldona Jonaitis, *Chiefly Feasts: The Enduring Kwakiutl Potlatch* (New York, 1991). The legal attempts to suppress the potlatch are examined by Douglas Cole and Ira Chaikin, *An Iron Hand upon the People: The Law against the Potlatch on the Northwest Coast* (Vancouver, 1990). For the many anthropological theories about the potlatch, see the useful summary in Robert Grumet, *Native Americans of the Northwest Coast: A Critical Bibliography* (Bloomington, Ind., 1979), 23–9; and Joseph Masco, 'Competitive Displays: Negotiating Genealogic Rights to the Potlatch at the American Museum of Natural History', *American Anthropologist* 98/4 (1996), 837–52.

Studies by cultural region

Tlingit arts: The most comprehensive study of art is Aldona Jonaitis, *The Art of the Northern Tlingit* (Seattle, 1986), which also offers a structuralist reading. Much information on shamanism is contained in Frederica de Laguna's edition of George Thornton Emmons' *The Tlingit Indians* (New York, 1991). Two important early essays by George T. Emmons, 'The Basketry of the Tlingit' and 'The Chilkat Blanket', have recently been reprinted in a single volume by the Sheldon Jackson Museum (Sitka, Alas., 1993). Frances Paul's study of basketry, *The Spruce Root Basketry of the Tlingit* (Lawrence, Kan., 1944), provides detailed technical information written by a Tlingit woman. Allen Wardwell's *Tangible Visions: Northwest Coast Indian Shamanism and its Art* (New York, 1996) contains excellent photographic documentation and a useful concordance of the ethnographic literature. Two museum publications have useful sections on Tlingit art, Susan Kaplan and Kristin Barsness, *Raven's Journey* (cited in bibliographic essay for Chapter 5, above), and Peter L. Corey (ed.), *Faces, Voices and Dreams: A Celebration of the Centennial of the Sheldon Jackson Museum* (Sitka, Alas., 1987).

Haida: George MacDonald's, *Haida Monumental Art: Villages of the Queen Charlotte Islands* (Vancouver, 1983) is a very useful summary work on architecture and monumental sculpture; his overview, *Haida Art* (Vancouver, 1996), has good photo documentation of masks and other carvings but contains also a number of contested attributions. Margaret Blackman, 'Totems to Tombstones: Culture Change as Viewed through the Haida Mortuary Complex, 1877–1971', *Ethnology* 12 (1973), 47–56, is an insightful study of Haida culture change highly relevant to material culture and art. Marius Barbeau's *Haida Carvers in Argillite* (Ottawa, 1957, repr. 1974) contains important documentation of over fifty carvers and their works, though some of his attributions are disputed by more recent scholars. See also his *Haida Myths: illustrated in Argillite Carvings* (Ottawa, 1953). The most satisfactory recent works on the historical development of argillite are Peter L. Macnair and Alan L. Hoover, *The Magic Leaves: A History of Haida Argillite Carving* (Victoria, British Columbia, 1984), and articles by Robin Wright in *American Indian Art Magazine*, including 'The Depiction of Women in Nineteenth Century Haida Argillite Carving', 11/4 (autumn 1986), 36–45 and 'Haida Argillite—Carved for Sale', 8/1 (winter 1982), 48–55. A more controversial attempt to interpret changes in imagery is Carol Sheehan, *Pipes That Won't Smoke: Coals That Won't Burn: Haida Sculpture in Argillite* (Calgary, Alberta, 1981). Important studies of individual artists include Bill Holm's classic article, 'Will the Real Charles Edenshaw Please Stand Up', in *The World is as Sharp as A Knife* (cited above), which sheds light on problems of attribution.

Tsimshian: Viola Garfield's *The Tsimshian: Their Arts and Music*, Publication of the American Ethnology Society 18 (New York, 1951) with articles by Paul S. Wingert and Marius Barbeau provides a useful introductory discussion. Marjorie Halpin's *The Tsimshian Crest System: A Study Based on Museum Specimens and the Marius Barbeau and William Beynon Field Notes*, unpublished PhD Dissertation (Vancouver, 1973) provides the best modern anthropological investigation. Marius Barbeau's study *Totem Poles of the Gitksan, Upper Skeena River* (Ottawa, 1929), while not free of error, is an important

documentation. George F. MacDonald's *The Totem Poles and Monuments of Gitwangak Village* (Ottawa, 1984) draws together documentation for one village from Barbeau and other sources. A volume of documentation on the poles and related histories of the village of Kitwancool was edited by Wilson Duff (ed.), *Histories, Territories and Laws of the Kitwancool* (Victoria, British Columbia, 1959).

Kwakwaka'wakh, Nuxalk, and Heiltsuk: Audrey Hawthorn's overview *Kwakiutl Art* (Vancouver, 1967) focuses on the important collections of the Museum of Anthropology at the University of British Columbia. A study of one twentieth-century master carver is provided by Bill Holm, *Smokey-Top: The Art and Times of Willie Seaweed* (Seattle, 1983). On the Nuxalk see Margaret Stott's *Bella Coola Ceremony and Art* (Ottawa, 1975) and on the Heiltsuk see Martha Black's *Bella Bella: A Season of Heiltsuk Art* (Toronto, 1997).

Nuu-chah-nulth and Makah: There is almost no literature specifically on art, but Eugene Arima, *The Westcoast (Nootka) People* (Victoria, British Columbia, 1983) provides a good introduction. For early Nuu-chah-nulth material, see J. C. H. King, *Artificial Curiosities* (below) and his *Portrait Masks from the North-west Coast of America* (London, 1979); on the Makah, see Wright, *A Time of Gathering* (cited in the following section). The short *'Ny-tka: The history and survival of Nootkan culture'*, *Sound Heritage* VII, 2 (1978), edited by Barbara S. Esprat and W. J. Langlois, is one of the few publications dedicated to Nuu-chah-nulth art. For Wolf Society masks by the contemporary artist Art Thompson see Margaret B. Blackman, 'Facing the Future, Envisioning the Past: Visual Literature and Contemporary Northwest Coast Masks', *Arctic Anthropology*, 27/2 (1990), 27–40. Aldona Jonaitis' *The Yuquot Whalers' Shrine: A Study in Representation* (Seattle, forthcoming) considers a unique Nuu-chah-nulth sculptural assemblage.

Coast Salish: The most useful study of art is Wayne Suttles, 'Productivity and its Constraints: A Coast Salish Case', in Carlson (ed.), *Indian Art Traditions of the Northwest Coast* (cited above). On spirit dancing see Jay Miller, *Shamanic Odyssey: The Lushootseed Salish Journey to the Land of the Dead* (Menlo Park, Calif., 1988). An excellent overview of Coast Salish art from the state of Washington is contained in Wright (ed.), *A Time of Gathering* (cited in the bibliographic essay for Chapter 4, above). On weaving, see Paula Gustafson, *Salish Weaving* (Vancouver, 1980). Basketry is discussed in Nile Thompson and Catherine Marr, *Crow's Shield: Artistic Basketry of Puget Sound* (Seattle, 1983). Recent developments in Salish textile art are described in Elizabeth L. Johnson and Kathryn Bernick, *Hands of Our Ancestors: The Revival of Salish Weaving at Musqueam* (Vancouver, 1986).

Collecting and museum representation
For the history of collecting, early exploration, and the fur trade, see J. C. H. King, *Artificial Curiosities from the Northwest Coast of America: Native American Artefacts in the British Museum Collected on the Third Voyage of Captain James Cook and Acquired through Sir Joseph Banks* (London, 1981); Christian Feest, 'Cook Voyage Material from North America: The Vienna Collection', *Archiv für Völkerkunde* 49 (1995), 11–186; and Bill Holm and Thomas Vaughan, *Soft Gold: The Fur Trade & Cultural Exchange on the Northwest Coast of America* (Portland, 1982). A study of collecting during the second half of the nineteenth century is Douglas Cole's influential *Captured Heritage: The Scramble for Northwest Coast Artifacts* (Seattle, 1985). For the important collections of the American Museum of Natural History see Aldona Jonaitis, *From the Land of the Totem Poles* (New York, 1988). For the engagement of twentieth-century surrealist artists with this material see Cowling, 'The American Indians and the Surrealists', *Art History* (cited in the bibliographic essay for Chapter 5, above).

Twentieth-century Northwest Coast art
The early institutional support for contemporary art is documented in Audrey Hawthorne, *A Labour of Love: The Making of the Museum of Anthropology, UBC, the First Three Decades* (Vancouver, 1993); Macnair, Hoover and Neary's *The Legacy* (see above) includes important discussions of contemporary art, and George MacDonald's *'Ksan, Breath of our Grandfathers* (Ottawa, 1972) gives a brief account of the founding of the 'Ksan school. See Phil Nuytten, *The Totem Carvers: Charlie James, Ellen Neel and Mungo Martin* (Vancouver, 1982) for short discussions of three significant artists who continued to make Northwest Coast art during the first half of the twentieth century. Edwin S. Hall, Margaret B. Blackman, and Vincent Rickard documented two decades of contemporary printmaking in *Northwest Coast Indian Graphics: An Introduction to Silk Screen Prints* (Seattle, 1981) an overview of the early development of this tradition. A fine exhibition

catalogue of Northwest Coast art from the 1980s is Barbara DeMott, *Beyond the Revival: Contemporary Northwest Native Art* (Vancouver, 1989). There are two good studies of Bill Reid's art, Doris Shadbolt's *Bill Reid* (Seattle, 1986) and Karen Duffek's *Bill Reid: Beyond the Essential Form* (Vancouver, 1986). On Robert Davidson, see Hilary Stewart, *Robert Davidson, Haida Printmaker* (Seattle, 1979) and Ian M. Thom (ed.), *Robert Davidson: Eagle of the Dawn* (Seattle, 1993).

Chapter 7. The Twentieth Century
General works
There are several useful compendiums of biographical information on twentieth-century artists. Jeanne O. Snodgrass, *American Indian Painters: A Biographical Directory* (New York, 1968) is not illustrated but provides much useful information. The successor to that groundbreaking work is Patrick D. Lester, *The Biographical Directory of Native American Painters* (Tulsa, Okla., 1995). It, too, is virtually unillustrated. The most recent such survey at the time of writing is *Contemporary Native American Artists*, edited by Roger Matuz (St James Press, 1997), with artist profiles written by many scholars, and illustrated with over 150 works of art and portraits of artists. Critical writings on contemporary Native artists can be found in numerous art periodicals. A special issue of the American art periodical *Art Journal* 51/3 (1992), edited by W. Jackson Rushing and Kay WalkingStick, was devoted to the topic of 'Recent Native American Art'. *Native Peoples* magazine (published in Phoenix, Ariz., in conjunction with the National Museum of the American Indian) and *Indian Artist* magazine (published in Santa Fe) both provide coverage of contemporary arts. Substantive interviews with seventeen important contemporary artists appear in Lawrence Abbott (ed.), *I Stand in the Center of the Good* (Lincoln, Nebr., 1994). Gerhard Hoffman's *Im Shatten der Sonne: Zeitgenössische Kunst der Indianer und Eskimos in Kanada* (Stuttgart, 1988) translated as *In the Shadow of the Sun: Perspectives on Contemporary Native Art* (Hull, Quebec, 1993), and *Indianische Kunst im 20. Jahrhundert* (Munich, 1985), and Margaret Archuleta and Rennard Strickland, *Shared Visions: Native American Painters and Sculptors in the Twentieth Century* (Phoenix, Ariz., 1991) provide overviews of twentieth-century art. For contemporary traditional arts see Ralph T. Coe, *Lost and Found Traditions: Native American Art 1965–1985* (New York, 1986).

Questions of definition, commoditization, and moments of beginning
Many important works on this topic were cited above in the bibliographic essay for Chapter 1. A recent book that examines the controversial US law defining who can claim to be the maker of 'Indian' art is Gail K. Sheffield, *The Arbitrary Indian: The Indian Arts and Crafts Act of 1990* (Norman, Okla., 1997). Alfred Young Man (ed.), *Networking: Proceedings From National Native Indian Artists' Symposium IV* (Lethbridge, Alberta, 1988) contains position statements by contemporary Canadian artists. See also Robert Houle's essay in *New Work by a New Generation* (Regina, Saskatchewan, 1982). For an analytical schema, see Edwin L. Wade and Rennard Strickland, *Magic Images* (Norman, Okla., 1981). Lucy R. Lippard, *Mixed Blessings: New Art in a Multicultural America* (New York, 1990) offers a valuable cross-cultural context. Jamake Highwater's *Song from the Earth: American Indian Painting* (Boston, 1976) considers Indian painting from 1875–1975. His *The Sweet Grass Lives On: Fifty Contemporary North American Indian Artists* (New York, 1980) contains brief profiles and illustrations of the work of many contemporary artists. David M. Fawcett and Lee A. Callander, in *Native American Painting: Selections of the Museum of the American Indian* (New York, 1982) also consider work from 1875 through to the twentieth century.

The Southern Plains and the Southwest
A fine survey of Native painting, focusing in detail on the twentieth century and the role of the Studio School, written by the influential first teacher at the Studio, is Dorothy Dunn, *American Indian Painting of the Southwest and Plains Area* (Albuquerque, 1968). J. J. Brody's *Indian Painters and White Patrons* (Albuquerque, 1971) was the first critical scholarly study of twentieth-century Native painting. As the author points out in that work, because the documentation for the Oklahoma artists was less complete than the concurrent situation at the Santa Fe Studio School, many discrepancies remain about the exact development of this movement. Slightly divergent accounts are presented by Dunn and Brody. For other accounts, see Myles Libhart (ed.), *Contemporary Southern Plains Indian Painting* (Anadarko, Okla., 1972), which, despite its title, considers work from 1875–1970, and is particularly useful for its concise history of the first three decades of the twentieth century, and Lydia Wyckoff (ed.),

Visions and Voices: Native American Painting from the Philbrook Museum of Art (Tulsa, Okla., 1996) which illustrates all 484 Native American paintings in the collection of the Philbrook and is noteworthy for the extensive quotations from interviews with the artists. For a romantic, Jungian view of the Kiowa Five, and the first published images see Oscar Jacobsen, *Kiowa Indian Art* (Nice, France, 1929) which was influential in first disseminating these works to an international audience. For early twentieth-century Northern Plains painting, see Jacobson's *Sioux Indian Paintings* (Nice, France, 1938). A detailed update on the history of Oklahoma painting is provided by John Anson Warner, 'Native American Painting in Oklahoma: Continuity and Change', *The Journal of Intercultural Studies* 23 (Osaka, Japan, 1996), 14–129. A well-illustrated survey of an important collection of early twentieth-century Southwestern paintings is Tryntje Van Ness Seymour, *When the Rainbow Touches Down* (Phoenix, Ariz., 1987). Bruce Bernstein and W. Jackson Rushing, in *Modern by Tradition: Native American Painting in the Studio Style* (Santa Fe, 1995), provide an illuminating look at this key era and illustrate many previously unpublished works.

The display and marketing of American Indian art: exhibitions, mural projects, and competitions

Some of the major surveys of twentieth-century art cited above cover this topic. See also Rushing, *Native American Art and the New York Avant-Garde*, cited in the bibliographic essay for Chapter 1, above; Robert Schrader, *The Indian Arts and Crafts Board: An Aspect of New Deal Indian Policy* (Albuquerque, 1983), and Christine Nelson, 'Indian Art in Washington: Native American Murals in the Department of the Interior Building', *American Indian Art* 20/2 (spring 1995), 70–81.

Native American and Native Canadian modernisms

A fine essay on three important artists by W. Jackson Rushing, 'Authenticity and Subjectivity in Post-War Painting: Concerning Herrera, Scholder, and Cannon', is included in Archuleta and Strickland, *Shared Visions*, cited above. Important group catalogues include: Garry Mainprize, *Stardusters* (Thunder Bay, Ontario, 1986); Vancouver Art Gallery, *Beyond History* (Vancouver, 1989); Jaune Quick-to-See Smith, *Our Land/Ourselves: American Indian Contemporary Artists* (Albany, NY, 1990); Marcia Crosby, *Nations in Urban Landscapes* (Vancouver, 1997); Janet Clark (ed.), *Basket, Bead and Quill* (Thunder Bay, Ontario, 1996); Lloyd Kiva New, *American Indian Art in the 1980s* (Niagara Falls, NY, n.d.); and Karsten Ohrt, Lucy Lippard, and Vagn Lundbye, *Skijin Ao Waja, Indian Time: Contemporary Indian Art* (Odense, Denmark, 1994). Two female artists, one Native and one non-Native, curated a landmark exhibition and catalogue of women's arts in diverse media: Harmony Hammond and Jaune Quick-to-See Smith, *Women of Sweet Grass, Cedar, and Sage* (New York, 1985). See also Rick Hill (ed.), *Creativity is Our Tradition: Three Decades of Contemporary Indian Art at the Institute of American Indian Arts* (Santa Fe, 1992).

Several major exhibits and catalogues organized in response to the Columbus Quincentenary of 1992 include: Jaune Quick-to-See Smith, *The Submuloc Show/Columbus Wohs: A Visual Commentary on the Columbus Quincentenial from the Perspective of America's First People* (Phoenix, Ariz., 1992); Gerald McMaster and Lee-Ann Martin (eds), *Indigena: Contemporary Native Perspectives* (Vancouver and Quebec, 1992); Diana Nemiroff, Robert Houle, and Charlotte Townsend-Gault, *Land Spirit Power: First Nations at the National Gallery of Canada* (Ottawa, 1992).

Many useful works have been published focusing on regional Canadian traditions. These include: the Winnipeg Art Gallery, *Treaty Numbers 23, 287, 1171: Three Indian Painters of the Prairies* (Winnipeg, 1972); Norman Zepp and Michael Parke-Taylor, *Horses Fly Too* (Regina, Saskatchewan, 1984); Royal Ontario Museum Ethnology Department, *Contemporary Native Art of Canada—The Woodland Indians* (Toronto, 1976); Elizabeth McLuhan and Tom Hill, *Norval Morrisseau and the Emergence of the Image Makers* (Toronto, 1984); Mary E. Southcott, *The Sound of the Drum: The Sacred Art of the Anishnabec* (Erin, Ontario, 1984); Royal Ontario Museum, *The Art of the Anishnawbek: Three Perspectives* (Toronto, 1996); Norma Dinniwell and Tom Hill, *From Masks to Maquettes* (London, Ontario, 1985); Wolfgang M. Prudek, *Carrying the Message: An Introduction to Iroquois Stone Sculpture* (Dundas, Ontario, 1986); and Vivian Gray and Mora Dianne O'Neill, *Pe'lA'tukwey: let me … tell a story—Recent Work by Mi'kmaq and Maliseet Artists* (Nova Scotia, Halifax, 1993).

Photography

Superb surveys of photographs of and by Native Americans, with critical writings by Native American artists themselves, can be found in Lucy Lippard (ed.), *Partial Recall: Photographs of Native North Americans* (New York, 1992), and in a special publication of *Aperture* magazine (1995) entitled *Strong Hearts: Native American Visions and Voices*. Work by an early Kiowa photographer is documented in Linda Poolaw, *War Bonnets, Tin Lizzies, and Patent Leather Pumps: Kiowa Culture in Transition, 1925–1955* (Stanford Calif., 1990). Lynn Hill examines work by Canadian Native photographers in **Alter** *Native: Contemporary Photo Compositions* (Kleinburg, Ontario, 1995). See also Victoria Henry and Shelley Niro, *From Icebergs to Iced Tea* (Ottawa, 1994).

Individual artists

Catalogues and monographs on individual artists (in alphabetical order by the name of the artist) include: Elizabeth McLuhan, *Altered Egos: The Multimedia Work of Carl Beam* (Thunder Bay, Ontario, 1984); Winnipeg Art Gallery, *Jackson Beardy: A Life's Work* (Winnipeg, 1995); William Wallo and John Pickard, *T. C. Cannon— Native American: A New View of the West* (Oklahoma City, 1990); Thunder Bay National Exhibition Centre and Centre for Indian Art, *Joane Cardinal-Schubert: This is my History* (Thunder Bay, Ontario, 1985); Deidre Simmons, *Colleen Cutschall: Voice in the Blood* (Brandon, Manitoba, 1990); Shirley Madill, Allan Ryan and Ruth Phillips, *Colleen Cutschall: House Made of Stars* (Winnipeg, 1996); Laura Mulvey, Dirk Snauwaert, Mark Alice Durant, *Jimmie Durham* (New York, 1995); Jonathan Batkin (ed.), *Harry Fonseca: Earth, Wind, and Fire* (Santa Fe, 1996); Jeanette Ingberman, *Claim Your Color: Hachivi Edgar Heap of Birds* (New York, 1989); Jay Scott, *Changing Woman: The Life and Art of Helen Hardin* (Flagstaff, Ariz., 1989), W. Jackson Rushing (ed.), *The Studio of Allan Houser* (Santa Fe, 1996); the Heard Museum, *Houser and Haozous: A Sculptural Retrospective* (Phoenix, Ariz., 1984); Frederick J. Dockstader (ed.), *Oscar Howe: A Retrospective Exhibition* (Tulsa, Okla., 1982); Lee-Ann Martin, *The Art of Alex Janvier: His First Thirty Years, 1960–1990* (Thunder Bay, Ontario, 1993); Andrea Liss and Roberto Bedoya, *James Luna—Actions and Reactions: An Eleven Year Survey of Installation/ Performance Work 1981–1992* (Santa Cruz, 1992); Gerald McMaster (ed.), 'Savage Graces "after images"', *Harbour* 3/1 (winter 1993–4); Allan J. Ryan, *The cowboy/Indian Show: Recent Work by Gerald McMaster* (Kleinburg, Ontario, 1991); Lister Sinclair and Jack Pollock, *The Art of Norval Morrisseau* (Toronto, 1979); Minnesota Museum of Art and Tweed Museum of Art, *Standing in the Northern Lights: George Morrison, A Retrospective* (Minneapolis, Minn., 1990); Elizabeth McLuhan and R.M. Vanderburgh, *Daphne Odjig: A Retrospective 1946–1985* (Thunder Bay, Ontario, 1985); Samuel L. Gray, *Tonita Peña* (Albuquerque, 1990); Gerald McMaster, *Edward Poitras: Canada XLVI Biennale di Venezia* (Hull, Quebec, 1995); Thunder Bay Art Gallery, *Who Discovered the Americas?: Recent Work by Jane Ash Poitras* (Thunder Bay, Ontario, 1992); Bob Boyer, *Kiskayetum: Allen Sapp, A Retrospective* (Regina, Saskatchewan, 1994); Adelyn Breeskin, *Two American Painters: Fritz Scholder and T. C. Cannon* (Washington, DC, 1972); Fritz Scholder and Joshua C. Taylor, *Fritz Scholder/ The Retrospective 1960–1981* (Tucson, Ariz., 1981); Alejandro Anreus (ed.), *Subversions/ Affirmation: Jaune Quick-To-See Smith, A Survey* (Jersey City, NJ, 1996); Lee A. Callander and Ruth Slivka, *Shawnee Home Life: The Paintings of Earnest Spybuck* (New York, 1984); Hugh A. Dempsey, *Tailfeathers, Indian Artist* (Calgary, 1978), Sally Hyer, *'Woman's Work': The Art of Pablita Velarde* (Santa Fe, 1993); Andrea Robinson, *Denise and Samuel Wallace: Ten Year Retrospective Exhibition* (Scottsdale, Ariz., 1996); and Lucy Lippard, *Neezáá: Emmi Whitehorse, Ten Years* (Santa Fe, 1991).

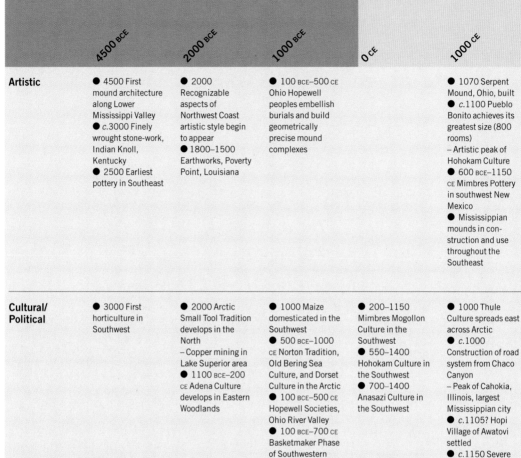

	4500 BCE	**2000 BCE**	**1000 BCE**	**0 CE**	**1000 CE**
Artistic	● 4500 First mound architecture along Lower Mississippi Valley ● c.3000 Finely wrought stone-work, Indian Knoll, Kentucky ● 2500 Earliest pottery in Southeast	● 2000 Recognizable aspects of Northwest Coast artistic style begin to appear ● 1800–1500 Earthworks, Poverty Point, Louisiana	● 100 BCE–500 CE Ohio Hopewell peoples embellish burials and build geometrically precise mound complexes		● 1070 Serpent Mound, Ohio, built ● c.1100 Pueblo Bonito achieves its greatest size (800 rooms) – Artistic peak of Hohokam Culture ● 600 BCE–1150 CE Mimbres Pottery in southwest New Mexico ● Mississippian mounds in construction and use throughout the Southeast
Cultural/ Political	● 3000 First horticulture in Southwest	● 2000 Arctic Small Tool Tradition develops in the North – Copper mining in Lake Superior area ● 1100 BCE–200 CE Adena Culture develops in Eastern Woodlands	● 1000 Maize domesticated in the Southwest ● 500 BCE–1000 CE Norton Tradition, Old Bering Sea Culture, and Dorset Culture in the Arctic ● 100 BCE–500 CE Hopewell Societies, Ohio River Valley ● 100 BCE–700 CE Basketmaker Phase of Southwestern Culture	● 200–1150 Mimbres Mogollon Culture in the Southwest ● 550–1400 Hohokam Culture in the Southwest ● 700–1400 Anasazi Culture in the Southwest	● 1000 Thule Culture spreads east across Arctic ● c.1000 Construction of road system from Chaco Canyon – Peak of Cahokia, Illinois, largest Mississippian city ● c.1105? Hopi Village of Awatovi settled ● c.1150 Severe drought in Southwest affects settlement and migration ● 1200–1500 Athapaskan peoples (Navajo and Apache) arrive in Southwest

- *c.*1250 Highpoint of architecture at complexes such as Cliff Palace, Mesa Verde
- *c.*1300–1500 Heightened ceremonial activity associated with 'medicine wheels' on the northern and central Plains

- 1500 Northwest Coast community of Ozette, Washington, covered by mudslide, which preserves plank houses and numerous artefacts
- 1500–1800 Navajo learn weaving and ceremonial arts from Pueblo neighbours

- 1540 Cicuye (Pecos) Pueblo at its height as great architectural complex and trading centre

- *c.*1275 Second widespread drought in Southwest causes migration to Rio Grande River Valley and Mogollon River area
- *c.*1390 According to historians, the date of the founding of the League of the Haudenosaunee (Iroquois)
- 1492 Columbus reaches the Americas
- 1497 John Cabot's voyage of exploration

- 1500 Calusa culture flourishes at Key Marco in southern Florida
- 1503 Passamaquoddy and Abenaki (Maine) trade with English fishermen
- 1506–18 Huron and Iroquois trade with Basque and French fishermen and fur traders
- 1513 Calusas drive off Ponce de Leon expedition, Florida

- 1521 Second Ponce de Leon expedition among the Calusa, Florida
- 1523–4 Verrazano encounters Narragansett and Wampanoag Indians along the Atlantic Coast
- 1528 Timucua resist Spanish settlement near Tampa Bay, Florida
- 1534 Mi 'kmaq Indians trade with Jacques Cartier, Gulf of St Lawrence
- 1535–41 St Lawrence Iroquois trade with French at Hochelaga, Montreal
- 1539–43 Hernan de Soto's expedition through southeastern US unleashes violence and epidemics across a broad region

- 1540–2 Coronado's expedition from Mexico into the Southwest
- 1541 Tigeux Rebellion, Kuaua Pueblo, New Mexico

- 1576 Martin Frobisher's first contact with Inuit of Eastern Arctic
- 1579 Sir Frances Drake sailed into bay near Point Reyes, California

- 1585–1607 Sir Walter Raleigh founds settlement on Roanoke Island, North Carolina
- 1590–8 Invasion of Rio Grande Pueblos by Spanish
- 1598 Acoma resistance to Spanish invasion of Southwest

	1600 CE	1625 CE	1650 CE	1675 CE	1700 CE
Artistic	● 17th century Northeastern peoples enrich burial offerings of indigenous shell and copper with new trade goods				● 18th century Wampum belts and strings come into use to seal agreements between Europeans, Iroquois, and Anishnabe nations – The Pawnee's Calumet dance spreads east to the Iroquois
Cultural/ Political	● 1600 Juan Oñate colonized New Mexico for Spain; Apaches, Navajo, and Utes taken as slaves ● 1607 Jamestown, Virginia, settled by British ● 1609 War between Powhatan and English in Virginia ● 1616 The Huron welcome Champlain, leader of New France, as a guest in their villages; French–Huron trading partnership formed ● 1616–19 Smallpox epidemic decimates Indian tribes of New England ● 1620 Arrival of Pilgrims at Plymouth, Massachusetts ● 1622 Jamestown Colony burned by Powhatan	● 1633 Zuni Revolt aginst the Spanish ● 1636–7 The Pequot War (Connecticut) ● 1636–48 The Iroquois and Huron Wars result in the destruction of the Huron Confederacy ● c.1637 Ute (Great Basin) acquire Spanish horses ● 1638 Quinnipiac Indians confined to reservation (Connecticut) ● 1639 Taos Indians take Spanish horses to the Southern Plains	● 1670–85 Hudson's Bay Company builds five fur-trading forts on Hudson Bay	● 1675–6 King Phillip's War, New England ● 1680 Pueblo Revolt ● 1682–3 Lenape Indians (Delaware) make a treaty with William Penn permitting a colony in Philadelphia	● c.1700 Siouxian speaking peoples migrate from Great Lakes to Plains ● 1713 Mi 'kmaq and Maliseet remain loyal to French and to Catholicism, refusing to recognize the authority of the English (Maritime Canada) ● 1721 Danes and Norwegians settle in Greenland ● 1722–3 The Tuscarora join the Iroquois Confederacy ● 1724–9 The Natchez revolt against the French on the Lower Mississippi River

● 1725 Quebec nuns, taught to use moose hair by Native women, invent souvenirs of moose hair and birchbark
– Mi'kmaq invent new forms of porcupine quillwork for the curio trade

● 1750 Creek, Anishnabe, Iroquois and other eastern peoples invent new styles of dress combining European and Native elements

● c.1820 Haida invent new uses for argillite to supply the European curio trade
● 1820s Tuscarora artists Dennis and David Cusick use Western pictorial formats to record indigenous oral traditions and to chronicle contemporary events

● 1830–50 Grey Nuns begin to teach floral embroidery to Métis and Dene at schools in Fort Chipewyan and Winnipeg; style spreads widely
● c.1830–1900 Northeastern Native artists create new souvenir commodities in beadwork, basketry, and quillwork to serve demand at Niagara Falls and other sites

● 1741 Vitus Bering explores the Northwest Coast and Russians settle in southwestern Alaska

● 1754–63 French and British ally with Indian nations during the Seven Years War
● c.1760 The horse spreads to all Nations on the Great Plains
● 1763 British victory at Quebec ends the Seven Years War and drives the French out of Canada
● 1769 First Spanish mission, San Diego, California

● 1774–80 Canadian traders and Hudson's Bay Company establish fur-trade posts across Northern Plains
● 1778 Captain James Cook sails along Northwest Coast, contacts Nuu-chah-nulth and Haida
● 1780–2 Smallpox epidemic decimates tribes on the Great Plains
● 1783 American Revolution creates conflicts among Iroquois, and destabilizes the Confederacy
● 1784–5 Joseph Brant leads Mohawk and other Iroquois groups to lands reserved for them by British in Upper Canada (Ontario)

● 1791 Alejandro Malaspina sails through Northwest Coast region
● 1799 Seneca clan leader Handsome Lake receives the visions which later result in the Longhouse religion

● 1802 Tlingit Indians destroy Russian settlement of New Archangel (Sitka)
● 1805–6 Sacajawea, a Shoshone woman, serves as interpreter and guide on Lewis and Clark's expedition
● 1823 Sequoyah develops the Cherokee syllabary

● 1830–60 US Government Removals policies force the Five Civilized Tribes of the Carolinas and many other Eastern tribes to 'Indian Territory' (Oklahoma)
● 1833–4 Artist Karl Bodmer and Prince Maximilian of Wied visit Missouri River tribes
● 1837 Smallpox epidemic decimates Mandan and Hidatsa on the Northern Plains
● 1848 Maidu discovery of gold on the American River (California) inaugurates the Gold Rush
● 1849–50 Pomo massacre in California

	1850 CE	1870 CE	1880 CE	1885 CE	1890 CE
Artistic	● 1850 Navajo Atsidi Sani learns jewellery making techniques from Mexican blacksmiths; technology spreads throughout Navajo and Pueblo regions ● 1870–80 'Eyedazzler' patterns and Germantown yarns introduced in Navajo weaving	● 1875–8 Southern Plains warriors incarcerated at Fort Marion, Florida draw many autobiographical sketchbooks ● 1879–85 As part of its massive collecting project, Smithsonian Institution anthropologists remove more than 6,500 pottery vessels from Pueblo towns		● 1885–90 Hopi potter Nampeyo and husband Lesou revive the 15th and 16th century Sityatki style based on study of pots recently excavated by Fewkes ● c.1885–1905 Influx of prospectors and tourists to Alaska causes a boom in the curio trade	● 1890s Kiowa artist Silverhorn works with anthropologist James Mooney of the Smithsonian ● 1890–1920 Persian carpet designs adapted by Navajo weavers ● 1899–1908 Pueblo and Navajo artists make first paintings on paper for non-Native audience
Cultural/ Political	● 1851 First Treaty of Fort Laramie with Plains Indians ● 1862 Smallpox epidemic decimates Haida on Queen Charlotte Islands ● 1862–4 Navajo Long Walk and imprisonment at Bosque Redondo ● 1864 The Sand Creek Massacre of Southern Cheyenne people by the Colorado militia ● 1867 Transcontinental railroad built through Northern Plains – Inauguration of 'Reservation Era' on the Great Plains	● 1875 Gold Rush in Black Hills, South Dakota ● 1876 Lakota, Cheyenne, and Arapaho kill Custer's 7th Cavalry at the Battle of Little Big Horn ● 1877 The Nez Perce War – Sitting Bull and his Lakota followers flee to Canada to avoid persecution by US Government forces ● 1878 Hampton Institute, Virginia, a school for blacks, accepts Native students ● 1879 Carlisle Indian School founded, Pennsylvania	● 1880 Bacone College established as an Indian College, Oklahoma ● 1882 Railroad brings manufactured goods and tourists to Navajo and Pueblo region ● 1883 Sun Dance banned by US Government ● 1871–90 Near extermination of the buffalo by white hunters on the Great Plains	● 1885 Canada passes the Indian Act—potlatch and traditional rituals become illegal ● 1887 US Congress passes Dawes Severalty Act—facilitates alienation of Native reservation lands ● 1889–90 Ghost Dance Religion spreads across Great Basin and Plains through teachings of Paiute prophet Wovoka	● 1890 Massacre of Lakota at Wounded Knee by US Government soldiers

1900 CE

1910 CE

1920 CE

1930 CE

1940 CE

1945 CE

- 1904 Maria and Julian Martinez demonstrate pottery making at the St Louis World's Fair

- 1914 Washoe basketmaker Louisa Keyser's fame reaches its peak
- 1915 Baleen baskets first made by Iñupiaq men as a by-product of whaling
- 1918 Maria and Julian Martinez make first modern black-on-black ware

- 1927 Northwest Coast and Euro-Canadian art exhibited together in 'Exhibition of Canadian West Coast Art', National Gallery of Canada
- 1927–8 'Kiowa Five' study art with Oscar Jacobson at University of Oklahoma
- 1929 Work of Kiowa Five exhibited at the International Folk Art Congress, Prague, Czechoslovakia

- 1930s US Government New Deal programmes support Native art initiatives across the US
- 1931 Exposition of Indian Tribal Art, New York City
- 1932 Dorothy Dunn establishes Studio School art programme, Santa Fe Indian School
- 1936 Indian Arts and Crafts Board established in US
- 1939 Indian art featured at the Golden Gate International Exposition, San Francisco

- 1940 Oscar Howe paints WPA-sponsored murals, Carnegie Library, Mitchell, South Dakota
- 1941 'Indian Art of the United States' exhibition, Museum of Modern Art, New York City

- 1945 Hopi artist Fred Kabotie receives Guggenheim Fellowship
- 1946 Annual juried exhibitions inaugurated, Philbrook Museum, Tulsa, Oklahoma

- 1910–20 Many Native children in Canadian residential schools die of tuberculosis
- 1912 Jim Thorpe (Sauk and Fox) wins the decathlon at the Olympic Games, Norway
- 1918 Formal establishment of the Native American Church (peyote religion)

- 1921 Forty-five Kwakwaka'wakw people arrested for attending Daniel Cranmer's potlatch. They are forced to surrender all masks and other regalia to avoid imprisonment
- 1924 Native American peoples granted US citizenship and voting rights

- 1934 The Indian Reorganization Act ('The Indian New Deal') passed in US

- 1944 National Congress of American Indians founded in US

- 1945 Native soldiers returning from World War II boost Native political activism in the US and Canada, increase trend to urban migration
- 1948–60 Canadian Government establishes permanent settlements for Inuit in the Arctic, some groups experience forced relocation

Timeline

	1945 CE	1950 CE	1955 CE	1960 CE	1965 CE
Artistic	● 1949 Apache artist Allen Houser receives Guggenheim Fellowship – Success of the first exhibition of Canadian Inuit soapstone sculptures, Canadian Guild of Handicrafts, Montreal, leads to rapid growth of the new art	● 1950 Mungo Martin hired to restore totem poles at the University of British Columbia, an initial moment of the Northwest Coast 'Renaissance'	● 1958–62 Norval Morrisseau develops the elements of the new Anishnabe art in northern Ontario mentored by several Euro-Canadian artists ● 1959 West Baffin Eskimo Co-operative issues first edition of graphic art prints	● 1962 The overnight success of Norval Morrisseau's first one-man show, Toronto, gives momentum to new school of Anishnabe painting – Founding of the Institute of American Indian Art, Santa Fe	● 1965 Native Arts Program inaugurated, University of Alaska, Fairbanks – Bill Holm publishes influential *Northwest Coast Indian Art: An Analysis of Form* ● 1967 Newly commissioned Native art from across Canada appeared in Indians of Canada Pavilion, Expo '67, Montreal World's Fair – Canadian Inuit artist Kenojuak Ashevak awarded the Order of Canada
Cultural/ Political		● 1950 Lakota openly revive the Sun Dance ● 1951 Canada's Indian Act amended; compulsory enfranchisement and ban on the potlatch dropped ● 1953 Mungo Martin holds potlatch at the British Columbia Provincial Museum		● 1961 National Indian Council, the first national Canadian Native political organization formed	● 1968 US Congress passes American Indian Civil Rights Act – American Indian Movement (AIM) founded by Dennis Banks and Russell Means ● 1969 N. Scott Momaday (Kiowa) is awarded the Pulitzer Prize for Fiction – At the Haida Village of Masset, Robert Davidson errects the first new Haida totem pole to be carved since the late 19th century

1970 CE	1975 CE	1980 CE	1985 CE	1990 CE	1995 CE

● 1970 'Ksan Art School and Cultural Centre established, Hazelton, northern British Columbia – Six Nations Iroquois Confederacy petitions US courts for the return of wampum belts held in New York State Museum
● 1972 Sarain Stump founds the Ind[ian]art Project, Saskatchewan Indian Cultural College – Saulteaux artist Robert Houle helps to establish Manitou College, La Macaza, Quebec
● 1974 Canadian Inuit artist Pitseolak Ashoona elected to the Royal Canadian Academy of Arts

● 1975 Woodland Cultural Centre Museum, Brantford, Ontario, initiates annual exhibitions of contemporary Native art
● 1976 Bill Reid's monumental sculpture, 'Raven and the First Men', unveiled at the new Museum of Anthropology, University of British Columbia

● 1984 Canadian Inuit artist Jessie Oonark awarded the Order of Canada

● 1989 US legislation authorizes establishment of the National Museum of the American Indian

● 1990 US Government passes the Indian Arts and Crafts Act
● 1992 Assembly of First Nations and Candian Museum Association accept report of Canada's Task Force on Museums, and establish guidelines for partnership and repatriation – Columbus Quincentennial marked by major exhibitions of contemporary Native Art: 'Land/Spirit/Power', National Gallery of Canada; 'Indigena', Canadian Museum of Civilization; 'The Submuloc Show/Columbus Wohs' organized by Atlatl

● 1995 The works of Plains Cree artist Edward Poitras represent Canada at the Venice Biennale in an exhibition curated by Plains Cree, Gerald McMaster

● 1971 Alaska Native Claims Settlement Act awards 44 million acres and $962 million to indigenous people of Alaska
● 1973 AIM occupation of Wounded Knee on Pine Ridge Reservation, South Dakota, and siege by FBI

● 1976 Saskatchewan Indian Federated College is first Native-controlled college in Canada
● 1977 First Inuit Circumpolar Conference, Barrow, Alaska
● 1978 American Indian Religious Freedom Act signed and incorporated into US law

● 1980 U'mista Cultural Centre opens at Alert Bay, British Columbia

● 1988 Indian Gaming Regulatory Act permits establishment of gambling facilities on Indian land in the US

● 1990 Elijah Harper (Cree) stops ratification of the Meech Lake Accord in the Manitoba legislature – Mohawk protests over the building of a golf course on a burial ground at Oka and Kahnawake, Quebec escalate into a summer-long confrontation with the Canadian army

● 1996 Canada, British Columbia, and the Nisga'a Tribal Council initial an Agreement in Principle, the future basis for the first modern-day treaty in British Columbia

Index

The Oxford History of Art is an important new series of books that explore art within its social and cultural context using the most up-to-date scholarship. They are superbly illustrated and written by leading art historians in their field.

'Oxford University Press has succeeded in reinventing the survey ... I think they'll be wonderful for students and they'll also appeal greatly to members of the public ... these authors are extremely sensitive to works of art. The books are very very lavishly illustrated, and the illustrations are terribly carefully juxtaposed.'
Professor Marcia Pointon, Manchester University speaking
on *Kaleidoscope*, BBC Radio 4.

'Fully and often surprisingly illustrated, carefully annotated and captioned, each combines a historical overview with a nicely opinionated individual approach.'
Independent on Sunday

'[A] highly collectable series ... beautifully illustrated ... written by the best new generation of authors, whose lively texts offer clear syntheses of current knowledge and new thinking.'
Christies International Magazine

'The new series of art histories launched by the Oxford University Press ... tries to balance innovatory intellectual pizzazz with solid informativeness and lucidity of presentation. On the latter points all five introductory volumes score extremely well. The design is beautifully clear, the text jargon-free, and never less than readable.'
The Guardian

'These five books succeed admirably in combining academic strength with wider popular appeal. Very well designed, with an attractive, clear layout and carefully-chosen illustrations, the books are accessible, informative and authoritative.'
The Good Book Guide

'A welcome introduction to art history for the twenty-first century. The series promises to offer the best of the past and the future, mixing older and younger authors, and balancing traditional and innovative topics.'
Professor Robert Rosenblum, New York University

Oxford History of Art

Titles in the Oxford History of Art series are up-to-date, fully-illustrated introductions to a wide variety of subjects written by leading experts in their field. They will appear regularly, building into an interlocking and comprehensive series. Published titles are highlighted